THE
35MM
HANDBOOK

THE
35MM
HANDBOOK

MICHAEL FREEMAN

A COMPLETE COURSE FROM BASIC
TECHNIQUES TO PROFESSIONAL APPLICATIONS

NEW
BURLINGTON
BOOKS

A QUARTO BOOK

New Burlington Books
32, Kingly Court
London W1.

ISBN 0 906286 21 2

© Copyright 1980 Quarto Publishing Limited
All rights reserved.

Filmset in Britain by Parker Typesetting Service, Leicester
Color origination by Dai Nippon, Hong Kong
Printed in Hong Kong by Dai Nippon.

Consultant Editor
John Smallwood
Editor
Gillian Harvey
Art Editor
Neville Graham
Designer
Clive Hayball

Illustrators
Sotos Achilleos
Richard Blakely
Bill Easter
Edwina Keene
David Mallott
Chris Mynheer
Simon Roulstone
David Staples
Ed Stuart
David Weeks
Martin Woodford
David Worth

Picture Research
Mark Dartford

Paste-up
Gunna Finnsdottir

All photographs by Michael Freeman
except where individually credited.

Contents

Introduction

UNLIKE ANY OTHER important creative medium, photography is instant. Complex scenes can be recorded in a fraction of a second, and with great simplicity. No apprenticeship is necessary to be able to take a basic picture, and with the latest automatic cameras a technically accurate photograph is virtually assured.

Nothing has contributed more to the popularity of photography than the 35mm camera. It was invented to make use of 35mm cine film stock; for the first time, a large number of pictures could be taken, rapidly and without the inconvenience of re-loading after each shot. Small, highly portable and fast to operate, this new format quickly became popular, first with professional photojournalists who saw the opportunities it gave for a new, more immediate kind of photography, and later with the general public. The 35mm camera now dominates the mass camera market; its manufacturing development is highly sophisticated, and constant improvements in design make it easier to handle yet more accurate and versatile.

Photography is now so simple and so immediately gratifying that for millions of people it has become the most popular means of self-expression. Because of this, the range of photographs taken is enormous, and the majority have no pretensions to creativity. They are usually straightforward, record-keeping memories of holidays, family and friends. It is the sheer ubiquity of the camera and its simple operation that have broadened the way it is used. It can be simply a kind of notebook, or a means of producing fine art; the results can range from the striking to the banal; and the only link between all these images is the photographic process.

With modern 35mm cameras and photographic pro-

cedures, there may seem less and less need for craftsmanship. The very fact that a photograph can be taken so rapidly, and often effortlessly, makes it difficult to distinguish between serious purpose and casual snapshot. There appear, on the face of it, to be few accepted standards. Even in serious, creative photography there is such a diversity of styles, approaches and philosophy that there is seldom complete agreement over what makes a successful picture. Most photo-journalists hold strongly to simplicity and honesty in their work, whereas the success of still-life photography often hangs on an ability to manipulate the subject and create illusions.

Nevertheless, whether photography is concerned with reporting events or with creating pictures from the imagination, some underlying qualities remain constant. First, craftsmanship *is* necessary if full use is to be made of the camera's possibilities; without technical skill, the photographer is at the mercy of chance. Second, in order to develop a style, it is important to be subjective, to follow one's own ideas rather than other people's; a bland point of view and lack of conviction tend to produce bland photographs. Third, and most important, good photography is innovative. For better or worse, it is strongly influenced by fashions in imagery; successful photography builds on, and develops from, existing styles rather than repeating them.

Whatever the theme or subject, there is always one essential element in good photography – the image is in some way fresh and striking. There may be more opportunities for this in some fields of photography than in others, but there are very few picture-taking situations that cannot be improved by a new, fresh look. This is the most important standard of photography.

1: Techniques

PHOTOGRAPHY RELIES MORE on technology than any other major creative medium. Not only do you need a thorough knowledge of the equipment in order to make the most of it, but the processes themselves can influence the work you do.

One result of the constant flow of technical improvements that has occurred throughout the history of photography has been to simplify basic picture-taking. Most aspects of camera work are becoming automated, from loading film to exposure measurement, and even focusing. These advances are usually aimed at the amateur, and are often made at the expense of creative control. Cameras that automatically adjust the exposure do so by making an 'average' judgement of the scene; inevitably this works against the originality that lies at the heart of good photography. Technical improvements, therefore, need to be approached with some caution.

Familiarity and proficiency with camera technology are essential for two reasons. Firstly, there now exists a vast technological clutter that can easily get in the way of actual photo-

graphy. If you have a good knowledge of the equipment and processes – and their merits – you can avoid getting trapped into using technique for its own sake.

Secondly, the increasing rate of technological innovation opens up new possibilities in imagery. In the search for new approaches to photography, new techniques can stimulate fresh ideas. The invention of the motor drive, for example, not only opened up new possibilities in action photography, but also made remote control photography realistic and practical. Much modern wildlife photography would not have been possible without it.

New techniques, in all areas of photography, are developed and marketed each year. Some are little more than gimmicks, others fail to live up to the manufacturers' claims, and sifting through all of them can seem a bewildering exercise. As a general rule, first master the basic techniques, and then judge each new product in terms of what it can do for your particular style of work.

Optics

The eyeball

Nearly spherical and slightly more than 2cm (¾in) in diameter, the eyeball is filled with a jelly-like fluid – the vitreous humor – that keeps it firm. The transparent cornea is part of the eye's outer surface, and is primarily responsible for forming an image. The iris behind is an adjustable diaphragm that controls light intensity and the lens adjusts fine focus by changing shape. The image is projected onto the light sensitive retina, which transmits the information to the lens through the optic nerve. This direct neural link to the brain makes the eye virtually an extension of the brain.

Rods and cones. A cross-section through part of the retinal wall at the edge of the fovea (below) shows the eye's light-gathering apparatus – rods and cones. Light-sensitive, pigmented chemicals in the cones react to different wavelengths – red, green or blue – and record color. The rods, insensitive to color but very sensitive to the intensity of light, contain a pigment called rhodopsin. Rods and cones are not evenly distributed across the retina – in the fovea, the area where the most detailed images are recorded, only cones are found.

An arrangement of neural linkages assembles all the information and transmits it towards the brain.

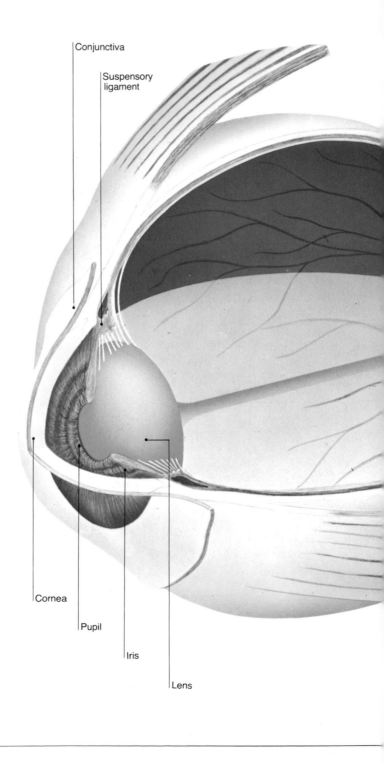

Conjunctiva

Suspensory ligament

Cornea

Pupil

Iris

Lens

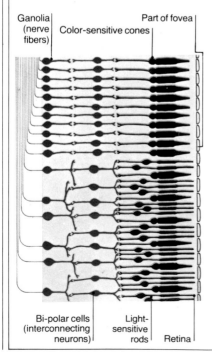

Ganolia (nerve fibers)

Color-sensitive cones

Part of fovea

Bi-polar cells (interconnecting neurons)

Light-sensitive rods

Retina

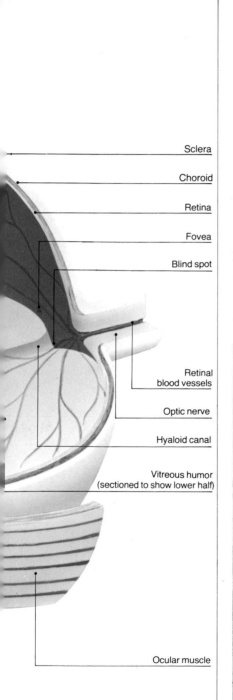

Sclera

Choroid

Retina

Fovea

Blind spot

Retinal
blood vessels

Optic nerve

Hyaloid canal

Vitreous humor
(sectioned to show lower half)

Ocular muscle

PHOTOGRAPHY IS THE manipulation of light to create and fix images. The study of light and the way it behaves is optics. The physical properties of light, such as wavelength and refraction, determine the way it can be used, but ultimately, images are only recognized and interpreted by the complex mechanism of the eye and brain. Perception goes beyond physical processes, and it is this that is the final concern of photography.

The human eye and brain

Close comparisons are frequently made between the operation of the camera and the human eye. Many features of both function in the same way, but the similarities, though interesting, can be misleading when it comes to understanding still photography. What is important, however, is the relationship between our visual interpretation of a scene, and our reaction to the photographic record of that scene. A photograph is a graphic, two-dimensional, selective instant of time and place. As photographers, our perception of a scene coupled with a knowledge of what our camera can do, determine the final image. As viewers of photographs, we have no direct experience of the event displayed; rather we make our own reconstruction from the image in front of us.

In our conscious activity we probably now rely more upon our vision than on any other sensory input, although there is no way of

How the eye focuses

Although most of the eye's focusing depends on the shape and thickness of the cornea, the fine adjustments are made by changing the shape of the lens. Because we use distant vision more than anything else, this is the relaxed state of the eye, with the ligaments pulling the lens into a flat disc. For close focusing, the shape of the lens must be more circular; to do this, the ciliary muscles constrict while the ligaments relax.

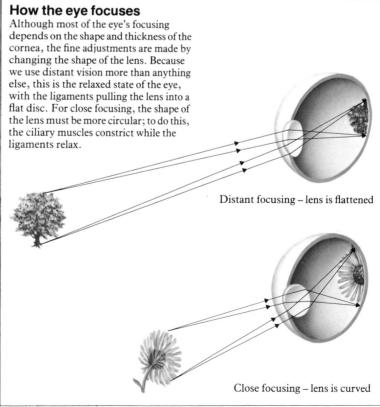

Distant focusing – lens is flattened

Close focusing – lens is curved

11

quantifying this. Our eyes are essentially extensions of the brain, with direct neural links through the optic nerves. The image that is recorded by light-sensitive cells in the retina is not transmitted as a kind of internal picture to a viewing screen in the brain. Rather, the neural activity that is stimulated by the image on the retina represents the object to the brain.

Light sensitivity

The eye's light-sensitive mechanisms are relatively straightforward. The retina is a highly specialized part of the brain located at the back of the eye – in the equivalent position of the film plane in a camera. It contains a dense pattern of light-sensitive receptor cells, some of them (called cones) having evolved to work in bright light and capable of analyzing color, others (the rods) providing a coarse gray vision in dim light.

The density of these photo-receptors is one of the things that determines the eye's ability to resolve fine detail. In the central region, they are packed tightly together, and it is this part of the retina, the fovea, that gives us our sharpest vision. Away from the fovea, the cells become more spread out, and correspondingly our peripheral vision is more blurred. There is an obvious comparison with the grains in a photographic emulsion, but in the case of the human eye, these are the equivalent of two interlocking emulsions. The cones, for daylight color vision, are one pattern, and the rods, more widely spaced, another coarser pattern. To stretch the analogy, this is like having a

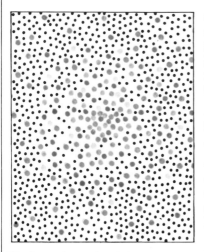

The fovea. Across the whole retina, there are more than 120 million rods, here represented by black dots, yet less than ten million of the color sensitive cones. However, close to the fovea (above) there are fewer rods, and actually in the fovea there are none at all. This is the region of sharpest perception, where extra information, such as color, is important.

The eye's trichromatic vision

The retina's receptors are sensitive to different wavelengths, some to blue, others to green, and a third group to red. By combining the information from these receptors, and calculating the relative responses, the brain can interpret color. Color film uses exactly the same principle. One difficulty, as can be seen from the graph (below), is that the "green" receptors are much more sensitive than the others, and the "blue" receptors much less.

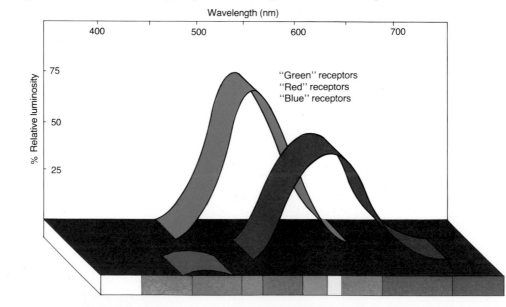

slow, fine-grained color film together with a fast, grainy black-and-white emulsion.

As the light alters, stalks contract and push either the rods or cones in front of the other, in order to get the best vision.

Image formation

The light waves from a subject are collected and focused onto the retina by the eye's lens system. Most of the refracting is done not by the actual lens, but by the cornea. The crystalline lens, attached at its edges to six muscles, focuses by changing its shape. The iris, with a close resemblance to an aperture ring, controls the area of the lens that is used, concentrating light waves on the more efficient central part when there is sufficient brightness; and increasing the depth of field for close vision. The image is projected, inverted, onto the retina, where the photopigments are briefly bleached to record it. This bleaching is transformed into neural activity.

Color sensitivity

The ability of the eye to perceive color appears to rely on a trichromatic process – three different types of receptor, each sensitive to a different color. The efficiency of the "blue", "green" and "red" receptors in the eye varies considerably, as the diagram below left shows. We are least sensitive to blue wavelengths, and most sensitive to green. Adding these three responses together, the eye's overall sensitivity is at its peak at about 555 nanometers – yellow-green. For

How the eye scans a scene. With good resolution limited to just the center of vision, the human eye builds up a picture by flicking rapidly from one part of a scene to another. Largely involuntary, these jerky flickerings are called saccadic movements. Based on detailed research, the first few moments of seeing the picture above could produce the overlaid pattern. Focusing first on points of emotional or graphic interest, the eye begins to assemble the main elements of the scene.

The visual luminosity curve

Combining the three different color responses of the retina's receptors, a composite graph (below) shows the relative importance of different colors to the human eye. Greens and yellows record the greatest attention, even when they are dark. On the other hand, we find the colors nearer the ends of the spectrum less easy to perceive.

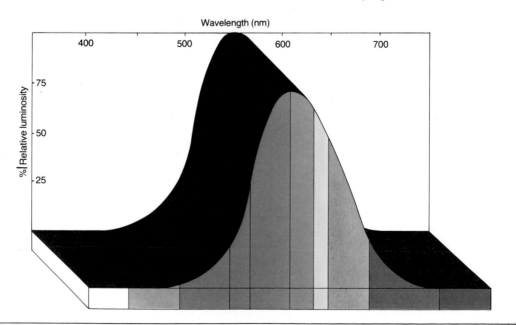

this reason, any yellow, even a deep shade, appears light, while most blues appear dark.

Unusually, in contrast to the efficient design of most parts of the eye, chromatic aberration is almost uncorrected. The standard technique for overcoming this in photographic lenses is to combine lens elements of two different materials, and this is probably not possible for living organisms. Instead, the eye has evolved yellow filters to cut down ultra-violet and violet vision, where chromatic aberration is greatest – one filter is the yellow color of the lens, the other is the yellow color over the fovea. In a sense, the eye has forfeited ultra-violet vision for sharper images in other wavelengths.

Perception

The mechanisms we have looked at so far are concerned only with recording light images on the retina. Exactly how the brain interprets the images is at the heart of the interpretation of photography, and is also an elusive and complex issue. The image available to the brain in good lighting is first of all in color; it is spread over an angle of 240°, but is quite indistinct near the edges and only really sharp over the 1.7° that the fovea covers. Looking directly at a subject means moving the eye so that the image falls on the fovea, which is smaller than the head of a pin. Yet, despite the tiny area of the subject that can be sharply focused, the human eye is capable of discerning considerable detail over a large scene.

The way it does this is by rapid scanning, moving the eye quickly so that one part of the scene after another falls on the fovea. This jerking, largely unconscious eye movement is called the saccade, and takes only a few milliseconds from one image to the next. In a few seconds this scanning can build up a detailed picture. How the brain processes this information is imprecisely known, and the psychology of perception involves much more than vision. The brain does not receive information from the retina passively, rather it imposes its own controls and expectations. As an example, unpleasant images may be entirely rejected by the brain, even to the most extreme case of hysterical blindness.

The nature of light

Light is radiation visible to the eye. Occupying a small central portion of the electro-magnetic spectrum, it behaves both as waves and particles. For the purpose of photography, it has three important characteristics – intensity, wavelength and polarization. Intensity determines the brightness of the light, and is related to the height of each wave; wavelength establishes its position in the electromagnetic spectrum, and therefore its color, and is measured as the difference between wave crests; polarization is the angle at which the waves are oriented.

Light is generated at the atomic level when an electron drops back from a high-energy orbit around the nucleus to a more stable orbit – a light wave is part of the lost energy, and its wavelength is determined by the size of the energy loss. This light wave is part of a continuous series of waves, each with a different wavelength. At one end of this electro-magnetic spectrum, with wavelengths of as little as .000000001

The complete coverage of the human eye is approximately 240°, although this varies from person to person. However, with the eye in a fixed position, most of the view is fuzzy and ill-defined, with only a tiny spot covering less than 2°, being completely sharp. Away from this central point of focus, the resolution deteriorates, and the process of seeing involves rapid scanning to build up a sharp image in the brain. The blank area off-center is the blind spot, where the optic nerve joins the retina.

millimeter are highly energetic gamma rays, while at the other end of the scale are radio waves that measure up to 6 miles (10km) between crests. The eye is sensitive only to a narrow band between about 400 nanometers and 700 nanometers (a nanometer is 10^{-9}meter) – this is the visible spectrum. Photographic emulsions vary in their sensitivity, but most tend to have more sensitivity to the blue, violet and ultra-violet end of the spectrum than the human eye, and some are sensitive to infra-red. With specialized equipment, wavelengths recorded from large parts of the invisible spectrum can be made visible, after a fashion.

Wavelength determines color: the shorter wavelengths appear violet and blue, the longer wavelengths, red; you can see this in a rainbow or in the way a prism breaks up light. The spectrum changes smoothly, without a break, from one wavelength to another, but it can be simplified by treating it as three "blocks" – blue-violet from 400 to 500nm, green from 500 to 600nm, and red from 600 to 700nm. Mixed together, these wavelengths produce white light.

For photographic purposes, there are two kinds of light source – radiating and reflecting. The sun, for example, radiates light as part of the energy it creates. So does a light-bulb, when its tungsten filament is heated to the point where it begins to emit visible radiation. Most materials around us, however, are passive in their relationship with light. Under normal circumstances, they do not release sufficient energy themselves to generate light (except when they are set on fire). They reflect some of the radiated light that strikes them. If they are very reflective, such as magnesium powder or white paint, they bounce back nearly all the light, and we call them "white". If they absorb most of the light energy that reaches them, we call them "black". A lump of coal does this, although if it is heated it will start to

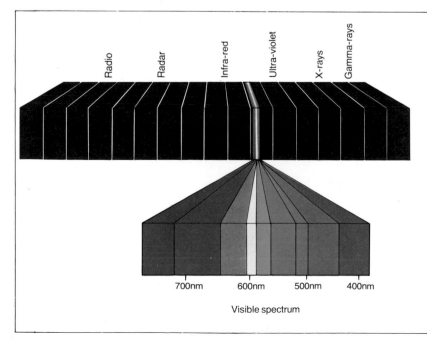

Radio Radar Infra-red Ultra-violet X-rays Gamma-rays

700nm 600nm 500nm 400nm

Visible spectrum

The electro-magnetic spectrum

The complete range of waves travelling in space, from the shortest to the longest, makes up the electro-magnetic spectrum. This radiation takes many different forms, yet there are no breaks in the series, simply a steady progression of wavelength. At one end of the scale are the very energetic gamma rays, which can penetrate even thick steel. At the other end are radio waves, which have too little energy to be experienced by the human body. Between these two extremes is a small group of wavelengths which we experience as light. This is the visible spectrum, the precise wavelength determining the color. For practical purposes, the range of the eye's sensitivity runs from violet to red – that is, from about 400 to 700 nanometers – although it has a slight ability on either side.

Refraction. At the heart of the process of forming an image is the bending of light, known as refraction. Passing from one transparent medium to another, a light ray is bent if the two substances have different optical properties. A ray of light passing obliquely into glass from the air is bent towards the normal. As it re-enters the air from the other side of the glass, it is bent back by the same amount, but if the two surfaces of the glass are at an angle to each other, their refraction can be controlled. This is the principle of the prism.

radiate energy in the visible spectrum, and glow red-hot (light is a form of energy).

Most radiating light sources emit over a range of wavelengths – they are easily measured, and the sum total determines the color. With a reflecting light source, its structure and composition determines which wavelengths of incoming light are absorbed, and which are reflected. If sunlight strikes a blade of grass, some of it will be absorbed – most of the wavelengths below 500nm, and most of those above 600nm. What is reflected is the remainder, green.

Forming an image

When light waves strike any material, they interact with it. They are partly absorbed, partly reflected and sometimes partly transmitted. When a material absorbs some of the light, it re-appears in some other form, often as heat. Reflection can either be direct, as from the surface of a mirror, or diffuse, when surface irregularities cause scattering. Transmission occurs with transparent materials, such as clear glass, and it is this property that makes it possible for an image to be focused with a lens.

When light passes from one transparent material to another, it changes direction slightly. This bending is called refraction, and can

Lens qualities
Focal length and image size. By altering the design of the lens to change the focal length, the size of the image at the focal plane can be altered. Reducing the focal length makes the image smaller (below); increasing it makes the image larger. With a smaller image, there is a greater angle of view.

Covering power. A lens projects a circular image. The image quality is highest at the center, deteriorating towards the edges. The point at which the image falls below an acceptable standard marks the circle of good definition, and this represents the covering power of the lens. In photography, the film format must fit within this circle. On a camera,

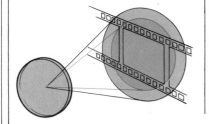

the covering power is increased slightly by stopping down the aperture.

Sharpness. A lens brings light waves to a point only at the focal plane. In front of, or behind this plane, it projects a circle. This "circle of confusion" increases with its distance from the focal plane (below), causing parts of the image to appear unsharp (out of focus).

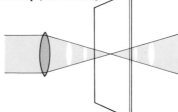

Depth of focus. The smallest circles of confusion appear sharp enough to be satisfactory. There is therefore a small range on either side of the film plane that still gives an acceptably sharp image. This is called the depth of focus, and is defined as the distance through which the *film* or *lens* may be moved before the image becomes unsharp.
Depth of field. This is the distance through which the *subject* may be moved before the image becomes unsharp. A related feature, hyperfocal distance, is the closest at which the subject is sharply recorded when the focus is set at infinity.

Lens faults
Simple lenses have a variety of faults, some due to the inherent nature of light, others to the inefficiency of the lens itself. Most can be partly corrected at least in the design of a compound lens.

Flare. This is caused by reflections from surfaces within the lens body, and causes an overall loss of contrast. It is sometimes made worse by reflections within the camera body. A lens hood partly overcomes the problem by cutting down the light that does not play a part in forming the image. More corrections are possible with lens coatings, which are on nearly all modern camera lenses. They work by setting up a second reflection from the lens surface that interferes with the original reflection, nearly cancelling it out. The principle is called destructive interference.

Chromatic aberration. The different wavelengths that comprise white light travel at different speeds through the lens, and pass through a lens at slightly different angles; this is called chromatic aberration (above right). Blue-violet light is focused slightly closer to the lens than green light, which in turn is focused closer than red light. As the focus is spread in this way, there is some loss of definition. One answer in lens

be seen in the way light behaves as it passes through a glass prism: the approaching light wave is bent once as it enters the glass at an angle, and then a second time as it leaves the prism back into the air. The angle at which the light is refracted depends on the refractive index of the glass, the angle at which the light strikes its surface, and the wavelength of the light itself.

A simple lens can be thought of as a collection of different prisms, each one bending the incoming light waves to a different angle. If the light comes from a point source, the lens will collect the spreading light rays and bring them together at a point behind the lens. In other words, it focuses the image of the light source at a point. This is the focal point of the lens; if the object is at infinity, the distance from the focal point to the lens is the focal length of the lens.

With an extended object rather than a point source, the image is formed not at one focal point, but over an area, called the focal plane, and is also reversed, upside-down and left-to-right.

A compound lens is one which combines more than one element. By being able to use different shapes of glass, compound lenses can be designed that correct the normal aberrations found in a simple lens, to give better image quality and different sizes and shapes of image. All modern photographic lenses are compound.

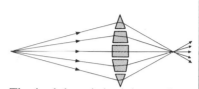

The simple lens. A simple lens works as if it were made up of small individual prisms. Like the prism, each lens section bends light rays. By shaping this lens, each refracted ray from a single point can be made to meet at a common point behind the lens. A subject is made up of an infinite number of points. Focusing each of them behind the lens forms an image.

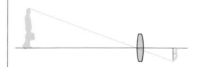

design is to use different lens materials, so that the chromatic aberration of one cancels out the slightly different chromatic aberration of the other. Another effect of chromatic aberration that is less easy to correct is the color

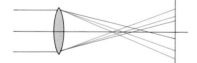

fringe at the film plane caused by the slight divergence of the wavelengths. A recent solution is extra low dispersion glass made by including rare earths in the manufacture of the glass. Fluorite also has low dispersion qualities, but is damaged by the atmosphere and changes shape with temperature changes.

Spherical aberration. It is cheaper to produce a lens with a spherical curved surface than one in which the curvature changes. The cost of this is spherical aberration (above right), where the edges of the lens focus the light waves at a different point from the center of the lens, causing unsharpness. In the case of oblique rays passing through the lens, they fall on different parts of the film plane in a blur rather than being superimposed. This slightly different

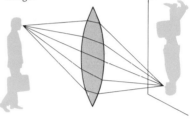

aspect of spherical aberration is called coma. There are several ways of overcoming this, and for lens manufacturers, it is principally a matter of cost. Mirror lenses, which use reflective surfaces, do not suffer from such aberrations.

Distortion. The aperture stop of the lens prevents oblique light waves from passing through the center of the lens, and, as the lens surfaces at the edges are not parallel, the image-forming light is bent. This does not affect sharpness, but does distort the image shape. If the shape is compressed, it is called barrel distortion; if stretched, pincushion distortion. Symmetrical lenses (that is,

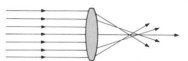

Normal

Barrel

Pincushion

with complementary elements at the front and back) cancel out this distortion, but telephoto or retrofocus designs, which are asymmetrical, suffer to some degree. A fish-eye image is an extreme example of barrel distortion, because the lens uses an extreme asymmetrical design.

Field curvature. The focal plane of a simple lens is not precisely flat, but curved so that if the film is flat, not every part of the image will be sharp (below). Curving the film is one answer, but some modern compound lenses are designed to have a flat field.

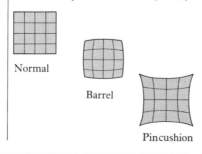

Diffraction. The edge of an opaque surface, such as the aperture blades, scatters light waves slightly. If the aperture stop is closed down to its smallest size, this scattering, called diffraction, is increased (stopping down, which tends to correct most lens faults, actually worsens this one). In practice, most lenses perform at their best when stopped down about three aperture stops from their maximum – this is called their optimum aperture.

The camera

ALL CAMERAS, FROM the simplest to the most sophisticated, function in the same basic way. The housing is a light-tight container that admits only image-forming light through an aperture. This light is focused by means of a lens system, and the unexposed film is positioned so as to receive the image. The increasing complexity and specialization of modern cameras is due to the variety of jobs that they have to perform. Much of the internal complexity is designed to make operation simpler and less demanding.

The single lens reflex

Most modern 35mm system cameras are of single lens reflex (SLR) design incorporating a viewing system that enables the photographer to see exactly what the film will record. The heart of the single lens reflex is a mirror/prism arrangement that directs the focused image to the viewfinder during focusing, or the film during exposure. A hinged mirror in the center of the light path directs the image upwards into a pentaprism, which rectifies it so that it appears corrected left to right and the right way up through the eyepiece. When the shutter mechanism is activated, the mirror lifts up, allowing the light to reach the film plane, and the shutter opens and closes, exposing the film. The cycle ends with the return of the mirror. In order to fit the mirror in, the camera body has to be of a certain minimum width, and the shutter must be located in the body, close to the film (hence the name "focal plane shutter").

Advantages
1. The most outstanding attribute of the single lens reflex, which alone probably outweighs its drawbacks, is that the photographer can see precisely what the lens is imaging – not only what it is framing, but

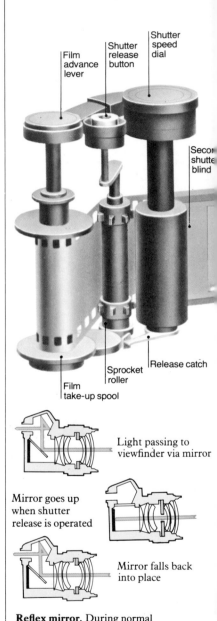

Film advance lever

Shutter release button

Shutter speed dial

Secor shutte blind

Sprocket roller

Release catch

Film take-up spool

Light passing to viewfinder via mirror

Mirror goes up when shutter release is operated

Mirror falls back into place

Reflex mirror. During normal viewing, the hinged mirror remains lowered, directing light rays from the lens up to the ground glass screen and ultimately to the eyepiece. Pressing the shutter release button raises the mirror an instant before the shutter operates, allowing the light to fall directly on the film plane and at the same time blocking off any extraneous light from the viewfinder.

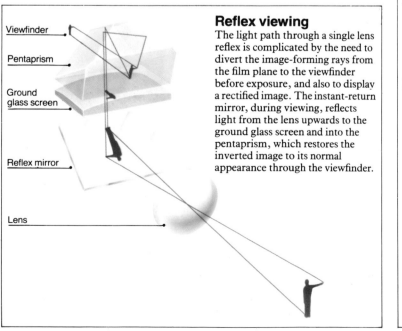

Viewfinder

Pentaprism

Ground glass screen

Reflex mirror

Lens

Reflex viewing
The light path through a single lens reflex is complicated by the need to divert the image-forming rays from the film plane to the viewfinder before exposure, and also to display a rectified image. The instant-return mirror, during viewing, reflects light from the lens upwards to the ground glass screen and into the pentaprism, which restores the inverted image to its normal appearance through the viewfinder.

Single lens reflex camera

The basic feature of this type of camera (below) that distinguishes it from simpler designs is the arrangement of reflex mirror and pentaprism that allows direct viewing through the picture-taking lens. The hinged mirror controls the direction of the light path. Light readings are possible at various places along the light path inside this housing; in this model, photo-electric cells are placed over the pentaprism.

Focal plane shutter. Designs for the focal plane shutter vary and some shutters even operate vertically. This horizontal arrangement (left), however, is the most common. The primary blind contains a rectangular opening to the dimensions of the picture area. The secondary blind also contains a gap, the position of which, relative to the primary blind's gap, is adjusted by the shutter speed dial; the narrower the resulting slit, the faster the shutter speed and the shorter the exposure.

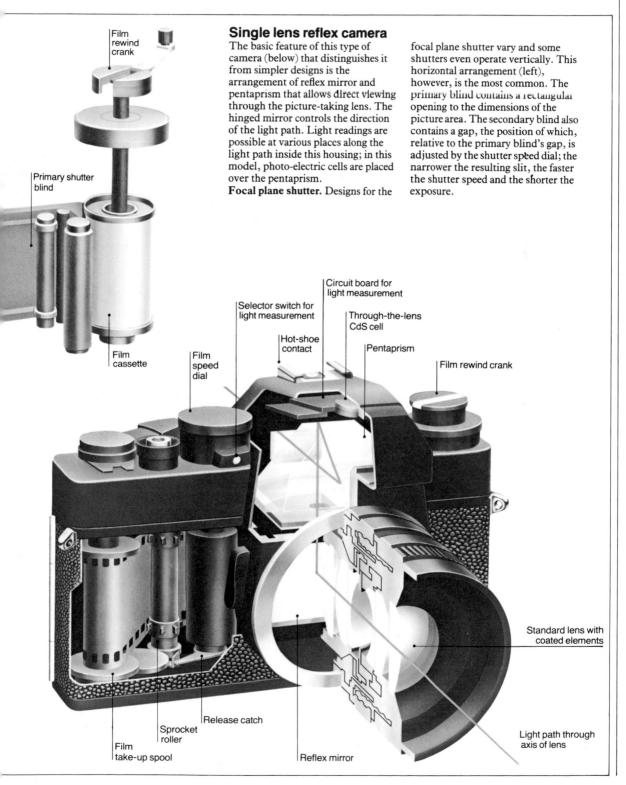

Film rewind crank

Primary shutter blind

Film cassette

Film speed dial

Selector switch for light measurement

Hot-shoe contact

Circuit board for light measurement

Through-the-lens CdS cell

Pentaprism

Film rewind crank

Standard lens with coated elements

Light path through axis of lens

Release catch

Sprocket roller

Film take-up spool

Reflex mirror

also the depth of field. There is none of the parallax error that occurs with a separate viewfinder, and accurate composition and picture selection are possible.

2. By incorporating light-sensitive cells inside the camera, highly accurate exposure measurement of the area to be included in the picture is made possible (see p72).

Disadvantages

1. The mechanisms are complex, bulky and difficult to repair in the field, in comparison with the simpler, direct viewfinder design.

2. During exposure, viewing is not possible. At fast speeds this is hardly noticeable, but it makes some techniques, such as long, panned exposures, difficult.

3. Under low light conditions or with lenses that have small maximum apertures, viewing and focusing can be difficult. To compensate

How the Fresnel screen works. Acting just like a condenser lens, which is flat on one side and convex on the other, the Fresnel screen distributes a bright image over the whole area of the screen. It does this so compactly because it is designed as a series of concentric, stepped rings, each one a section of a convex lens surface.

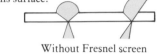

Without Fresnel screen

With Fresnel screen

Direct viewfinder camera

This advanced non-reflex camera incorporates both through-the-lens light measurement and a focal plane shutter. Until recently, these were characteristics of the single lens reflex design. The CdS photo-electric cell covers an area approximately equal to the rangefinder field seen through the viewer, and is linked to the focal plane shutter mechanism so that it swings out of the way at the moment of exposure. The finder system uses a half-silvered mirror and prism to achieve binocular vision; this makes distance measurement possible and the controls are linked to the focusing ring on the lens.

Shutter speed dial

Shutter release button

Film advance lever

Hot-shoe contact

Rangefinder lens and prism

Viewfinder lens

Half-silvered mirror

Viewfinder eyepiece

Light path

Standard lens

CdS cell

Focal plane shutter

Battery test button

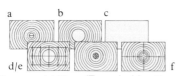

Screens. (a) Matte/Fresnel with split-image rangefinder (general purpose). (b) Matte/Fresnel with ground glass center (combines clear image and fine center focusing). (c) Plain matte (gives unobstructed view, good for long-focus lenses). (d) Matte/Fresnel with grid (architecture and copy work). (e) Matte/Fresnel with microprism (easier focusing for slow lenses). (f) Fresnel with millimeter-scaled reticle (close-up work).

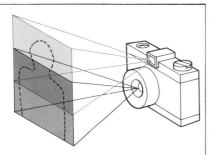

Parallax error. Because the viewfinder is in a different position from the lens, it sees a slightly different picture at close distances. Most viewfinder cameras indicate the amount of displacement.

Rangefinder focusing. With a prism and mirror to combine the images, a rangefinder uses binocular vision to measure distance. Normally coupled to the lens, the two images are aligned with the focusing ring.

Leaf shutter. A series of blades are arranged around the lens axis so that they operate simultaneously, letting light pass through a circle of increasing diameter.

for this, most lenses are "pre-set", which means that normal viewing and operation take place with the aperture diaphragm fully open; it stops down to the set aperture only at the moment of exposure. At times, therefore, the view normally seen through the eyepiece can be misleading, and for an accurate preview of the depth of field a special lever must be depressed.

4. The mirror/shutter mechanism is noisy, which can be a problem in candid reportage or wildlife photography, and the amount of mechanical movement can cause camera shake even on a tripod. On a tripod, it is advisable to lock the mirror up before operating the shutter.

The direct viewfinder camera

The direct viewfinder camera *was* 35mm photography until the introduction of the single lens reflex. Its simplicity was responsible for its success, and as long as the accessory equipment was equally simple (a variety of lenses all close to a normal focal length), the separation of viewing from picture-taking was no great disadvantage. Now, however, the introduction of the "system" principle, with an ever wider range of lenses and ancillary equipment, has meant that the limitations of the direct viewfinder are increasingly evident.

On a direct viewfinder, a small separate viewfinder lens gives a view corresponding to the image recorded by the main lens. When the main lens is changed, different systems are employed to alter the framing appropriately. For accurate focusing, some models incorporate a separate rangefinder coupled to the lens focusing ring. The double image this gives in the viewfinder coincides when the subject is in focus. On some cameras, a sophisticated through-the-lens metering system operates on principles similar to those of the single lens reflex. In fact, generally, there is a trend towards increasing complexity in direct viewfinder cameras to compete with the single lens reflex.

Advantages

1. The simplicity of the design makes direct viewfinder cameras relatively light, compact, and reliable.
2. The absence of a mirror makes operation quiet and unobtrusive: a real advantage in candid work. (A leaf shutter set in the lens is possible, with the advantages of accuracy and flash synchronization at all speeds, but the demand for interchangeable lenses has made this alternative expensive.) Advanced models like the current Leica use a focal plane shutter.
3. Focusing and viewing are possible with a direct viewfinder camera even in low light conditions and during exposure.
4. The lack of a mirror gives more freedom in lens design, as shown by some very successful wide-angle lenses, like the Zeiss Biogon.

Disadvantages

1. Parallax error is a real problem with objects close to the lens, and care must be taken composing the image.
2. It is not practical to use lenses with very long focal lengths without a supplementary reflex viewing system.
3. Unlike the single lens reflex cameras, the viewfinder cannot give depth of field preview.

Camera handling

Loading

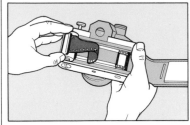
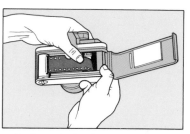
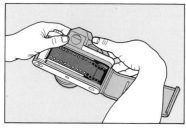

1. Open the camera back and pull out the rewind knob. In subdued light insert the film cassette so that the protruding end of the spool is at the bottom. Push back the rewind knob.

2. Pull out the film leader, and by rotating the take-up spool insert the end of the film into one of the slots, making sure that the perforations engage the lower sprocket.

3. Wind on the film until the top row of perforations engage the upper sprocket and the film is tensioned across the film guide rails.

CAMERA AND LENS controls naturally vary between makes of equipment, but most of the important functions have similar mechanisms. Learning how to operate a camera is straightforward, but learning how to use the controls to create a desired effect needs practice and a more thorough understanding. Focusing, for instance, is perhaps the most crucial technique in photography, yet it is so much taken for granted that many pictures are lost through carelessness.

Loading and unloading film

Even in one film size – 35mm – the mechanical details of loading and unloading film vary between makes of camera. The sequences illustrated here show the most common design and cover the essential principles, but you should study the manufacturer's instructions for your own camera.

After loading, you may find it useful to take off the end of the film carton and insert it in the holder built into the back of most cameras. You will then remember what type of film you are using. On a camera with through-the-lens metering, remember to set the film selector to the appropriate ASA or DIN figure.

Unloading

1. Press the rewind button. Unfold the film rewind crank and rotate it in the direction of the arrow. Continue to do this until you feel the tension ease. This indicates that the film has been fully rewound.

Focusing

The focusing ring of the lens moves the lens elements backwards and forwards so that images of objects at different distances from the camera can be brought into sharp focus at the film plane. When the lens elements are at the setting closest to the film, objects at infinity are in focus. For closer objects, the lens elements must be moved forward. Close-focusing lenses, such as those intended for macro work, have an extended focusing mount so that the lens elements can be displaced over considerable distances.

Focusing with a single lens reflex is visual; viewfinder cameras sometimes include a rangefinder system where two images of the

Right: With a subject of considerable depth, the selective nature of focusing can be seen clearly. Focusing a normal 55mm lens at different distances along this row of mail-boxes at full aperture produces quite different images. Note that the movement of the lens elements that occurs during focusing results in the displacement of the nearest part of the image.

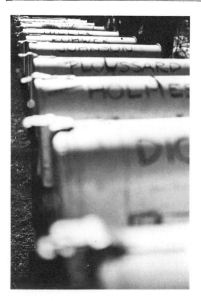

4. Close the camera back and gently turn the film rewind knob in the direction of the arrow until you feel resistance. This is to check that the film is fully tensioned.

5. Advance the film two frames, making two blank exposures. The frame counter should now read "0". Advance the film one more time and the first frame is ready for exposure.

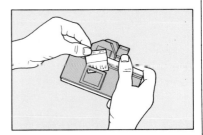

6. Tear off the end of the film carton and place it in the holder on the back of the camera to remind you what type of film you are using.

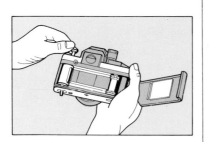

2. In subdued light, open the camera back. Pull out the rewind knob and take out the film cassette.

subject coincide with the focus (see p 20), otherwise the distance scale on the focusing ring must be used.

Except with very wide-angle lenses, whose depth of field (see p 24) is great, some parts of a scene will be in sharper focus than others. Consequently, the precise part of the scene that you choose to focus on can have a profound effect on your image. Selective focusing can single out elements of a scene to bring attention to them and it can submerge other elements in an out-of-focus blur. The parts of the picture that are out-of-focus can be used compositionally to frame the sharply focused element or to supply washes of color.

The exact definition of "sharp" depends on the size of the circles of confusion (see p 16) and the distance at which they are viewed. At 10 inches (25cm) a circle of 1/100th of an inch 0.25mm) appears sharp. Even with the aperture wide open, a certain distance in front of, and behind, the plane of critical focus is, by this criterion, sharp. The sharpness falls off gradually from the plane of critical focus.

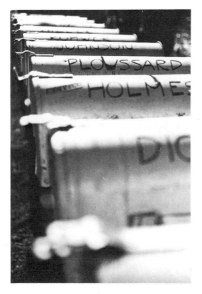

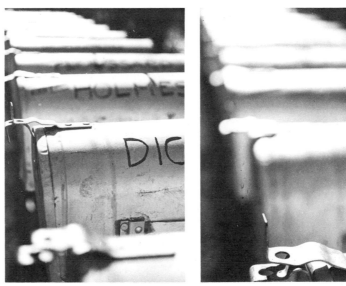

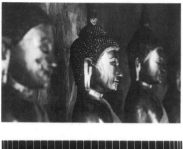

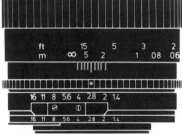

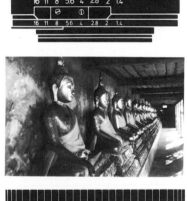

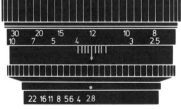

These two photographs (above) of a row of Buddhas in Bangkok's Wat Phra Jetupon were taken from exactly the same camera position at the same distance – 12ft (3.6m). The depth of field for the 180mm lens encompasses only one Buddha, whereas the depth of field for the 35mm lens is greater and extends to the two Buddhas on either side.

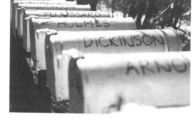

With a lens of normal length – 55mm – this row of mail boxes was photographed at three different apertures, but in each case the lens was focused on a distance of 7ft (2m). The mail boxes are spaced

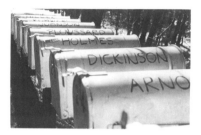

slightly more than 1ft (.3m) apart. At f3.5 (left), the depth of field extends only a little on either side of the focused point. At f8 (center) the limits of the depth of field are 6ft (1.8m) from the camera and

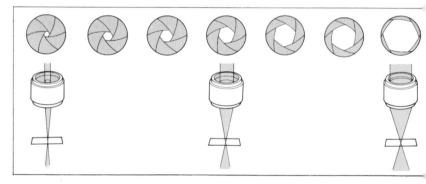

Making the best use of depth of field

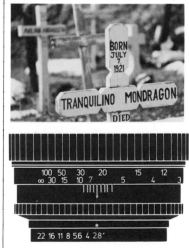

In this Indian cemetery in Taos Pueblo, New Mexico, the nearest cross was 23ft (7m) from the camera. With a 180mm lens focused on it (above), the other crosses were completely out-of-focus at the maximum aperture of f2.8. With the lens focused on the far cross (above right) – 33ft (10m) away – the nearest

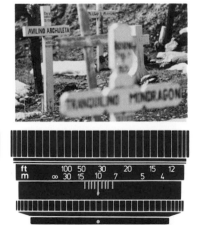

cross became unsharp. I adjusted the lens focusing ring so that the 23ft (7m) and 33ft (10m) marks of the distance scale were equally spaced on either side of the central focusing mark. The depth of field scale showed that it was just possible to extend the depth of field to these near and far limits by stopping the

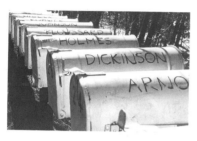

9ft (2.7m). At f22 (right), stopped down almost to the limit, the depth of field extends from 4½ft (1.4m) from the camera to 16ft (4.9m), bringing most of the boxes into acceptably sharp focus.

Aperture and focal length

Lens focal length affects depth of field. With a long-focus lens, to give the same exposure, for any given f-stop, the actual diameter of the aperture must be larger than that needed by a lens of short focal length. As the diagram shows, to achieve as bright an image the aperture opening of the 180mm lens has to be much greater than that of the 35mm lens. Because the aperture is larger, the depth of field must be less.

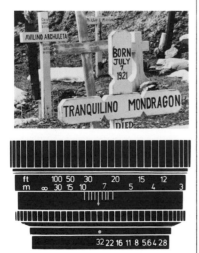

lens down fully to f32 (above). As the limits of the depth of field are not equally on either side of the plane of sharpest focus, this could not have been done simply by focusing on a point half-way between the nearest and farthest crosses.

Aperture

The aperture control is a diaphragm of overlapping leaves connected to an exterior ring on a lens. Turning the ring in one direction opens the diaphragm to the point where it does not obstruct any of the light passing through the lens. Rotating the ring in the opposite direction closes down the diaphragm until only a small circular opening is left for the light to pass through. The aperture controls the amount of light reaching the film so that correct exposure can be made under different lighting conditions.

On all lenses, the aperture ring is calibrated in a standardized series of "f-stops". Along with the focal length, the maximum aperture is normally used to designate a lens. The actual range of f-stops varies between lenses and the maximum aperture can be "non-standard", but the sequence progression is the same: f1, f1.4, f2, f2.8, f4, f5.6, f8, f11, f16, f22, f32, f45, f64. These numbers denote relative apertures, that is, they are the ratio of the diameter of the aperture to the focal length of the lens. For example, on a 100mm lens, an aperture setting of f4 means that the actual opening is 25mm (100/4), on a 28mm lens set to f4 the opening will be 7mm wide (28/4). Because the image given by lenses reduces in brightness proportionally as the focal length of the lens increases, this use of relative aperture enables you to change lenses, yet, by keeping the f-stop constant, still give the same exposure.

To simplify camera exposure further, each f-stop progressively doubles or halves the exposure, thus matching the shutter speed sequence. This means that you can adjust shutter or aperture, matching a change in one by an equal and opposite change in the other, and still maintain the same exposure.

Stopping down has an important effect on the image apart from altering exposure: it increases depth of field. The depth of field is the distance through which the subject extends and still forms an acceptably sharp image. It is an area that extends on either side of the plane of sharp focus. Normally, there is greater depth of field beyond this plane than in front of it. Simply put, the more the aperture is stopped down, the greater the depth of field.

A crude guide to the depth of field is marked on most lenses adjacent to the distance scale. For any aperture setting, you can read off the maximum and minimum distances that will be sharp against the appropriate f number on your depth of field scale.

Shutter

Whatever type of shutter your camera has – leaf or focal plane – it does two important things. It controls the amount of light reaching the film and it determines the way that motion is recorded. In regulating the exposure its action is quite straightforward. What is mechanically important is that all areas of the film are equally exposed at the same time. With a focal-plane shutter, the lateral or vertical movement of the slit in the blinds means that all parts of the film are not exposed instantaneously, and although for most purposes the time lag is too short to be noticed, there are certain conditions under which it can produce distortion (notably when photographing an object moving in the same direction as the slit).

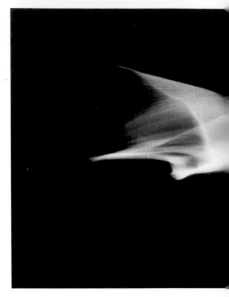

Except with programmed shutters, speeds are calibrated in a standardized fashion, each one being half or twice that of the adjacent setting. In this way, the quantity of light reaching the film is either halved or doubled and shutter and aperture together can be used to control exposure in parallel. At one stop slower speed with one stop smaller aperture, for example, there is no change in exposure.

In controlling motion the effects of the shutter speed are interesting. The shutter not only "freezes" action; it can be used to permit varying amounts of blurred movement. The value of controlled blur is explored fully on page 194, and the ways in which the sense of motion can be depicted are examined.

What determines the "stopping-power" of a given shutter speed is the speed of the subject movement *as it appears in the picture frame*. With a normal lens, the image of a car moving across the field of view at 50 mph (80 kph) will flash through the viewfinder if it passes close to the camera, but at a much greater distance the passage of the car may take the better part of a minute. Similarly, changing to a wide-angle lens will reduce the image-size of a moving object, so its motion will be relatively slower in the frame.

Another consideration is the direction of movement. A car travelling across the field of view has a greater apparent movement than it would if it were moving diagonally towards the camera, and if it were heading directly towards the camera there might be very little visible movement in the image.

With many subjects, some parts move at different speeds than others. The movement of a cyclist's legs is faster than that of the bicycle itself, and the rotation of the wheels is fastest of all. Therefore,

Panning the camera to follow a moving subject, and using an intentionally slow shutter speed, can turn even the prosaic into a graceful design. By choosing a dark background – a group of trees – the seagull (above) was kept clearly visible even through a one-second exposure. *Nikon, 400mm, Kodachrome, 1 sec, f32.*

In the rapids of a fast-flowing river (right), even the individual drops of spray are frozen with a shutter speed of 1/1000th sec; there is no image movement visible. At the other end of the scale, at one second, the water has lost all recognizable characteristics and appears almost as a dense fog. In between these two extremes, varying amounts of blur are visible. At 1/250th sec the brightest reflections and the fastest moving flecks of foam begin to show a little streaking; at 1/15th sec no part of the scene is crisp.

To produce this series of photographs both shutter and aperture controls were altered in tandem, as described opposite so as to preserve the same exposure. At the slowest shutter speeds not even the minimum aperture of f32 was sufficient to keep the light level down to the right amount, and a neutral density filter was placed in front of the lens (see p60). Note that, although all the exposures are identical, the slow-speed shot appears lighter. This is because the movement of the white foam across the picture "wipes out" the images of the darker rocks (with blurred movement, lighter subject areas always tend to eliminate the darker ones).

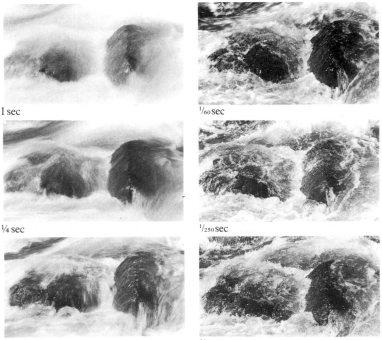

1 sec

$1/60$ sec

$1/4$ sec

$1/250$ sec

$1/15$ sec

$1/1000$ sec

To demonstrate the effects of camera shake, the camera was mounted on a tripod and the end of the lens tapped in the middle of an exposure. Very pronounced shake causes an easily recognizable double image (far left), but a small amount (left) can cause a slight blur whose cause is not easy to identify.
Nikon, 180mm, FP4, ¹/₆₀sec, f16.

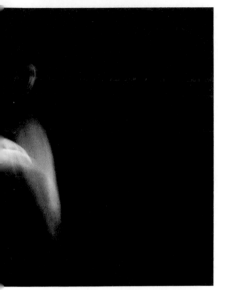

to arrest the movement of the complete bicycle requires a slower shutter speed than to freeze the motion of the wheels so that the spokes are clearly visible.

Stopping all movement, even when possible, is not always the best way of showing action. Our appreciation of motion in everyday life comes from observing a continuous sequence, and the still photo graph that freezes one moment of this sequence may look static and odd. It is important to know the pictorial effect of various degrees of blurring, so that you can choose the result that best suits the situation. The series of photographs showing water flowing over rocks illustrates the range of the shutter's performance from one second to 1/1000th of a second.

Another method of controlling the image movement that can be combined with different shutter speeds, is by panning. Panning is smoothly following the movement of the subject with the camera during exposure. This technique can allow you to use quite slow speeds with fast-moving objects and has the additional advantage of blurring a static background, so reducing its interference in the image and isolating the moving subject.

Shutter and aperture together

Because both the shutter and aperture are calibrated so that each setting changes by a factor of two, they are, to some extent, interchangeable as controllers of light. To double exposure, either the shutter speed control can be moved to the next slower setting or the aperture control on the lens can be turned to the next wider opening.

However, as each has quite different pictorial effects, you can choose from a variety of settings and produce quite different results. The two basic considerations are depth of field and blurring of movement and, except in the very dimmest of lighting conditions, you have a range of choices. Altering the two controls in tandem produces no change in exposure, but gives you greater creative freedom. A setting of 1/125th of a second at f5.6 lets in the same quantity of light as 1/30th of a second at f11 or 1/8th of a second at f22. Whether you give priority to shutter speed or aperture depends on how you see the subject. You may treat the movement as the most important part of the photograph, allowing the depth of field to fall where it will, or you may sacrifice some sharpness in a moving subject in order to achieve the maximum depth of field.

Holding the camera

Camera shake is unintentional movement to be avoided at all costs. If you are to induce blurring by panning or moving the camera during exposure, it must be definite. Even a very small amount of camera shake can spoil a picture – it may hardly be noticeable but nevertheless reduces the sharpness of the image.

Eliminating shake is the main aim when holding a camera, but in addition you should learn the positions which give you the greatest facility in operating the controls. There are subtle differences in the steadiest positions for holding different makes of camera so you only should use the examples illustrated overleaf as a guide rather than as literal instructions.

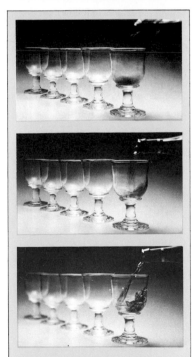

This picture requires a shutter speed and aperture setting to cope with movement and depth of field. A fast speed (top) with the lens wide open gives little depth of field. Stopping down the lens (bottom) improves sharpness but the movement is blurred. The middle picture is a compromise.

Holding the camera

The most common method is to support
the weight of the camera equally between
the left and right hands (below), but in
both cases using the palm or heel of the
hand as much as possible to leave the
forefingers and thumbs free to operate the
controls. The left hand operates the focus
and aperture rings in the lens, the right
forefinger presses the shutter release, and
the right thumb operates the film advance
and cocking lever. Press the camera
against your face as an extra brace.
Squeeze the shutter release gently, but
firmly. Jabbing it is a frequent cause of
camera shake.

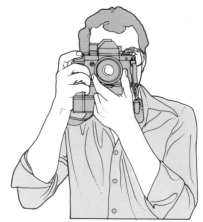

With a motor drive or automatic winder
attached to the body, the camera, though
heavier, is usually much easier to hold
steady (above). This is partly because
only the forefinger of the right hand has
anything to do. Many photographers
prefer to support the whole weight of the
camera in the right hand.

Use your body as a support. If standing,
place your feet slightly apart, one foot a
little forward (below). Whenever
possible, pull your elbows into your body
and press your arms against your ribs.

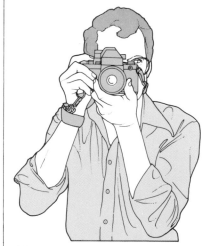

Winding part of the camera strap around
the right wrist is an additional support
(above). Tensioning the camera against it
makes it easier to hold steady. In any case,
always have a strap attached to the
camera.

For vertical shots, the camera can be used
with the shutter release above or below. If
above (right), then the camera's weight
falls naturally into the cupped left hand,
but again use the heel and palm to free the
thumb and forefinger for the lens
controls. Press the back of the right hand
against the forehead for greater
steadiness.

If the camera is held in the alternative
vertical position (above) with the shutter
release below, then the palm of the right
hand becomes the main support. This
frees the left hand almost completely for
fine control of the lens and is particularly
useful with zoom lenses which have a
third control ring. Operating the film
advance lever, however, is a little
awkward. Because the fingers of the left
hand are floating free, be especially
careful with wide-angle lenses so that
they do not obtrude.

During shooting
1. Be certain that the camera you are
using is loaded; check by gently
tensioning the rewind knob and also
by watching to see if the rewind knob
rotates as you wind on.
2. Keep a constant check on the
number of exposures left.
3. Check that your light meter or
through-the-lens meter is set to the
correct film speed.
4. Make sure that the lens cap has
been removed.

Various sitting and kneeling positions (below) are steadier than standing. By placing your elbow on your knee, the forearm acts as an extra support. Sitting cross-legged gives two points of support for the elbows, and is even steadier. With very slow shutter speeds, take several exposures in the hope that one will be free of shake.

A heavy, long-focus lens is particularly susceptible to camera shake. The prone position (above) is one of the steadiest, and if you can use an extra support, such as a camera bag, there is even less risk of movement. When standing, either support the lens from below with the left hand, or grip the barrel very firmly and pull it back to brace against your face (right).

Borrow the marksman's technique of taking a moderately deep breath and then squeezing the shutter release as you lightly exhale. In really adverse conditions, take several exposures in the hope that one will be free of shake.

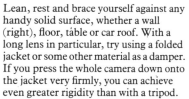

Lean, rest and brace yourself against any handy solid surface, whether a wall (right), floor, table or car roof. With a long lens in particular, try using a folded jacket or some other material as a damper. If you press the whole camera down onto the jacket very firmly, you can achieve even greater rigidity than with a tripod.

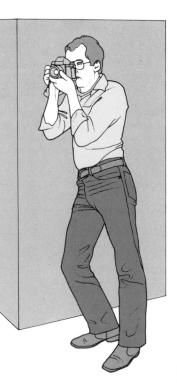

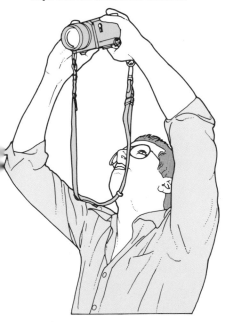

For ground-level shots (right), take off the pentaprism (if possible) and compose directly on the ground glass screen. With rather greater difficulty you can use this technique to hold the camera over the heads of a crowd (above).

For very critical work, especially with long exposures, use a cable release. Turning up the mirror also removes another potential cause of mechanical vibration.

Supports and accessories

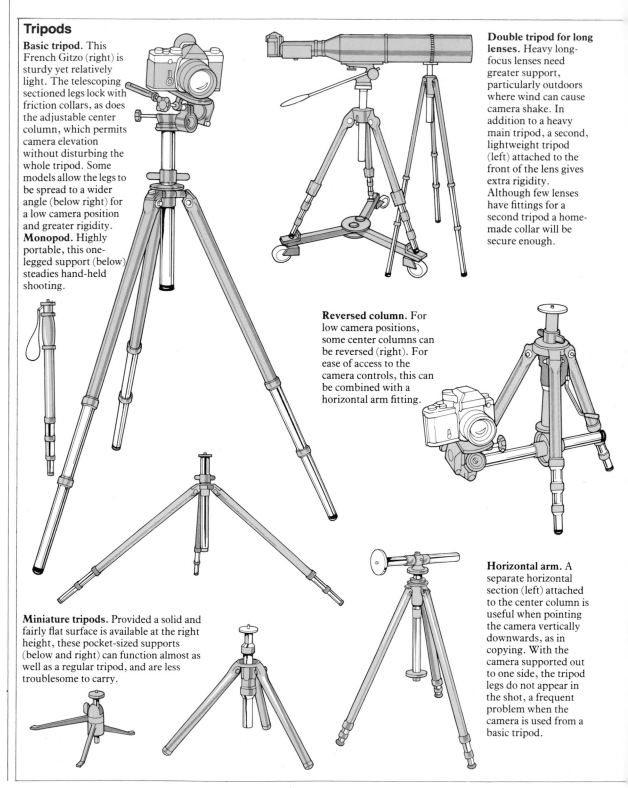

Tripods

Basic tripod. This French Gitzo (right) is sturdy yet relatively light. The telescoping sectioned legs lock with friction collars, as does the adjustable center column, which permits camera elevation without disturbing the whole tripod. Some models allow the legs to be spread to a wider angle (below right) for a low camera position and greater rigidity.

Monopod. Highly portable, this one-legged support (below) steadies hand-held shooting.

Miniature tripods. Provided a solid and fairly flat surface is available at the right height, these pocket-sized supports (below and right) can function almost as well as a regular tripod, and are less troublesome to carry.

Double tripod for long lenses. Heavy long-focus lenses need greater support, particularly outdoors where wind can cause camera shake. In addition to a heavy main tripod, a second, lightweight tripod (left) attached to the front of the lens gives extra rigidity. Although few lenses have fittings for a second tripod a home-made collar will be secure enough.

Reversed column. For low camera positions, some center columns can be reversed (right). For ease of access to the camera controls, this can be combined with a horizontal arm fitting.

Horizontal arm. A separate horizontal section (left) attached to the center column is useful when pointing the camera vertically downwards, as in copying. With the camera supported out to one side, the tripod legs do not appear in the shot, a frequent problem when the camera is used from a basic tripod.

Tripod heads should offer the greatest freedom of movement. The basic choice is between the highly flexible ball-and-socket head, and those with separately controlled movements.

Monoball. This Arca-Swiss head is the most secure ball-and-socket design available, capable of holding the heaviest 35mm configuration in any position.

Pan-and-tilt head. Separate movements on this Gitzo Rationelle head allow individual adjustments with greater accuracy.

Ball-and-socket head. Lighter and more common than the Monoball, this head is secure enough for most combinations of camera and lens.

AN IMPRESSIVE AND growing array of ancillary equipment is available from photographic dealers. Photography is markedly gadget-prone, and choosing which accessories are essential is often difficult. As a general rule, buy the highest quality basic equipment to start with rather than try to improve mediocre cameras and lenses with an extensive collection of accessories.

Camera supports

At slow speeds, particularly with long-focus lenses, some kind of camera support is necessary. It is possible to improve your ability to handhold the camera without shaking, but after a certain point, a tripod or other means of rigid support must be used. When precise composition is important, as it often is in the studio, it is an advantage to control the camera position exactly.

Tripods: A tripod is the standard means of camera support. Ideally it should be solid enough to hold the camera and lens rigid under the prevailing conditions, but light enough to be portable. In the studio, portability is not particularly important, so that heavy tripods and camera stands are usual (see left). On location, the tripod you choose will inevitably be a compromise between weight and rigidity. Even though the heaviest tripods are normally the firmest, this is not necessarily so, and different brands vary. When buying a tripod, test not only its ability to hold a steady weight, but also its resistance to torque (try to twist the head; if it moves significantly, the design is poor). The acid test is to mount a camera and reasonably long lens on the tripod and tap the end of the lens; use this method to compare tripods. With a heavy extreme long-focus lens, such as 1000mm, not only will a heavy duty tripod be necessary, but also perhaps a second smaller tripod to support the front of the lens.

Most tripods have telescopic sectioned legs; if you are using the tripod less than fully extended, make sure that the narrowest sections are retracted. A useful design is one that enables the legs to be spread to a wider angle for a lower camera position; an alternative is to reverse the center column so that the camera hangs from the tripod. Some center columns have a ratchet and crank for raising and lowering, but on cheap tripods this device can simply make them less steady.

Although tripod heads are a separate piece of equipment, they become, for the purpose of rigidity, a part of the tripod. Ball-and-socket heads come in all sizes and are very rapid to alter in position.

The gyro stabilizer

Photographs taken from a moving vehicle inevitably lack sharpness due to the vibration of the vehicle. A gyro stabilizer, like this Kenyon model, attaches to the camera base and can compensate for most vibrations. Weighing just over two pounds, this unit contains two small gyroscopes. When set in motion they start to spin, reaching a top speed of 20,000 rpm. At this point the vibration is overcome and the camera is steadied.

Accessories

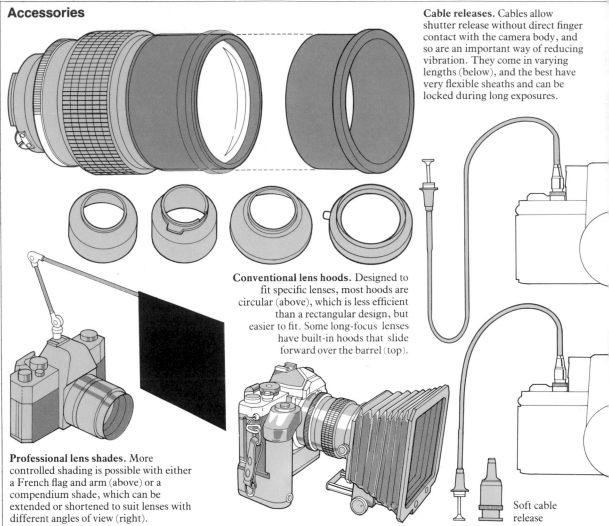

Cable releases. Cables allow shutter release without direct finger contact with the camera body, and so are an important way of reducing vibration. They come in varying lengths (below), and the best have very flexible sheaths and can be locked during long exposures.

Conventional lens hoods. Designed to fit specific lenses, most hoods are circular (above), which is less efficient than a rectangular design, but easier to fit. Some long-focus lenses have built-in hoods that slide forward over the barrel (top).

Professional lens shades. More controlled shading is possible with either a French flag and arm (above) or a compendium shade, which can be extended or shortened to suit lenses with different angles of view (right).

Soft cable release

Some tripods have the facility of fitting a lateral arm – useful for vertical copy shots – while pan-and-tilt heads allow more controlled movements. To reduce further the risk of camera shake, use a cable release or the camera's own self-timer; locking up the mirror of a single lens reflex also reduces vibration.

Other camera supports: In the absence of a tripod, any support is useful. A G-clamp specially adapted with a ball-and-socket head is one alternative; a monopod, while hardly rigid, adds some steadiness. Even a pistol grip can help, while rifle stocks are available for hand-held shooting with long-focus lenses. At worst, either wrap the camera strap tightly around your wrist, or rest the camera on something soft, like a folded jacket.

Useful accessories

There is a wide, seemingly endless, choice of accessories available to supplement the basic 35mm camera system. Some are essential, others are gimmicks of limited practical value, and yet others have highly specialized applications.

Lens shades: Flare degrades the image, even with the latest multi-coated lenses, and a lens shade that cuts off extraneous light from outside the picture frame will improve image quality. Some lenses have built-in lens hoods that retract when not needed; most take separate hoods that screw or clip onto the lens front. A lens shade also

Other camera supports

A highly adaptable support (below) can be made by combining a small ball-and-socket head with a clamp or vise-grip.

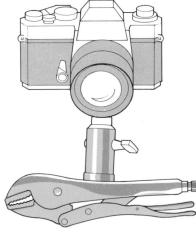

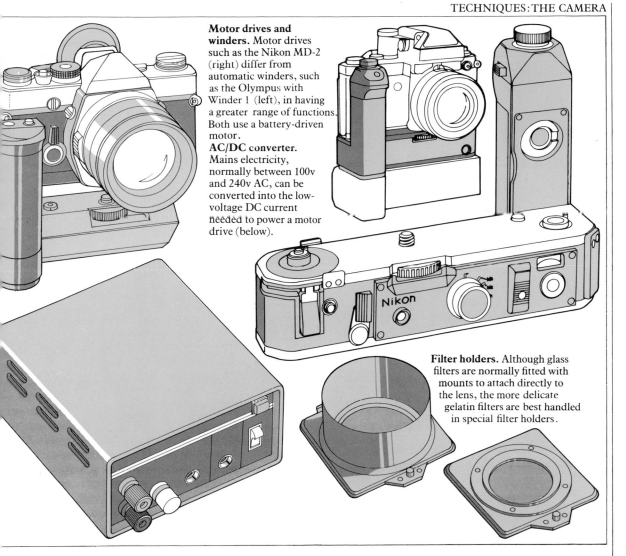

Motor drives and winders. Motor drives such as the Nikon MD-2 (right) differ from automatic winders, such as the Olympus with Winder 1 (left), in having a greater range of functions. Both use a battery-driven motor.
AC/DC converter. Mains electricity, normally between 100v and 240v AC, can be converted into the low-voltage DC current needed to power a motor drive (below).

Filter holders. Although glass filters are normally fitted with mounts to attach directly to the lens, the more delicate gelatin filters are best handled in special filter holders.

Pistol grips (below) and rifle stocks are both aids to handheld shooting, useful mainly with long lenses.

has a second use in protecting the front of the lens from scratches or abrasions. The most efficient lens shade is an adjustable bellows that can be altered to suit a variety of lenses. Alternatively, a piece of black card held close to the lens will shield it from a single light source, such as the sun.

Motor drives and winders: The value of a motor drive is not simply that it permits fast action shooting (see p 192). By substituting an electric motor to trigger the shutter and wind on the film, the camera becomes a more flexible instrument and two mechanical operations are made less distracting – a valuable asset in situations where you need all your concentration for the subject. The firing rate is usually adjustable, normally up to 5 frames per second on most models, and the unit can also be set to fire single frames. Power is normally from a battery pack which can be separate or integral. Automatic winders are basically simplified motor drives without the capacity for continuous firing.

Filter holders: When using gelatin filters, which are less expensive but more fragile than screw-on glass filters, a filter holder reduces wear and tear.

Manual shutter releases: Cable releases are flexible sheathed cables that screw into or around the shutter release button. The longer and more flexible the cable, the less the risk of vibration. Most cable releases have a locking device to keep the button depressed for time

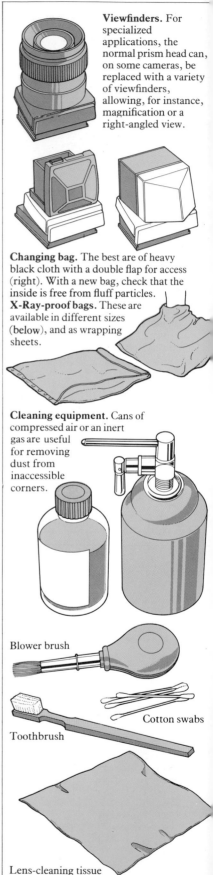

Viewfinders. For specialized applications, the normal prism head can, on some cameras, be replaced with a variety of viewfinders, allowing, for instance, magnification or a right-angled view.

Changing bag. The best are of heavy black cloth with a double flap for access (right). With a new bag, check that the inside is free from fluff particles.

X-Ray-proof bags. These are available in different sizes (below), and as wrapping sheets.

Cleaning equipment. Cans of compressed air or an inert gas are useful for removing dust from inaccessible corners.

Blower brush

Cotton swabs

Toothbrush

Lens-cleaning tissue

exposures. Where the camera body and lens are mechanically separated, as with some bellows, a double cable release is necessary.

Viewfinders: Many single lens reflex cameras have interchangeable viewing heads. A magnifying pentaprism head allows rapid viewing of an enlarged screen without having to press the eye up close to the camera. A waist-level finder is essentially a hood that shades the light from the ground glass screen and is used for low-level viewing or when a two-dimensional view is desirable. A high-magnification focusing viewer also facilitates a right-angle view of the image, but is particularly useful for close-up or copy work.

Cleaning equipment: Constant use, particularly outdoors and in wet or dusty conditions, causes eventual wear and tear on all parts of the camera system. Lens surfaces and the camera's moving parts are particularly vulnerable. Always keep a small brush (preferably a blower brush), lens cloth or cleaning tissue, a toothbrush and small cotton swabs with your equipment. A small bottle of de-natured alcohol and a can of compressed air or an inert gas are also useful for cleaning lens surfaces and removing dust and grit.

Maintenance and repair equipment: Advanced camera repair is a specialized skill, demanding great precision, but there are often occasions when you have no alternative but to try it yourself.

Changing bag: A changing bag is a light-tight black cloth bag with an inner liner, double zips and two sleeves. It is used as a portable darkroom that can be used if the film jams in the camera, or if you have to load a very sensitive emulsion like infra-red.

X-ray proof bags: Lead-lined bags in various sizes are one way of ensuring that airport X-ray machines do not fog your films (despite inevitable assurances, some do). If you have to mail unprocessed film, they also provide an extra measure of safety.

Cases: Cases prolong the life of equipment. Ever-ready cases for cameras and individual lenses provide excellent protection, but if you have a lot of equipment, it may be more convenient to pack everything into one compartmentalized case. The cases that provide the best protection are aluminium, gasket-lined and are proof against water, dust and grit. Some have adjustable compartments, others have foam blocks which can be cut to take your own choice of equipment. They should have either a reflective metallic finish or be painted white, to reflect as much heat as possible.

Clips, clamps and tape

An assortment of devices for holding things together is always useful. Use G-clamps, spring clamps, alligator grips from electric stores, and the ubiquitous Gaffer tape, capable of supporting more than you imagine.

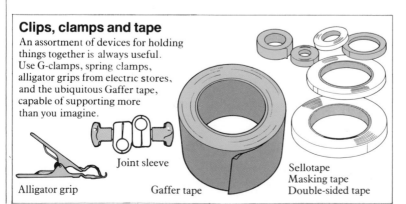

Alligator grip

Joint sleeve

Gaffer tape

Sellotape
Masking tape
Double-sided tape

Equipment cases. The main function of a camera case is to provide maximum protection. Moulded aluminium cases such as this American Haliburton, or the West German Rox, are the most secure, and are gasket-sealed against grit and water.

Camera cases. These can be rigid and an exact fit for the camera (top) or made of soft leather (above) which will fit several models.

Lens and body caps. Caps for the front and rear of lenses, and for the camera body, are a necessary protection against dust particles.

Camera straps. For safety, a strap (below) should always be fitted, except when the camera is being used on a tripod.

Shoulder bag. Many styles are available. Separate pockets help prevent equipment scraping together. Some models have rigid compartments.

Tripod case. An alternative to carrying the tripod attached to a shoulder bag is a separate case (below), like a miniature golf club bag.

Repair equipment. Simple on-the-spot repairs are usually possible with a few basic tools such as these.

Pencil claw

Tweezers

Allen keys

Set of jeweller's screwdrivers

Lens cases. Cases for individual lenses are available in hard leather, soft padded leather (above), or clear plastic with a screw base (right).

File

Sharp-nosed pliers

Standard pliers

Exotic accessories

If your photographic interests lean in specialized directions, some of the accessories shown here will be essential, but in most cases you will need them only infrequently. Accessories for quite large specialized fields, such as photomicrography, are dealt with in the relevant sections.

Effects filters: Despite their popularity in many amateur magazines, the majority of effects filters produce such unusual and gaudy results that it is worth pausing to consider whether, in using one, you are actually making it solve a problem, or whether you are making the picture fit the filter.

Multiple-image filters use glass facetted in a variety of ways to give secondary "ghost" images.

A split-field filter uses a plus-diopter lens across the bottom half of the filter ring to bring close foreground objects into focus at the same time as distant backgrounds, rather like bi-focal spectacles.

Colored filters provide strong overall color effects that can be duplicated easily by selecting your own gelatin filters. The latest commercial filters are color polarizers – two polarizing screens, one containing dichroic color material, so that the intensity or combination of colors can be adjusted by rotating the front element.

Colored graduated filters are similar to the neutral graduated filter described on p157, but with a color cast. Two together can give a different hue above and below the horizon in a landscape shot.

Diffraction filters use a transmission diffraction grating (which has the effect of large numbers of minute regularly-spaced prisms) to break up bright sources of light into the components of the spectrum.

Star filters use cross-screens to give a pointed "star" effect to point sources of light. The etched pattern on the filter determines the number of points to the "star".

Soft-focus filters soften the image, obscure detail slightly, and create flare around highlights. Their most frequent use is in flattering portraiture, as they tend to hide skin blemishes. The soft-focus effect is usually achieved by either an irregular surface to the glass or finely

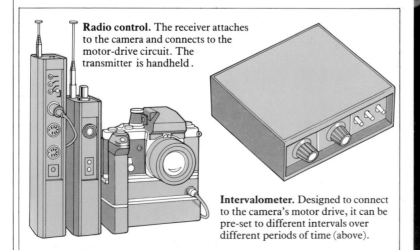

Radio control. The receiver attaches to the camera and connects to the motor-drive circuit. The transmitter is handheld.

Intervalometer. Designed to connect to the camera's motor drive, it can be pre-set to different intervals over different periods of time (above).

Step prism. This has half of its surface cut into horizontal angles. As a result it produces, in addition to the basic image, a succession of secondary images, each one fainter than the previous one. For a magazine cover on the topic of fleet car pools, I used one of these filters to convey the impression of repeated identical images (below).

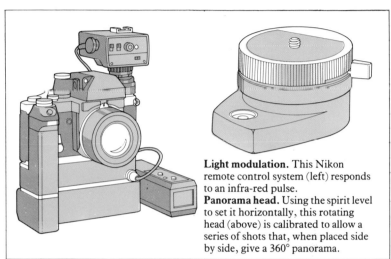

Light modulation. This Nikon remote control system (left) responds to an infra-red pulse.
Panorama head. Using the spirit level to set it horizontally, this rotating head (above) is calibrated to allow a series of shots that, when placed side by side, give a 360° panorama.

etched concentric circles; the latter leave the center of the picture in sharper focus than the edges. Do not use these filters with a stopped-down wide-angle lens, as the filter's irregularities or etchings will come into focus. You can make your own soft-focus filters by smearing petroleum jelly over the surface of a clear filter (not the lens!) or by shooting through any translucent material, such as muslin.

Remote control: There are a number of ways of operating the camera at a distance, a useful ability in wildlife and surveillance work. The simplest is a pneumatic shutter release, although this alone has no provision for winding on to the next frame and re-setting the shutter.

A motor drive or automatic winder is practically essential for most remote control operations. An extension cord attaches to the motor-drive trigger mechanism for operation from a distance. Even more remote control is offered by a radio receiver attached to the camera and a transmitter; there is usually a choice of wavelengths, but you may find that other transmissions, from model aircraft controls for instance, may trigger the camera. Light modulation is the basis of a simpler and less expensive system. Totally independent operation is possible with an intervalometer, which can be set to fire the shutter at pre-arranged intervals from a few seconds to many hours. You can also design your own triggering systems based on wires, photo-electric cells or pressure plates. Two accessories for remote-control systems are bulk film camera backs, accommodating rolls of film of up to several hundred exposures, and servo attachments that automatically adjust the lens aperture with changing light levels.

Data back: A replacement for the normal camera back, the data back "leaks" light onto a small area of the film to record information.

Special attachments: Apart from the microscope attachments described on p178, some manufacturers supply attachments for endoscopes, oscilloscopes and astronomical telescopes.

Panorama head: To take a 360° sequence of photographs that can later be joined together to form a panoramic view, a panorama head can be used fitted between the camera base-plate and tripod. It can be set to the horizontal and is calibrated for use with different lenses.

Lenses

LENSES ARE NORMALLY classified by their focal length because it is this characteristic more than any other that determines the kind of image they produce. The focal length (see p16) is essentially the distance from the lens to the focused image when the lens is set at infinity. In a camera the focused image is at the film plane. A lens which has a short focal length – 28mm for example – will bend the incoming light rays sharply, to produce only a small magnification and include more of the scene in front of the camera. A long focal length lens, on the other hand, refracts the light at a more gentle angle, giving greater magnification of the subject but eliminating much of the scene from the final image.

Since, in the camera, focal length is a measurement of the distance between the lens and the film plane, long-focus lenses tend to be physically larger than short-focus lenses, and at either extreme of focal length this can cause problems in handling. A traditionally designed 1000mm lens can be very heavy and unwieldy, while a lens with a focal length much shorter than the thickness of the camera body, such as 24mm, would prevent the use of the viewing mirror in a single lens reflex camera. However, there are ways of altering the physical dimensions of lenses. For wide-angle lenses, the retrofocus design increases the physical size of the lens while preserving the short focal length to allow enough clearance for the movement of the camera's mirror. The telephoto design does exactly the opposite for long focus lenses, by shortening the internal distances. Both operate on the same principle of using two groups of elements, one diverging and the other converging. A long-focus lens, therefore, is not necessarily a telephoto, although nowadays most are, for sheer convenience.

Yet another loophole in this optical problem is the possibility of "folding" the light paths in a long-focus lens by means of mirrors, producing the same focal length but in a much more compact body. This principle (the same, incidentally, as used in many large telescopes) means that quite powerful "catadioptric" mirror lenses can be relatively short and stubby.

How focal length controls image size

The convex lens of a short-focus design bends the light rays from the subject (in this case a man) at a sharp angle to bring the image into focus only a short distance behind the lens: hence its name. Because the light is bent so sharply, the image is small. The long-focus lens is less convex than a short-focus design and so brings the light rays together farther behind to form a larger image. This also means that a long-focus lens is more selective, as less of the subject's surroundings are included in the picture.

Long focus

Short focus

Making lenses more convenient to use

The retrofocus design (right) is used for very short-focus lenses whose lens elements would otherwise interfere with the operation of the camera mirror. Light is first collected by a front group of diverging elements; the spreading light rays are then brought together by a rear group of converging elements. The interaction of these two opposing lens groups allows the image to be focused much farther behind.

The telephoto design (above) uses the same principle of a converging and a diverging lens group as a short-focus lens, but the order is reversed. Incoming light rays are collected first by the converging group, and this convergence is reduced by the rear diverging elements to shorten the overall length of the lens. In some more sophisticated designs the focusing system is arranged so that only the central elements move, thereby eliminating the change in the length of the lens as it is focused.

The mirror lens (right) as its name implies, uses two mirrors to compress the distance that the light rays must cover into a short tube. The use of mirrors reduces chromatic aberration (see p16), but the lens does not have an aperture because there is no means of incorporating a diaphragm, so exposure must be controlled by shutter speed alone or by neutral density filters.

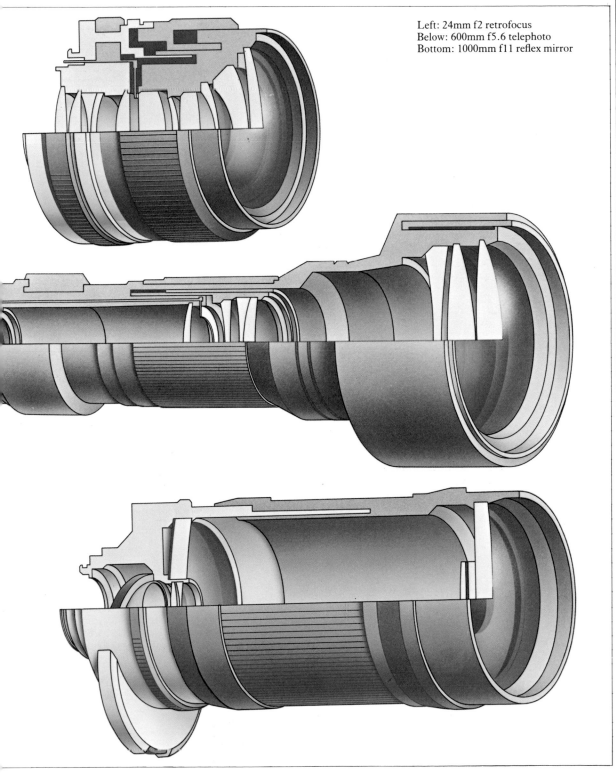

Left: 24mm f2 retrofocus
Below: 600mm f5.6 telephoto
Bottom: 1000mm f11 reflex mirror

The range of focal lengths

An effective demonstration of the characteristics of lenses of different focal lengths is to choose one viewpoint and, with a selection of lenses from very short to very long focus, shoot the same scene with the camera pointing in the same direction. The opportunities for making as good a composition with every lens are very rare, and inevitably one or two stand out as more effective. In this series, shot in a Hong Kong harbor, the camera position was unchanged, but the lenses used ranged from a 16mm fish-eye to an 800mm telephoto. The extent of the magnification (which can be calculated by dividing 800mm by 16mm – 50 times) is so great that the final telephoto image cannot be seen on the fish-eye photograph even with a magnifying glass. In fact, the pictures at either end of the scale are so completely different that only the intervening shots, which are less satisfactory, show the gradual progression.

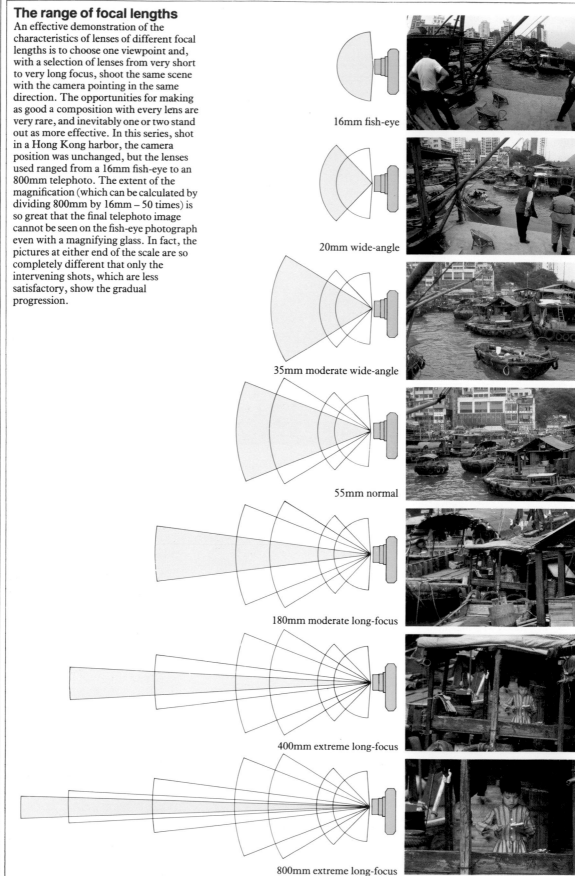

16mm fish-eye

20mm wide-angle

35mm moderate wide-angle

55mm normal

180mm moderate long-focus

400mm extreme long-focus

800mm extreme long-focus

The normal lens

The range of lenses available for modern 35mm cameras is extensive. The angles of view range from more than 200° to less than 1°; and those few lenses that are in the middle of the spectrum – neither wide-angle nor long-focus – are generally considered normal. "Normal" in this case means that the lens covers approximately the same angle of view as the human eye, without perspective distortion.

Lens descriptions – "normal", "wide-angle", and so on – depend on the film size, for a lens that gives a certain coverage on one film format will project a wider angle on a larger format. When the focal length of the lens equals the diagonal measurement of the film frame, the image will appear normal. A 35mm film frame measures 43mm diagonally, so theoretically 43mm is normal. In practice, the most common lens (supplied by manufacturers as normal) is 50mm, and any length between 40mm and 55mm will appear free of perspective distortion. These figures are necessarily imprecise because of the way the eye sees (see p 14). The eye scans the view in front of it, and the whole scene is recorded on the retina in different degrees of sharpness, from the fuzzy borders of view at about 240° down to perfect sharpness over an angle of just 2° in the center. Nevertheless, the apparent coverage is around 45°–50°, and a lens that comes close to this appears to have none of the distortions associated with wide-angle and long-focus lenses.

Of all focal lengths, the normal lens is the least obtrusive picture-making tool. Its distortion-free optics allow a faithful, straightforward treatment of the subject imposing little graphic control. Photographers looking for a literal rendering find it indispensable.

Yet, precisely because of these qualities, many photographers find this normal view too ordinary and restricting, and look for more dramatic and unusual images at the ends of the focal length scale. The

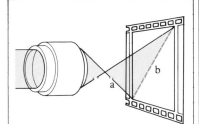

When the lens focal length (a) is approximately the same as the diagonal measurement of the film format (b), the image will appear normal.

Calcutta. Both the pictures (below and bottom) were taken with a normal focal length lens. As candid street photographs they rely on their subjects for interest and the 50mm lens imposes little graphic influence.
Both Nikon, 50mm, Kodachrome, ¹/₁₂₅sec, f2.8.

Normal lens. This standard 50mm lens has a 46° angle of view that gives a natural perspective and a moderately wide minimum aperture of f2. Its six elements arranged in four groups allow the manufacturer design flexibility to correct most common aberrations.

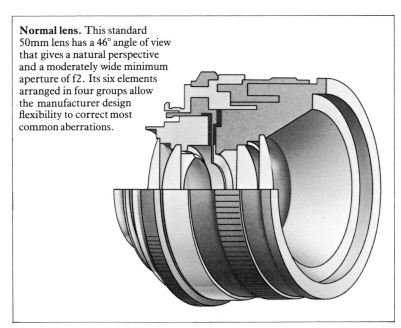

wide range of lenses now commercially available has accustomed us to stronger graphic images.

One very practical advantage, however, that is associated with a normal focus length, is the ability of the lens manufacturer to increase its light-gathering power, and therefore its speed. The additional optical problems of the wide-angle and long-focus lenses restrict their maximum aperture: the very fastest lenses are around the normal focal lengths and can have a maximum aperture of up to f1.2, and in the case of some specialized night-time lenses, this can be even faster.

Wide-angle lenses

Lenses with a shorter focal length than a "normal" lens can be divided into two categories – moderate wide-angles which give little noticeable distortion, and extreme wide-angles that unmistakably impose their distortion on the picture. Short-focus lenses enable the photographer to obtain a wide angle coverage even in small spaces and give great depth of field. Together these properties open up exciting possibilities of controlling the relationships between different elements of a scene.

The most noticeable property of the wide-angle lens is its coverage, 62° in the case of a moderate focal length such as 35mm, or a wide 94° in the case of a 20mm lens, for example. In cramped spaces where the photographer cannot move back far enough to cover the scene with a normal lens, a wide-angle lens is essential. Its generous coverage gives a feeling of space to interior views and will often best convey the full sweep of an open landscape. Perhaps most important is its ability to include both the immediate foreground and distant objects, which allows the relationship between near objects and their backgrounds to be explored.

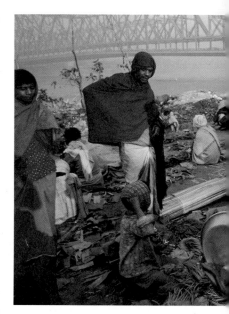

Howrah Bridge market, Calcutta. A 24mm wide-angle lens was ideal for this shot (above). Because of the great depth of field of this lens, there was no need to re-focus, and because of the wide angle of view, careful composition was unnecessary. This made it possible to use the camera very rapidly.
Nikon, 24mm, Kodachrome, 1/125sec, f3.5.

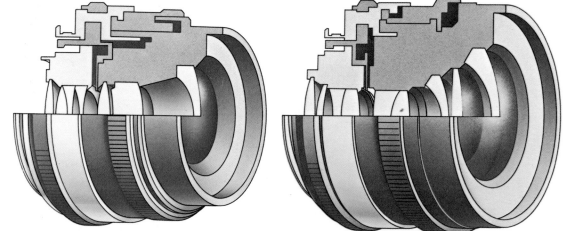

Wide-angle lens. The 24mm lens (above left), with an angle of view of 84°, uses a retrofocus design (see p38) to lengthen its extremely short focus so that it can be used with the reflex mirror in the camera housing. To overcome the problem of poor image quality at close focusing, the elements 'float' inside the housing. Their relative positions can therefore be changed as the lens focuses closer. The 35mm (above right) is much closer to the perspective of a 'normal' focal length, but it does not have the great depth of field at full aperture of wider-angle lenses.

From qualified optimism about British farming we come to qualified pessimism about the world's food prospects. Dame Barbara Ward, President of the International Institute for Environment and Development, examines the balance sheet. On the debit side, increasing direct and oil-related costs, diminishing returns, and the weather. On the credit side, is the growing recognition of an enlightened community approach to the world's nutritional needs. The American 'grain sheikhs' will be balancing the books.

Typographic sphere. This was one of the rare occasions when a true fish-eye lens was indispensable to give a circular setting of typography the appearance of being a sphere. The original typography measured only 4in (10cm) in diameter, so to achieve this degree of distortion, the front element of the lens had to be less than 1in (2.5cm) from the paper. To preserve the focus, the lens had to be stopped right down, and as reflex viewing was not possible with this design of lens, positioning was done by opening the camera back and placing a ground glass screen on the film plane before loading the film.
Nikon F2A, 6mm, (220° coverage), Kodalith line film, 10 sec, f22.

Extreme wide-angle lens. A true fish-eye design, covering exactly 180° and producing a circular image, this 8mm lens produces images with extreme barrel distortion, straight lines at the edge of the picture being bent to the circumference. Because of the wide coverage, the lens contains its own built-in filters in a revolving turret. This fish-eye lens allows reflex viewing, although less expensive models can only be used with the camera's mirror locked up.

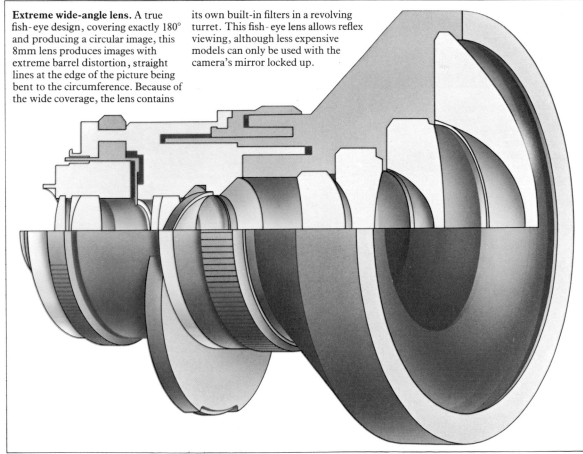

Pennzoil Building. Using a fish-eye 16mm lens for effect rather than for coverage, I chose the uncomplicated skyscraper skyline of downtown Houston (above). The lens imposed a symmetry on what was already a very ordered and precise arrangement of buildings.
Nikon F2AS, 16mm, (170° coverage) Kodachrome 25, ¹/₁₂₅sec, f5.6.

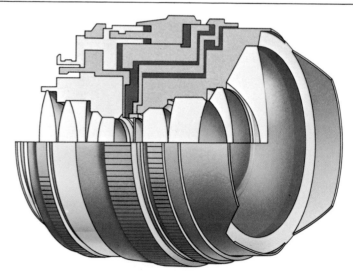

Extreme wide-angle lenses. Designed for its pictorial effect rather than for scientific use, this f3.5 16mm full-frame fish-eye lens (above) covers an angle of view of 170°. It contains four interchangeable filters built into the housing. The f5.6 15mm lens (right) has a 110° angle of view, yet is corrected to overcome the basic distortion typical of fish-eye lenses. Because of the difficulty of covering the front element with a filter, the lens contains small built-in filters.

Because the lens compresses the image on to the film plane, it is very efficient at gathering light, so the wide-angle lens needs only a small aperture even when it is wide open. As a result, the depth of a wide-angle lens is much greater. In reportage photography, for example, this can be perfect for unplanned shots that need quick reactions – with, say, a 28mm lens on a fairly bright day, anything from a few feet to infinity will be sharp, so the photographer can aim and shoot without adjusting the focus.

Extreme wide-angle lenses

The extreme wide-angle lenses have angles of view well over 100°, the majority of them around 180°, but the price of this coverage is extreme distortion, demanding careful and restricted use. Most, including the "fish-eyes", are uncorrected, and give a very characteristic curved distortion, bending straight lines around the circumference of the picture. Only lines that pass through the center (radial lines) remain straight.

The most extreme of these uncorrected lenses compresses the image into a circular frame – a "fish-eye". When fish-eyes first became commercially available, they enjoyed a brief vogue, but the strong graphic control that they impose swamps the subject matter and restricts their use.

More adaptable is the kind of uncorrected wide-angle lens that covers the full frame. It can be used either as a problem-solving lens, utilizing its wide angle of coverage and depth of field, or for the dramatic effect of its distortion. In small spaces it comes into its own, but in this case the distortion is usually a nuisance and you should try

Apollo 11 Command Module. A 'classical' use of the extreme wide-angle lens, this shot of the interior of the Apollo 11 Command Module (top) was only possible with a lens that could cover nearly 180°. The conical interior and unfamiliar layout of the equipment helped to mask the distortion, which I deliberately wanted to avoid. I was amazed at the lack of room inside the capsule, where three space-suited men spent more than a week.

I could not mount the camera on a tripod without appearing in the picture myself, so I jammed myself between the wall and a stanchion and took a hand-held shot at 1 second, which is feasible with such a wide-angle lens. Even at full aperture, the depth of field was quite adequate. Illumination was provided by photoflood lamps and diffusing sheets were placed over the module's ports, as shown in the diagram (above).
Nikon F2AS, 16mm, (170° coverage), Kodachrome 64 + 80B gelatin filter, 1 sec, f3.5.
Photo: Courtesy of Harry N. Abrams Inc.

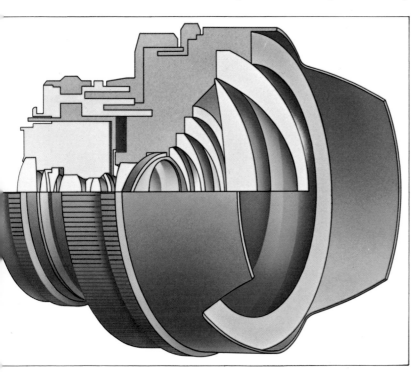

Perspective correction. The optical axis of this 28mm lens can be shifted laterally by up to 11mm. A locking screw near the center of the housing controls this, and the mount rotates a full 360° so that the shift can be used horizontally, vertically or diagonally. Its chief use is to avoid converging parallel lines, particularly in architectural photography.

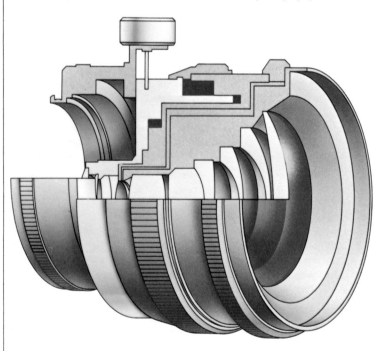

Man reading, Benares. For this shot (above), taken across a street, a moderate long-focus lens of 180mm gave the right framing, and at this distance was unobtrusive.

Nikon, 180mm, Kodachrome, ¹/₂₅₀sec, f4.

to avoid the more glaring effects. If possible, compose in such a way that any clean, straight lines or familiar shapes are near the center, where the distortion is less.

Using the extreme wide-angle lens for effect is technically much simpler, but excessive use is tempting. Try to use the curvature to some graphic effect rather than playing with it for its own sake. Complicated outlines and irregular shapes are normally poor subjects with this type of lens since they are further complicated by the lens.

Because of the wide coverage, it is often difficult to avoid having the sun in frame in an outdoor shot. As a result, it is important to take great care when setting the exposure; the sun or a large area of pale-toned sky in the frame can easily result in the main subject being underexposed. When taking a TTL reading, either aim the camera in a slightly different direction, or cover the image of the sun with your hand.

Correcting the curvilinear distortion of the lens is possible, at a price. Such lenses are usually bulky and very expensive, and none can reach the coverage of an uncorrected lens. In any case, although all straight lines do appear straight in the picture, there is considerable angular "stretching" towards the edges, and circular objects (or faces) distort badly near the corners.

Attaching filters can be a problem, as the angle of view is so wide

that the rim of the filter would appear in the picture frame. Consequently, all these lenses feature built-in filters, situated between the elements, but for some reason, most manufacturers have failed to appreciate that most photographers work in color, and the filters are usually geared to black-and-white photography. As a last resort, it is just possible to bend an oversize gelatin filter around the front of the lens, holding it in place with tape.

Long-focus lenses

If the wide-angle lens draws together all the components of the scene and involves the viewer, the long-focus lens is a device that isolates and detaches. Through its magnification, it can be used to pick out individual elements of a scene. This ability is enhanced by the shallow depth of field of all long-focus lenses. Because they need to gather more light for their magnified images, these lenses have relatively large apertures; as a result, the depth of field is limited even when the lens is stopped down; and the subject in focus often appears against a blurred foreground and background.

Practically, long-focus lenses have the great advantage that the photographer can work at a distance – especially useful when making candid shots of people. With a 135mm lens, a figure will fill the frame at 24 feet (7 meters), and a tightly-cropped portrait can be taken at 6 feet (1.8 meters). Most moderate long-focus lenses cannot, in fact, focus closer than about 5 feet (1.5 meters).

An extra bonus for portraiture is the flattening effect that a long-focus has on perspective. Whereas a wide-angle lens exaggerates perspective, increasing the apparent difference in size between near and far objects, the long-focus lens compresses it.

An alternative to a long lens is a tele-converter, essentially a supple-

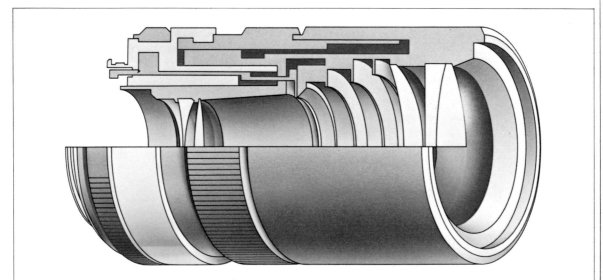

Long-focus lens. A favourite of many photo-journalists, the fast 180mm lens has a maximum aperture of f2.8 which makes it fairly easy to handhold at quite slow speeds. For color work in poor lighting conditions it is an ideal telephoto lens. It is quite heavy for its size but this can be an advantage, as it lies steadily in the hand.

mentary set of elements that fits behind an ordinary lens to increase its focal length. A converter will multiply the focal length of the lens it is used with. A two-times teleconverter, for example, will double the effective focal length of the lens. Until recently, the inferior image quality of teleconverters was such that they had little serious application, but more recent designs, such as the Nikkor TC range, give quite acceptable definition. Their greatest advantage is their small size, and when used with a long-focus lens they can save quite a lot in weight. The disadvantage, apart from a slight loss of image quality, is a drastic reduction in speed, so that the maximum effective aperture is cut sharply.

Extreme long-focus lenses

Lenses of 300mm and longer share the same characteristics as moderate long-focus lenses, but they also present new opportunities and problems. Foreshortening is an essential quality with these lenses, making distant objects, such as mountains or the sun, loom large over the foreground and middle ground. Their extreme magnification allows them to be used at considerable distances from the subject, and as a result they are indispensable for wildlife photography. Also, try using a very long-focus lens for candid shots of people; although more difficult to handle, it makes it possible to work completely unobserved.

The very shallow depth of field of these lenses has a special advantage – by keeping the aperture wide open, distracting foregrounds such as foliage are thrown so far out of focus that they virtually disappear. Practically speaking, the lens shoots right through the obstruction.

Inevitably, such lenses are heavy and bulky, even with space-saving improvements in design. They combine all the worst camera-handling problems: they are heavy and difficult to hold steady, and any camera shake is more apparent at these greater magnifications.

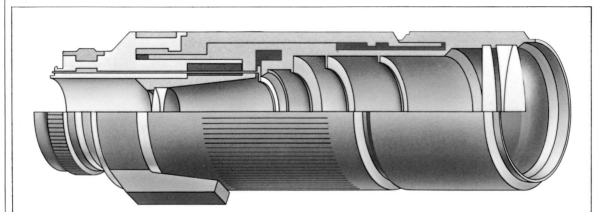

Extreme long-focus lens. One of several relatively recent long-focus lenses that are both compact and quite fast, this 400mm f5.6 telephoto design allows handheld shooting under many conditions. Extra-low dispertion glass is used, and although this is expensive, it reduces chromatic aberration, the chief cause of unsharpness in long-focus lenses. It also allows the lens to operate at its optimum performance while at full exposure.

Relative movement of the subject is also greater, and needs a faster shutter speed (from the same viewpoint, a moving object will cross the narrow picture frame of a long-focus lens faster than that of a wide-angle lens). To make matters worse, long-focus lenses tend to be slow. They must gather more light for their magnified images, and therefore essentially have maximum apertures that are sometimes as little as f8 or f11.

Because of these problems, very long-focus lenses usually need a secure support, such as a tripod, and even then the vibration of a single lens reflex camera mirror can blur the image at speeds slower than 1/60 sec. To get the maximum use out of these lenses, practise holding them steady, using a wall or whatever support is available. It is possible to improve the slowest speeds at which you can hand-hold them with practice.

The very best long-focus lenses are extremely expensive, mainly because optical excellence is difficult to achieve. Chromatic aberr-ation (see p 16),where the blue and red light rays do not quite come together in focus at the film plane, is more apparent at great magni-fications, and even when the characteristic colored "fringe" has been corrected, the image often remains subtly unsharp. New optical glasses now overcome this, but they are costly.

Zoom lenses

A zoom lens has a variable focal length, which means that, in a single housing, a range of different magnifications and angles of view can be combined. The image quality possible with this kind of lens used to be noticeably poorer than that which could be achieved with a conven-tional, fixed focal length lens. Recently, however, lens design has improved, and modern zoom lenses can have excellent optics.

Zoom lenses are available in different ranges, from a wide-angle range to a very long-focus range. These often overlap slightly so that almost the complete spread of possible focal lengths can be encom-passed in three or four zoom lenses. Generally, the range of a zoom

Basin Street, New Orleans. The severe compression of perspective that is such a noticeable feature of very long-focus lenses reveals strong patterns in a city thoroughfare. With this kind of picture (above), which relies strongly on its graphic elements, it is usually important to stop the lens aperture down sufficiently to render everything in sharp focus. *Nikon, 400mm, Kodachrome, ¹/₆₀sec, f16.*
Test match crowd. Another useful quality of long-focus lenses is their ability to isolate small subject areas from their surroundings. This photograph (above right) was composed so that only the massed faces of these cricket spectators would appear edge to edge, like an intricate pattern. *Nikon, 400mm + 2× tele-converter, ¹/₂₅₀sec, effective aperture f11.*

Car accident. To simulate a car speeding towards the camera (right), the camera was set up on a tripod in front of the stationary car, and the zoom ring turned during a long exposure. The resulting converging streaks are very characteristic of this technique.
Nikon, 200-600mm zoom, Kodachrome, 1 sec, f32.

lens is between two and three times its shortest focal length; 35–70mm is a popular lens, as are 80–200mm and 100–300mm. At the extremes of focal length, either very short or very long, the optical design is most complex and the lenses most expensive.

There are two clear advantages to a zoom lens. Firstly, although the lens may be heavier and bulkier than any single fixed focal length lens within its range, it is naturally much lighter than a range of several conventional lenses. For photographers who need a broad selection of focal lengths, a zoom may be more convenient and portable. Secondly, precise framing is possible without changing the camera position; this is particularly important when you do not have completely free access to your subject, as in many sports events, or when the subject changes position quickly, as in many wildlife situations.

Another, more specialized, use for zoom lenses is to operate the zooming control during an exposure. This produces a very characteristic streaking of the image, which can be used as a special effect.

This extremely useful facility to alter the focal length has certain drawbacks, however. Today, image quality among the best makes of zoom lens is very good, but in situations where high resolution is critical, a lens with a fixed focal length, of the same standard of manufacture, is still better. Lens flare tends to be more pronounced because there are more lens elements. Also, the widest aperture of a zoom lens is never as large as that of a conventional lens, so that where fast shutter speeds are needed, it is less useful. Finally, zoom lenses focus less closely than conventional lenses.

Whether you build up your range of lenses from those of fixed focal lengths, or from a lesser number of zoom lenses, depends on the kind of work you expect to do, and your personal taste. Except for some very specialized occasions, zoom and conventional lenses are not complementary; most photographers inevitably use one or the other.

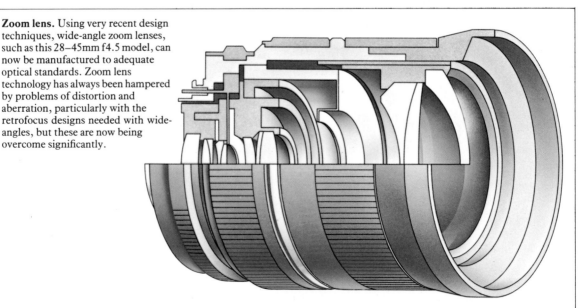

Zoom lens. Using very recent design techniques, wide-angle zoom lenses, such as this 28–45mm f4.5 model, can now be manufactured to adequate optical standards. Zoom lens technology has always been hampered by problems of distortion and aberration, particularly with the retrofocus designs needed with wide-angles, but these are now being overcome significantly.

Close-up photography

There is no strict definition of close-up photography; it falls some-where between the closest focusing distance of a normal lens and photomicrographs. The greatest magnification that a normal lens can give is in the region of 1/7 the size of the subject – in other words, a reproduction ratio of 1:7. For magnifications greater than this, special equipment is needed, whether simply an auxiliary lens that screws on the front of the normal camera lens, or a "macro" lens designed to cope with the special optical problems of close-up photography. From

Mosquitoes. This was a laboratory setting for a magazine feature on medicine (above). The studio flash backlighting was powerful enough to allow a small aperture and considerable depth of field.
Nikon, 55mm Macro, Agfachrome, flash sync, f27.

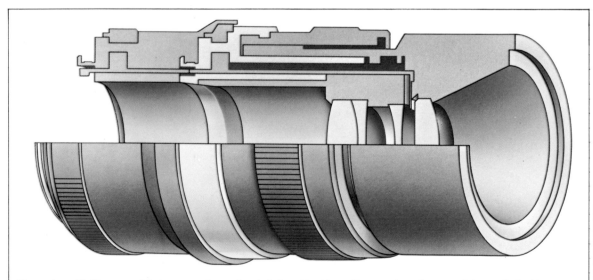

Macro lens. Unlike normal designs which perform at their best when focused on infinity, this 100mm f4 lens is intended for optimum use at close distances. It is supplied with an extension ring for even closer focusing.

Moth's wing. The colorful iridescence on the wing of this Madagascar moth (below) was best illuminated with the direct shadowless lighting from a Medical-Nikkor's built-in ringlight. The reproduction scale was dialled on a separate control and leaked internally. *Nikon, 200mm, Medical-Nikkor, Kodachrome, flash sync, f32.*

life-size reproduction (a ratio of 1:1) up to about 20:1, the techniques become more specialized; this range of magnification is called photo-macrography. For magnifications beyond 20:1, a microscope is necessary, and the camera is fitted over the eyepiece by means of an adaptor.

Image sharpness, depth of field and lighting are the three main problems of close-up work. Most lenses are computed to perform at their best at normal focusing distances – between a meter or so and infinity – and the image they record deteriorates when they are used significantly closer. At ratios of 1:1 or greater, close-up sharpness can be improved by reversing the normal lens using a reversing ring, but it is always better, if possible, to use a macro lens.

Depth of field at these magnifications is extremely shallow, and it is often not possible to keep the whole subject in sharp focus. To improve depth of field, work at small apertures (for this reason, macro lenses stop down to at least f32) and position the camera carefully.

The principal lighting difficulty at close working distances is that the lens itself can cast a shadow on the subject. Some ingenuity is called for in using reflectors and small mirrors in order to re-direct light to fill in shadowed areas. Because everything is on a much smaller scale, normal lighting appears more diffuse. Sometimes this is an advantage, but to give definite shadows very small light sources are needed. For this, pocket flash units are ideal (see p 90). Whatever lighting is used, an increase in exposure is necessary to compensate for the extension of the lens. Light intensity obeys the inverse square law (also p90) so that a 2 times magnification will need 4 times as much light to make the correct exposure. If you have a through-the-lens meter, it will automatically compensate for the lens extension and the necessary adjustments will be made.

Teeth. A more traditional use of the Medical-Nikkor is in dentistry, where the shape and size of the mouth usually prevents a separate light being used adequately. A portable flash held to one side would create strong shadows that would conceal detail. *Nikon, 200mm Medical-Nikkor, Kodachrome, flash sync, f32.*

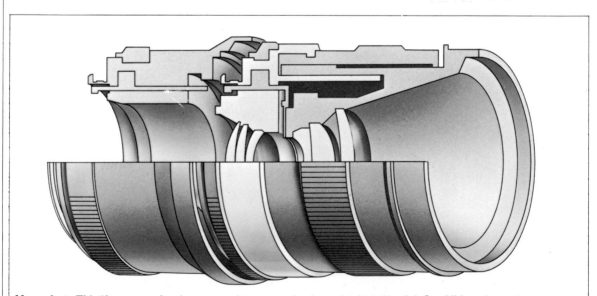

Macro lens. This 60mm macro lens has an angle of view of 39° and a wide focusing range from infinity down to 27cm, giving a maximum reproduction scale of 1:2. By adding the accompanying extension ring, the reproduction scale can be increased to 1:1. In addition, the maximum aperture of f2.8 is wide enough for most general applications.

Close-up equipment

Medical lens. Specialized medical lenses (below) contain their own built-in ringlight. The circular flash tube surrounding the front of the lens is so compact that the unit can be used in very confined spaces and provides its own shadowless lighting. Auxiliary lenses vary the magnification.

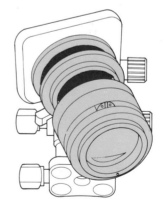

Ringlight. To give virtually shadowless lighting a ringlight (above) can be either a simple circular flash tube that fits over the lens, or an adjustable unit with supplementary lights to give some modelling. Power packs are always separate.

Auxiliary lens. This is a simple lens (below) that screws on to the front of a normal camera lens and shortens the lens-to-subject distance, so increasing magnification. For small magnifications, up to about 1:2, they are very useful, as no additional exposure is needed, but beyond this, image quality suffers.

Extension rings. These are used to extend the lens from the camera body in order to increase magnification. They are available in various sizes (below right) for manual, semi-automatic, or automatic use, and can be fitted to a variety of lenses. Use them singly or in sets.

Bellows. An extension bellows (left) gives the best quality close-up images, and allows continuous focusing. Some even offer shifts and tilts in the front lens panel, giving fine control over perspective and depth of field.

Reversing ring. Normal lenses are inefficient when the lens-to-film distance is greater than the lens-to-subject distance – in other words, at magnifications greater than 1:1. A reversing ring (below) enables you to turn the lens around and reduce lens-to-film distance.

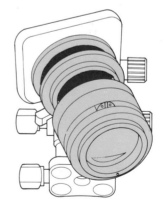

Auxiliary lenses

Extension rings

The nature of film

THERE ARE TWO major steps in creating an image on film. The first occurs during exposure – the reaction of photo-sensitive crystals to light, an imperfectly understood process that is completed when a latent ("hidden") image has been formed. The second step is the development, essentially a process of amplifying the sensitivity of the crystals to such a degree – about ten million times – that the image finally becomes visible.

Film exposure starts with a photon of light striking the surface of the film emulsion. Modern film emulsions are made up of tiny crystals of silver bromide, commonly called grains, embedded in a layer of gelatin. The size and distribution of the grains vary according to the type of film, but in an average emulsion, each grain measures about 1/1000th of a millimetre across. The silver and bromide are held together in a cubic lattice arrangement by electrical attractions. What the light photons do is to put extra energy into the crystal, disrupting the electrical status-quo.

Different speeds and contrasts. Using the characteristic curve described below, films which have different speed ratings or have been developed to different contrasts are displaced in relation to each

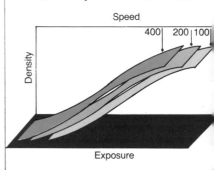

How film is constructed

The construction of most black-and-white film emulsions starts with the film base, typically a cellulose acetate that is tough, stable and almost non-flammable. On top of this, the emulsion of silver bromide grains in gelatin is attached with an adhesive layer. Gelatin is used because of its water solubility, its ability to hold grains in a fine, even dispersion and the fact that it swells when wetted, allowing development solutions to permeate through it. The emulsion is protected by a thin coating that resists scratching and an anti-halation layer backs the film base to prevent unwanted light being reflected into the emulsion.

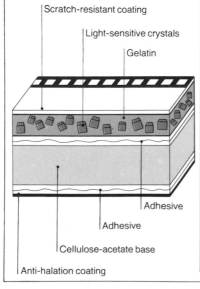

Scratch-resistant coating

Light-sensitive crystals

Gelatin

Adhesive

Adhesive

Cellulose-acetate base

Anti-halation coating

How film reacts to light

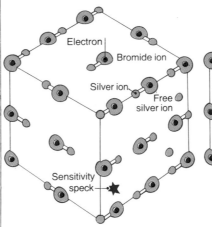

Electron

Bromide ion

Silver ion

Free silver ion

Sensitivity speck

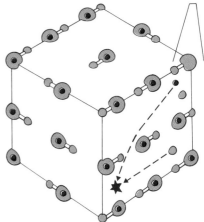

1. Unexposed, a grain of silver bromide is a crystal composed mainly of pairs of silver and bromine atoms. Because these atoms do not have the same number of electrons as ordinary uncharged silver and bromine atoms, they have an electrical charge and this holds them together. In this form, they are called ions; the silver ions are missing one electron and so have a positive charge; the bromine ions have an extra electron (represented by the small red dots) and have a negative charge.

In addition to this basic lattice, there are two irregularities – a few independent silver ions (also with a positive charge) and small specks of impurity, such as silver sulphide. It is these imperfections that start off the process of building an image.

2. A photon of light striking the crystal excites the extra electron, giving it higher energy and freeing it to move around the crystal. The function of the impurities seems to be as a site for the accumulation of these wandering electrons. With their negative charge, they then attract the free positively charged silver ions.

other. Films of different speeds have the same shape of curve, but the displacement is horizontal, in the direction of exposure. Films with different contrast ranges differ in the steepness of the slope.

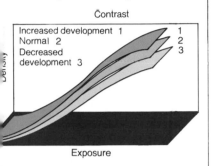

Contrast

Increased development 1 1
Normal 2 2
Decreased 3
development 3

Density

Exposure

Black-and-white film

The key to the way film responds to light is the individual silver bromide crystal or grain. In order to produce black-and-white films with different characteristics, it is the size, number and distribution of these grains that must be altered. The two characteristics that most concern photographers are sensitivity and resolution and, to contrast and improve these, film manufacturers have had to experiment with the granularity of the emulsion.

To achieve more sensitivity to light, all that needs to be done is to increase the size of the grains. The effect of this is quite simple – the larger grains need no more light than a small grain in order to initiate the formation of metallic silver, yet because there are more silver ions to start with, the size of the developed clump of silver will be larger. So the film with larger grains reacts more readily to light and is "faster". The speed of the film can be enhanced even further by packing more of these large grains to a thicker emulsion. However, the price that has

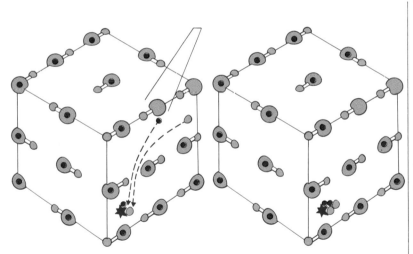

3. As light continues to add energy to the system, more electrons are freed and they in turn migrate to the specks of impurities, pulling after them more free silver ions. The two electrical charges balance each other and the small clumps of silver ions become silver metal.

4. These aggregations of silver constitute the latent image. It is still invisible and will only turn into a real image when the action of a developer increases its sensitivity about 10 million times.

The characteristic curve

A one-line notation that reveals many features of a film or paper, the characteristic curve (below) is the result of plotting density against exposure on a log scale. The angle and shape of the straight-line section shows the basic behavior of the film. Although more exposure to light naturally results in an increase in density, the rate at which this happens is not constant. At first only a few free electrons are excited and there is a slow start. Later the established clumps of silver act like magnets for further silver ions and electrons. Finally, very few free silver ions remain and the process slows down again. This change in the pace of image formation is graphically represented by the resulting S-shaped curve.

If the curve is steep, this shows that the film achieves maximum density very quickly and therefore has a high control. If, on the other hand, the slope is shallow, then the film has low contrast. A long flat toe indicates lack of detail in the highlights and a flat shoulder shows compression of tone in the shadows.

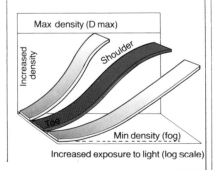

Max density (D max)

Increased density

Shoulder

Toe

Min density (fog)

Increased exposure to light (log scale)

to be paid for this increase in film speed is a coarser image. The increased granularity gives rise to a grainier appearance which in the very fastest films or with enlargement actually breaks up the image into a pronounced speckled texture.

This runs exactly counter to the second ideal of good resolution. For higher resolution, the film manufacturer uses an emulsion with fewer and smaller grains set in a thinner emulsion, so as to reduce the internal reflections that degrade the image in a thick layer of gelatin. This type of emulsion has a fine grained appearance but reacts less well to light and is therefore "slower".

In the end, the photographer must make a choice between the two ideals. If high speed is essential, as it would be in low-light action photography, then fine grain is out of the question. On the other hand, if the photographer wants to capture the finest detail in the subject, then the exposures will have to be longer. Black-and-white film with a speed rating of about ASA 125 is a general purpose compromise, combining some speed with fairly good resolution.

A quality that is related to graininess is sharpness. This is a subjective impression of a photograph, but it is also an indication of how well an edge is recorded in the image – the boundary, for example, between

Grain and graininess

Graininess is the subjective impression that a viewer has of the speckled pattern in the photograph and depends very much on the way in which the photograph is seen. The specks that can be seen in a grainy picture are not actually the individual grains themselves, which never measure more than 1/5000th of a millimetre. Instead, they are the larger clumps formed by overlapping grains. At this scale, the gelatin base in which they are embedded is relatively deep and the grains are jumbled on top of each other. To see the grains would need a magnification of about 50 times.

Graininess is, of course, a special problem for small formats, such as 35mm film, for negatives are commonly enlarged to 10 times and often more. Larger negative sizes which require only modest enlargement, of say two times, show less evidence of graininess.

ASA 32. Using a fine-grain, high-definition emulsion, Kodak Panatomic-X, even an enlarged detail (left) remains sharp and clear. There is virtually no sensation of graininess because the silver bromide crystals used in its manufacture are extremely small and spread in a thin layer of gelatin. However, the price that has to be paid for this superb definition is insensitivity. This type of film is excellent for still subjects where detailed structure is important.

a dark area and a light area. The objective measurement of this is acutance.

Together, graininess and sharpness make up an even more subjective impression of definition. Of the two, strong graininess is usually thought to be less objectionable than unsharpness by most people viewing a photograph. Indeed, with a grainy but slightly out-of-focus negative, the fact that the clumps of grain are visible often seems to compensate for the slight blurriness of the image.

Recording color on black-and-white film

In a single layer of emulsion of black-and-white film, the silver bromide reacts solely to the quantity of light that reaches it and the film displays only the tonal differences in the subject. However, its sensitivity to different wavelengths of light varies, and it reacts more strongly to some than to others.

The human eye reaches its peak of sensitivity at the wavelength of yellow-green (555 nanometers); it reacts very poorly to any wavelength slower than violet and longer than red. Silver bromide crystals, however, do not have the same sensitivity. Untreated, they are very blue-sensitive, reacting to ultra-violet through blue-green, but no

ASA 400. With 3½ times the sensitivity of the previous film this moderately fast emulsion, Kodak Tri-X, can be used with relatively poor light, but the penalty, as can be seen from the enlargement of the winder knob, is definite graininess, appearing as a mottling and general fuzziness. Such films are not intended to be used for big enlargements, and it is important to use as much of the negative area as possible. For general reportage and action photography, it is excellent.

ASA 2000. This extremely fast emulsion is Kodak Recording Film 2475, which can be rated successfully as high as ASA 4000. Graininess is extremely noticeable even without any significant enlargement, and it is unsuitable for recording detail. For available light photography, however, it is unsurpassed, and if the main aim is simply to make a recognizable image, in very poor light, it is the best choice. It has extended red sensitivity, and is contrasty.

The color sensitivity of eye and film

Some of the most obvious anomalies in the way black-and-white film records color are explained by comparing its color sensitivity to that of the human eye. Although the eye reacts most strongly to green (see p 12), film, by comparison, over-reacts to the blue end of the spectrum. Orthochromatic film does not respond at all to red, but modern panchromatic films cover the full range of visual colors.

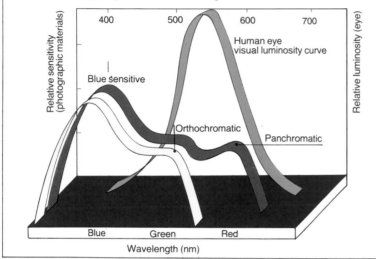

farther. 'Orthochromatic' film, available for over 100 years, has extended sensitivity into the yellow through the inclusion of a dye. Nevertheless, it is still incapable of reacting to reds, and all modern general purpose films are panchromatic, incorporating other dyes so as to be sensitive to all the colors that the eye can see.

For a realistic monochrome treatment of color subjects, it is obviously important that the film should have approximately the same responses to colors as the eye does. The eye must make allowances when viewing a black-and-white photograph because the colors are reproduced only as tonal values. If the tones of different colors are roughly in accord with the viewer's experience of them, then the photograph is acceptable. So, yellows and yellow-greens are expected to be light in tone while reds and blues are expected to be dark.

Modern panchromatic films come quite close to this and are certainly an improvement over orthochromatic films. Nevertheless, one continuing problem with panchromatic films is that they are still too sensitive to blues, violets and ultra-violets. This, for instance, causes a blue sky to reproduce poorly in a black-and-white print, as if over-exposed. As a result, the photographer may decide to manipulate tones by using filters.

Colored filters

With black-and-white film, a colored filter placed in front of the lens will pass more light of its own color and block the light of other colors. The contrast between, for example, the tomato and the lettuce leaves is immediately apparent when seen in color, but is lost in black-and-white without the use of filters. A red filter will pass the light from the

Arizona landscape. Three different filters vary the tones in this scene (below and right). Without a filter the sky appears light, due to the film's strong response to blue. A blue filter increases this, and introduces a sense of perspective due to haze. A yellow filter deepens the sky tone by blocking blue light. A red filter also deepens the sky and the shadows, and lightens the red rocks.

No filter

Blue filter

Petroglyph, Utah. The shiny surface of this weathered sandstone rock (below) illustrates the effect of a polarizing filter. In the upper half of the picture, taken without the filter, the reflections virtually swamp the Indian carvings. In the lower half, taken with the polarizing filter, the reflections are eliminated.
Nikon, Kodachrome, 55mm.

tomato unhindered, so that it is well-exposed on the negative and appears light on the final print; the green of the lettuce, being almost complementary in color, is partly blocked, and prints darker. With a green filter the tonal values are reversed: this time the green light passes through to the film, and so prints light; most of the red is stopped by the filter, and therefore prints dark.

Outdoors, most scenes usually have less vivid color differences, but filters still have an important use in black-and-white photography. Because standard panchromatic film is over-sensitive to blue and ultra-violet, blue skies are normally over-exposed and reproduce a disappointing light gray. Holding back the blue with a filter of its complementary color – yellow – gives it a more natural appearance, as in the view of cliffs at Oak Creek, Arizona. A red filter would have an even stronger effect on the sky, but at the same time also darkens the already somber green of the pine trees. A blue filter removes any trace of tone left in the sky and enhances the aerial haze.

With a filter in front of the lens, the film will need extra exposure. Suggested adjustments appear on page 61, but different films have slightly different responses, so it is best to make your own tests.

Other filters

Apart from tonal manipulation, black-and-white exposures can also be controlled by using a range of filters all producing different effects.

Polarizing filters: Light from the sun travels in waves that vibrate in

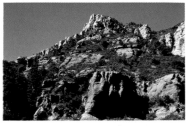

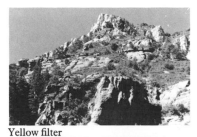

Yellow filter

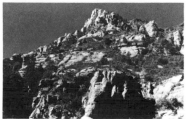

Red filter

Lettuce and tomato. Colored filters provide necessary contrast in black-and-white photography. The tomato appears light on the left-hand side of the picture because a red filter was used. On the other side it is the lettuce which is lighter because a green filter was used. Without a color filter both would look the same.

A red filter passes red light easily, but holds back green.

A green filter, being the complementary of red, passes green but blocks red.

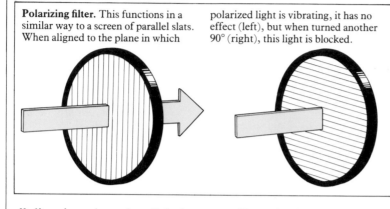

Polarizing filter. This functions in a similar way to a screen of parallel slats. When aligned to the plane in which polarized light is vibrating, it has no effect (left), but when turned another 90° (right), this light is blocked.

all directions, but when light bounces off certain kinds of material – notably glass and water – the waves are reoriented to vibrate in just one plane. This reflected light produces clear reflections, as in shop windows for example. The sub-microscopic structure of a polarizing filter acts like a grid with parallel slats, passing only those light waves oriented at the same angle. By rotating the filter to the correct angle, reflections can be completely eliminated.

Neutral density filters: Occasionally, there may be too much light for a particular shot, when for instance, a low shutter speed/aperture combination is needed for a deliberately blurred movement or intentionally shallow depth of field on a bright day. Neutral density filters reduce the light entering the lens by blocking all wavelengths equally to allow long exposures. These gray filters are available in varying strengths. The long exposure photographs of flowing water on p 26 were taken with a neutral density filter.

Infra-red black-and-white film

Just as dyes have been incorporated in black-and-white emulsion to give them the same (or nearly the same) color sensitivity as the human eye, so other dyes can extend the range of film. Infra-red films have dyes that make them sensitive as far as 1200 nanometers into the infra-red region – much farther than is visible to us. Any hot object emits infra-red, and the way that different substances reflect the infra-red output of the sun or a lamp can be quite different from the way they reflect visible light. Large water droplets, for example, reflect infra-red quite strongly, so that clouds appear brilliant white in infra-red photographs. Healthy vegetation reflects infra-red waves powerfully, giving leaves and grass a snowy appearance.

However, like other bromine emulsions, infra-red films are overly sensitive to ultra-violet and blue, so for the most vivid result use a red filter to black out these lower wavelengths. One remarkable attribute of infra-red film used this way is that it can cut right through haze to produce clear images of distant views, even in poor visibility.

Because infra-red waves are so much longer than visible light, they are brought into focus further behind the lens. Most modern lenses have a red dot engraved on the mounts to indicate infra-red focusing. Alternatively, re-adjust the focus by one quarter of one per cent forward from the visual focus.

Palm trees, Florida. On high-speed infra-red film, this landscape (below) is an ideal subject. The clouds and vegetation all reflect infra-red radiation strongly, and appear brilliantly white. A Wratten 87 filter cuts out visible light to which the film is also sensitive.
Nikon, 180mm, ¹/₃₀sec, f16. Correct focus: ¼ of 1% closer than visible focus.

Filter checklist for black-and-white film

All the filters below, except the polarizer, are available in either glass or gelatin. As the glass thickness can distort, high optical quality is important in a filter, and this is expensive. Gelatin filters, on the other hand, are too thin to affect the optics of a lens, but must be handled carefully to avoid marking.

Filter (Kodak Wratten No.)	Effect	Use	Filter factor*	Additional f stops*
Yellow (8)	Absorbs UV and some blue	Darkens blue sky to an acceptably normal tone, accentuating clouds. Lightens foliage	2×	1
Deep yellow (18)	Absorbs UV and most of the blue	Similar to yellow but with a more pronounced effect. Also darkens blue water and lightens yellow subjects, such as some flowers	4×	2
Red (25)	Absorbs UV, blue and green	Turns blue sky and water very dark, increases contrast and deepens shadows. Cuts haze and lightens red objects. In portraits, lightens lips and skin blemishes	8×	3
Green (58)	Absorbs UV, blue and red	Lightens foliage and slightly darkens sky. Makes red objects darker and deepens skin tone in portraits	8×	3
Blue (47)	Absorbs red, yellow, green	Lightens blue subjects, increases haze in landscapes	6×	2½
Neutral density	Absorbs all colors in equal proportions	Reduces exposure, enabling a slower shutter speed or wider aperture to be used	Various	Depends on which filter factor
Polarizing	Controls reflections and darkens blue skies at right angles to the sun	Can eliminate reflections when photographing still water and windows. Darkens blue skies under some conditions	2.5×	1½
Ultra-violet	Absorbs ultra-violet	Cuts haze in landscapes, giving sharper image with better color saturation		

★This list of filter factors and the related increase in aperture is based on normal daylight. When the color temperature changes, in the evening, for instance, these factors will change.

The principles of color reproduction

Color reproduction in slides or prints is made possible by one basic fact – the continuous spectrum that makes up white light can be analyzed into three equally spaced wavelengths: blue, green and red. These colors each occupy a third of the spectrum and, by using them in carefully chosen proportions, almost any color can be reproduced; combined equally, they make white light.

The two fundamental methods of using this three-color principle for reproduction, are the additive and the subtractive. The additive method is simpler but less commonly used. It uses combinations of blue, red and green (these three colors are called the additive primaries) to reproduce subject hues.

The subtractive process starts with white light and uses colored dyes or pigments to subtract from the light selectively. To do this, it uses three different, complementary colors – yellow, magenta (purple-pink) and cyan (blue-green); these three colors are complementary to blue, green, and red respectively. (Complementary means that they absorb their respective primaries; in other words, yellow absorbs, or blocks, blue light; magenta absorbs green, and cyan absorbs red.)

The color wheel. This is really a simplified spectrum bent into a circle clarifying the relationships between colors. Any three equally spaced colors (blue, green and red, or yellow, magenta and cyan) combined together equally give white. Combining any two colors that are directly opposite each other also produces white. For example, yellow, when added to its complementary color, the primary blue, produces white in the additive process. Conversely, in the subtractive process superimposing yellow and blue (or red and cyan, or green and magenta) gives black.

Color film – the tri-pack

Using the three-color principle, a color film can be constructed with the same basic emulsion as black-and-white film – a silver compound that is sensitive only to the *amount* of light. The difference, however, is that color film uses three layers of emulsion, each one of which is made sensitive to one of the three primary colors – blue, green and

Reversal processing

In this series of illustrations, the colored disc, shown below, is photographed and the film processed to produce a transparency. During exposure, the three layers of film each respond individually to particular colors, and this latent image begins development with the basic silver process. The images are then 'reversed' by a brief second exposure, and complementary colored dyes formed at these new sites. When the original silver is finally removed, a sandwich of these transparent layers remains which, when projected, gives the final positive image.

1. The exposure and first development of each layer in the tri-pack is the same as for black-and-white film. Exposure produces a latent image which is converted by the developer into metallic silver.
Each layer is sensitive only to one third of the spectrum, and forms the base for producing the positive images.

2. A brief exposure to light, or a chemical that performs the same function, starts a second image-forming process: the silver compounds that remained after the first development are now fully converted by the second developer. Special compounds known as "couplers" then combine with the oxidized developer to produce a separate dye in each layer complementary in color to its original sensitivity.

These diagrams (below) show how colored filters subtract from basic white light. The three filters are of the complementary colors, yellow, magenta and cyan. The yellow filter blocks the path of blue light rays, allowing red and green to pass unhindered. In the same way the magenta filter blocks green light rays, and the cyan filter blocks red. When all three filters are combined together no light at all is allowed through, and the result is black.

The two sets of circles (right) show the two ways of creating colors photographically. The three primary colors – blue, red and green – when mixed equally create white. In combinations of two they create complementary colors – blue and red make magenta, green and red make yellow, and blue and green make cyan. This is the additive process. In the subtractive process, complementary colors subtract from white light to produce the primary colors and black.

Additive process

Subtractive process

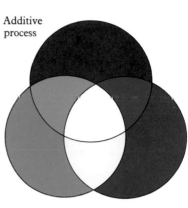

Yellow Magenta Cyan

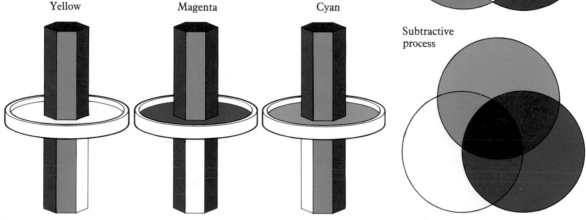

3. Everything is now present in the tri-pack film to form the full color image, but the metallic silver formed by the two developments obscures the colors. This is now bleached out, leaving three layers of pure color. The image is viewed by shining light through it (in a projector or on a light box) and the complementary dyes subtract the colors not needed, producing a positive image.

red. In principle, this is similar to the way that ordinary black-and-white film is made sensitive to different wavelengths (see p58). Color film that uses this system is known as integral tri-pack and is the most usual.

For the photographer there are two main types of color film: those that produce transparencies or slides (positive images), and those that give negatives. Film that produces transparencies is also known as reversal film. The construction of the two types of film, however, is essentially the same; the differences result from the processing and not the film emulsions.

Reversal film

During exposure three separate latent images are formed on reversal film which, when developed, become three black-and-white negatives, corresponding respectively to the blue, green and red light in the subject. (This is very similar to the separation negatives necessary to print color images in this book.) The positive image is formed in the second stage: after these negative images have been developed, the film is briefly exposed (either chemically or with light) so that the silver compounds that had remained untouched, now form reverse positive images. This is the reversal that gives the process its name. A second color development is then given. During this stage, the developer oxidizes and combines with other compounds in the emulsions to produce complementary colored dyes in the positive areas of each layer. At this stage, the three layers of film each contain a silver,

Negative processing

The steps in forming a color negative are simpler than those for reversal film, because the negative itself is only an intermediate stage. The three layers of film respond to exposure in the same way as reversal film, but during development the three complementary colored dyes – yellow, magenta and cyan – form in the same places as the silver images. No reversal is necessary, and the final step is simply to bleach away the silver. An orange 'mask' is always built into color negative film, to correct color distortions that would appear in the final print if the pure dyes alone were used.

1. As with black-and-white film, exposure produces a negative latent image in the silver compounds, but in color film, three images are formed, each corresponding to one of the primaries.

2. During development a complementary colored dye image is produced in the same places as the silver image. Bleach then removes the silver, and the three layers of color that remain form a negative image ready to make a positive print.

negative image (which is not needed) and a positive color image. After the silver is bleached out, three complementary colored images are left in the layers which, when held against the light, give the effect of the original subject colors.

Negative film

Negative film has essentially the same tri-pack construction as reversal film. Its development, however, is simpler as it is only producing intermediate negative images. There is just one development; this produces three negative, complementary colored images, and the process is completed in the same way as for reversal film, the unwanted silver being bleached out to leave three layers of colors. Colored negative film, when developed, has a distinctive orange appearance – this is a mask designed to compensate for color distortion that would otherwise occur in printing.

Types of color film

Apart from the basic division between reversal and negative film, there are also important differences in characteristics between color film emulsions. As with black-and-white film, emulsions differ in graininess and sensitivity to light; but, in addition, there are different color films designed to be used with different light sources.

Speed and resolution

Because the basic operation of color film emulsion is the same as black-and-white film emulsions, manufacturers face the same dilemma when aiming for fast films and good resolutions. The two qualities are essentially incompatible, and very sensitive emulsions

Saguaro, Arizona. The uppermost shot was taken without a filter. In the lower shot, the scattered reflections from the blue sky have been polarized by a filter. This darkening effect is strongest at 90° to the sun. With a wide-angle lens a variation in tone is noticeable across the sky.
Nikon, 20mm, Kodachrome, 1/250sec, f8 (top), 1/125sec, f5.6 (bottom).

Reciprocity failure

At 1/30 second on Kodachrome, the whites and grays of this head (above) are faithfully recorded as neutral. At 1 second on the same film, the overall color balance (below) has shifted towards green.

Films are designed to work best over a limited range of exposure times, and this varies according to the use that a particular film is put to, whether in bright sunlight or the lower illumination of photoflood lamps in a studio. Most daylight films are intended to be used between 1/10 sec to 1/1000 sec. At much slower or higher shutter speeds, reciprocity failure occurs, resulting in an under-exposed image, altered contrast and, in color film, a shift in the color balance. Individual makes of film react differently; use the manufacturer's notes packed with the film as a guide. Increase the exposure to compensate for loss of film speed, but remember that if you do this by increasing the exposure time rather than the lens aperture, you will have to make a further adjustment for reciprocity failure; for this reason there is a practical limit of exposure at low light levels. At very fast speeds there is also a loss of contrast which you can correct by increasing development time. At slow speeds contrast is increased, and with color film the color can be altered.

function only at the expense of being grainy. This happens even though the metallic silver responsible for graininess in black-and-white film is bleached out of color film. Instead, the dyes form "dye clouds" at the sites of the developed silver grains, so although silver no longer exists, the dye clouds give the same sensation of graininess. The eye cannot distinguish color at these measurements of 1000ths of a millimeter, otherwise the presence of three different colors of dye cloud would appear even grainier than their black-and-white equivalent. As it is, the magenta clouds are the ones that cause most of the grainy appearances as they absorb the green light to which the eye is most sensitive.

Most color reversal films already contain the couplers in the emulsion's layers; among other things, this makes processing simpler. Some, however, are manufactured without the couplers, which are introduced later during development. This adds to the complexity of the processing, putting it out of reach of the home user, but it does have one real advantage – the emulsions can be thinner and the dye can spread more evenly. Because of this, graininess is reduced and more detail can be resolved. Kodachrome is a notable example of this system.

Film for different light sources

In theory, if color film has almost the same response to color as the human eye, then it should be suitable for all lighting conditions whatever the color temperature (see p76). But, in practice, a daylight film used indoors with tungsten lighting will produce a photograph that is definitely reddish and a tungsten film used outdoors will appear bluish. The problem is that the brain adjusts its perception to accommodate a wide range of light sources. Light from a domestic bulb is really much redder than midday sunlight, but after a short while the brain accommodates the differences and begins to treat the bulb as a source of white light.

Because so much artificial light is tungsten, many manufacturers produce color film that treats tungsten illumination as if it were white. As a result, tungsten balanced film reproduces colors as we remember them, not as they really are. Pages 83–86 describe more fully how to make the best use of this type of film under various artificial lighting conditions.

Filters for color film

It is harder to manipulate color film than black-and-white film with filters. Color film renders colors literally and, generally, the most that can reasonably be done is to make subtle adjustments to the overall color balance.

There are two kinds of filters designed to balance color film with a particular light source. Color conversion filters alter color temperature and are available in a variety of strengths from yellowish to bluish; these are dealt with on page 76.

Color compensation filters alter the actual color of a picture and can be used to correct deficiencies in either the emulsion or the light source. They are available in different strengths in the primary colors: blue, green and red, and in their complementary colors: yellow,

Canyonlands, Utah. With no filter over the lens, this distant scene over the Colorado River canyon has a blue cast and weak contrast due to haze (left). An ultra-violet filter (center) noticeably improves color saturation and contrast, but the greatest improvement comes when a polarizing filter is used (right). *Nikon, 400mm, Kodachrome* .

magenta and cyan. Few color films are manufactured to very precise tolerances and can in any case change color with age or as a result of poor storage conditions, so keep a range of these filters at hand.

A polarizing filter is one of the few ways of making a noticeable change in colors, and is used principally to improve the color of blue skies. With a polarizing filter, the area of blue sky at right angles to the line of view to the sun is made darker. When used with an extreme wide-angle lens that covers a large part of the sky, including both the polarized and non-polarized area, the effect can be disturbing as the sky moves from light to dark in the picture frame.

One of the most valuable effects of a polarizing filter is that it enhances color saturation generally, by suppressing white light reflections from all objects including particles suspended in the air.

An ultra-violet filter has the same use with color film as with black-and-white, improving haze penetration. If anything, it is even more desirable with color film, as it reduces the overall blue cast associated with atmospheric haze and increases color saturation. With long-focus lenses and distant scenes a filter is essential.

Color infra-red film

Color infra-red emulsion is sensitive to infra-red, green and red, rather than blue, green and red. Strictly speaking, it is a false-color film. A yellow-orange filter gives the most normal results, although other filters, such as red or green, can give unusual pictures. The chlorophyll in plants reflects infra-red so strongly that healthy vegetation has a reddish cast, strikingly different from the expected green. Ordinary exposure meters do not measure the infra-red component, and bracketing exposures is essential.

Mazaruni River, Guyana. False-color infra-red film and a recommended yellow-orange filter reveal this South American rainforest (above) as a healthy red, due to the infra-red reflectance of chlorophyll.
Pentax, 55mm, Ektachrome Infra-red, ¹/₂₅₀sec, f4.
Island of Staffa, Scotland. A red filter with the same infra-red film has a more unusual effect (right) turning rocks green and sky yellow. Vegetation remains red.
Nikon, 180mm, Ektachrome Infra-red, ¹/₁₂₅sec, f8.

Exposure

THE FULL RANGE of tones in a photograph runs from white through gray to black. It can be limited in a subject to a few close shades of gray, as on a foggy morning, when there are no bright highlights and no deep shadows. On the other hand, in bright sunlight, the darkest shadows can reflect 200 times less light than the most brightly lit areas. Some night-time scenes with artificial lighting can have an even greater tonal difference. Capturing these highly variable ranges of light on film, and doing it in such a way that the result is acceptable, is the task of making an exposure.

Exposure range

Whereas the eye can rapidly accommodate different levels of brightness, flicking from highlight to shadow without much difficulty, film has a fixed range. There is a lower limit to this range, beyond which film can record no detail in shadows, and there is an upper limit, where the highlights are completely white. This exposure range is crucial to making a satisfactory exposure, and varies from film emulsion to film emulsion. Most fast films, for example, have a relatively small range; in other words, they are contrasty. Some very slow emulsions, on the other hand, can record a wide range of tones.

For the average subject, most films have latitude to spare: their exposure range is greater than the brightness range in the subject. If the exposure range of the film is exactly the same as the range in the subject, then there is just one correct exposure that will record everything properly. But if, in a harshly lit scene, the range between highlight and shadow is greater than the exposure range of the film, then no exposure will be right. Whatever you do, some detail will be lost, either in the bright areas or in the shadows. In cases like this, you must decide where you are willing to sacrifice detail.

Exposure latitude

When there is a low range of brightness (the difference between the brightest and darkest areas) in the subject, there are a number of different exposures you can make without losing detail. This freedom of choice is called exposure latitude; technically, it is the increase in exposure that can be made from the minimum needed to record shadow detail while still preserving details in the highlights.

Measuring exposure

There are two stages to deciding on an exposure. The first is to record the levels of light that actually exist in the scene in front of the camera. These measurements then have to be translated to the exposure that will suit the film speed you are using.

This first stage is an objective measurement; there are certain levels of brightness, and the only problem is the technical one of being sure that the readings you take are accurate. The second stage, however, is not automatic, but involves a decision on the part of the photographer. Sometimes it is a very subjective decision, and there are surprisingly many photographic situations where different photographers would choose different exposures. About the only thing that can be said as a general rule is that, in some situations, there is one single exposure that will give the most complete record of everything

The exposure latitude of color fi

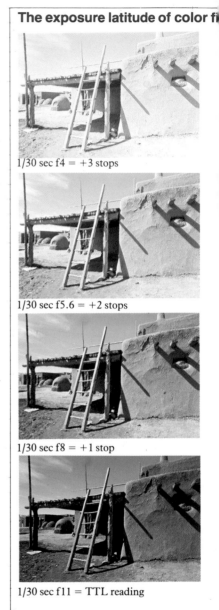

1/30 sec f4 = +3 stops

1/30 sec f5.6 = +2 stops

1/30 sec f8 = +1 stop

1/30 sec f11 = TTL reading

This sequence of exposures, each varying by one stop, shows how one popular make of color film, Kodachrome 64, reacts to different quantities of light. The through-the-lens meter reading, averaging all the tones in this scene of an Indian pueblo in New Mexico, indicated an exposure of 1/30 sec at f11. This is the exposure shown at bottom left. With one stop more exposure, the sky is noticeably affected; it is less intense and has a slight greenish tinge. With yet another increase in

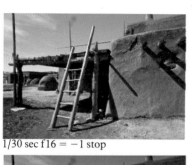

1/30 sec f16 = −1 stop

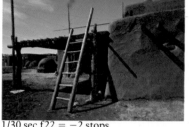

1/30 sec f22 = −2 stops

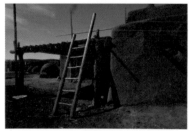

1/60 sec f22 = −3 stops

1/125 sec f22 = −4 stops

exposure large areas of highlight become a featureless white, while the most extreme over-exposure at top left records virtually no hues and very little detail. Decreasing exposure, shown in right-hand column, is subjectively more acceptable to many people. One stop under-exposure seems quite satisfactory, with little loss of shadow detail and an actual improvement in color saturation. With progressive under-exposure, shadow areas become featureless.

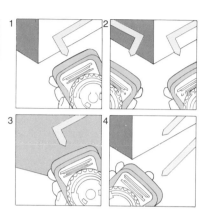

The four basic methods of using a hand-held meter:
1. With the reflected-light method, the meter is pointed directly towards the subject to measure the light.
2. With contrasty subjects, it is a good idea to take readings from the brightest and darkest areas of the subject and then make a compromise between them.
3. An 18% gray card, which has average reflectance, can be used as a substitute for the subject.
4. An incident-light reading measures only the light falling on the subject. A translucent plastic cover is fitted to the meter.

in the scene. Tastes differ, and they also change with time; Bill Brandt's later prints, for example, show much less detail and more contrast than his earliest prints from the same negatives.

There are a number of ways of taking light readings from a subject. One is to measure the light reflected from a small part of the scene; another is to take an overall reading of the whole subject, including shadows and highlights, to give an average value. In situations where the subject cannot be measured in this way, a substitute reading can be taken directly from the light source; hand-held meters have a special diffusing attachment designed to do this, or a reading can be taken from an 18% gray card, which itself is an average tonal value.

Hand-held meters

Even though most 35mm cameras now incorporate their own metering systems, hand-held meters are still extremely useful. They are very flexible instruments, and can be used in situations which are difficult for the camera's internal meter. In construction, all have a light-sensitive cell, a read-out which is normally a moving needle, and a calculator which converts the read-out to the appropriate camera settings. Selenium cell meters generate their own power from the light they are measuring, and so do not need a battery. CdS (cadmium sulphide) meters use a cell that is many times more sensitive to light, and therefore particularly useful in dim lighting, but must be powered by a replaceable battery.

To take a reflected-light reading, use the meter to measure the light that is reflected from the subject; in other words, the actual brightness levels in the scene in front of the camera. First set the ASA or DIN rating of the film you are using on the meter's calibration. Then point the light-sensitive cell towards the subject. Ideally, you should be able to measure the brightness levels of each part of the scene; from these figures you would then know the range of brightness in the subject, and whether all the tones would fit into the exposure range of the film. In practice, however, there is often no time for this; provided that the subject contains no obvious extremes of brightness, it is usually enough simply to take an average reading and make this the basis of your exposure. Most hand-held meters accept a cone of light of about 40° – roughly equivalent to the coverage of a normal lens. If extremes of brightness do exist, such as in a strongly backlit scene, you can

make a broad measurement of the range by taking two readings. Take a reading of the shadow area, and then a second reading of the highlight area. The mid-point between the two measurements is the average, and this will generally produce the best compromise. Nevertheless, you must use these measurements only as an aid to producing the image you want, and rather than try to preserve the maximum amount of detail in a backlit scene, you may choose, for instance, to exploit the graphic possibilities of a silhouette.

Particularly in outdoor scenes, existing light may overly influence the meter, and result in an underexposed picture. Unless you are deliberately exposing for the sky or main light source, use your hand to shade the light-sensitive cell when taking a reading.

If you are using a wide-angle or long-focus lens, the hand-held meter may not give you an accurate reading, as it is designed to measure a "normal" angle of view. Some meters have additional attachments to alter their angle of "view" for use with such lenses, but if yours does not, and you are photographing a distant subject with a very long-focus lens, then you may have to use another method, such as an incident light reading.

Hand-held light meters are particularly suited to incident-light readings. These are really substitute readings, where a dome or cone of translucent plastic is fitted over the light-sensitive cell to give an average reading of all the light striking the subject. It measures the light source rather than the subject. One advantage outdoors is that, as the light reaching the subject is often the same as the light reaching

A hand-held light meter such as this Gossen Lunasix (right) is normally powered by a selenium cell. Although less sensitive than battery-powered CdS cells, the reading is not in danger of being affected by loss of power. A hand-held spot meter, like the Minolta (below) takes highly accurate reflected light readings, and can be aimed optically at subjects.

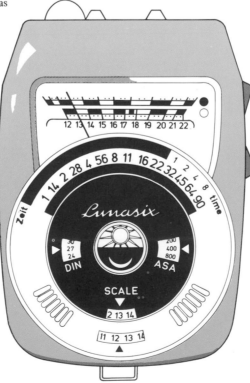

the camera position, you can take the reading without moving. Nevertheless, because incident-light readings take no account of the reflective qualities of the subject, whether it is a white house or a dark hill, you should interpret them with care. If the reflectivity of the subject is close to average – such as a Caucasian skin – then the reading will be suitable; but if not, you may have to compensate.

Spot meters

A hand-held spot meter gives you the opportunity of making the most accurate light measurements. It takes reflected-light readings, but with an optical viewing system has an angle of acceptance of as little as 1°. With this precision, you can measure the brightness levels from the smallest visible parts of a scene. You can then, for example, accurately measure the brightness range, and so calculate an average

When using a hand-held meter outdoors, shade the meter with your hand (above) so that the reading is not overly influenced by the sky.

This biplane at an air-show (above left) was a difficult problem for exposure. It inevitably occupied only a small part of the frame, so that the reading by any reflected light method would be influenced too strongly by the blue sky. An incident light reading from the ground was the best solution.
Nikon, 400mm, Kodachrome, $^{1}/_{250}$sec, f8.
Left: This rural scene of a church in gently rolling downland on a bright, partly cloudy day, is ideally suited for a hand-held meter reading. The contrast range is low, so that a broad average reading will be adequate, and the reflected-light method can be used successfully.
Nikon, 135mm, Kodachrome, $^{1}/_{125}$sec, f8.

Where the main subject of interest occupies only a small part of the picture frame, such as these cottages (left), a spot meter can be extremely valuable. The whitewashed walls had a higher exposure value than the surrounding scene, and without a spot reading would be over-exposed.
Pentax, 135mm, High-Speed Ektachrome, ¹/₁₂₅sec, f11.
Below: The light levels of this evening scene were rather low for a hand-held meter's selenium cell; the camera's TTL meter was more convenient to use.
Nikon, 20mm, Kodachrome, ¹/₁₂₅sec, f3.5.

reading. Alternatively, you can select that part of the scene which you want correctly exposed. The actual method of use varies according to the make, but all incorporate an engraved spot on the viewer that indicates the precise area that is being measured. If you have sufficient time when taking the photograph, and need the accuracy, there is no doubt that a spot meter is a superior light-measuring device. It comes into its own when the subject of most interest in a scene has a completely different brightness level from its surroundings; a normal hand-held meter would merely average the whole scene, but a spot meter can pin-point the part you select.

Through-the-lens meters

Most cameras now incorporate light-sensitive cells within the housing, so that readings can be taken of the actual image about to be recorded on the film. The small size and great sensitivity of modern photo-resistant cells, particularly silicon photodiodes, make this possible, and for many situations, through-the-lens (TTL) metering is the most accurate and convenient. The different light-transmitting properties of lenses and extensions are automatically compensated for, and the image measured is the exact one exposed on the film.

Ideally, the cell or cells in a camera should be at the focal plane but, as the shutter must also be there, they are normally located around the mirror, ground glass screen, or pentaprism. To compensate for un-even illumination from lenses of different focal lengths, it is common to have more than one cell and to weight the reading towards the center of the picture area.

One of the latest systems, on the Olympus OM2, coming very close to the ideal location at the focal plane, uses two silicon cells that measure light reflected from the film itself. This is done so rapidly that

TTL meter cells. CDS cells inside the camera can be fitted in many different positions, according to what the manufacturer is trying to achieve. The most common method is to take integrated readings from the ground glass screen, either directly through the pentaprism (a,b) or by means of a beam-splitting prism (c,d). Cells can also be placed in a position that is the equivalent of the focal plane (e,f) using a beam-splitter to re-direct some of the light towards them. Another position is just in front of the film plane (g), the cell being swung away mechanically at the moment of exposure. A sophisticated method is to aim cells towards the actual film or shutter blind surface (h).

An extremely long-focus lens calls for precise exposure measurements over a very small angle of view. For these San Franciscan houses on Telegraph Hill (left) shot with an 800mm lens, through-the-lens metering was ideal. A spot meter could also have been used.
Nikon, 800mm, Kodachrome, 1/125sec, f11.

Three types of TTL measurement

Integrated reading. This is the simplest system, where the entire picture area is measured, usually with two cells each reading a different section, and the results averaged. This is excellent for a subject with average brightness levels, but where there is a high contrast between major elements, such as a small white object against a dark background, it is inadequate.

Integrated

Spot reading. This type uses the principle of the spot meter. It demands more work, as you may have to point the camera at different areas of the scene in order to calculate an average reading. There is a risk of incorrect exposure if the centre "spot" is aimed at an atypical part of the picture.

Spot

Weighted reading. This combines the previous two in a compromise. The whole picture area is measured, but priority is given to the values in the center. In most situations this is convenient, following the principle that in the majority of photographs the center contains the main area of interest. The precise shape of the weighted area varies according to the manufacturers' ideas of what constitutes an average photograph.

Weighted

the system can respond to changes that occur *during* exposure, and can also be used to control a thyristor flash unit (see p 89).

There are three basic types of TTL measurement – integrated, spot, and weighted. Because the camera market is so competitive, each manufacturer stresses its own slightly different methods, but all fall into one of these categories.

In some cameras, the TTL meter system is linked to either the shutter or the diaphragm so that the "correct" exposure is made automatically. The most usual system is the programmed shutter: the photographer selects an aperture, and the (electronic) shutter is automatically programmed by the TTL meter's reading. The shutter speeds normally vary from 1/30 sec to 1/500 sec. This automatic control can be a great time-saver in situations where you want to shoot rapidly, but it has the same limitations as any metering system. If the scene is not "average", then the exposure may be wrong. If there is a manual override, you can use it to make compensations; otherwise, there is nothing that can be done.

The read-out projected through the viewfinder is commonly either a moving needle, light-emitting diode, or, as in the case of the Nikon F3, a liquid crystal display.

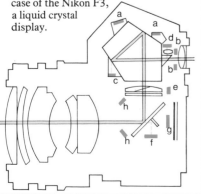

The Zone System

The Zone System is the simplest and best method yet devised for planning an exposure. Created by Ansel Adams and expounded by Minor White and others, it is more than just a shirt-sleeve approach to sensitometry (see p313); it is an elegant method of integrating all the decisions and techniques of exposure control. Used intensively, it can teach the photographer to plan each picture in advance. Obviously, forethought is not practical or possible in every picture-taking situation, but familiarity with the Zone System can only help most aspects of a photographer's work.

The practical essence of the Zone System is that, at every stage of the picture-taking process, from the subject itself to the final print, all tones are assigned to specific zones. The zones themselves run from black to white (excluding only the featureless white of highlights and specular reflections). In keeping with the normal mechanics of photography, each zone is one f-stop different from adjacent zones. In other words, each zone is twice the brightness (illuminance/exposure) of the one below it, and half the brightness/exposure of the one above it. The great value of the Zone System is that, from subject to final print, the tonal range in an image can be altered by converting it into zones and adjusting the exposure by the f-stops correspondingly.

By convention, there are 10 zones, from 0 to IX; the implication of this is that most photographic subjects have a contrast range within 10 stops. In fact, this means that in an outdoor scene encompassing deep shadows and bright high spots, the brightest area is likely to be in the order of 500 times brighter than the darkest shadow (ie a difference of 10 f-stops).

The Zones

0 Solid black; the same as the film rebate (edges).

I Nearly black; just recognizably different from Zone 0.

II The first hint of texture but nothing recognizable.

III Textured shadow; the first zone to show recognizable shadow detail.

IV Average shadow value on Caucasian skin, landscape foliage and buildings.

V Middle gray; 18% gray test card; the 'pivot' value; light foliage; dark skin.

VI Caucasian skin (36% reflectance); textured light gray; shadow on snow.

VII Light skin; bright areas with texture, such as snow in low sunlight.

VIII Highest zone with any texture.

IX Pure untextured white; little difference between this and unexposed print paper.

Altering contrast

Every stage of the picture-taking process offers opportunities for decreasing or increasing contrast. Black-and-white film is more amenable to alterations, and the methods below that are marked with an asterisk are unsuitable for color work.

Decreasing contrast		Increasing contrast	
In the subject 1. In a controlled situation, such as a studio, add fill-in lighting. 2. In an uncontrolled situation, such as a landscape or outdoors portrait, use fill-in flash for backlit subjects.	to compensate for this). 4. Pre-expose the film. 5. Use a proportional reducing solution on the finished negative.* 6. Make contrast masks to combine with the original negative in printing. 7. Re-touch.	*In the subject* 1. In a controlled situation, reduce fill-in lighting. 2. Wait for the natural lighting to change.	automatically have a higher contrast range. 6. Re-touch.
In the film 1. Select lower contrast (slower) film. 2. If the contrast is in part due to differences in hue, select a filter that brings the tones together, eg. with blue and yellow objects use a blue filter to lighten the blue and darken the yellow.* 3. Reduce the development time, or use a weaker dilution of developer (remembering to make the initial exposure longer	*In the print** 1. Select a softer grade of paper. 2. Use a weaker solution of paper developer. 3. Use a diffusing enlarger, or put a diffusing sheet in the carrier of a condenser enlarger. 4. Use local contrast techniques – shading highlights and printing-in shadows, ideally with variable contrast paper. 5. Re-touch.	*In the film* 1. Select higher contrast (faster) film. 2. Use a contrast-enhancing filter, such as a 25 Red, which will darken shadows.* 3. Increase the development time, or use a stronger concentration of developer (having reduced the initial exposure to compensate for the fuller development.) 4. Use a chromium intensifier solution on the finished negative.* 5. Make a copy negative or transparency. This will	*In the print** 1. Select a harder grade of paper. 2. Use a stronger concentration of paper developer. 3. Use a condenser enlarger, and put a card with a small hole in the carrier to reduced the diameter of the light source. 4. Use local contrast techniques – shading shadow areas and printing-in highlights, ideally with a variable contrast paper. *Black-and-white only.

How the Zone System works

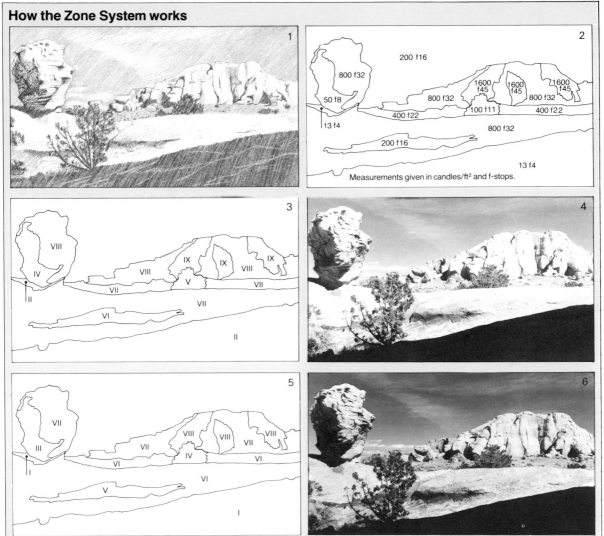

This sunlit scene covers many brightness values – in other words, it has a high contrast range. We will use it as a standard example for the uses of the Zone System, and return to it later in the book. An important thing to remember is that we are considering specific and subtle differences in tone. The printed page, unfortunately, cannot show all these differences, so it is important to make practical tests oneself, judging and measuring the subject and assessing the results in negatives and prints.

Because we are going to be discussing the tonal reproduction that a photograph offers, the original subject is represented here as an illustration (1).

Stage 1: Using the measuring methods described already, we can make a precise, objective record of the brightness levels in this original scene. This picture was taken on the Acoma Reservation in New Mexico, early in the afternoon of a bright March day.

Different exposure meters record their information in different ways. The next picture (2) shows the scene measured in candles-per-square-foot (c/ft)², a universal measurement, but not one normally used by photographers, and also in f stops – by assuming a film speed of 100 ASA and a shutter speed of 1/125 sec.

Stage 2: At this stage there is a choice – where to place one of the tonal values. The photographer has to decide subjectively what are the important areas of the scene. Different options can be considered, and there is no reason why the most literal interpretation should be made. Because Zone III ("textured shadow") is defined as the darkest shadow area in which detail is actually wanted, it is quite common to use this as the key zone. In this example (3), however, the immediate foreground is critical, for while it does not cover any significantly interesting detail to merit Zone III, it should have at least a hint of texture in the final print. So, as a first experiment, by placing the foreground in Zone II, everything else will fall in its own particular zone. In other words, placing an area in one zone determines every other zone. This creates a problem

with this scene, because the areas of the sandstone cliffs and rocks inevitably fall in Zone IX, which means that their texture will not register (4). In other words, the contrast range in the subject is too great, a common problem.

Stage 3: Unless something is done to alter the high contrast, either in the subject, the negative or the print, we will have to compromise by sacrificing detail at one end of the scale. In this example, it would certainly be better to sacrifice the foreground shadow detail (5). By moving everything down one zone, the foreground becomes nearly black (Zone I), but the cliff highlights become a satisfactory Zone VIII (6). On p 98, when processing techniques are examined, we will return to this example to see how different development times and developer dilutions can provide a better solution.

This completes the visualization, and all that remains is to make the exposure. We have calculated how the final print will look before even taking the shot – the essence of the Zone System's use.

Using light

THE BASIC SOURCE of illumination for most photography is either sunlight or artificial light. The sun furnishes a virtually endless variety of lighting conditions – from the hard direct light of the overhead sun to the shadowless enveloping light of thick fog. Even moonlight is a reflected version of sunlight.

By contrast, artificial light has many different sources. For practical purposes, the photographer differentiates between that over which he normally has no control, such as streetlights, and that which he intentionally provides, such as studio lighting.

The quality of light from all these sources varies enormously. The tonal differences are immediately obvious to the eye – compare the smoothly graduated tones under an overcast sky with the extreme contrast in objects lit by a car's headlights. Less obvious are the differences in color. This is partly because our vision accommodates small color changes in the overall light source so that we think we are seeing by white light even when we are not.

Color and wavelength

The color of any light source is determined by its wavelength. However, most light sources emit not just one single wavelength but many. They have what is called a continuous spectrum; if they radiate more energy at some wavelengths than at others, then they have a definite color. Some artificial light sources, on the other hand, radiate energy in just a few narrow lines of the spectrum. Sodium and mercury-vapor lamps are like this, and therefore have discontinuous spectra. Fluorescent tubes combine both kinds of spectra – as well as radiating in just a few spectral lines, they contain phosphors inside the tube that fluoresce at longer wavelengths.

Color temperature

One method of describing the quality of light sources is on a scale of color temperature. A solid substance, such as a piece of metal, begins to glow red when it is heated to a particular temperature. The hotter it becomes, the whiter it glows, and at very high temperatures, provided it undergoes no chemical changes, it glows blue. It is not the actual

Color conversion filters

A wide range of filters is available to raise or lower the color temperature of light reaching the film. The table below shows which filters you can use with which films to produce a normal lighting effect. Adding filters reduces the effective film speed. The mired scale gives the exposure increase you will need.

To work out your own filter requirements it is easiest to work in *mired shift values* which are a constant rating at any part of the scale of color temperature. The mired scale (below the table) is calculated by multiplying the reciprocal of the color temperature by one million

Light source	5500°K	3400°K
Film type		
Daylight	No filter	80B
Tungsten type A	85	No filter
Tungsten type B	85B	81A

Mired shift values for Kodak filters

Filter (*yellowish*)	Shift value	Approx. f-stop increase
85B	+131	⅔
85	+112	⅔
86A	+111	⅔
85C	+81	⅔
86B	+67	⅔
81EF	+53	⅔
81D	+42	⅓
81C	+35	⅓
81B	+37	⅓
86C	+24	⅓
81A	+18	⅓
81	+10	⅓

Color temperature

From candlelight at this end to the reflected light from a blue sky at the other end, this scale covers the range of color temperatures most likely to be met in photography. The lower color temperatures are associated with longer, redder wavelengths; the higher ones with shorter wavelengths that contain more blue. Noon sunlight, in the middle, is balanced. Individually, any color temperature within this scale may appear white to the eye, which can adjust to these differences, but in photography the film and filters must be chosen to match.

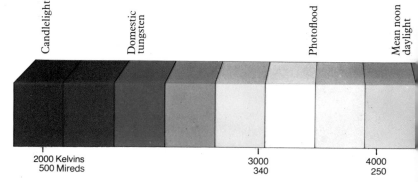

Candlelight · Domestic tungsten · Photoflood · Mean noon daylight

2000 Kelvins 500 Mireds · 3000 340 · 4000 250

(eg daylight at 5500°K has a value of $\frac{1,000,000}{5500} = 182$). To convert any light source to any color temperature find the difference on the mired scale and then select the filter, or combinations of filters, which have that value. For instance, the difference in the mired values between 5500°K daylight (182) and 2900°K tungsten lighting (345) is 163. To raise the color temperature means lowering the mired value, for which you would need, in this case, an 80A filter (-131 mired shift value) and an 82B filter (-32 mired shift value) combined.

3200°K	2900°K	2800°K
80A	80A+82B	80A+82C
82A	82C+82	82C+82A
No filter	82B	82C

Filter (bluish)	Shift value	Approx. f-stop increase
82	-10	$\frac{1}{3}$
82A	-18	$\frac{1}{3}$
78C	-24	$\frac{1}{3}$
82B	-32	$\frac{1}{3}$
82C	-45	$\frac{2}{3}$
80D	-56	$\frac{2}{3}$
78B	-67	1
80C	-81	1
78A	-111	$1\frac{2}{3}$
80B	-112	$1\frac{2}{3}$
80A	-131	2

composition of the substance which is important, but the temperature which defines the color precisely, on a scale from red, through white, to blue. Strictly speaking, this is intended only for measuring incandescent lights, but in practice it can include daylight and even fluorescent light. What makes it a particularly useful scale is that the differences between light sources can be measured, and it is quite a straightforward matter to select the right film for the light source and to choose filters that correct the light for the film you are using.

Color temperature is measured in kelvins – similar to degrees celsius, but starting at absolute zero – and occasionally by mired value which is a reciprocal of the kelvin measurement 1 million/kelvins. The practical value of the mired scale is that the differences between points on it are constant, which facilitates the use of conversion filters.

The scale illustrated here gives the color temperatures of many of the light sources encountered in photography, but a color temperature meter is the most accurate method of measurement. The key value for photography is *mean noon sunlight* – 5400°K, the average color temperature of direct sunlight at midday in Washington DC.

Remember, however, that the light from fluorescent tubes and other sources with discontinuous spectra does not fit particularly well into the color temperature scale and cannot be measured with a color temperature meter. Treat them as special cases and then follow the suggestions on page 86.

Natural light

One single light source illuminates Earth, yet with the help of an atmospheric screen and a constantly changing pattern of clouds, water-vapor and dust particles, it creates an infinite variety of lighting conditions. Several factors determine the direction, quality and color of natural light. For most occasions a photographer need only consider four: season, time of day, weather and atmospheric conditions. Altitude and latitude also affect the quality of natural light, but this only becomes noticeable when you are working at very high altitudes or close to the Equator.

No studio can reproduce the variations of natural light, which can

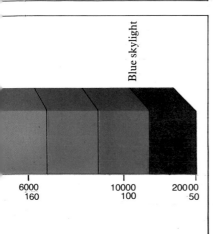

Blue skylight

6000	10000	20000
160	100	50

An outdoor studio

Thought of as a large studio set, any outdoor scene contains light source, diffusers and reflectors. The sun is a constant spotlight, changing angle throughout the day. The sky acts as both diffuser (more effective when the sun is low and its rays have to pass through a greater thickness of atmosphere) and reflector, making shadows blue during the middle of a cloudless day. Clouds, mist and fog are more variable but stronger diffusers and reflectors. Some light is even reflected back from the ground.

Direct sunlight

Atmospheric reflection

Reflection from clouds

Reflection from ground/water

Parthenon at dawn. Less than half an hour before sunrise, the eastern sky over Athens is a definite pink (below). At this low angle, the sun's rays have to pass through a large body of atmosphere and this scatters the blue and ultra-violet wavelengths. Sadly, it is the city's infamously high level of pollution that makes this scattering so strong.
Nikon, 180mm, Kodachrome, ¼ sec, f2.8.

Shaker Farm, New England. With the sun high on a cloudless day, shadowed areas receive most of their illumination from the blue sky. Ordinarily this is not very noticeable, but with a highly reflective white surface, such as this snow bank (right), the effect can be striking.
Nikon, 20mm, Kodachrome, ¹/₁₂₅sec, f11.

bring surprise and unpredictability to outdoor photography, but we can think of the outdoors as an enormous natural studio set. The atmosphere is an envelope, partly a diffusing screen for the sun, and partly a large reflector (a little light is also reflected back from the ground, more from snow, sand and other bright objects). Finally, a constantly changing and drifting screen of clouds and suspended particles function as a complex array of filters.

To understand the properties of this large natural studio, consider first the basic lighting set-up – the passage of the sun through a clear sky. Because our eyesight has evolved under the light of the sun, we think of normal midday sun as standard, and judge other colors against it.

When the sun rises and sets, natural light appears much warmer – anything from yellow to red. This is because the atmosphere acts as a screen, scattering some wavelengths and passing others. Short wavelengths, at the ultra-violet and blue end of the spectrum (see p 15), are those most affected; as the sun clears the horizon, its light is

passing through the greatest thickness of atmosphere, and the short blue wavelengths are scattered so much that only the longer green and red hues can penetrate. Whatever particles are in the air, even if just a light haze of water-vapor, reflect this warm light.

As the sun rises higher, it shines through a less heavily filtered sky, and appears a purer white. The same scattering that gave the pink hues of sunrise now makes the sky blue, because the short blue wavelengths are scattered less (they now penetrate) and also bounce around the air molecules to give an overall blue cast. This skylight is a vast bluish reflector, and shadows, particularly on neutral tones such as snow, are recorded blue on film (the human eye tends to ignore this cast when looking at the original scene).

At its zenith, the sun casts the sharpest and deepest shadows (its disc actually covers only ½° of arc), and the contrast range is at its greatest. In summer, or close to the Equator, the midday sun is most nearly overhead, and this flat, formless lighting is the most difficult to work with. Most scenes benefit from a lower angle of sunlight, but the very starkness of an overhead sun can be effective with a scene that has inherently strong shapes or tones. Of course, at high latitudes, the sun always remains close to the horizon.

The afternoon and evening are essentially a repetition of the morning, in reverse. Most photographers prefer the lighting at the beginning and end of the day when the quality of light changes most rapidly. A few hours before sunset (or after sunrise), the sun is low enough to use as backlighting without appearing in the shot and

Double Arch, Utah. At midday, the overhead sunlight is difficult to work with, and usually gives unattractive modelling. One exception is a subject such as these sandstone formations in Arches National Park, where the shapes are definite enough to benefit from the stark lighting.
Nikon, 20mm, Kodachrome, ¹/₁₂₅sec, f11.

Swans, western Scotland. When the sun is just a short distance above the horizon, it reflects strongly off any flat, reflective surface. By shooting directly into these reflections (above), colors are submerged and contrast increased to the point where the images can be virtually silhouettes. *Nikon, 400mm, Kodachrome, ¹/₅₀₀sec, f22.*

Castillo San Felipe, Cartagena. Well after sunset, or before sunrise, little light is left but a violet afterglow (above right). The effects can be subtle, but can generally only be used for silhouettes. *Nikon, 35mm, Kodachrome, ¹/₈sec, f1.4.*

creating flare in the image. This is the best time to use the strong reflections of sunlight from water and polished surfaces, which can give graphic silhouettes.

Sunset is a re-play of sunrise. In a clear sky, light from the reddish sun has little to reflect off, and such sunsets are not spectacular. Dusk is often more interesting, when the filtered light from below the horizon illuminates a graduated scale of subtle hues.

As the light fades, it passes below the threshold of our color vision (see p12), and we experience night-time as shades of gray and black, even in moonlight. In fact, the moon is simply a neutral reflector of sunlight, and its light is exactly the same as that of the sun, but 400,000 times less. Theoretically, a photograph by moonlight will appear exactly as if by day. In practice, the long exposure necessary causes a softening of the light as the moon crosses the sky, and the film's own reciprocity failure can cause color shifts (see p65). More-

over, we expect a night-time photograph to look quite dark and somber, another example of how our preconceptions determine what is acceptable.

Atmospheric conditions

What gives the most variety to natural light is the changing nature of the sky itself. There are innumerable patterns of cloud cover, and not only do they alter the appearance of the sky, but also filter, diffuse and reflect the light from the sun. Clouds, in all their forms, are no more than water droplets, which are so much larger than air molecules that they do not discriminate between the wavelengths that they refract and disperse. They scatter the whole of the spectrum, and as a result appear white. As reflectors, they are responsible for the visual appeal of the most dramatic sunsets and sunrises.

A thin haze over the sky reflects white rather than blue into

Farm by moonlight. In theory, a scene photographed by moonlight should appear almost identical to the same view by sunlight. However, the long exposures necessary at night cause shadow softening, and reciprocity failure gives the greenish cast.
Nikon, 20mm, Kodachrome, 30 mins, f3.5

Golden Gate Bridge, San Francisco.
Characteristically shrouded in a summer
fog, details of the bridge's suspension
(right) make an abstract pattern. Fog and
mist, although unpredictable, are useful
for isolating subjects. The light is so
diffused that it is almost directionless.
Nikon, 400mm, Kodachrome, $^1/_{125}$*sec, f6.3.*

Rice fields, northern Thailand. The
muggy heat haze over these flooded fields
(above) is almost as dense as a fog, acting
as a very efficient diffuser of sunlight so
that shadows are virtually eliminated.
The haze also separates the planes of huts
and trees, increasing the sense of
perspective.
Nikon, 400mm, Kodachrome, $^1/_{125}$*sec, f6.3.*

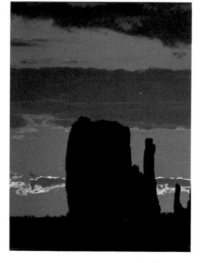

The Mittens, Monument Valley, USA.
At dawn, low layers of cloud act as
reflectors for the warm direct sunlight
and even redder sky. Provided that they
are not so dense as to block all sunlight, a
few sparse clouds nearly always add
drama to sunrise or sunset (above).
Nikon, 400mm, Kodachrome, $^1/_{250}$*sec, f5.6.*

Ultra-violet
This view of the Cascade Mountains has an overall blue cast due to the easier penetration of ultra-violet waves through the thinner atmosphere. Film is more sensitive to these longer wavelengths than the human eye, and so benefits from the use of an ultra-violet filter over the lens.

shadows, and softens their edges. As cloud cover increases, the sun's light is diffused over a greater area and becomes less directional until, on a completely overcast day, there are practically no discernible shadows and the quality of the light is almost flat. Although many subjects will look dull and unappealing in such weather, it can be very effective for subtle shapes and details, and gives the most faithful rendering to colors. Contrary to what many people imagine, green grass has a more intense hue under heavy clouds than in bright sunlight!

At the extremes of weather, in falling snow or rain, both contrast and colors are subdued, and subtle, often impressionistic results are possible.

Available light
If you are using artificial light that is specially designed for photography, such as flash or photoflood lamps, then you can control it quite precisely. But if you are working only with available artificial lighting such as household light bulbs or street lamps, your control is reduced. You may only be able to guess at the color rendering and frequently you will have a problem of excessive contrast; where the light source appears in the scene, for example, the contrast may be much too high for the film to handle.

In view of the problems of available lighting, it may seem surprising that many photographers deliberately choose to use it. One reason is that it can convey a naturalism and an atmosphere that are extremely difficult to create intentionally. There is no ideal style of lighting, and an important quality that well balanced, evenly distributed lighting usually lacks is excitement. In candid photography, of course, you have no choice but to use ambient lighting.

General techniques
There are certain techniques common to all available light situations. To begin with, there is nearly always less light than you would really like and this reduces your flexibility between film, lenses, use of depth of field and shutter speed. In many cases you will have to make some compromises, sacrificing some picture quality such as resolution or viewpoint in order to be able to take an acceptable picture. For this reason many available lighting techniques are concerned with getting enough light to the film.

To begin with, the film you choose is important – good fast films are available in black-and-white with speeds up to ASA 1000 and in color to ASA 400 and available film speeds are increasing all the time.

Shipley windmill, Sussex. Scattered clouds on a bright summer day reflect some of the sunlight back down to the ground, reducing the contrast range slightly. A polarizing filter was used to darken the appearance of the sky (left). *Nikon, 20mm, Kodachrome, ¹/₆₀sec, f5.3, plus polarizing filter.*

Uprating the film enables you to use faster working speeds (see p 111), but do not do this more than you need, as the image quality suffers.

If you think that you may do a reasonable amount of work in low-light conditions it may be worth getting a very fast lens that has a maximum aperture of perhaps f1.2. Such fast lenses are more expensive than normal and are available only in normal, or close-to-normal focal lengths. In dim light you will probably be unable to use long focus lenses, as they are usually slow (having small maximum apertures) and need fast shutter speeds to avoid blurred images. When hand shooting in low light, time your shots to coincide with the least movement in your subject. This will reduce blur at slow shutter speeds.

With the proper support, such as a tripod, time-exposures are another solution to the problem of dim lighting. Clearly this is only useful where the subject is static, although incidental blurred movement is acceptable where a more impressionistic result is wanted. If subject movement is too disconcerting, a long time-exposure of up to several seconds will make the blurs so extreme as to be largely unnoticeable in the image.

Most films are designed to work best with short exposures; long exposures create reciprocity failure. The "Reciprocity Law" – Exposure = Intensity × Time – suggests that 1/125 sec at f11, for instance, will give the same exposure as 1/250 sec at f8. However, at very long (or indeed, very short) exposures, this law fails. A 2-second exposure with most films will need an extra exposure to correct this failure. With black-and-white film you must increase either the exposure or the development time to compensate; color films also experience a color shift with long exposures of several seconds, and you will need an appropriate color compensating filter. The effect of reciprocity failure varies from emulsion to emulsion; follow the film manufacturers' instructions on how to overcome it.

Tungsten lighting

The most common form of artificial lighting is the tungsten lamp, particularly in domestic interiors. Essentially there is no real difference between household lamps and those made especially for photography except that the color temperature of domestic bulbs is lower and the light is therefore redder. Exactly how much redder you may not be able to tell without a color temperature meter, but as a general guide, domestic lamps of 100 to 200 watts have color temperatures of around 2900° Kelvin and those of 40 to 60 watts around 2800° Kelvin. Variations in voltage affect color temperature, as does age (blackened deposits inside old lamps make the light redder).

To render tungsten lighting as if it were daylight – in other words about 5500° Kelvin – use either tungsten balanced film or conversion filters or a combination of the two. Type A films are balanced for 3400° Kelvin, which is to say that they will reproduce the light from a photolamp as white. Type B films are balanced for 3200° Kelvin. With either film, domestic tungsten lights will still appear reddish, but as interior lighting is generally thought of by most people as being slightly warm you may decide not to correct it completely. If it is important to balance the lighting and you can measure the color

Goldsmiths' Hall, London. This ornate hall (above) was lit solely by chandeliers fitted with tungsten lamps and the contrast range was inevitably high. Tungsten-balanced film was used for a 'normal' effect.
Nikon, 20mm, Ektachrome (tungsten), ¹/₆₀sec, f3.5.
Thai boxer. Because the boxing ring was so dimly lit, I used a daylight-balanced film for its extra sensitivity (400 ASA) with tungsten lighting. The result (far right) is red but still acceptable.
Nikon, 180mm, Ektachrome (daylight), ¹/₁₂₅sec, f2.8.

Exposure settings for difficult available light conditions

These are approximate guides to use as starting points for a bracketed series of exposures where exposure readings are difficult to make. If the shutter speed still seems too slow for the subject, use a faster film or increase the development.

Film speed (ASA)	25	64	125	200	400
Brightly lit night time street scene	$^1\!/_8$ sec f2.8	$^1\!/_{15}$ sec f2.8	$^1\!/_{30}$ sec f2.8	$^1\!/_{60}$ sec f2.8	$^1\!/_{60}$ sec f4
Very brightly lit night scene, eg nightclub district	$^1\!/_{15}$ sec f2.8	$^1\!/_{30}$ sec f2.8	$^1\!/_{60}$ sec f2.8	$^1\!/_{60}$ sec f4	$^1\!/_{60}$ sec f5.6
Floodlit football stadium	$^1\!/_{15}$ sec f2.8	$^1\!/_{30}$ sec f2.8	$^1\!/_{60}$ sec f2.8	$^1\!/_{125}$ sec f2.8	$^1\!/_{250}$ sec f2.8
Moonlit scene (full moon)*	2 min f2	2 min f2.8	1 min f2.8	30 sec f2.8	15 sec f2.8
Town at night in the distance	1 min f2.8	30 sec f2.8	15 sec f2.8	8 sec f2.8	4 sec f2.8
Lighting	T f2	T f2.8	T f4	T f5.6	T f8
Firework display	T f2	T f2.8	T f4	T f5.6	T f8
Floodlit industrial factory at night (eg refinery)	2 sec f2.8	1 sec f2.8	$^1\!/_2$ sec f2.8	$^1\!/_4$ sec f2.8	$^1\!/_8$ sec f2.8
Moon in clear sky (full or nearly full)	$^1\!/_{60}$ sec f5.6	$^1\!/_{125}$ sec f5.6	$^1\!/_{125}$ sec f8	$^1\!/_{125}$ sec f11	$^1\!/_{125}$ sec f16
Candlelit close-up	$^1\!/_4$ sec f2.8	$^1\!/_8$ sec f2.8	$^1\!/_{15}$ sec f2.8	$^1\!/_{60}$ sec f2.8	$^1\!/_{125}$ sec f2.8
Neon sign**	$^1\!/_{15}$ sec f2.8	$^1\!/_{30}$ sec f2.8	$^1\!/_{60}$ sec f2.8	$^1\!/_{60}$ sec f4	$^1\!/_{60}$ sec f5.6
Fairground	$^1\!/_4$ sec f2.8	$^1\!/_8$ sec f2.8	$^1\!/_{15}$ sec f2.8	$^1\!/_{30}$ sec f2.8	$^1\!/_{60}$ sec f2.8
Boxing ring	$^1\!/_{15}$ sec f2.8	$^1\!/_{30}$ sec f2.8	$^1\!/_{60}$ sec f2.8	$^1\!/_{125}$ sec f2.8	$^1\!/_{250}$ sec f2.8
Theater stage, fully lit	$^1\!/_8$ sec f2.8	$^1\!/_{15}$ sec f2.8	$^1\!/_{30}$ sec f2.8	$^1\!/_{60}$ sec f2.8	$^1\!/_{125}$ sec f2.8

*Reciprocity failure is the chief problem here, and that varies with the emulsion. For some color film more exposure may be needed. Try to use a fast lens rather than long exposure times.
**If the neon sign is a changing display, use an exposure time long enough for a full cycle.

temperature precisely, then use an appropriate conversion filter. A pale blue filter will raise the color temperature of domestic tungsten lamps – with Type B film, try an 82B or 82C filter.

As tungsten balanced films are slower than their equivalent daylight balanced emulsions, you may find it easier to use a daylight film with appropriate conversion filters (the resulting speeds are similar). Once again decide to what degree you want to correct the lighting: an 80B filter will balance a daylight film for 3400° Kelvin lighting; an 80A filter gives stronger correction for 3200° Kelvin lighting; and 80A and 82C filters combined will render most domestic tungsten lighting to the equivalent of daylight.

Fluorescent lighting

Although potentially better for photography than mercury-vapor because the phosphors in the tube add a continuous background spectrum, fluorescent lighting is still the bane of available lighting assignments. Its ubiquity and unpredictability make it very important to test before shooting. The apparent color temperature of fluorescent

Fermenting wine, Napa Valley. This barrel-aging room in a California winery is typical of many industrial interiors, lit by overhead fluorescent lamps. The uncorrected exposure (above) has a characteristically green cast. Being unable to check the make of lamps, I tried several filter combinations; the most successful was CC30 magenta (top). *Nikon, 180mm, Kodachrome, ¼sec, f3.5. and f2.8.*

tubes varies with make and age, with no standardization among manufacturers or type classification. High efficiency tubes have a high output but are very deficient in red, while de-luxe tubes more nearly approach 'normal'. It is usually impossible to predict the correct filtration merely by examining the tubes, but a fairly strong magenta filter (from 20M to 40M) will usually figure prominently in the filter pack (this is with daylight film). If you have to work without testing, use daylight film (its added speed over tungsten balanced film is a big advantage) and experiment with 20M, 30M and 40M, perhaps adding a 20C or even a 20Y on some exposures.

A more elaborate alternative is to replace the existing tubes with tubes that are color corrected for photography.

Vapor discharge lighting

The most common type of discharge lamp is mercury-vapor, used increasingly in large industrial facilities and in some stadiums. Its advantages are low cost and low heat output, but, having a discontinuous spectrum, with great gaps in the red part of the spectrum, it can be disastrous for photography. Mercury-vapor lamps have a typically strong output of green-blue and ultra-violet but they are not consistently predictable. Test them if you can with different filters; if you cannot, bracket your filtration around 20M, 30M, 20R and 30R. Sodium vapor lamps are fortunately becoming less widely used; over 90% of their output is in the yellow region of the spectrum, making full correction impossible.

Mixed lighting

When one form of available lighting is dominant, whether tungsten, mercury-vapor, or fluorescent, then you need only concern yourself with balancing the film to that one type. However, when different sources are mixed in the same scene, you may have to compromise. Fluorescent and tungsten combined are particularly unpleasant. However, by using camera angle and position intelligently, you can

Space Shuttle External Tank. In a NASA hangar, the main fuel tank for the Space Shuttle (left) was lit with mercury vapor lamps. Even with a CC20 magenta filter, the blue-green cast is pronounced. *Nikon, 20mm, Kodachrome, ¼ sec, f3.5.*
Champagne tanks. Sodium vapor lamps are used to light this room full of stainless steel tanks. This comparatively rare type of lighting has a strong yellow emission. *Nikon, 20mm, Kodachrome, ¹/₁₅ sec, f3.5.*

London Stock Exchange. Interiors with mixed lighting are a problem. Here, the artificial illumination was fluorescent, but there was also daylight. In this instance, I preferred to accept pink light through the windows rather than have any hint of green from the interior lighting, and used a CC30 magenta filter (right).
Nikon, 20mm, Kodachrome, ¹/₈sec, f5.6.

Rod Stewart. Stage lighting at rock concerts is usually dramatic and interesting, and generally preferable to flash. The light levels, however, are often low, and up-rating the film by extended development is usually the only solution. In this shot (below) the small aperture on a long-focus lens made a tripod essential.
Nikon, 500mm, Ektachrome Type B, pushed 3 stops, ¹/₃₀sec, f8.(below).

The Strip, Las Vegas. In an overall night scene, particularly with display lighting, mixed illumination is rarely a problem. No one light source covers the whole scene, and although there is a large color difference between the reddish tungsten and greenish fluorescent lamps, it is not objectionable.
Nikon, 400mm, Kodachrome, ¹/₈sec, f5.6.

overcome the problem to some extent. In your composition, and in the placement of your model or subject if one exists, try to favor one of the light sources. For instance, if a room has fluorescent lighting at one end and tungsten at the other, and you are photographing a person, move the subject close to one end of the room and apply the filtration for that type of lighting. Also decide which of the lighting types, if uncorrected, would look least unpleasant. If an interior is illuminated by daylight and tungsten equally, and you add a blue filter to balance the film to the lamps, then the deep blue light from the window or doorway may look odd. In this case, balancing for daylight and accepting a very warm light from the tungsten lamps would probably be more acceptable.

There are no hard and fast guidelines for dealing with mixed lighting, and you will have to treat each situation as a new case. Depending on the subject, the contrast of color from the mixture of different light sources may even be attractive.

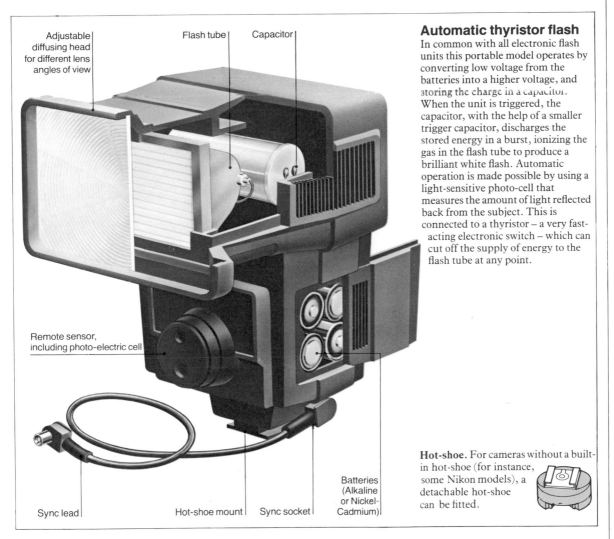

Adjustable diffusing head for different lens angles of view

Flash tube

Capacitor

Automatic thyristor flash

In common with all electronic flash units this portable model operates by converting low voltage from the batteries into a higher voltage, and storing the charge in a capacitor. When the unit is triggered, the capacitor, with the help of a smaller trigger capacitor, discharges the stored energy in a burst, ionizing the gas in the flash tube to produce a brilliant white flash. Automatic operation is made possible by using a light-sensitive photo-cell that measures the amount of light reflected back from the subject. This is connected to a thyristor – a very fast-acting electronic switch – which can cut off the supply of energy to the flash tube at any point.

Remote sensor, including photo-electric cell

Hot-shoe. For cameras without a built-in hot-shoe (for instance, some Nikon models), a detachable hot-shoe can be fitted.

Batteries (Alkaline or Nickel-Cadmium)

Sync lead

Hot-shoe mount

Sync socket

Portable flash

Although the available lighting discussed in the preceding pages is artificial, it is essentially uncontrolled by the photographer – it is "found" lighting. Lighting specifically intended for photography gives you more control over the choice of subject and its treatment.

In the studio, highly specialized light sources are used, and these are dealt with under the studio section on p215. The simplest method of providing your own light source is a portable flash unit. These are compact and powerful enough for many picture-taking situations, and can enable you to work in conditions of very low light. They can also give some control over balancing existing lighting.

Modern portable electronic flash units are powered by either re-chargeable batteries (usually nickel-cadmium) or replaceable ones. Many have automatic exposure control and in more recent models the camera's electronic shutter can be set automatically, overriding the through-the-lens metering information.

Guide number. This is the most common way of describing the flash unit's power. To calculate your exposure, use the guide number given by the manufacturer for the ASA rating of your film, and divide it by the distance between the flash and the subject. For example, if the guide number for your flash with 64 ASA film is 160 and your subject is 3m (10ft) away, you should set your aperture to f16. This is the simplest way of calculating the correct exposure without a flash meter.

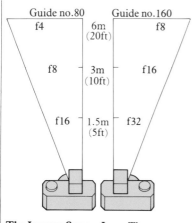

Guide no.80 Guide no.160
f4 6m f8
 (20ft)
f8 3m f16
 (10ft)
f16 1.5m f32
 (5ft)

The Inverse Square Law: The illumination from any light source falls off with distance. The rate at which it falls off is geometric, which means that at twice the distance the illumination will be *four* times less. Strictly, the illumination is *inversely* proportional to the *square* of the distance. As an example, consider the light falling from a lamp onto one square meter at a distance of one meter. Two meters away from the lamp the same amount of light has to cover four square meters (twice the distance = ¼ the illumination) and four meters away is spread over 16 square meters (four times the distance = ¹/₁₆ the illumination). Nearby reflecting surfaces will lessen the fall-off, as will any diffuser that broadens the source of light.

1 sq m

4 sq m

Softening the light from a portable flash

The harsh light from the small tube and polished reflector of a portable flash can be very unflattering to many subjects. One basic method of diffusing the light is to bounce it off a large white or neutral surface, such as a ceiling or wall. This drastically reduces the light reaching the subject, but the hard shadows are eliminated. Some flash units are deliberately designed for this, with heads that swivel upwards. If the flash unit is automatic, then the sensor must still point towards the subject to give correct exposure automatically.

A few flash units have special attachments either to diffuse or reflect the light, and so soften it. Although these are quite useful, they are usually small, and provide much less softening than a ceiling.

Bride, Calcutta. At the wedding of some friends in India (left), I had no fast color film, and the room lighting was too weak for handheld shooting. Although I dislike the hard, unnatural effect that a portable flash unit gives, there was no alternative. Here the ornamentation of the bride made the hard shadows less obvious.
Emerald boa constrictor. In wildlife photography, portable flash is often the only way of being able to take a picture (below). In deep shade, natural light photography is usually not possible with animals that have fast reactions.
Both: Nikon, 180mm, Kodachrome, flash sync, f11.

Vineyard. These leaves looked best when backlit by the sun. The grapes, however, appeared too dark (above) at the correct exposure of ¹/₁₂₅sec at f8. Using a small flash unit on an automatic setting, the indicated aperture for flash was also f8, but as this would have swamped the picture with artificial light, the aperture was reduced to f16, and the shutter speed increased to ¹/₃₀sec (right).
Nikon, 20mm, Kodachrome.

Fill-in flash

Where the contrast in a scene is extremely high, such as a backlit view, you can use a portable flash to fill in detail in the shadow areas. However, if you want to preserve a natural feeling in the picture, you should use the flash with restraint; if the flash output dominates the lighting it will produce an odd effect. As a guide, the maximum output of the flash should be only one-half of the recommended setting, and it may look even more natural if less. The exposure setting for the camera should be based on the highlight reading; the extra light from the flash will then just raise the shadow levels slightly. To reduce the flash output you can reduce the aperture setting. If, for example, the recommended setting is f5.6, you can provide ample fill-in flash at f8. To do this you will have to adjust the shutter speed, which must be no faster than its synchronization speed (1/60, 1/100 or 1/125 sec for a focal plane shutter, depending on the camera).

Alternatively, you can position the flash unit further away, using an extension cord. Following the inverse square law, if you move it twice as far from the subject, then the subject will receive a quarter of the light output. If the flash unit is automatic, switch to manual, or the thyristor circuit will compensate for the extra distance. Or, you can tape a neutral density filter over the flash head, remembering to switch to manual if the unit is automatic.

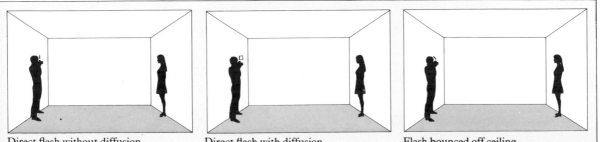

Direct flash without diffusion.

Direct flash with diffusion.

Flash bounced off ceiling.

The darkroom

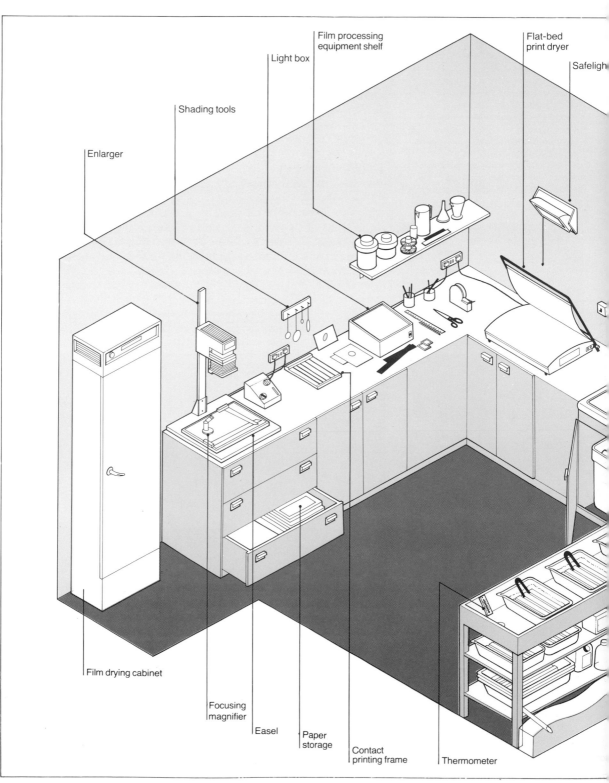

Film processing
equipment shelf

Flat-bed
print dryer

Light box

Safeligh

Shading tools

Enlarger

Film drying cabinet

Focusing
magnifier

Easel

Paper
storage

Contact
printing frame

Thermometer

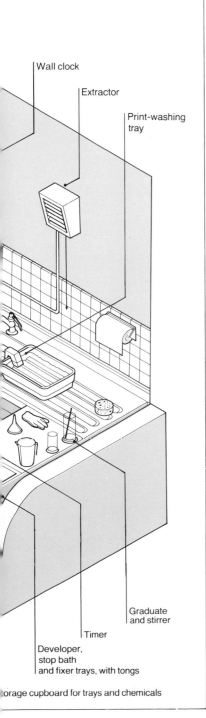

Wall clock

Extractor

Print-washing tray

Graduate and stirrer

Timer

Developer, stop bath and fixer trays, with tongs

Storage cupboard for trays and chemicals

DARKROOM LAYOUT needs careful planning, as the various stages of processing and printing need to be carried out with precise timing either without light or in near-darkness. As with studios, available space often dictates what is possible, but darkrooms can even be built from such unlikely spaces as closets and under-stair cupboards. The most important consideration is to make the room light-tight, yet also kept well ventilated. Remember that fumes from chemicals in concentrated form can be dangerous.

Arrange the workbenches so that, as far as possible, all the stages in a processing or printing sequence are adjacent. It is particularly important to separate 'wet' processes from 'dry' ones, so as to avoid contamination and splashing of emulsions. In printing, for instance, all the exposing equipment – enlarger, contact printing frame, boxes of paper, and so on – can be on one side of the darkroom, while the processing equipment – trays, chemicals, sink – is on the other side.

Order and tidiness are important, so that you can easily locate any item in the dark. The more comfortable and well-designed the darkroom, the easier it will be to work in for long periods.

Wet and dry. Draw an imaginary line through the middle of the darkroom to separate wet processes from dry ones. With equipment that is used in both, such as developing tanks, scrupulously remove all traces of moisture before returning them to the dry side.

The enlarger

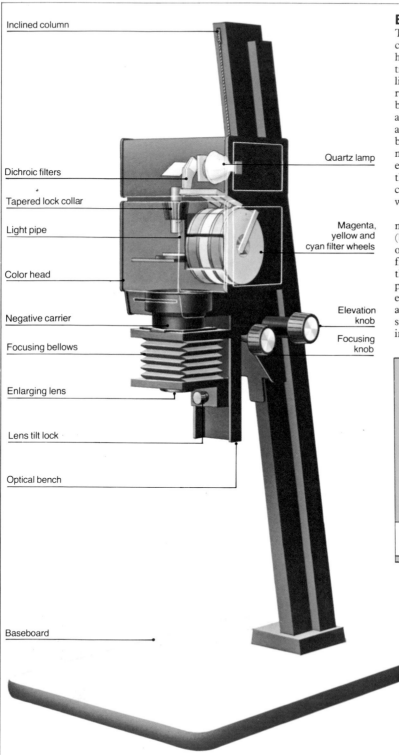

Inclined column

Dichroic filters

Tapered lock collar

Light pipe

Color head

Negative carrier

Focusing bellows

Enlarging lens

Lens tilt lock

Optical bench

Baseboard

Quartz lamp

Magenta,
yellow and
cyan filter wheels

Elevation
knob

Focusing
knob

Enlarger with color head

This advanced enlarger, fitted with a
color head, uses a standard quartz
halogen lamp as its light source, but
transmits the light through an acrylic
light pipe that absorbs the ultra-violet
radiation that would upset color
balance in printing. For focusing
accuracy, the enlarger's fine controls
are mounted on a vertical optical
bench which itself is attached to the
main column. The degree of
enlargement is controlled by moving
the whole assembly up or down on the
column; the image is then focused
with the bellows.

For color printing, three dials are
mechanically linked to three filters,
(below) which can be placed partially
or completely in the path of the light
from the quartz lamp. The amount
that each filter interrupts this light
path determines the filtration. Less
expensive enlargers use a filter drawer
above the negative camera; different
strengths of gelatin filters can then be
inserted by hand.

Filter pack. Color printing is possible even without a purpose-built color head. Gelatin filters (below) in the three colors – yellow, cyan and magenta – can be inserted in the enlarger's filter drawer.
Negative carriers. The negative is held in position in a frame, normally hinged and made of metal (1). To prevent buckling, a glass carrier (2) can be used, To mask off areas of the negative outside the area being printed yet which might otherwise cause flare, an adjustable masking carrier (3) is useful.

Color analyzer. For accurate, repeatable color printing, an analyzer is an undoubted help. Its light-sensitive probe can measure either individual areas of the negative projected onto the baseboard, or average the range of tones.
Voltage stabilizer. Small fluctuations in voltage are common on domestic circuits, and although this has little effect on black-and-white printing, it can alter the color temperature of the enlarger lamp. A stabiiizer compensates for these fluctuations.

Color
analyzer

Voltage stabilizer

THE BASIC COMPONENTS of an enlarger are quite simple – a light source, a holder for the negative, and a lens to project the image over a background, but for the highest picture quality and ease of use, the construction is often elaborate. When selecting an enlarger, follow two principles: first, the quality of the enlarger and lens should be at least equal to that of the camera and its lens. If the quality of the equipment in each stage of the picture-making process is not consistent, then the final image will be limited by the weakest item.

Secondly, anticipate your future needs. A cheap enlarger may serve quite adequately at the beginning, but its drawbacks will soon become clear when advanced printing methods are needed.

Check that the whole assembly is rigid – vibration can be as insidious a culprit as camera shake – and, if possible, choose an enlarger that has a geared drive rather than one where the main assembly slides up and down manually. An inclined column allows greater enlargements without obstruction. The quality of the light source is less critical for black-and-white work than for color, but if you decide to economize in this way, check whether the enlarger can be converted later for color printing.

In either case, accurate printing virtually demands that the light source be connected to a timer. Finally, select as good an enlarging lens as possible, as this controls image quality more than anything else. A focal length of 60mm is convenient for 35mm negatives.

Distributing the light

A naked lamp shining through the negative would give more exposure in the center of the picture than at the edges. To spread the light evenly, there are two basic systems: in one, a diffusing sheet of glass scatters the light; in the other, two condensing lenses collect and focus the light. Although the diffusing system gives a very even spread of light, some of the light rays cross each other's paths, and the image is softer and less contrasty than with the condenser system. The choice largely depends on personal preference. A compromise system places a diffuser below the condenser for a result intermediate in sharpness and contrast.

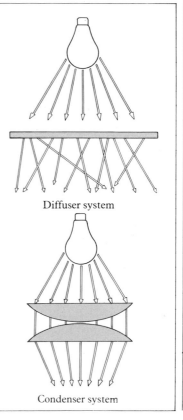

Diffuser system

Condenser system

Black-and-white processing

BLACK-AND-WHITE PROCESSING is a relatively straightforward operation, and the equipment is neither elaborate nor expensive. What is essential, as with any chemical process, is to follow the set procedures faithfully; more than anything else, you need consistency in this stage of the photographic process. By developing your own film, you can exercise a fine control over your photography; you can even plan to make adjustments in printing to the tonal range when you are taking the subject. Also, you are unlikely to find any commercial processing laboratory that will take the same care over your film as you will.

Equipment

Of all the processing equipment, the processing tank is the most important, and you should buy one of the highest quality. Whether made of plastic or stainless steel, it supports the film in a spiral, so that all the film can be exposed equally to the processing solutions in as small a space as possible. Tanks are available in different sizes, taking from one to several spirals. A good tank should be easy to load, and should hold the film without causing buckling or allowing sections of adjacent film to stick together.

A photographic darkroom is not essential for processing – just a small light-tight space where the film can be loaded into the tank. This can even be a closet with the light gaps sealed over with a blanket (check that the room is completely dark by waiting five minutes inside until your eyes have become adjusted to the dark – if there are still no chinks of light visible, it is dark enough for loading film). All the other steps can be carried out in normal light.

The chemicals must be kept at a constant temperature during processing; 20°C (68°F) is the temperature that is nearly always used. The simplest way to maintain this is to place the chemical containers and processing tank in a basin filled with water at this temperature.

Finally, make sure that every piece of equipment is kept scrupulously clean and is dry when it should be dry. To avoid marks and contamination, it is a good rule to separate wet stages of the process from the dry stages. Do not allow chemicals or water close to the place where you load the film, and, if you are using the tank several times, make sure that the spiral reel is dry before loading again.

Preparing the chemicals

Most chemicals come in concentrated form, either liquid or powder. Developers are commonly sold as powders, usually in two separate packs that must be mixed by the user in a particular order. With a typical developer powder, first fill a container with three-quarters of the final volume of water at a temperature of about 52°C (125°F), then slowly stir in the powder. Continue stirring until the powder has completely dissolved. If you pour in the powder too fast, it will accumulate on the bottom and dissolve more slowly. Add the remaining quarter of the volume of water, and store in a bottle. Prepare the solution well in advance, as you will need to allow it to cool and settle before use.

Both stop bath and fixer are commonly available as concentrated liquids, and are simply diluted before use. Stop bath, in particular, is highly concentrated, and the fumes can be dangerous. When using

Processing equipment

Developing tanks are available in two basic designs – with a stainless steel reel (1), and with a plastic reel (2) which is easier to load but less durable. Developer (3), stop bath (4), and fixer (5) should be kept in clearly-labelled, light-tight stoppered bottles; an even better alternative is an expanding container with a concertina shape (6) which adjusts so that air is excluded. For mixing chemicals, a graduated measuring flask (7) is essential, and to maintain them at a constant 68°F (20°C) they should be placed in a tray (8) filled with water at that temperature, using a thermometer (9).

Processing chemicals for film and paper

Print developing has much simpler needs than film processing. Only three chemicals are needed – developer, stop bath and fixer – and these are standard.

Developer
Print developers, either MQ or PQ types, are used at higher concentrations than film developer so that the image appears within a reasonably short time – 1½ to 2 minutes. Developers oxidize rapidly.

Stop bath
A typical acid bath is used to stop the developer's action. It is re-usable. Some printers prefer to use water instead. Although this considerably shortens the working life of the fixer which becomes contaminated more quickly, a print that has been 'stopped' by a plain water wash can be returned to the developer if necessary.

Fixer
Prints are normally fixed in an acid hypo solution, at weaker dilution than for film. As soon as discoloration is evident, discard.

Hypo eliminator
An oxidizing agent can be added to the wash to clear hypo from the film chemically. This can cut washing time by as much as five-sixths.

Wetting agent
A few drops of wetting agent can help the developer spread more easily over the film, and also reduces water marks during drying.

Types of developer

Different developer solutions are designed to alter or enhance the particular characteristics of a film – speed, grain size or contrast. Just as there is no ideal emulsion that combines the best of everything, so there is no perfect developer. You must not only choose the developer for the characteristic you value most; you must also match the developer to the emulsion. A fine-grain developer does not magically impart a fine grain to all emulsions, and if you have already chosen a fast (and therefore grainy) film, you should use a developer that enhances that characteristic.

Fine grain developers
These help to prevent the overlapping of individual grains that is visible as clumps in the developed image. They are slow and tend to produce low contrast.

High energy developers
These developers enhance graininess but enable the film to be used at a higher speed rating. They are very active, and produce higher contrast.

High contrast developers
These are used when maximum contrast is needed, and can produce extremely dense blacks in line film. For certain kinds of copying and masking work, they are ideal.

High acutance developers
These increase the apparent sharpness of the image by developing the grains near the surface of the emulsion. The silver image is therefore in a thinner layer, and there is less blurring from the gelatin thickness.

A timer (10) can be pre-set to the recommended developing and fixing times. Rubber gloves (11) prevent skin irritation from prolonged contact with the chemicals and a funnel (12) prevents spillage when returning chemicals to the bottles. A water hose (13) and filter (14) are used for washing the film, which is then hung to dry on clips (15). Excess moisture can be removed with a pair of squeegee tongs (16). The film is finally cut into strips with scissors (17). Wetting agent (18) is added to the final wash to help the developer spread more easily and to prevent drying marks.

this, and all other chemical solutions, keep the room well-ventilated.

All of these chemicals have limited lives, even when they are not being used but under ideal circumstances most developer solutions will last about 6 months. Exactly how long they last depends on how well they are stored, and you should protect them as well as possible from both strong light and oxidation through contact with air. Use dark, well-stoppered bottles, and fill them to the top; the less air contact, the more slowly the solution will oxidize. Some containers are made to expand when they are filled with solution, and contract as it is poured out, so keeping all air out.

Loading the tank and processing

This is the only stage that must be completed in total darkness. First practise with a discarded roll of film; it can be awkward to feed the roll on to the spiral without snagging or buckling, and there is always the danger that a part of the film may slip from its guide rails and touch an

adjacent part. There are two types of spiral – stainless steel models which feed from the center outwards, and plastic spirals which feed inwards from the edge. Become completely familiar with your tank; once you have started to load the film on to it, there is no going back. Always hold the film only by the edges during the loading.

Although straightforward, the processing sequence is a rigid one, and you should follow each step under exactly the right conditions of temperature, timing and agitation. To avoid mistakes and delays, you may find it helpful to write down the sequence before you begin, and, before pouring the first solution into the tank, check that you have everything to hand.

Washing, drying and filing

Take extreme care in these final stages; although the image has been developed and fixed, the emulsion is still very soft, and can be scratched easily. You can wash the film in the light, but avoid playing the water from the hose directly on to an area of emulsion – the water pressure can distort it. A water filter is useful to keep grit and particles out of the water supply, and a wetting agent in the final wash helps prevent drying streaks.

Hang the film up to dry in a clean, dust-free place. Then, when it is dry, file it for protection. Probably the most convenient method is to cut the roll into strips of 6 frames and store them in transparent sleeves, one roll to a sheet, numbered and dated.

Altering development

You can alter the development, temperature or strength of the processing solution for deliberate effect, and with experience you will be able to achieve a surprisingly wide range of control over the film's tonal range. The most basic use of altered development is to correct

Black-and-white film processing

1. In complete darkness, open the cassette by prising off the end with a bottle opener or special cassette opener. Take out the film and cut off the tongue.

5. Trip the timer switch. During development, agitate the tank by rocking it backwards and forwards to ensure even application of the solution. Agitate for 15 seconds every minute.

Compressing the tonal range by underdeveloping. Returning to the photograph that was used to illustrate the Zone System, reducing the development of the film provides a workable solution to the contrast problem. By underdeveloping one stop (and compensating for this by overexposing one stop) the tonal range of this picture is compressed to include approximately one extra zone. In the earlier print, on page 75, nine zones were beyond the paper's capacity to record detail.
Underdevelopment by one stop produces a negative that can be printed to include Zones I through to IX; as a result, detail in both the shadowed foreground and high-lighted cliffs is preserved.

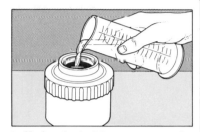

2. Holding the film by its edges, bow it carefully and attach the end to the spike or clip at the core of the stainless steel reel. Rotate the reel so that the film is pulled out along the special grooves and thread the film inwards from the rim.

3. Trim off the end of the film that was attached to the cassette spool, lower the loaded reel into the developer tank and replace the lid. The room light can now be switched on.

4. Having checked the temperature of the developer solution, pour it quickly into the tank. When full, tap the tank to dislodge air bubbles, and fit the cap that covers the lid's central opening.

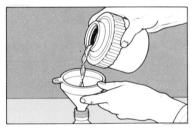

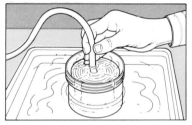

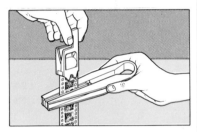

6. At the end of the development time, quickly pour out the developer. Pour in stop bath and agitate continuously for 30 seconds. Pour out and re-fill with fixer for the time recommended by the manufacturer.

7. When the fixing period is over, empty the tank, take off the lid and insert a hose from the cold water tap into the core of the reel. Wash for at least 30 minutes in gently running water. Strong water pressure may damage the emulsion.

8. Before removing the reel from the tank, add a few drops of wetting agent to avoid dying marks. Attach film to a hanger clip, pull out and gently wipe off the bulk of the moisture. Hang to dry in a space free from dust and air movement.

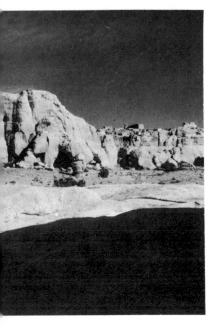

mistakes you have already made in the exposure. If you have inadvertently underexposed a roll of film, and realize it later, you can compensate for the weak latent image by overdeveloping the film. When in doubt, it is common practice among professionals to run a "clip-test" – a few frames cut from one end of the exposed roll and developed to see if any adjustment is needed for the rest of the roll.

Altered development is not just a means of salvaging a film; you can alter development having planned your exposures with this in mind. What makes increased or reduced development so useful is that the effect of the developer solution on the emulsion is not equally distributed over the whole silver image. When you change the standard development, you also alter the contrast, so that you are able to manipulate the tonal range of the film. In this way, if the lighting on the original subject was too flat for your liking, you can expand the tonal range later by overdeveloping. If, on the other hand, the brightness levels in the scene were too extreme for the film, then the tonal range can be compressed by underdeveloping and all the details can be brought out.

Naturally, you will have to vary the exposure so that the overall density of the image is satisfactory. If you know that you will later underdevelop a film by one stop so as to reduce the contrast, you must

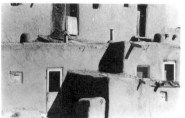 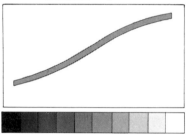 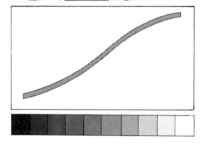

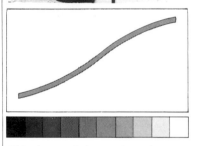

This characteristic curve has a shape typical of normal exposure and development.

With less development, the slope is flattened, affecting the highlights in particular.

Increasing development steepens the slope and therefore increases the density range.

increase the exposure by one stop to compensate for this.

Increasing development increases the density of the image and increases the contrast (expands the tonal range). Reducing development reduces the density and reduces the contrast (compresses the tonal range).

Development can be altered by varying the time, temperature or dilution of the chemicals. There is a limit to how little development time you can give, and under three minutes there is a real danger of uneven development (as a precaution, pre-soak the film in water before beginning processing). The latitude in temperature is also small; below about 13°C (55°F) some solutions stop working, and above 24°C (75°F) the emulsion becomes soft and is easily damaged.

Generally, changing the dilution is the best method of altering the development, although you can combine two or even all three of the methods. Follow the film manufacturer's specifications; but as a general rule, you can achieve one-stop differences in development by halving or doubling the dilution of the developer. Two stops on either side of normal recommended development is about the limit for a satisfactory image. Although you can alter the development by greater amounts, the image quality will suffer very much, and will probably be acceptable only when the lighting of the original scene is so dim that any kind of image is welcome.

1. In this normally-exposed, normally-developed negative (above left) of an Indian pueblo in New Mexico, the tonal range is quite full, but with a predominance of middle-grays in the center of the tonal range. The shadow and highlight areas occupy only a small part of the image, but are extreme. The film can just record all the important details at either end of the tonal scale.

2. By overexposing this negative (above center) one-and-a-half stops and then reducing the development time, the middle gray tones of the adobe wall remain the same. However, the whole tonal range of the film has been severely compressed, and the effect is flat.

3. This negative (above right) was underexposed by the same amount, one-and-a-half stops, and later overdeveloped. Again, the mid-tones over most of the picture are unaltered, but the highlights and shadows have lost a great deal of detail. The tonal range has been expanded, and the contrast increased, but this has gone beyond the film's capabilities of recording.

Assessing the negative

Before starting to print, carefully examine the negative on a light box, not only for faults that may impair the print, but also to determine the printing techniques you should use. Compared with film development, printing is a flexible process that allows almost infinite adjustment of the image and a wide variety of interpretative results in the print. Nevertheless, you should know the possibilities and limitations of each individual negative before starting.

A contact print (see p102) will give you an approximate idea of the picture, and is essential for reading facial expressions, but only direct examination of the negative will reveal the qualities of density, tonal range and sharpness.

Density is a measure of how dark or light and how contrasty the negative is. Look at the important highlight and shadow areas to see how much detail is recorded. With this kind of visual examination, you will need practice in order to be able to judge what is normal.

A negative's tonal range, or contrast, is the difference between the densest areas of silver (highlights) and the thinnest (shadows). The tonal range possible in a negative is considerably greater than that in a print, so some of the details that are apparent in the negative may not record on the print without special printing techniques.

Check the sharpness with a magnifying glass, examining the important areas of the picture (such as the eyes in a portrait) and those areas that have fine detail.

Look for scratches, holes, or particles embedded in the emulsion, finger marks, and stains that could result from uneven development, contaminated chemicals or uneven drying. Some faults can be corrected by re-touching, but whether this is better performed on the negative or on the print depends on the circumstances (see p272).

Faults on the negative

Light leak. An ill-defined dark area is characteristic of accidental exposure to light. Here, this includes the rebate, suggesting that the leak occurred outside the camera (top).
Incorrect loading to developing tank. Two adjacent pieces of the film stuck together in the developing tank, preventing full exposure to the processing solutions (middle).
Scratches and particles. The scratch was probably due to rough handling. Dust and grit adhered to the soft emulsion during drying. There are also water marks (above left).
Stress mark. This crescent-shaped mark (above right) is often found close to the beginning of rolls and is caused by crimping the film too hard.

This negative (right) was selected to be used in making the final print, as its contrast range is reasonably full but not too excessive. For the best results, it should be printed on Grade 2 paper.

| In the print crop out this girl as only half her face appears. | Key tones are the faces and arms of the girls. | Be careful in printing not to block highlights on these areas. | The shadow detail in the eyes needs to be retained. |

Black-and-white printing

PRINTING OFFERS A completely different field of control over the image. Although many black-and-white prints are intended to be no more than faithful reproductions of the already-photographed image, the negative can be just the starting-point for creating pictures that depend on darkroom skills.

Printing a contact sheet

A contact sheet provides you with a useful preview of the quality of each frame. Although on 35mm format it shows little detail, you can use it to select negatives for enlargement; without a positive image it can often be very difficult to judge which are the best frames on a roll. Making a contact sheet is a simple process and, because the negatives are exposed in contact with the printing paper rather than being projected, it can even be done without an enlarger.

Cut the film into strips of six frames; the whole of one 36-exposure roll can be contact-printed on to a single sheet of 8×10 inch (20.3× 25.4cm) paper. A hinged contact printing frame is the most convenient way of sandwiching the negatives and paper together, but it is almost as easy to use a plain sheet of clean glass, placing this carefully on to the strips of film arranged on the paper.

In order to identify the roll of film from the contact sheet, it is a good idea to mark the roll number directly on to the film so that this information is printed on the paper; many photographers write the number in indian ink with a fine pen on the clear rebate.

Printing equipment

In addition to the enlarger, you will need the following items for black-and-white printing: Developer (1), stop bath (2), fixer (3) and trays for each (4). Separate tongs (5) are needed to avoid contamination of the chemicals. Trays must be large enough to take the size of paper (6) you will be using. A focusing magnifier (7) allows the sharpness of the projected image to be checked accurately. For contact sheets (8) the negatives (9) are arranged with the paper in a contact printing frame (10). A pen (11) and indian ink (12) can be used to mark the negatives for identification, and a magnifying glass (13) is useful for selecting frames for final printing in the enlarging easel (14).

The contact sheet – procedure

1. Take the strips of film from their sleeves and dust them with an anti-static brush to remove particles.

3. Identify the emulsion side of the film (that side toward which the film curls) which also has a matte finish. Fit the negative strips into the glass cover of the frame, emulsion-side down.

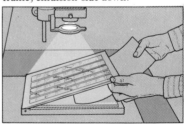

5. Under safelight illumination, place a sheet of normal (Grade 2) paper, emulsion side up, in the printing frame, under the negative strips, and close the glass cover.

The contact sheet. The selection process begins here with all the frames arranged in order on a single sheet. Use the contact sheet to assess picture content, rather than the quality of the negatives.

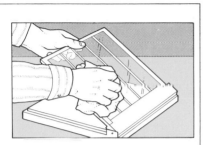

2. Clean the contact frame with a damp sponge and then with a dry cloth.

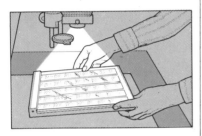

4. Position the frame directly under the enlarger head, and raise or lower the head until an even rectangle of light more than covers the area of the frame.

6. Make the exposure. The time will depend on your enlarger lamp and density of your negatives, but, as a guide, start with a five-second exposure with the enlarging lens at its widest aperture.

14

Making a test strip

Select a negative by carefully examining your contact sheet with a magnifying glass, and assess it by the criteria given on page 101. With experience, your assessment should give you an approximate idea of the exposure time needed for an enlargement. The next step is to check your estimate by making a series of different exposures from the negative. When processed, you will be able to make a side-by-side comparison of different times, and decide which one is best. Make the test strip large enough to show differences in density and to include a representative section of the image; you may find it easiest to use a whole sheet of paper rather than a strip.

Make four or five exposures on the strip, each substantially different from the next. One of these exposures should be correct, or almost so, and you can then go on to making the final print.

Examine the test strip to see which of the four exposures appears best. Look at the key, or most important, tones, the highlights and the shadow areas. Flesh tones in a portrait are crucial because they are so familiar and the tones in the print should correspond with your visual memory. Your personal preference plays a large part in this choice.

Check that there are no large areas of highlight where the detail appears washed out, and also look in the shadow areas for any detail that you want to preserve. You may find that no one exposure time represents all the tones well. If this is the case, then you may have to use some of the procedures described on pages 270 and 271.

If, even on the best exposure, the general appearance is either too flat or too contrasty, change to a different grade of paper and make a fresh test strip (see p 107). Alternatively, if you are using a variable contrast paper, make another test using either a yellowish contrast-reducing filter or a bluish contrast-increasing filter.

Positioning the test strips. Exactly where the different bands of exposure fall on the print is an important consideration. From the negative, choose the most important tones and try to cover these with each exposure. The jumping girl (above right) has to be divided vertically while a diagonal division on the still-life (right) gives similar coverage of all areas.

The test strip – procedure

1. Place the negative in the enlarger's negative carrier (emulsion side down), cleaning off any dust with a blower, anti-static brush or anti-static gun.

2. Insert the carrier in the enlarger head. With the room lights out, the enlarger lamp on and the lens aperture wide open, adjust the enlarger head until the image is focused and to the size you have chosen.

3. Make fine adjustments to the focus until the image is critically sharp. You can do this by eye or by using a focus magnifier which enables you to check the sharpness of the film's grain; (irrespective of whether the image is sharp, as long as the grain is focused you will have the sharpest print possible).

Assessing the test. A standard series of exposure times, from five to twenty seconds, gives a good indication of what the final exposure should be. From the examination of the negative, the central part of the picture with its range of skin tones is the most important, and the test bands were arranged so that the most likely exposure falls in this area. Twenty-second and fifteen-second exposures are too dark, with obvious loss of detail in shadow areas, while five seconds leaves the highlights white and featureless. The ten-second exposure is nearly right, although perhaps a fraction too dark.

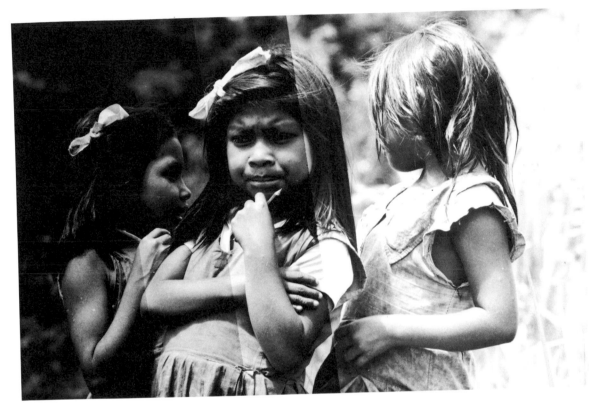

20 sec · f11 15 sec · f11 10 sec · f11 5 sec · f11

4. Close down the lens aperture about two stops (normally this would be f11). With a negative of normal density this will let you use reasonably short exposure times, and the lens performance will be at its peak. The increased depth of field will also compensate for slight focusing errors.

5. Under safelight illumination, and with the enlarger lamp off, insert a sheet of normal (Grade 2) paper, emulsion side up, into the printing frame. Set the timer to five seconds.

6. Hold a piece of black card over the sheet of paper, leaving just a quarter of its width exposed, and give a five-second exposure. Move the card along for second exposure of five seconds. Make third and fourth in the same way. The whole sheet will be exposed for the final exposure. Process as an ordinary print.

The final print

Having decided on an exposure time from the test strip, place a fresh sheet of paper in the printing frame and make the exposure. This may still not be perfect, as the test strip can give only an indication. Because prints are processed by inspection under a safelight, there is a strong temptation to use hit-and-miss methods rather than follow recommended timings. Although processing by inspection can be invaluable for difficult prints, consistent results are only possible by following set procedures. As much as possible, keep notes of exposure times, lens aperture, development time and other variables. This will form a record for later occasions when you need to reprint the negative for the same effect. After processing, make a careful examination under good lighting, and look not only for blemishes and white spots left by dust particles on the negative, but also for the preservation of highlight and shadow details. If the negative is good, and the tonal range is within that of the paper, then you should at this stage have a final print.

In the final printing, two areas proved a little difficult – the tonal separation between the dress of the center girl and the highlights on her forearm, and details in her eyes. Exposure and development times were both critical. The exposure at f11 was 9 secs, and development was by inspection under the safelight.

The final print – procedure

1. Check that the three chemicals – developer, stop bath and fixer – are in the right order, and that the developer is at 20°C (68°F). Make the exposure.

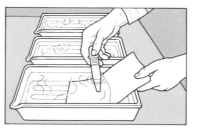

2. Slide the paper, emulsion side down, into the developer tray. Press it down with the developer tongs so that it is fully immersed.

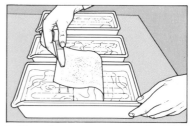

3. Turn the paper over so that the emulsion side is facing up and you can see the developing image.

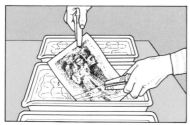

5. Lift the paper out of the developer tray with the tongs and allow excess solution to drip off. Transfer the paper to the stop bath, take care not to dip the developer tongs into the stop bath. Rock the tray as during development.

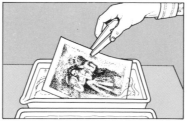

6. After 10 secs, lift the print out of the stop bath and drain. Transfer to the fixer (some mixture of stop bath to the fixer causes no harm) rocking the tray at intervals. After one or two minutes, you can switch on the room lights and examine the print. Leave it in the fixer for at least 10 mins, but no more than 20 mins.

7. Wash the print in running water to remove all traces of the chemicals; washing time varies according to paper manufacturer's recommendations. If the paper is resin-coated, it needs washing for only 4 mins; paper-based papers need about 15 mins.

Paper types

Choice of paper depends not only on personal preference (the sensual appeal of a finished print is important) but also on the purpose, whether for reproduction or gallery presentation.

Paper-based
Until recently, all papers had a paper base with an emulsion coating on one side. Those with the traditional paper base are still the most commonly used.

Resin-coated
Resin-coated papers have a plastic coating on both sides that is applied before the emulsion. This effectively seals the paper and the washing and drying stages are shortened considerably. Although popular because of this convenience, they have a limited range of textures, none of which corresponds to the standard "glossy unglazed". A more serious disadvantage for professional photographers is that they take re-touching very poorly.

Weight
Various paper weights are available and, although the thickest – "double weight" – is more expensive, it is less liable to creasing.

Texture
Apart from "glossy" and "mat", a range of special textures can be bought, but most have a gimmicky appearance. Glossy papers give the richest-looking blacks.

Tint
Each make of print has its own subtle tone, and in addition there are more noticeable ranges of base tint that include cream and strong primary colors.

Grade
Printing paper is normally available in several contrast grades – usually 0 to 4 in increasing contrast (see below). The choice of grade can be used to compensate for variations in negative density or can be used to create special effects.

4. Agitate the solution by rocking the tray gently. This ensures that the paper receives even development. Develop for 90 seconds.

8. Put the print against a smooth flat surface, and wipe off water drops.

Drying the print

Resin-coated prints. Dry them flat without using a dryer. Air-drying print racks are ideal, as water cannot get trapped underneath the prints.

Paper-based prints. These should be dried in a heated dryer (a flatbed machine is normal). Glossy prints can be glazed by being placed face down on the dryer's metal plate. The majority of professional photographers use glossy paper unglazed (ie dried face up).

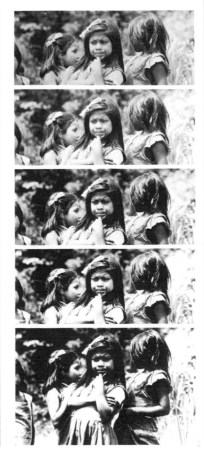

Shading and printing-in

One of the most useful and important controls of a darkroom printer is to be able to alter the exposure given to small areas of the print. By holding back some parts of the negative, and giving more time to others, the final print can be completely altered. Holding back details is called 'shading' and giving extra exposure is known as 'printing-in'.

Having assessed the negative and made a test print, you will be able to judge if any parts of the print need special attention. The most frequent need for shading and printing-in is when the contrast range of the negative is too high for the paper, and the highlights would appear 'blocked' or the shadow areas lose their detail. From the test print, make a base exposure for the areas of average density. While you are doing this, shade the thinnest parts of the negative with your hand, a piece of card, or a special shading tool, keeping it moving, so that the borders of the shaded area blend in with the rest of the print.

Without moving the baseboard or enlarger, print in the densest areas of the negative. Use either a large sheet of black card with a small hole in the center or cup your hands to form a gap of roughly the right shape. Again, keep moving so that no hard edges are formed, but take care that no unwanted light spills onto the corners of the print.

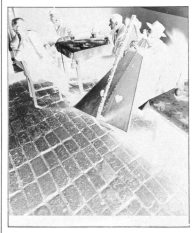

Man playing harp. The negative of this harp player in a Peruvian café (above) had an exceptionally high contrast range; the only illumination had come from the open doorway. Although I wanted to preserve the feeling of contrast, a straight undoctored print would have lost all shadow detail and the highlights would have been washed out. A soft paper grade would have turned the potentially rich blacks into grays. The only solution was to shade and print-in. Paying attention only to the shadow areas, an exposure of 10 seconds at f11 (above right) leaves most of the print completely over-exposed. Alternatively, a print made to record just the highlight details – 30 seconds at f11 (right) – is mostly a featureless black.

For the final print (left), first of all a base exposure was made. This was 12 seconds at f11, calculated from the central part of the picture – the stone flags close to the base of the harp. During this exposure, the lower right-hand corner was shaded by hand for two seconds (see below). The shadowed faces of the harp player and the man sitting second from the left were also shaded for two seconds, using a shading tool (see below).

Following this, the printing-in took much longer. The table was given an extra 12 seconds, as were the lightest parts of the harp and the stone flags nearest the doorway. In addition, the extreme highlights on the harp received a further 12 seconds, and those on the floor a further 24 seconds.

Finally, the lit side of the man's face at the far left was given 12 seconds. Cupped hands were used for all the printing-in (see below) and a footswitch was used to operate the enlarger light.

The lower right-hand corner was shaded by hand for two seconds during exposure.

A shading tool was used to shade the two shadowed faces.

Cupped hands were used to control the size of the area during printing-in.

Color processing

COLOR PROCESSING and printing follow many of the procedures of black-and-white darkroom work. Most of the working principles established there still apply to color materials and most of the processing and printing equipment can still be used. In color darkroom work, however, control over temperatures and times is more critical to good results so it is advisable to start work in the color darkroom only after you have mastered the techniques of black-and-white work.

In addition to all the qualities discussed in black-and-white work (see p 101) – contrast, tone, density and so on – there is, of course, the major addition of color to your image. Like the other qualities, color is not a separate feature but integrally related to tone, density and so on. As a result, at both exposure and darkroom stages, if you do something to alter one quality of the image, say the density, you will inevitably affect all the other qualities, including the color. The best results come from balance and control of all the qualities of the image.

Processing the film
As in black-and-white work, you do not require a darkroom to do your own color film processing. And if you are using color transparency film, which follows a different procedure than negative film, you will be able to obtain finished images. The majority of color transparency and color negative films can be user-processed. However, a few brands, such as Kodachrome, are "non-substantive" and can only be processed by the manufacturers or their agents on special machines.

Color processing chemicals are available in kits which contain all the required materials. Not only should you make sure you have the right kit for the type of film – transparency or negative – but also that your chemicals are compatible with your film brand.

Color processing chemicals, both transparency and negative, can have a short life, so mix them up just before you start and store them in tightly sealed containers, preferably the plastic "concertina" bottles that can be compressed to expel air. Most of the chemicals, including the developers, can be reused; check the manufacturer's recommendations for this.

Color film can be processed in exactly the same type of light-tight processing tank as is used for black-and-white processing (see p 96). The first stage, then, involves removing the film from its cassette in total darkness, loading it on to the tank's reel, placing the reel in the tank and sealing the top. The room lights can now be switched on and the remaining steps carried out in normal light. (If you are processing in trays, the room lights can be turned on after the reversal bath with slide film and after the bleach with negative film.)

The three major variables in black-and-white processing – times, temperatures and agitation – also apply in color work but are far more critical. Poor control over the temperatures of the solutions is probably the single most common reason for mistakes in processing at first. In both transparency and negative processing, the temperature of the first developer is most critical, having a latitude of as little as ¼°F (0.15°C) with color negative film. As a result, you may find that you want to use a more accurate thermometer than for black-and-white work. Apart from this, the only other extra equipment you are likely to need is extra graduates and a large, deep tray.

Equipment

In addition to the developing tank and other basic items needed for black-and-white film processing, color film needs its own developer, bleach, fixer and stabilizer, a graduated thermometer and a deep bowl that is filled with warm water to maintain the temperature of the chemicals at the right level.

Color film processing – procedu

1. Having loaded the processing tank with film in total darkness, as shown on p 98, mix and pour out measured quantities of the solutions into separate, clearly marked containers.

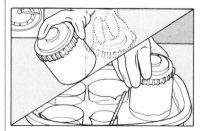

3. Follow the same procedure for every solution. Hold the tank at an angle to pour in the solution. Start the timer, then agitate the tank, as recommended, placing it in the water bath between agitations. Use the final ten seconds of each stage to drain the tank thoroughly.

Altering development of color film

As in black-and-white, color film can be rated at different speeds and over- or under-developed to compensate. However, the three different layers of emulsion in color film react differently to altered processing.

Follow manufacturers' instructions for the mechanics of over-developing ('pushing') and under-developing ('cutting'). As an example, Kodak E.6 reversal films can be treated in the following ways:

Camera exposure	Desired effect	Alteration of First Developer time
2 stops under	Push 2 stops	Increase by 5½ mins
1 stop under	Push 1 stop	Increase by 2 mins
Normal	Normal	Normal
1 stop over	Cut 1 stop	Decrease by 2 mins

The effects vary between makes of film, but in general they are:

Over-developed reversal film
1. Loss of maximum density, causing thin, foggy shadow areas.
2. Increase in contrast.
3. Shift of color balance. This varies by

make of film, but, for example, E.6 emulsions tend to become warmer – Ektachrome 64 and 200 tend towards magenta, and Ektachrome 400 tends towards yellow. This is only pronounced when pushed more than one stop.

Under-developed reversal film
1. Loss of contrast in the highlights.
2. Shift of color balance. As with over-development, this varies by make of film and is not very noticeable with small alterations. E.6 emulsions tend towards magenta.

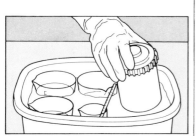

2. Fill a deep tray with water at about 110°F (44°C) and put in the loaded tank and numbered graduates. Leave to stand for a few minutes, when all solutions are between 95° and 105°F (35° and 40.5°C). Rinse the thermometer when passing it from one solution to another.

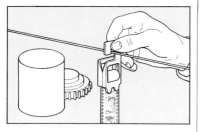

4. Remove the film from the tank and hang up to dry in a dust-free place.

Timing and temperatures

Although the number of solutions and their times vary between color slide and negative film, the basic preparation and routine during processing is the same. Remember to have an accurate timer and thermometer and follow the times and

temperature recommended by the film manufacturer. The two most common processing sequences – Kodak C41 and E6, for negative and slide film respectively – are shown in the tables below.

Processing 'Kodak Ektachrome' Films (Process E-6)

Processing step	Minutes*	°F	°C
1. First developer	7†	100±½	37.8±0.3
2. Wash	1	92–102	33.5–39
3. Wash	1	92–102	33.5–39
4. Reversal bath	2	92–102	33.5–39
5. Color developer	6	100±2	37.8±1.1
6. Conditioner	2	92–102	33.5–39
7. Bleach	7	92–102	33.5–39
8. Fixer	4	92–102	33.5–39
9. Wash (running water)	6	92–102	33.5–39
10. Stabilizer	1	92–102	33.5–39
11. Drying	10–20	75–120	24–49

*Includes 10 seconds for draining in each step
†See instructions for using solutions more than once

Processing 'Kodacolor II' and 'Kodacolor 400' Films (Process C-41)

Processing step	Minutes*	°F	°C
1. Developer	3¼	100±¼	37.8±0.15
2. Bleach	6½	75–105	24–40.5
3. Wash	3¼	75–105	24–40.5
4. Fixer	6½	75–105	24–40.5
5. Wash	3¼	75–105	24–40.5
6. Stabilizer	1½	75–105	24–40.5
7. Drying	10–20	75–110	24–43.5

*Includes 10 second draining time in each step

Color printing

AS IN BLACK-AND-WHITE printing, the most important piece of equipment is the enlarger. It must have some facility for filtering the image, either a filter drawer or a dial-in head; in all other respects it will be exactly the same as the enlarger used for black-and-white work (most enlargers are adaptable for both). Of the two, a dial-in head gives more control and is simpler to use than a filter drawer and a pack of colored filters. It works by moving three filters, corresponding to the subtractive printing colors, yellow, magenta and cyan, progressively into the enlarging light as the controls are altered. If your enlarger has a filter drawer instead of a dial-in head, you must use a filter pack of 21 acetate or gelatin filters, and select filters from the pack.

There are several optional accessories which will help to improve the quality and consistency of your prints. An electronic timer, wired-in to turn off the enlarger automatically, helps to make exposure times more accurate. A voltage regulator prevents changes in the electricity supply that affect the enlarging light intensity and color. More expensive is a color analyzer which will read out an exposure time and filtration for an image from the baseboard, so improving the accuracy of your prints. Before starting, an analyzer should be calibrated for a typical negative on your enlarger.

All color paper is resin-coated and therefore must be air-dried. It is available in three surface finishes but, unlike black-and-white papers, only one contrast grade. It can be used safely under a deep amber safelight but is generally handled in total darkness. The characteristics of color paper vary, so that one negative printed on two different batches of paper will appear slightly different. To allow for these inconsistencies, manufacturers put batch numbers on the paper's packs that enable you to recalculate exposure and filtration when changing batches. To find the new filtration for a negative, you subtract the recommended filtration for the previous batch from your actual filtration, then add this result to the filtration values on the new paper batch. For example, if your old filtration was 40Y+50M with a paper batch of recommended filtration 10Y+5M and your new batch values are 20Y+00M, then your new filtration for the new batch should be 50Y+45M. To obtain the new exposure time, divide the speed factor on the new label by the one on the old label and multiply the result by your original exposure time.

Exposure and filtration

In color work, not only the exposure time for each image must be assessed, but also its filtration. Together, exposure and filtration determine the tone and color in your print, and almost every image requires some filtration. Different subject lighting, film brand or speed result in different filtrations. Even the same image printed on a different enlarger or with a different paper batch needs a different filtration.

As a result, for each negative there must be two tests, the first for the exposure time (using an estimated filtration), the second for the filtration. These two tests are separated for convenience; in reality they are interdependent so that an alteration in exposure time affects color (and therefore filtration), and vice versa.

Assessing the filtration to obtain the best color balance in the print

Making an exposure test

1. With the filtration set to an estimated combination, insert your negative into the enlarger and compose and focus your image on the baseboard.

2. In total darkness, insert a piece of printing paper under the easel large enough to include a representative section of the image. Using a piece of black card as a mask, make a series of increasing exposures across the paper. In principle, this is similar to making a black-and-white test print (see p 104).

Print processing equipment

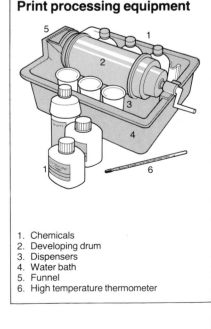

1. Chemicals
2. Developing drum
3. Dispensers
4. Water bath
5. Funnel
6. High temperature thermometer

Assessing the exposure test

Once your test has been processed and is dry, you can begin to judge it. Ignore color at this stage and look at it as you would a black-and-white print, concentrating on the tonal range and detail in highlights and shadows. In this case the best exposure is in the 4 secs band.

2 sec f16 4 sec f16 8 sec f16

Because color paper should be handled in near or total darkness, it is advisable to use a light-tight drum for paper processing, rather like a film developing drum. This also reduces the likelihood of mixing different chemicals, improves control over temperatures and agitation, and requires less chemicals than trays. Paper processing drums can be hand or motor-driven, and some float in their own water bath, which helps to maintain solution temperatures. Rubber gloves are essential when handling color chemicals.

is probably the most difficult skill in color printing. Unless you have the subject in front of you under identical lighting conditions to the time when the picture was taken, you will have to rely to a great extent on your memory of the scene and match the colors in the print to that. This means that within broad limits of "acceptable" results, two people will probably produce different prints from the same negative. With experience, you will find that you are able to refine your assessment and criticism to a point where your tests are taken very close to an "acceptable" print.

Subtle areas of color, such as skin tones, and areas of white most readily betray a color bias in your tests or prints. It is therefore easiest to begin by looking at these areas. The cardinal rule for controlling print color is that to remove a cast from the image you increase that color in the filtration. Because the filters work subtractively, adding yellow to the filtration, for example, reduces the yellow in the print. To remove a primary colored cast – red, green or blue – you add its two complementaries to the filtration. A test filtration strip is a useful aid to assessing your print, especially if you make one yourself on your own enlarger using a fairly standard negative.

Every filtration should be of no more than two of the filter colors. A third color cancels out some of the other two by creating neutral

density, and results in longer exposure times. It can be eliminated in every case by simply subtracting the lowest filter value from the total filtration. For example, a filtration of 55Y + 50M + 10C uses all three filter colors, creating neutral density. Subtracting the lowest filter value – 10 – throughout gives a filtration of 45Y + 40M that will give the same color in the print but with a shorter exposure time.

One simple way of beginning to assess the color in your prints is by viewing your results through colored filters. When the midtones and whites look correct, remove filters of the same color from your filtration.

Each time you alter your filtration you have to recalculate your exposure to compensate for the changed density of the filtration. To

This table shows filter factors from which you can calculate your new exposure to allow for filter changes – divide your original time by the factor(s) for the

Filter	Factor	Filter	Factor	Filter	Factor
05Y	1.1	05M	1.2	05C	1.1
10Y	1.1	10M	1.3	10C	1.2
20Y	1.1	20M	1.5	20C	1.3
30Y	1.1	30M	1.7	30C	1.4
40Y	1.1	40M	1.9	40C	1.5
50Y	1.1	50M	2.1	50C	1.6

Making a filtration test

Use the exposure test as a basis for estimating the likely filtration. Accurate estimation at this stage comes with experience, but at the start you may find it easier to try a few different filtrations (right). Do not make the changes too great , and remember to compensate in exposure for filtration changes. Make three or four separate exposures with different likely filter combinations.

Red bias

Green bias

Correctly balanced

Assessing the filtration test

After processing and drying, judge the prints (far left) in good light, preferably natural. The first two of these prints show definite bias towards a primary color (red and green) but the third print, with a filtration of 61Y 31M, appears correctly balanced. A final perfect print (left) can now be made with this filter combination. Remember that with color negatives, a color bias in the print is corrected by increasing the filter strength of that color. In other words, if a test print appears too yellow, you must add yellow (or subtract blue) from the filter combination (see table above).

Filter variations

These strips of different color filtrations (right) shows the effect of using varying strengths of the primary filters – blue, green and red (top row) – and the complementary filters – yellow, magenta and cyan (bottom row). In each case, the departure point is the correctly filtered normal print. At the beginning, you may find it helpful to prepare a similar strip from a standard negative; by referring to it when making new prints, assessing filtration can be made easier.

filter(s) you have removed. Then multiply the result by the factor(s) for each filter you have added and round off your result to the nearest second.

Filter	Factor	Filter	Factor	Filter	Factor
05R	1.2	05G	1.1	05B	1.1
10R	1.3	10G	1.2	10B	1.3
20R	1.5	20G	1.3	20B	1.6
30R	1.7	30G	1.4	30B	2.0
40R	1.9	40G	1.5	40B	2.4
50R	2.2	50G	1.7	50B	2.9

recalculate your exposure, use the filter factor table shown here.

Exposure time must also be altered if you raise or lower the enlarger head (since the same amount of light is being spread over a different area, you must increase the time, and vice versa). The effect can be calculated using the following formula:

$$\text{New time (secs)} = \text{Old time (secs)} \times \frac{(\text{New enlarger height})^2}{(\text{Old enlarger height})^2}$$

When making adjustments in exposure time, avoid very long exposures by adjusting your aperture setting, because they can create some color distortion with reciprocity failure in the paper.

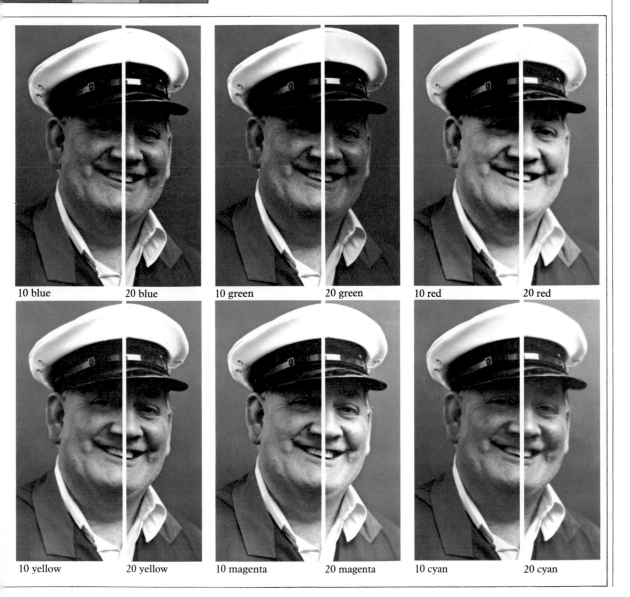

10 blue 20 blue 10 green 20 green 10 red 20 red

10 yellow 20 yellow 10 magenta 20 magenta 10 cyan 20 cyan

Print processing

Color prints are best processed in a light-tight developing tank which takes one print at a time. The best tanks to use are those with their own bath that also takes the processing chemicals.

Before starting, mix up sufficient quantities of the chemicals, following manufacturer's recommended dilutions. Then place the solutions in the hot water bath in clearly marked containers, perhaps ordering them in sequence of use. The recommended temperature for all solutions is usually 91°F (32.8°C) with a latitude of only ½°F (0.3°C), so accurate temperature control is critical, particularly of the first developer. Bring the solutions up to this temperature and then maintain the temperature of the bath at 92°F (33.5°C) – one degree higher than required to allow for the loss of heat through the plastic of the containers.

As in film processing, leave about the last fifteen seconds of each stage for draining the tank. None of the chemicals can be re-used.

All color papers must be air-dried; to speed up the process, you can use a hair dryer but take care not to get the print too hot.

Printing color negatives in black-and-white

You can enlarge color negatives on to normal bromide black-and-white printing paper. Some distortion occurs in the conversion of the colors into tones of gray. Because regular bromide paper is blue sensitive, blue areas are lost or much lighter than they would be normally, and red areas are darkened. Partly because of the orange mask on a color negative, you will need about three times the normal exposure for a black-and-white negative.

Panchromatic bromide paper will give tones closer to "normal": blues, for example, are not lost and appear close in tone to the way they would record on black-and-white film. This paper should be handled in total darkness or with a very dark green safelight.

Making prints directly from transparencies

Reversal printing is making prints directly from transparencies by using special dye-destruct or "reversal" papers. The main difference between this and normal color printing is that the principles of exposure and filtration work in reverse (as you are working with a positive original). For example, more exposure lightens, not darkens, the print, and to reduce a color cast you remove, not add, a filter of that color. The table on the right summarizes the differences.

In every other respect you follow the same procedures, taking the same care as in normal color printing. Tests for exposure and filtration are still required, but because transparencies are frequently high in contrast reversal materials have low contrast to compensate. As a result you may have to make larger filtration and exposure changes to get the similar changes to normal papers. On average, you will have to make around 0.20 density change for a slight color adjustment. Some subtleties of tone and color will be lost in the print; the best transparencies to choose are those which are not too contrasty.

Reversal materials are usually supplied in packs or kits that include recommended filter and exposure settings for different brands of film. As in normal color printing, you must compensate in exposure for

Developing the print – procedure

1. In total darkness, insert the exposed print into the developing drum, emulsion side inwards. Replace the drum lid and turn on normal lighting.

When printing in black-and-white from a color negative, use panchromatic paper for a better distribution of tones, otherwise reds will reproduce too dark, and blues too light.

2. Wearing rubber gloves, pour out all the solutions into the dispensers. Place these, with the drum, in a water bath and add hot or cold water to the bath until the solutions are within the recommended temperature range.

3. Check the temperature of the developer, and when it is correct, pour it into the drum. Start the timer and agitate the solution by revolving the drum. About 15 seconds before the end of each stage begin to drain the drum. Return the drum to the bath and repeat the same routine with the next solution.

4. Remove the print from the drum (having taken off the gloves), and wash it thoroughly for the recommended time. Finally add the stabilizer. Air-dry the print, as for black-and-white resin-coated paper, preferably on an air-drying rack.

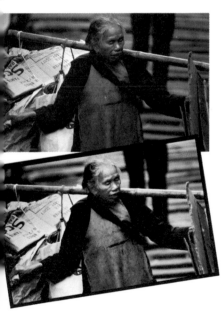

Transparency to print in one step. From an original Ektachrome transparency (top) a Cibachrome print (above) was made directly. With a reputation for strong, rich colors, Cibachrome can give faithful, if slightly contrasty, results.

adjustments in filtration, or for altering the enlarger head height, and you should avoid the neutral density caused by using filters of all these colors together (see pages 114 and 115).

There are two types of materials for making positive prints from transparencies: dye-destruct, such as Cibachrome; and a reversal paper, such as Kodak Ektachrome paper.

Follow the same processing routine as has just been described for normal paper – the principles remain the same although solutions, times and temperatures may vary. Cibachrome processing is a short process, using only three chemicals, and the colors produced are claimed to be better-saturated and more resistant to fading than normal papers. Ektachrome paper has many more processing stages, but takes about the same amount of time in total. The processing chemicals for both materials, in particular the acidic Cibachrome bleach which must be neutralized before it is poured away, are very powerful and rubber gloves should be worn at all times.

Differences between reversal and negative/positive color printing		
	Reversal	Neg/Positive
More exposure	final print lighter	final print darker
Less exposure	final print darker	final print lighter
Printing-in	area is made lighter	area is made darker
Shading or dodging	area is made darker	area is made lighter
Covered edges	gives black borders	gives white borders
Correcting color casts		
	Reversal	Neg/Positive
Print too yellow	reduce yellow filters	add yellow filters
Print too magenta	reduce magenta filters	add magenta filters
Print too cyan	reduce cyan filters	add cyan filters
Print too blue	reduce magenta and cyan	reduce yellow filters
Print too green	reduce yellow and cyan	reduce magenta filters
Print too red	reduce yellow and magenta	reduce cyan filters

2: Applications

ALTHOUGH MASTERY OF photographic techniques is, of course, crucial groundwork, there are definite limitations to photography that leans completely on technology and method. The next step is to *apply* the techniques described in the first section of the book, and it is here where standards of good photography are set. It is true that good individual pictures can result from pure technique; the deep space photographs from the unmanned Voyager spacecraft are outstanding examples of this – dramatic shots produced by remote control through what is essentially an 'idiot savant'. Nevertheless, technique alone cannot produce a good photographer.

Technique is relatively easy to teach, maybe because it can be categorized and is naturally suited to step-by-step methods. The *application* of this technique, on the other hand, does not lend itself to such a didactic approach. In the area of creativity, too rigid a system can stifle imagination. What this section sets out to do is to present the actual practice of photography in a logical, sequential fashion, divided into its major fields. The more abstract areas of study, such as composition, color and harmony, are treated in a strictly practical manner, where they occur.

Take composition as an example. Isolating it as an independent factor, and treating it on its own tends to divorce it from the practical, and is an essentially academic, classroom exercise. Instead, in this section, compositional techniques are treated in the places where they are appropriate. For instance, the way in which spatial relationships are altered by the placement of the horizon line is discussed principally under landscape photography, where it is particularly important.

Having mastered photographic technology, what is really needed is not more theory, but encouragement to practise. Textbooks that take a broad treatment of photography seem to fail at this point. In this book, each field of photography is treated in such a way that, even if it does not sound familiar, you can ease your way into it as simply as possible. As an example, I know from my own experience how discouraging first efforts at wildlife photography can be if one unwittingly starts with an

elusive subject. Wildlife photography, by its nature, is rather unpredictable, and although an experienced professional can learn to shrug off the disappointment of a fruitless day in a hide, a beginner takes it more to heart. In this case, it is far better to select situations and subjects which are more or less guaranteed to produce some results, if only to build confidence. This means, for example, choosing a well organized National Park known for its accessible wildlife and choosing the time of year when the animals are most approachable.

The structure of this section of the book, from reportage to the imaginative freedom offered by dye transfer re-touching, is deliberate. The sequence followed is that of increasing control by the photographer over the results. It begins with real-life subjects over which the photographer normally has no control, and moves towards images that owe more and more to the photographer's own ideas. There are two large jumps in this sequence; the first is the point at which photography enters the studio, and the second takes place in the darkroom. The studio is where controlled photography really begins – shots planned in advance and assembled from the raw ingredients of props, background and lighting. In the darkroom this control can be extended to the point where it becomes manipulation and the line between photography and illustration is progressively erased.

This is not to say that subjects over which the photographer has greater control are any easier to handle. Each field of photography has its own particular problems and opportunities; between, say, candid photography of people and the studio still-life, ease of control is traded for sound creative decision and sometimes elaborate preparation. In order to exercise control you need experience of the way subjects, settings and lighting behave in real life. Eventually, each photographer builds up a mental library of visual effects, from the mannerisms and gestures of people in the street to the way in which a particular quality of sunlight falls on an object. In this way the unpredictable photography of the real world feeds the images produced in the studio and darkroom.

Reportage

THE RICH AND DIVERSE field of reportage photography as it exists today owes more to the development of the 35mm camera than to any other single factor. Being essentially concerned with transient human events, it demanded the development of an unobtrusive, fast-operating camera that could react almost as quickly as a journalist's eye, in order to become the major field of photography that it is today. When the inventor of the Leica, Oskar Barnack, realized the potential of a camera that could utilize sprocketed 35mm motion picture film, he revolutionized hand-held photography. Photo-journalism has not looked back since then.

While few photographers are in any doubt about the broad scope of reportage photography – or photo-journalism as it is also known – it does not lend itself as readily to precise definition as do such self-explanatory fields as fashion, still-life or landscape. Perhaps the most important link between the different kinds of reportage picture is the underlying theme of journalism, an inquisitive and often inter-pretative interest in people's actions and activities, individually and in social groups.

This journalistic undercurrent need not necessarily be news jour-nalism, reporting current events at great speed. In fact, the logistical problems of meeting urgent deadlines and using wire services often preclude in-depth picture coverage. Some of the strongest single photographs have been hard news pictures, but one of the most highly-developed photographic forms – the picture story – is princi-pally a product of the less urgent format of feature journalism.

At the heart of reportage photography lies an interest in people; this in itself broadens the scope of the subject considerably. Individuals may be subjects because of some uncommon interest – they may be famous or unusual personalities – or for precisely the opposite reason because they may be typical of a quality that the photographer wants to convey. The range of actions and activities in which people become involved is so great that there is always opportunity for fresh pictures.

One important alternative to the portrait of the individual is the interaction between people and their society, their environment and other individuals. The involvement of one person with another is one of the most fascinating areas of interest for practically everyone, and in the frozen instant of a still photograph, the shifting currents of these relationships are ideally captured. By means of composition and juxtaposition, the camera is also perfectly suited to showing the relationship between man and his environment, the extent to which he controls it as well as the way he is influenced by it. The image of, say, an individual dwarfed by a giant construction project, can show at the same time both man's ability to shape his environment at will, and the amount by which it can come to dominate his life.

Composition and interpretation
The degree of interpretation and comment can vary widely from subject to subject. The photographer is not necessarily committed to making a social statement in every picture, although some of the best reportage pictures usually succeed in making the viewer aware of something more than the simplest visual components of the scene. Because photography has the potential to be a strongly graphic

Red Karen woman. In a hill tribe village in northern Thailand, my guide and I were introduced to this frail, old woman who had never left the village in her whole life. She told us that she was either 104 or 106 years old – the passage of time had blurred the individual years. I wondered if she might be exaggerating a little, so I asked her about her children. She waved a thin, brittle arm in the direction of the other huts and said, "They are all my descendants". Later she showed me her great-great-grandchild, born the previous year. As we talked she smoked her first pipe of the day and then, with the sunrise, she prayed for us before we left.
Nikon, 20mm, Ektachrome , 1/60 sec, f4.

medium, the pictorial qualities alone may be sufficient reason for using the camera.

Photography does more than simply convert a journalist's interest into a picture; it is never merely the visual equivalent of the text. The camera's inherent qualities determine the treatment – one of the key elements in photo-journalism is a sense of moment, the aptly phrased 'decisive moment'. The still photograph inevitably freezes action, and the captured momentary image can either sum up the complete flow of events, or show an unusual instant that the eye might easily disregard.

This decisive moment is often the central feature of a single picture; indeed, individual images were the chief concern of the earliest photo-journalists. However, the desire to treat a story in depth, of which *Life* magazine was such an outstanding pioneer, led to the development of the idea of a *series* of photographs presented together. The picture story, as it became known, was in every way a product of reportage photography and, although other photographic fields now use it, it is still most closely associated with journalism.

Art directors soon learnt that, with a picture story, the layout can be just as important as the photographs themselves. The way in which a number of pictures are arranged on a spread can determine the way in which they are seen. A skilful layout can even lead the reader's eye around the page. Even more important is the relationship between pictures. By juxtaposing photographs, their meaning can be reinforced or even substantially altered. Comparisons and contrasts can be drawn between a pair of pictures that go beyond the contents of two photographs viewed individually.

The power of juxtaposition is no less for being unintentional; Ed Thompson, for many years managing editor of *Life*, tells the story of how he lost the advertising account of a large national canned soup manufacturer in just this way. A regular editorial feature, which customarily ran opposite the soup manufacturer's advertisement, was a full-page single photograph of unusual interest. In one issue, the picture in question was of a pair of Siamese twin babies being breast-fed together, one from a woman's left breast, the other from her right breast. Unhappily, the canned soup advertisement that happened to be running opposite in that issue showed a child rushing into the house, with the headline, "Hi, Mom! I'm home and hungry!" The advertiser was less than amused.

Events

In reportage photography, one of the hardest things for most photographers to overcome is shyness. It is quite understandable and entirely normal to feel embarrassment at intruding on other people's lives. With time, of course, one inevitably becomes inured to it, at least to some extent. This is not necessarily a good thing; a completely thick skin breeds an insensitivity that is at odds with good reportage photography.

Nevertheless, some situations are more approachable than others, and an easy entry into reportage photography is to cover an event. This catch-all term includes all those situations where people get together to take part in ceremonies, celebrations and parades, whether it be St Patrick's Day in New York, the Bun Festival in Hong

The Lord Mayor's show, London.
Flanked by pikemen, the new Lord Mayor of London (above) waves to the crowd during his inaugural parade through the City's streets. Only on this one day of the year does the coach make an appearance, and a picture like this is clearly a key photograph in covering the event. For this close view, I walked alongside the parade, using a wide-angle lens. Even without a press card or authorization, it is usually possible to get close to the action on relaxed occasions like this. Just behave as a press photographer would.
Nikon, 20mm, Ektachrome, $^1/_{125}sec$, *f5.6*.
Right: Knowing the route in advance, I chose a footbridge for this nearly-vertical shot of the coachman, using a medium telephoto lens for very tight framing.
Nikon 180mm, Kodachrome, $^1/_{125}sec$, *f2.8*.

Kong, or the Lord Mayor's Show in London. On occasions like these, people are actually putting themselves on display, and the photographer has an open hand. They may not be typical of everyday life, but they nearly always provide good visual material and they are invaluable for building confidence.

By definition, events are not hard to find, usually being well-publicized. Planning ahead, however, is the key to success. There are two main preparations to make in advance – find out exactly what is going to happen and at what time, and find the best locations to be in. Events have organizers, who are normally only too willing to answer these kinds of questions. If you are able, an early visit to the site will give you an idea of what to expect. A view from a height – a balcony along the route of a procession, for instance – will give an overall shot, but is little use for interesting details and close-ups, and can limit the variety of pictures you are able to take. In front of the crowds, where press photographers are usually found, is often an ideal location and may not be too difficult to reach, with perseverance. Permission to be on the official side of barriers is more readily given than you might

imagine, particularly if you ask a few days in advance. But, although it may be tempting to follow the local press photographers in order to find the best site, their aims may not coincide with yours – they are usually after little more than a superior spectator's eye view of the climax of the event.

Some of the most rewarding picture possibilities are the ones that many photographers tend to ignore – behind-the-scenes preparations and the unselfconscious expressions of spectators. Off-duty participants can be a rich source of interest, whether you manage to take a candid shot or persuade them to pose for you. When the event is under way, you can take pictures of the spectators very easily and obtain a variety of unposed natural expressions – rapt, bored or excited. The pictures on this page were taken at the Lord Mayor's Show in the City of London which takes place on one day each year, at the beginning of winter. Although the weather is unreliable, the parade is concentrated and colorful, lasting half a day, and is full of the regalia and pomp of the City's long traditions. A normally rather secretive and restrained financial community, the City of London lets its hair down at this annual event.

The plans and route are well-publicized – the Show is organized around a winding procession through the city streets, with the new Lord Mayor in his ornate gilded coach as the focal point. The only

Off-stage, there are unguarded moments and small details that can make even more interesting pictures than the main show. An alderman's hurried cigarette (top left), or a stick of chewing gum for a Doggett's Cap and Badge oarsman (top right) make interesting anachronisms. The proprietorial air of a member of the Honourable Artillery Company (above) as he surveys the beginnings of the parade perhaps reflects the fact that, beneath all the pomp and circumstance, the participants *do* collectively control a huge financial club.

A miniature Tower of London and a finely-worked royal insignia on a bugler's coat (above left) are two details that could easily be missed during the actual parade. *All Nikon, 180mm, Kodachrome.*

Right: In the cobbled yard of a City brewery, the gilded coach is made ready. Pulled by six white dray horses, the coach is heavier and more elaborate than even the Royal Coronation Coach. Access to preparation scenes like this can be gained by contacting the event's organizers. *Nikon, 20mm, Kodachrome , 1/125sec, f3.5.*

permission I needed was to be present when the coach was made ready in the early morning, and this was readily given.

I then made a mental list of the key shots that I wanted: the coach being hitched to its team of horses in the old brewery yard where it is kept; the participants in the parade at the assembly point, just before the start; the scene at the parade's first halt, the Guildhall, where the Lord Mayor and other dignitaries enter their coaches; the parade itself; a close, wide-angle shot of the Lord Mayor in his coach waving to the crowds; various ceremonial details. From this, I could work out my own route, which would involve some running, the minimum equipment I would need, and the type and quantity of film.

People

In terms of the quantity of pictures taken, portraits of people – formal and informal, individuals and groups – have been photography's major pre-occupation since its beginnings. Daguerre's invention in 1839 achieved success through the insatiable demand of the public to perpetuate their images. The cheaper and more ubiquitous tintype introduced in the 1850s kept up the momentum while the Kodak box camera, launched in 1888, which enabled people to take photographs of themselves, resulted in an explosion of amateur photography that, far from diminishing, is increasing year by year. The photo-journalist, when photographing people with their knowledge and cooperation (the alternative is candid photography, discussed on p 131) is heir to this tradition.

In some walks of life – politics, for instance – posed photography is an accepted and expected routine, but generally people are more likely to be intrigued or puzzled by a request to photograph them. Clearly, the relationship between the subject and photographer is most important in this kind of reportage. This can only be worked out in the particular situation, depending on your own feelings and on the appearance and behavior of the person in front of the camera. You may decide to treat your subject very formally; alternatively you may

Sasha Kagan. For this working portrait of a craftswoman (left) who produces very distinctive knitted designs, I used the mirror propped on a corner of her worktop for a very practical reason – she characteristically uses found objects as a basis for the small details, in this case shells, and I wanted this feature to dominate the picture. The mirror effectively reduced her size in the photograph, without separating her pictorially from her work. The only adjustment I made was to re-arrange the knitted specimen. Natural lighting from the window was the only source of illumination.
Nikon, 20mm, Kodachrome , ¹/₈sec, f6.3.

Karen girl, northern Thailand. This young girl (far left) was standing inside the doorway of her family's hut. Rather than give a full exposure that would have recorded her outline and some of the background, I deliberately reduced the exposure to emphasize just a part of the girl's face and her large eyes. This is one example of a lighting situation where there is not one correct value but a range of different images.
Nikon, 180mm, Kodachrome , ¹/₁₂₅sec, f4.

Old woman, Athens. I went into this old woman's house (below) looking for a good location for a portrait. She began joking with my interpreter on the doorstep. The contrast between the interior and the sun-lit exterior was extremely high; with the exposure set for the outside, the shadows formed strong graphic shapes. The sunlight striking just a part of her face was enough to convey her whole attitude.
Nikon, 20mm, Kodachrome , ¹/₂₅₀sec, f8.

try a more unobtrusive, naturalistic approach, showing the normal, everyday behavior and environment of your subject.

What is important, as with studio portraiture, is to present something more than a simple outward, physical likeness. This is not to say that every photograph you take of a person should have deep psychological insight. Nevertheless, even after a short while, you must have formed some feelings about their character and personality. The lack of a studio reduces your control over the final image, but in its place you have the infinite possibilities of a natural setting. Photographing people where they live and work, in familiar surroundings, not only tends to put them more at ease, but it can also provide insight into

Woman and her son, Athens. On a hillside below the Acropolis, this woman's house (above) could have been on a remote Cycladean island instead of in a large city. As I was taking pictures, she began to talk about her son who, like thousands of Athenians, died of starvation during the Nazi occupation of the city. Realizing that the portrait on the wall was of the son, I changed the camera viewpoint to include it in the picture with the woman.
Nikon, 20mm, Ektachrome, ¹/₃₀sec, f4.

their life, feelings and attitudes. Making your subject feel relaxed and natural may, at first glance, seem to be the ideal approach (it certainly is the most common), but the relationship between a subject and the camera is more complex than that. Even in the less predictable area of reportage, for example, it may be more revealing deliberately to isolate the subject either through techniques, such as flash, or through an unfamiliar location. The formality of this kind of approach, where no props are available to diffuse the person's character can, at its best, produce remarkably open, and occasionally disturbing portraits, such as those by Diane Arbus.

Quite apart from the different degrees of involvement of subject and camera, you can consider whether to photograph the person's private or public moments. The exuberance of the City of London's Lord Mayor on p 123 shows this man at his most outgoing; he is probably as delighted and gregarious at this moment as he has ever been. How different is the kind of photograph that shows someone involved in their private thoughts and personal rituals. Neither moment is necessarily more revealing than the other – they are simply different sides of one character.

Group portraits

Group shots need a special approach: one composed principally of good organization and stage direction. It is important to give your group some visual rationale or identity – people form groups for a specific purpose, whether they live or work in the same building, perform the same job or share the same interest, and you should usually try to include a visual reference to the thing or things that

Family in Cartagena. This impromptu group (right) arranged themselves in the small main room of their house in one of the poorer districts of Cartagena, a South American port. Although re-grouping and extra lighting would have shown the children's faces more clearly, I preferred to keep the feeling of spontaneity. The elder sister's slight reserve and distance was an extra bonus, giving a counterpoint to the children's ingenuous love of simply having their picture taken.
Nikon, 24mm, Tri-X, 1/30sec, f5.6.

Old man in café, Colombia. For this picture of an elderly workman in a South American café (below), I used one of the techniques described on this page. He was standing at the counter close to my table and had already seen me. It would therefore have been impossible for me to take a natural-looking shot in the normal way. Instead, having taken a reading with a handheld meter, I set the camera on the table, removed the prism head, and made a show of cleaning it. In this way, I was able to take several shots without him being aware of it, by using the ground glass screen.
Nikon, 180mm, Kodachrome, 1/60sec, f3.5.

Evzone's dress inspection, Athens. I had already obtained permission, with some difficulty, to photograph inside the barracks of the Greek palace guard, so in a way the situation was partly controlled. While I was recording the involved process of donning the ceremonial uniform, I spotted this moment of unconscious humor (right). The cropping is the key to this shot, and fortunately the lens I was using at the time, a 180mm, was just right. A zoom lens is even better in this kind of situation, as it gives extremely fine control over the framing of the image.
Nikon, 180mm, Kodachrome, 1/125sec, f2.8.

bring them together. Seeing every face is the principal mechanical problem; if you arrange the people into a tight group, you will either have to shoot from a high viewpoint in order to record, or have some kneeling, sitting or standing. After arranging the group, take several frames – on many of them you will find at least one face turned away, blinking, yawning or scowling.

Candid

You may not always want to become involved with the people you photograph, and some involvement is necessary for any portrait. Although a posed shot may create strong eye-to-eye contact, it lacks the spontaneity and interest of a secretly observed action. In a way, candid photography is similar to wildlife photography – the photographer tries to capture the natural behavior and expressions of his subjects as unobtrusively as possible.

At times there is a certain element of risk, as people vary in their reactions to discovering that they are being photographed. In some Middle Eastern cities the photographer is likely to have things thrown at him, whereas in parts of India the only risk attached to being discovered with a camera is to be surrounded by an instant crowd, each member of which wants to be in the picture. And of course in countries where political tensions run high, candid street photography can be very dangerous. To start practising candid photography, you might choose, for instance, a museum or market where people's attentions are occupied with other things.

If you are noticeable, because you are carrying a large gleaming metal camera case or because you are dressed outlandishly, you will disrupt all the natural activity that you set out to photograph. Keep your camera out of sight – an old carry-all, or even a shopping bag, will be better than a customized camera case.

Avoid pointing the camera in anticipation – sooner or later your subject will see you. Instead, wait for the moment that you think is right and then raise the camera.

Your choice of equipment can help you stay out of sight. Henri Cartier-Bresson, for instance, was so adept at being unobtrusive that he had no trouble taking close shots with a normal lens, but most reportage photographers find that a medium telephoto lens can put a useful distance between them and their subject. For even more free-

Street directions, London. A very long-focus lens makes street photography possible without anyone being aware of it. The level of activity in the center of a city also provides an effective mask for the camera. This woman's uncertain acceptance of a police motorcyclist's directions (left) was shot across a main road in London. The horizontal streaks of passing traffic add to the feeling of confused city life. The small maximum apertures of long-focus lenses normally require slow shutter speeds; waiting for pauses in people's actions prevents blurring.
Nikon, 400mm, Kodachrome, $^1/_{100}$sec, f5.6.

dom in choosing your shots, practise hand-holding a long telephoto lens, such as a 400mm, at speeds down to 1/125 sec.

One useful trick for taking pictures at close range is to remove the prism head, if possible, and then shoot by focusing directly on the ground glass screen. By not holding the camera to your eye, you do not have to look at the person you are photographing.

Pre-set as much of your equipment as possible. Take a series of exposure readings for the locality you are in – the sunlit and shaded areas, interiors of doorways, etc – and keep the lens set at the reading you think you will be most likely to use. If an unexpected picture presents itself, take one shot immediately and then follow up rapidly with bracketed exposures. I nearly always use a motor drive for this reason. If you have a little time, take a reading off another similarly lit area before pointing the camera at your subject.

The human environment

The scope of reportage photography goes beyond portraits of people and their activities. It includes the relationship between man and his environment; the way he uses it, assimilates himself into it or ignores it. At one end is the relationship between man and the natural landscape; at the other end the special environments that man creates for himself. These special environments – villages, towns, cities – reflect the way in which different human societies function. The modern urban industrial landscape is the most intensely developed form of the human environment. Here, man has completely shaped his surroundings to his needs. Sometimes this landscape is deliberately planned, a purpose-built environment to suit a particular human activity or style of life; more often than not, however, it has simply evolved. In one sense, city-scapes and town-scapes can be treated photographically in the same way as natural landscapes (see p151), but they have one special additional quality – they reflect human life. In an urban landscape, the graphic possibilities are normally abundant; you can

A wide-reaching field that covers many different kinds of image, photography of the human environment usually sets out to convey aspects of life by concentrating on the location rather than on its inhabitants. The marks left by people on the places where they live can be as revealing as human behavior.
Rolls-Royce, City of London. Parked in the heart of London's financial center, beside the Mansion House and in front of the Bank of England, this Rolls-Royce (right) is in the ideal location. This is a place where money is made and this car is one of the fruits of money-making – a world-renowned symbol of wealth. By using a wide-angle lens from close-up, the car is made to dominate the view. Even without people in the picture it is possible to convey a sense of human activity.
Nikon, 20mm, Kodachrome , 2 secs, f4.

Navajo Reservation, Arizona. From the ground, this single Navajo dwelling (below) would seem like just another lonely spot along the highway. From the air, however, it looks totally isolated and vulnerable. Here is one place where the environment rules.
Nikon, 180mm, Kodachrome , $^1/_{500}$sec, f2.8, plus Polarizing filter.

also use its elements to describe or comment on the way people live. An industrial town might seem ugly and depressing, dwarfing the people who live in it, but alternatively you might focus on its productivity – a place where things are being created.

Urban environments are always a rich source of detail. Stay alert to the possibilities in close-up shots, such as signs and graffiti. They can be representative or idiosyncratic, but if carefully chosen can be revealing. There is a fascination in being able to make an oblique comment on the way people live by focusing on one small detail.

Liverpool Street Station, London. The muted colors caused by polluted haze and the compressed perspective of a long-focus lens both help to convert this image (below) into a flattened pattern of girders and brickwork – archetypal industrial scenery. The equally drab figures of the people passing by blend in with joyless architecture to complete the overall depressing atmosphere of the scene. *Nikon, 400mm, Kodachrome, 1/125sec, f9.*

Street details. Although the locations may not be immediately obvious, each of these closely-observed details of city life (right) from different parts of the world is entirely typical. The window display of Greek Orthodox plaques (1) is common to many religious shops in Athens. The polished brass doorbell of a long-established London bank (2) recalls an era when transactions between financial institutions were carried by hand. A quite different design with the same function is the Greek door knocker in the shape of a hand (3). A Calcutta blood bank uses the swastika to advertise its presence (4); for Hindus the sign means 'good luck' but appears disquieting to most Westerners who remember its Nazi associations. The discreet formality of a well-known merchant bank in the City of London is displayed in its brass plate facing the street (5); a passing double-decker London bus adds a flash of color. A skewed nightclub sign fastened to a wrought-iron balcony (6) is typical of the French Quarter of New Orleans. The center of the city's nightlife, this area has seen better days, and a tawdry atmosphere overlays the French colonial architecture. Rows of customers' portraits displayed in the window of a photographic studio in a South American city (7) make up an instant catalogue of the people who live there. The particularly American appeal to patriotism and family that this poster makes (8) is marred only by its torn surface, giving it a rather neglected air.

		6
1		
		7
2		
3		8
4		
5		

Suitcase vendor, Calcutta. Even the most inactive work can be pre-occupying. Sitting by his roadside stall in the evening sunlight, this salesman (below) was lost in thought. His stock of gaudy metal cases was clearly not attracting too many customers, but he seemed accustomed to the slow turnover.
Nikon, 180mm, Kodachrome, ¹/₂₅₀sec, f5.6.

Ship painter, Piraeus. Suspended from the ship's rail, a painter (right) was putting the finishing touches to this brilliantly white Greek island ferry. In the bright morning sun, the man's shadow was cast so clearly on the hull that it conveyed every important detail of what he was doing. It therefore made a more interesting and less obvious picture to concentrate on the shadow rather than on the man himself.
Nikon, 400mm, Kodachrome, ¹/₂₅₀sec, f9.
Construction worker, Calcutta. As I passed this building site in the late afternoon, I thought the strong lines of the girders might form the basis for a good composition. The workman (far right) was carrying bags of cement, and although this in itself was not particularly interesting, his appearance contrasted sharply with the new construction – for Calcutta a rare sign of industrial progress. I waited until finally he stopped to drink from his brass bowl. To compress the background I used a telephoto lens, supporting it against a fence.
Nikon F2AS, 400mm lens, Kodachrome ¹/₁₂₅sec, f5.6.

People at work

Some of the best opportunities for photographing people occur when they are thoroughly absorbed in some form of activity. At work, most people are too preoccupied with the job at hand to pose consciously for the camera or be distracted by it. They tend to be less self conscious about their working lives than they might be during more private moments, so you may find it easier to capture natural expressions and gestures then. Also, people at work often show a close relationship with their surroundings and their society. A dock-worker in a Greek port, and a Bengali construction worker in Calcutta both reflect certain aspects of the places in which they live as well as revealing something about themselves as people.

You can either use the working environment as a convenient place for taking candid shots, or you can try and show something of the work itself. Many jobs are highly specific to a place or a particular kind of society, and can be interesting because they are unusual. Most of us are fascinated by what other people do, and few activities are clearer than work and the way in which people do it. It is rarely enigmatic, but it can be revealing.

The assignment

A reportage assignment, particularly a long one, can involve you in considerations which you might not at first anticipate. To begin with, having accepted an assignment, you are under an obligation to complete it, or at least to deliver a certain amount of work to a set standard. This can put you under some pressure, to which it is easy to over-react. In view of all the things that can go wrong, many of them unconnected with the actual photography and some beyond your control, it is not uncommon to feel anxious about the success of your assignment. This can happen particularly at the beginning of the job, when you have had little chance to shoot. If you fail to get some necessary permission from an official, say, or if the weather turns bad, you may lose the story.

Good preparation and organization is the best remedy. You should understand not only the aims of the story and the art director's expectations, but also the background to the commission. If the client has not already researched the story, you will have to do it yourself.

Some assignments needing a great deal of organization seem to be exercises in logistics more than in anything else. Essentially, logistics embraces everything you need to do in order to put yourself and your cameras in front of the subject; the skill of being in the right place at the right time is the paramount quality you need. The checklists of equipment and administrative details are given on page 292.

A work plan

When you are on the assignment, you may-have to adopt a new regime, built around the activities of your subject. If, for example, you are doing a story on the night-life of a city, then you will have to start working night shifts.

Plan your workload. Assignments can be demanding in all sorts of ways, and if you have to work continuously for a number of weeks, you want your creative output to last the distance. Pace yourself, like a runner. Do not expect to be able to maintain a continuous, unflagging level of energy – you may have ups and downs of enthusiasm and ideas. Expect them, allow for them and take time off if you need it. Assignment photography is sometimes more strenuous than people expect; whilst travelling can have its exciting moments, it can be very boring. Waiting, whether for planes or people, can be frustrating and discouraging, but it is inevitable on any story.

The pictures on these pages were taken as part of an assignment to Surinam, the former colony of Dutch Guiana, sandwiched between Cayenne and Guyana on the north-east coast of South America. My subject was the Bush Negro people who live in the interior of the country along the rivers that flow down from the Guiana Highlands. At the time of the story there was nothing particularly newsworthy about the Bush Negroes, but their history was fascinating, unique and generally little known.

When the Dutch colonized the coastal swamps north of the Amazon, they planted sugar cane and, along with the other European colonists settled around the Caribbean and in the southern states of America, imported slaves from West Africa to work on them. The conditions under which the slaves lived in Dutch Guiana were par-

Bush Negroes in Surinam. The Ndjuka tribe are, in every way, a river people. The waters of the Tapanahoni are a highway, a source of food, a spiritual presence, and above all, a place to relax and enjoy life.

Left: In the late afternoon sun, a girl bathes in the shallows below the Granholo Rapids. Compressing the perspective, a 400mm lens made a simple, uncluttered composition, with the river a continuous pattern of ripples.

Below: Two children use the bathing rocks of Loabi village as a relief from the oppressive midday heat. A single strand of beads around the waist is worn by all girls still in puberty.

Far left: One of the Ndjuka's characteristic long canoes, designed to negotiate the frequent rapids, is prepared for a journey. Inveterate travellers, the Ndjuka constantly visit other settlements, renewing the family ties that make their society so closely knit. For this shot I hired a light high-winged plane, using a fast 180mm lens through an open window as the pilot banked steeply for a near-vertical view.

Left: Most household chores are done by the water, and the river bank is inevitably a meeting place for the women. The towels and plastic buckets are relatively recent signs of an encroaching way of life that may eventually overtake the Bush Negroes' self-contained society.

139

ticularly brutal, even by the general standards of slavery, and during the 17th and 18th centuries large numbers escaped the plantations on the coast and fled into the thick rainforest.

Escaped slaves were nothing new to the American plantations, but something happened in Dutch Guiana that was different. Fearing cruelty upon recapture even more than their contemporaries (Dutch punishments were horrendous), yet at the same time concealed by the impenetrable forest and swamp, many of the slaves were able to stay free. Retreating further and further into the interior, they made an unusual cultural attempt to re-create, as far as possible, their original West African tribal societies. The difficulties were enormous, not least because the groups of escapees often did not even share a common language, but they nevertheless succeeded. In fact, they were so successful that, even today, they remain isolated and independent in the South American rainforest, protected by inhospitable country and unnavigable rivers from any cultural contact.

My first job was to research the background, so that I would have a good idea of what to cover. Fortunately, the author had already been to the interior and I was able to rely very heavily on him for information. Two things in particular emerged. One was that the Bush Negroes' way of life was completely dominated by their Amazonian forest environment; the tribe I was going to visit lived on small scattered islands in the fast-flowing Tapanahoni River, on which both their economy and society depended. The second thing was a recent

Fish are a natural part of the Bush Negroes' staple diet in Surinam. Sprawled over the tribal chief's outboard motor, a woman waits casually for a bite (above). Another cleans and prepares the freshly caught fish (right). The boy (above right) is working on Paramaribo's waterfront. He lives in the city for most of the year to earn money which he sends back to his village.
Far right: On my first journey up river, as we started to shoot a new set of rapids, I saw this girl fishing from a canoe moored at the river's edge. It was dusk and the very last of the evening sun caught the edge of her fishing line. I didn't really expect to be able to take a sharp unshaken picture from the rocking canoe, but I thought it was worth a try. I squeezed off two frames with a long-focus lens at $^1/_{125}$ second, and luckily the shot worked.

140

Traditional crafts, such as basket weaving
(below left) are still practised by the older
members of the Ndjuka tribe. A boy gives
his model plane its first flight through the
village (below). Some Ndjuka, such as
this barrow-boy in Paramaribo's market
(bottom), have abandoned river-life for
the financial rewards of work in the city.

and not particularly happy development; the Bush Negroes were
starting to become involved in Surinam's money economy, but, as
there were no opportunities for employment in the interior, many of
the young men were beginning to spend most of the year in Para-
maribo, the capital. There they could find only the most menial work,
whilst the villages became half-empty. Apart from covering this, I
needed a number of portraits – by continuing to marry only within the
tribe, the Bush Negroes retain a strong sense of lineage and are
physically quite distinctive in appearance – and I wanted to show not
only the day-to-day life but also some aspects of the ceremonial ritual.

Logistically, I needed permission to visit the villages, local contacts
and a guide and interpreter. I also had to make the somewhat compli-
cated travel arrangements. Again, the author had already made help-
ful contacts; both the tribal chief and the "Boslanddienst" of the
Surinam government were expecting me. My guide and interpreter,
arranged through these people, was a young man who lived on the
Tapanahoni River but worked part of the year in Paramaribo.
Through him, I was able to stay in the village and take virtually
whatever pictures I wanted. Alone, or with a guide who was a stranger

In their ceremonial life, the Ndjuka celebrate their animist beliefs and a near-obsession with the dead. Exactly a year after the death of one man, the villages of Loabi and Sanbendoemie hold a *brokodé* (literally meaning 'break-of-day'). Cayenne rum and the monotonous drum-beat help induce a near trance as they dance through the night until dawn (left). Above: Two women make final adjustments to their exotic hair arrangements before the *brokodé*. They incorporate more up-to-date items such as bras and towels into their ceremonial dress.
Below: Loabi and Sanbendoemie occupy a typical and highly ordered site on a small island in mid-river.

Left: Location map
1. Paramaribo.
2. Albina.
3. Stoelmanseiland.
4. Blommesteinmeer.
5. Marowijne River.
6. Tapanahoni River.
7. Sanbendoemie and Loabi.

Right: The villages of Sanbendoemie and Loabi.
Sanbendoemie Village
1. Chief's house.
2. Landing place.
3. Village shrine.
4. Bathing and washing rocks.
5. Sugar cane press.
6. Funeral hut.

Loabi Village
1. Chief's house.
2. Bathing rocks.
3. Washing rocks.
4. Funeral hut.
5. Village shrine.
6. Chief's shrine.

Tapanahoni River

Sanbendoemie Village

Loabi Village

N 0 100 mts

himself, photography would not have been possible in the short time I had for the assignment.

The travel was something of a headache, as not only is Surinam rather remote, but the Bush Negro villages are deliberately difficult to reach. From Paramaribo, I had to hire a small plane to fly to the nearest landing strip, nearly 200 kilometers (124 miles) upriver from the old French penal settlement at St Laurent. From there, the only method of transportation for the final 50 kilometers (31 miles) up the rapids of the Tapanahoni was by canoe.

The equipment needed careful packing; the cameras were in water-tight, gasket-sealed cases, and everything else was wrapped in water-proof plastic bags. The combination of heat and high humidity is the worst possible for film, and, as there was no Kodachrome processing facility within 3000 kilometers (1860 miles), and no mail, I had to keep the exposed film with me. I sealed the rolls in airtight plastic bags together with packets of silica gel desiccant.

The white doll (left) had no special significance but as a white man I remained very conscious of my colour, particularly as slavery was directly responsible for the Bush Negro way of life. The smaller children called me 'bakka', and, afraid that in the Bush Negroes' old-fashioned pidgin dialect this might have an embarrassing origin, I only asked its meaning on the last day. "Simple," my guide said, "It means 'baker', just as it sounds." I was still puzzled. He explained, "Bakers are covered in flour, so they're white." With such black skin, the portraits (above) had an unexpected problem – exposure. A through-the-lens reading would have resulted in over-exposure; it was better to use an incident hand-held meter.

Bangladesh 1970. Lying on a bed in a
makeshift hospital, a young girl recovers
from cholera (right).
Below: An Indian woman pours water
over her child. Unbeknown to her, the
child has cholera.
East Beirut 1976. An old Palestinian lady
and her husband surrendering to
Christian Falangist gunmen (far right).
Photos: Don McCullin.

Violence and suffering

One very special kind of reportage photography is concerned with the limits of human experience; in particular, the violent and the extraordinary. War, famine, crime are all things which clearly fall outside the normal run of photography, and as a result, pose several problems of motivation and intent. Images from extreme conditions such as these can be extremely powerful in their emotional content, and can be deeply shocking. One important question is whether, in magazines and newspapers, they produce the indignation that they should (and are usually intended to), or whether constant repetition merely anaesthetizes the public's sense. It could be argued that images of violence and misery are in some way pornographic, and certainly there is the suspicion that many newspapers use such photographs not to enlighten their readership, but rather as a form of sensationalism designed to increase circulation.

As with so many other areas of photography, reportage lends itself to every kind of treatment, from the crass to the committed. It can be performed as sensational news journalism, but it can be used to make a deeply felt statement as in the work of W. Eugene Smith, for example. Clearly, where the effects and uses of violent and painful images are disputed it is hardly surprising that many photographers involved take a personal and protective attitude towards their work.

War creates human suffering and violence on such a scale that the photographer becomes totally involved. The dilemma of this involvement can be severe, and every photographer faced with excessive situations has, at some time, had to consider whether his or her rôle should be as observer or participant. Don McCullin, whose pictures are featured on these pages, is a major exponent of the photographic presentation of human misery and conflict. He puts it like this: "Once in Vietnam, I tried to stop a stream of lorries passing two wounded men. I snatched a rifle and held it up towards the lorries, but no one stopped. In most of the war situations one is like a speck of dust. If men are bent on killing and destruction, one photographer with a Nikon will not really affect their actions."

Vietnam 1968. US Marines in action during the Tet offensive in Hué, drag a wounded comrade to safety.
Photo: Don McCullin.

Landscape

LANDSCAPE PHOTOGRAPHY is at the same time one of the easiest and most difficult subjects to approach. It is easy because landscapes are so familiar and accessible – they are all around us, and by now most of the obvious scenic views are catalogued tourist attractions with established viewpoints. In addition, landscapes are permanent; they don't move, and so all that is necessary is to get there with a camera. Finally, for the simplest shot, there are no extreme technical difficulties.

Despite this, there is an outstanding difference between the ordinary "postcard" views and the finest creative landscape photographs. Many casually-conceived photographs of interesting views that stimulated the photographer turn out to be disappointing, failing to capture the essence of the scene. This is precisely because landscapes are such familiar, accessible subjects. Many photographers do not put a great deal of effort into a shot, yet to lift a landscape photograph out of the ordinary requires considerable perception and technique.

The first major problem is that most people react to a scene in an intuitive way – without being able to pinpoint exactly what elements appeal to them, they form an overall impression of which the visual element may be only a part. The wind, the sounds, the smells, the relationship of distant mountains to nearby rocks – all these things are the landscape, but the task of the photographer is to isolate the important ones and somehow convey them in a purely visual way. A casual snapshot usually fails in this. Apart from any other faults, it may include too much in its frame, cluttering up the scene, or it may exclude elements that forethought would have indicated were crucial.

The first step is to decide precisely what it is about a particular landscape that characterizes it, defining the nature of the subjective impression – what Ansel Adams, probably the finest of landscape photographers, called "the personal statement". Here there are no rules. It may be the inherently spectacular nature of the view – the Grand Canyon, for instance – or it may be simply the play of light and shade. It could be the lushness of fields and copses in summer, or the transience of a spring shower over the desert. What is important is to

Sunrise behind Bear and Rabbit Rocks, Monument Valley, USA. Using a long-focus lens to isolate and abstract these rock formations (far right), I chose sunrise at the best time to show their silhouettes. The rabbit is more easily recognizable than the bear. Forecasting the exact position of sunrise is always difficult; I set up the tripod on a nearby road, with the car engine running, so that I could make a quick last-minute change to the camera position.
Nikon, 400mm, Kodachrome, 1/250sec, f16.
Rapids, Guiana Highlands. By contrast, this wide-angle shot of a South American falls in the late afternoon (right) makes no attempt to abstract the landscape. Crouching low in the water, I used a slow shutter speed and small aperture for maximum depth of field.
Nikon, 20mm, Kodachrome, 1/30sec, f16.

White Rims of Green River Canyon, Utah. This naturalistic treatment of an evening landscape (below) was taken with a medium long-focus lens. Choosing the right time of day was essential as the river, scarcely visible during the afternoon haze, clearly reflected the sky after sunset. *Nikon, 180mm, Kodachrome , ¹/₃₀sec, f2.8 plus Polarizing filter.*

maintain a logical approach. In most cases the scene is not going to change in a few minutes, so it is worth taking time to think about it; Adams emphasized the importance of what he called "visualization" – anticipating the shot even before setting up his camera.

Approaches

There are many ways of composing a landscape photograph, and to attempt to categorize all of them would be to trivialize the subject. There are, however, some common approaches which are useful to consider. At opposite extremes, a landscape photograph can be representational or abstract. A representational photograph attempts a faithful evocation of the subject that conveys a great deal of information. An abstract approach selects strong graphic elements from the landscape, and tends to be more subjective. In the past, photography, and particularly landscape photography, has drawn heavily from the traditions of painting, and has not explored the potential offered by the new medium.

On a more practical level, there are some useful compositional techniques. The relationship of nearby objects to a distant scene, such as ripples in a sand-dune to a desert horizon, is often extremely interesting. It involves the viewer, and can bring a completeness to the landscape. By using a wide-angle lens and a low viewpoint, this can be conveyed in a wide-field view (it is a pity that the tilting fronts and backs of view cameras, which are the classic way of achieving great depth of field on a plane, have no equivalent in 35mm cameras, but the depth of field of most 35mm wide-angle lenses is considerable). Parallax problems make composition with wide-angle lenses on direct viewfinder cameras more difficult than on a single lens reflex.

A telephoto lens can be used to isolate given elements, and will compress perspective, making distant features more dominant in relation to nearer objects. It can give a more remote, detached feeling, and is often excellent for selecting items to give abstract patterns.

White Sands, New Mexico. In the early morning sunlight the dune crests (left) appeared naturally graphic. A wide-angle lens and vertical format made it possible to include the close foreground as well as the horizon; the effect is an unusual sense of scale, with the distant mountains no larger than the ripples in the sand.
Nikon, 20mm, Kodachrome , ¹/₆₀sec, f16.

Equipment checklist

This ideal list would serve for almost any conceivable shot under normal conditions.
1. Camera body: an SLR, perhaps with a spare body.
2. Spare ground glass screen marked with grid lines, for levelling horizons.
3. Lenses: in terms of priority, a wide-angle lens would probably be the first choice, perhaps a 24mm or 28mm, for wide-field views. For a telephoto approach, a 200mm would be a useful all-rounder, with a 400mm, 600mm or longer for really compressed perspectives and distant details.
A normal or macro lens for detail work.
4. Tripod and cable release: the most useful tripod is one that permits the legs to be spread for a very low position.
5. Neck strap.
6. Lens hoods.
7. Lens caps.
8. Lens cleaning tissues and blower brush.
9. Filters: B/W – yellow, deep yellow, red, green, blue. Color – UV, polarizing, graduated neutral, color correction filters for warming/cooling and for reciprocity failure.
10. Film: B/W – fine-grain for detailed work, fast film for grainy effect and for poor lighting conditions. Color – ditto.
11. Camera case: preferably airtight and reflective.
12. Spare meter batteries.
Special options for adverse conditions:
A. Bad weather:
1. Plastic bags, film wrap and rubber bands, for enclosing cameras.
2. Lint-free handkerchiefs for wiping equipment.
B. Mountains:
1. Small camera system, eg Olympus, Nikon FM.
2. Gloves, inner and outer (also for snow).
3. Well-padded case suitable for back-packing, or individual padded bags to go in a mountaineering stuff-sack.
4. Motor-winder for use with gloves on.
5. Selenium-cell lightmeter (less affected by cold than cadmium- sulphide cells).
C. Deserts:
1. Plastic bags, film wrap and rubber bands, for enclosing camera.
2. Airtight reflective case, or reflective material for covering.
D. Rainforest:
1. Fast film.
2. Silica gel.
3. Airtight case.

Dawn at Monument Valley, USA. With an interesting dawn sky over one of the world's most famous natural skylines (below), it was an easy choice to place the horizon line at the bottom of the frame. The strong shapes of the mesas and buttes constantly draw the eye back down to the bottom of the picture.
Nikon, 35mm, Kodachrome , ¼ sec, f4 .

Evening storm, West Scotland. This unpredictable combination of sky and horizon (below) developed in minutes and disappeared as quickly. I used the car roof as a brace for the camera. In contrast with the photograph opposite, the focus of interest is the weather itself rather than the skyline.
Nikon, 400mm, Kodachrome , ¹/₁₂₅ sec, f5.6 .

In landscape, as in other forms of photography, a simple rule can be applied in most instances – "less is more". That is, a detail can sometimes convey more than an overall view. It is, however, easy to overdo this approach, and it often works best when detail photographs are set alongside more open shots.

The relationship between the land and the sky is an important factor – the horizon is probably the strongest line dividing up the picture frame – and in interesting weather conditions it is worth experimenting with different proportions of sky to land. With dynamic clouds dominating the composition, over just a thin strip of land, an entirely different feeling is created, often more majestic. These sky-land variations can also be applied to water and land, and to water and sky.

Equipment and materials

Partly because the appeal of representational landscape photography involves a large and detailed informational content, and partly because the photographer can normally take his time in shooting, classical landscape photography has frequently been on large format cameras with fine-grain film. In comparison, 35mm cameras can be at a slight disadvantage, but with good lenses, careful technique, and the use of fine-grain films with fine-grain developers, good results can be achieved. And, as the rules are not fixed, the very coarseness of the grain in a fast film can be used for its graphic effect. In adverse weather conditions (see p157), the speed and facility of the 35mm camera make it ideally suited, and results can be realized that would be impossible with a view camera.

Whether color or black-and-white film is used is largely a personal decision, although certain conditions favor one or the other. Simply because of the importance of color in some scenes, black-and-white film could be inadequate. This should not be confused with the *quantity* of color in a landscape, which can swamp the view, and can be treated effectively in black-and-white. In any case, black-and-white

St Mary Lake, Montana. In late summer, the weather in Glacier National Park (below) was just beginning to turn. I chose to focus attention on the sky and used a neutral graduated filter to darken the upper half of the picture and exaggerate the threatening clouds. *Nikon, 24mm, Ektachrome , ¹/₁₂₅sec, f9 plus graduated filter.*

Volcan Poas, Costa Rica. Stuck on the summit of this Central American volcano (below) for three days, waiting for a clear view of the crater, I took this picture of a high-altitude dwarf forest in high winds and driving rain by wrapping the camera in an anorak. The lens poked through one sleeve, secured by a rubber band. *Nikon, 20mm, Kodachrome , ¹/₁₂₅sec, f3.5.*

film focuses attention on tone, shape, and shadow, and where these are dominant, it may be the better choice.

Because careful composition is central to landscape work, a tripod is useful. It is essential with a telephoto lens, or in a wide-field approach where obtaining maximum depth of field requires a slow shutter speed. More often than not, sharpness is desirable across the whole field, especially in a representational photograph.

Filters have an important role in landscape photography, and in black-and-white allow a large measure of control over different elements. The most frequent need is to darken a blue sky, very often to emphasize cloud patterns. Red gives the darkest rendition, but it does carry the double disadvantage of a high filter factor and a strong effect on green vegetation (see p61); orange gives a close approximation to actual tones without serious side-effects. The

relationship between colors in a landscape, such as grass and red rocks, can also be manipulated with appropriate filters. A polarizing filter (see p 66) can reduce reflections, and with color film is the only way of darkening a blue sky (apart from graduated filters, which can only be used with a straight horizon line). UV filters reduce haze in distant and mountain views.

Timing

The beauty of landscape work is in its variety – even one viewpoint can provide infinite possibilities, depending on the weather, time of day, and season. Usually, the photographer has a limited choice in this respect; few people can afford the time to make several visits to a location in order to capture the right conditions. Nevertheless, within the constraints, the photographer should anticipate the appearance of a scene at different times, and try to work to the preferred one. As a general rule, sunrise and sunset are good times. Then, a wide variety of lighting conditions obtain in just one or two hours, giving warm colors and low-angled lighting that shows up textures. The flat lighting of the midday sun, particularly in the tropics, is often hard to cope with adequately, and is usually more satisfactory with inherently strong shapes, tones and colors. Dull, overcast skies are an even more severe problem, for although the diffuse lighting gives accurate color rendition to everything, the quality of light is formless, and the contrast between sky and land is too high to record both at a proper exposure. A graduated filter or print shading in the darkroom may compensate for this extreme contrast.

Adverse conditions

Landscapes do not always present themselves under perfect photographic conditions. Bad weather may be immensely frustrating to a photographer who can well imagine how things would appear at a better time, but adverse conditions can provide a challenge and an opportunity for unusual and original photographs (after all, driving hail or a dust storm are precisely the conditions when most photographers pack up and leave). Also, from a purist's point of view, such conditions are an essential element in the landscape's profile.

Bad weather, rain, hail, snow and dust, show the landscape in its more violent moods, but for the photographer who is looking for an original treatment of a well-known scene, they offer many possibilities. The image can change constantly and rapidly under these conditions, and fast reactions are needed. Here, therefore, the 35mm camera comes into its own, and through-the-lens metering is particularly useful. The one essential precaution is to protect your equipment.

Earth's extreme environments such as mountains, deserts and rainforests, are the least accessible, yet they offer the most dramatic landscapes. In particular, the absence of people gives more scope to the photographer. To anyone seriously interested in landscape work, a visit to one of these regions is essential, and can give a concentrated opportunity to develop ideas. Each has its special photographic problems, and all of them, as harsh environments, need to be approached with commonsense and caution.

The mountain photographer does not have to be a mountaineer, but without rock- and ice-climbing skills, many shots will inevitably be missed. UV scattering at high altitudes is considerable, and a strong UV filter is essential. A telephoto will clearly suffer more than a wide-angle lens. The bonus of high altitudes is clear air and fine visibility (but not all the time!), and a viewpoint that often permits shots down onto clouds. The physical difficulties of mountaineering preclude heavy equipment, and professional mountaineer/photographers such as Chris Bonington, leader of the 1975 Everest expedition, carefully select their cameras for weight. At high altitudes, just moving can be a great effort. The low temperatures can affect the mechanical operation of the camera, and it may be worth having the lubricants, which become more viscous at low temperatures, removed before a long trip. Also, if the additional weight of a motor-winder is acceptable, it will allow gloved operation and prevent frostbite!

San Andres Mountains and White Sands, New Mexico. Taken within half a mile of the photograph on p152, this shot (above) abstracts the desert landscape in quite a different way. A long-focus lens compressed the planes of dunes and mountains. By waiting until dusk I could combine the sunset colors with the cool reflections of the sky in the white sand. *Nikon, 180mm, Kodachrome , ¼ sec, f16.*
Sierra Nevada de Santa Marta, Colombia. Half an hour after sunset in the tropics little light remains, most of it from the blue evening sky. This softened the appearance of these peaks (left) as the clouds rolled up from the valley floors. *Nikon, 500mm Tele-Tessar, Kodachrome , ¹/₁₅ sec, f8.*

Snow, even at low altitudes, is a special photographic problem. Realistic rendering is quite difficult, and both over- and under-exposure are common errors, particularly when using a through-the-lens meter. Remember that any meter averages the exposure and delivers a reading equivalent to an average (18%) gray. Snow crystals are also good reflectors of UV light, and snow in shadow under a blue sky will be recorded a distinct blue on color film. Low-angled sunlight is best at bringing out texture in snow, and backlighting can give a sparkle to the crystals.

Deserts and rainforests

Deserts offer different problems, chiefly dust and heat. Use a clear lens filter to protect the lens and keep equipment in an airtight case when it is not being used. Your camera case should be white or silvered and kept in the shade as much as possible. Summer daytime

159

Mesas, Guiana Highlands. Strong verticals are surprisingly rare in most landscapes. Where they do occur, as in these South American sandstone cliffs (right), a long-focus lens can usually show them off best. Sunrise is unpredictable, but it can transform the picture; here sunlight briefly lit up a plume of cloud. *Nikon, 400mm, Kodachrome , ¹/₃₀sec, f5.6.*

temperatures in the American south-western deserts regularly exceed 110°F (43°C), and any black surface on a camera can absorb enough heat in a few minutes' direct exposure to the sun to alter the sensitivity of the film or weaken the lens cement.

Sand dunes, which are not quite as typical of deserts as many people imagine, are particularly interesting in low-angled sunlight, which reveals the delicate texture of ripples and shows the pattern of crests. In this respect, they are similar to snow. In the pre-dawn, or after sunset, the effect is more subtle.

Rainforests, covering 3 million square miles of the Amazon Basin and large areas of the African and Asian tropics, are an exciting, largely unexplored region, but pose some photographic difficulties. Characterized by dense stands of tall hardwood trees, they offer limited vistas and very low levels of illumination. High rainforest has

Andean cloud forest. Rainforests of one kind or another are a problem because of the restricted view. One solution is to shoot upwards, choosing definite, isolated shapes such as solitary palm trees. In cloud forests, the shifting visibility can lend considerable atmosphere to the picture (far left). *Nikon, 24mm, Ektachrome , ¹/₆₀sec, f5.6.*
Puracé National Park, Colombia. Although this flower (left) could have been the subject for a close-up portrait, I wanted to include its habitat. With a tripod and slow shutter speed, a wide-angle lens at its smallest aperture gave great depth of field. *Nikon, 20mm, Kodachrome , ¹/₈sec, f22.*

an atmosphere of cathedral gloom, which can be expressive, but makes long exposures with a tripod practically essential. Open views are generally possible only on river banks and cliffs. Photographic possibilities are much harder to find in rainforests than in mountains or deserts, but as these regions have been relatively ignored by photographers, the opportunity is there.

The combination of heat and high humidity in the rainforest can be quite destructive to film and equipment. Once again, an airtight camera case is important, and a desiccating agent such as silica gel should be packed with the cameras. Its drying properties can be re-activated by heating it in an oven or over a fire. Make regular inspections of the equipment for green mould. Look carefully at the lenses, even inside – a rash of small spots can be the first sign of fungus, which literally etches the glass and can ruin a lens.

Wildlife

WILDLIFE PHOTOGRAPHY follows naturally from a study of landscapes, for within each landscape, even the most inhospitable, is a complete cycle of life – an ecosystem – often of surprising range. However, the two subjects, landscape and wildlife, normally inspire quite different approaches. Landscapes tend to be received as subjective impressions, whilst wildlife photography encourages a more detailed, literal treatment.

Nevertheless, whilst it has to be more literal and faithful to its subjects, wildlife photography does not have to be an uninspired scientific record. The best work in this field has long since passed the 19th century stage of showing what an unusual or rare animal looks like to those who have never seen one. It aims to give new insight into the way creatures behave, and works to high pictorial standards.

The immediate connotation of "wildlife" may be elephant and giraffe, but here it includes all living things, and the way they live. The only proper way to consider wildlife is in relation to its natural environment. Animals only live in isolation in zoos.

Here, perhaps for the first time, you will find the need for specialized knowledge *outside* the field of photography. It is possible to practice reportage photography on native wit, and landscape photography is usually more personal than informative. In wildlife photography, however, it is difficult to do without a knowledge of the creatures you are looking for. The rewards, nevertheless, are enormous, for the fascination of wildlife in a natural environment provides a great contrast to the organized urban life that most of us are familiar with.

Techniques

The techniques of wildlife photography are not dissimilar to those of hunting, but are less destructive. To be put into practice effectively, they require fast reactions, some stealth, anticipation and an appreciation of how animals are likely to behave. There is a basic division between stalking and the use of hides. Hides, whether natural places of concealment or artificial constructions, are located close to a place that the particular animal frequents, commonly a watering-place, nest or other sleeping place. They can also be used in combination with a bait or lure to increase the chances of the animal putting in an appearance. In whatever form they are used, they are quite specialized, and usually require more than average dedication and patience from the photographers.

Stalking is the more common technique, and although the results are more unpredictable and opportunistic, its prospects are less daunting than the hardships of carrying, constructing and waiting in a hide. Nevertheless, patience is still the most honored virtue, and to begin with, you should be prepared to take considerable time and effort to produce photographs you are satisfied with.

Approaching animals in vehicles – cars, jeeps, boats – may sometimes be better than trying on foot. Either through familiarity or because it does not *look* threatening, a vehicle can inspire little fear, provided it is not too noisy. However, make sure that you shoot from a car window rather than open the door – the trick is to be a *part* of the vehicle yourself.

Limpkin, Suwannee River. In the first light of dawn, a limpkin searches for food in a northern Florida cypress swamp. Although there was little light, I was able to use a long-focus lens with a very slow shutter speed by wedging the camera against a tree stump, and waiting for pauses in the bird's movement.
Nikon, 400mm, Kodachrome, ¹/₃₀sec, f5.6.

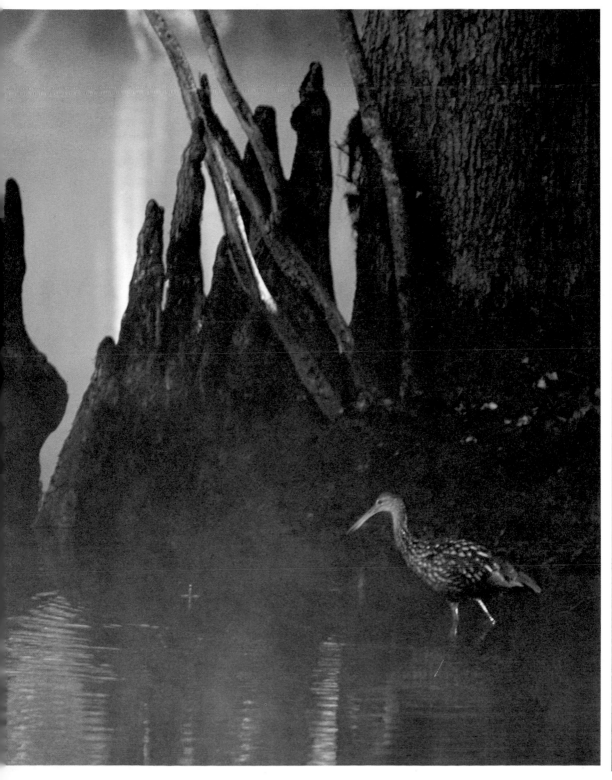

Equipment checklist

What equipment you carry depends on
how specialized your involvement is.
This basic list covers the majority of
subjects and their environments down to
moderate close-ups.

Tripod and cable release.

Lenses: The longer focal lengths are the
most important, but exactly what you
take will depend on your budget and how
much weight you are prepared to carry.
Lenses of 600mm and over are very
effective but invariably need a tripod. An
alternative may be a 300mm or 400mm
which, with practice, can be hand-held at
speeds as low as 1/125 (just!). A more
moderate focal length, of around 200mm,
may be useful for more approachable
subjects, and a wide-angle lens can be
used for overall environmental shots. For
close-up work, a macro lens with a set of
extension rings will cover everything
down to the scale of quite small insects.

Special options

1. Motor drive.
2. Flash unit.
3. Flash intensifier – by mounting the
flash unit to point *backwards* into a
specially-designed parabolic mirror, its
light can be concentrated into the small
field of view of a long-focus lens,
increasing its effective range to as much as
50 meters (164ft).
4. Remote control device, either radio or
infra-red controlled.
5. Soundproof blimp for working by
remote control or in a hide close to the
subject.

A custom blind. A portable one-person
blind can be constructed with a box frame
and canvas covering. Camping
equipment can be adapted – tent poles for
the frame, uprights and guy-lines to hold
the blind steady in wind.

Equipment

The long-focus lens is the basic tool of wildlife photography, and a lot of the techniques revolve around its use. It is needed mainly because the majority of wildlife subjects are shy and elusive, and rarely allow close approach. A long lens has the additional advantage of being able to isolate an animal from a frequently confusing tangle of foliage by means of its shallow depth of field. Practise holding and using a long lens until you can improve the lowest speed at which you can achieve a sharp image (see p 29). Use trees, bushes, rocks as cover in the same way that your prey does, and don't hesitate to shoot through intervening foliage – the shallow depth of field will throw it out of focus, and the resulting blurred foreground may help convey the excitement of stalking in the final photograph.

Constantly check and adjust the camera and lens settings, anticipating the lighting conditions under which an animal may appear. At the fleeting sight of a deer bounding across a clearing, you may not have time to make any adjustments. Keep a careful eye on the film counter. If there are only a few frames left, it may be a good idea to change film rather than risk losing a good shot. Also, don't be afraid to risk a few frames when the light is too dim.

A motor drive is well worth its weight, not only because it can cram the maximum amount of pictures into the short flurry of activity common with many wildlife subjects, but also because it removes the distraction of manually winding the film. If there is any doubt about the correct exposure in a situation where there is no time to check it, use the motor drive to bracket the exposures – whilst firing a continuous sequence, rotate the aperture ring. When stalking a particularly skittish or alert animal, however, use the motor drive with discretion. It is noisy, and will startle the animal more easily than the manual shutter release. In fact, it often happens that the first time the shutter release is pressed the prey will bolt, and some fine judgement

Pygmy Marmoset, Amazon. The smallest of all primates, this Pygmy Marmoset (far left) from the upper Amazon valley measures less than four inches (10cm) from its head to the base of its tail. Using a moderately long lens at nearly full aperture foreshortened the background vegetation and threw it out of focus, making the tiny creature stand out clearly. Like many rainforest animals, this marmoset has a patchy distribution – rare in most parts, but extremely common in some areas.
Nikon, 200mm, Ektachrome, $^1/_{125}$sec, f5.6.
Great Egret, La Guajira. One solitary clump of mangroves on a long stretch of desert coastline in Colombia has become an oasis for flocks of egrets and herons. Close approach was easy, as the dense vegetation kept me hidden, and although my view of this bird (left) was partially obscured by leaves, a long lens reduced this screen of foliage to a soft blur.
Nikon, 300mm, Ektachrome, $^1/_{250}$sec, f8.

Black-necked Storks, India. Normally solitary and secretive, these birds are difficult to stalk. As with most animals and birds, they are most active in the early morning, and I surprised this pair shortly after sunrise in the marshy acacia forest of a bird sanctuary in central India. There was time only for this one shot.
Nikon, 180mm, Kodachrome, $^1/_{125}$*sec, f2.8.*

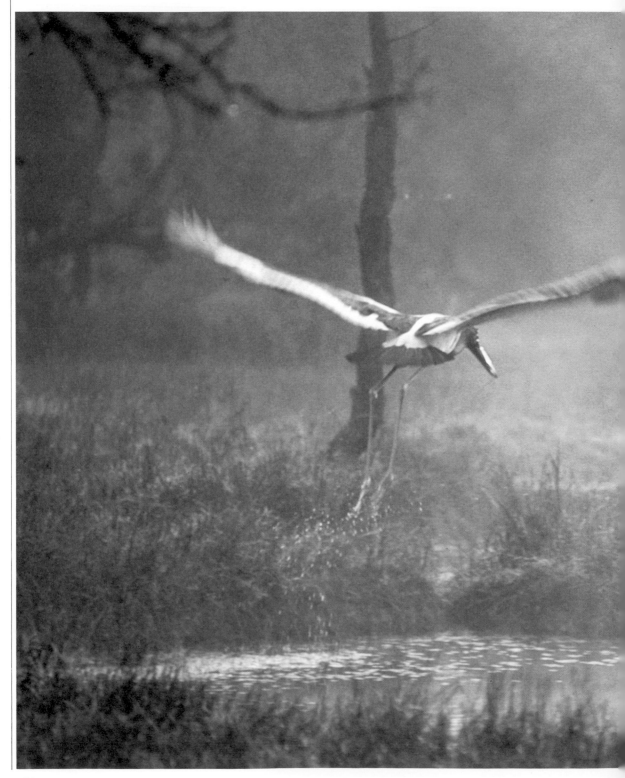

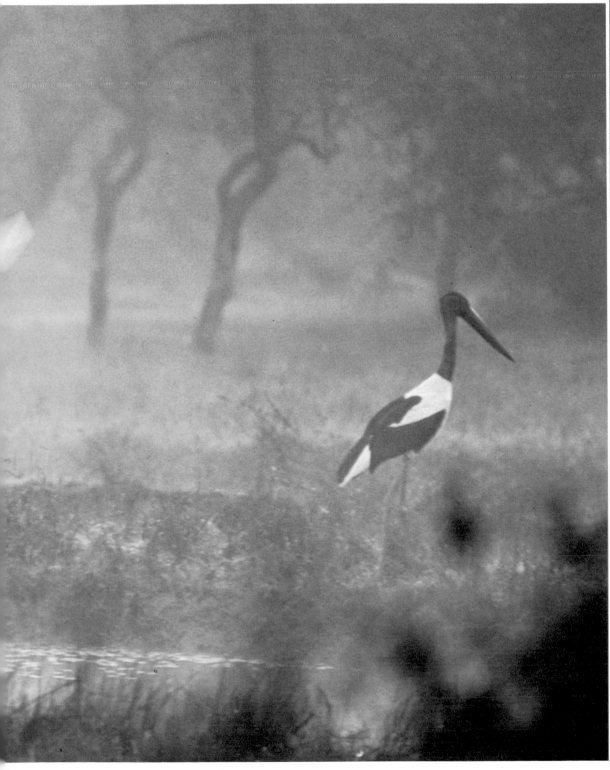

Moose, Madison River. Browsing on river vegetation in Yellowstone National Park, this bull moose was only a matter of yards from the highway. In this well-organized park, many animals have become relatively accustomed to humans. Judging backlit exposures can be difficult, and I bracketed widely.
Nikon, 400mm, Kodachrome , ¹/₅₀₀sec, f11.

must be exercised as to the best moment to shoot. When the animal takes off because the camera has surprised it, it will nearly always head in the opposite direction and present an uninteresting rear view. This is particularly a problem with birds on a perch or nest; having already photographed them you might be tempted to encourage them into flight by making a noise. It is better to wait for them to make a more natural exit of their own choice.

Flight

Birds in flight present their own special problems. Everything is at its most difficult, for whilst you will need a long-focus lens to fill the picture frame, the longer lenses are the more difficult to focus and have a very shallow depth of field. It is extremely difficult to keep a bird in continuous focus as it flies diagonally or directly towards you; your rate of focus change rarely coincides with the bird's rate of approach. One answer is to re-focus continuously as you follow the bird; another is to put all your bets on a single shot by pre-focusing ahead of the bird and waiting until it reaches that point. A bird flying across your line of vision is easier, and successful panning is possible at speeds too slow for a static hand-held shot (although the wings will be blurred). Obtaining the correct exposure is also a problem. As in all wildlife photography, it is essential that you correctly expose for the subject – the animal – rather than its surroundings. This becomes critical when the animal takes up a comparatively small area of the picture frame and is further aggravated when it is against a very dark or very light background (a bird against a pale sky being an example of this). If in doubt, bracket your exposures.

A place to begin

Given the inherent difficulties of photographing wildlife, it is a good idea to choose your first location carefully, and to prepare yourself for likely picture possibilities and conditions. Attempting to photograph rare animals in an inaccessible environment without some experience is to court disappointment. It is also better to start with somewhere that is *organized* to show wildlife to visitors – in other words, a wildlife sanctuary of some sort. Although opinions vary, I would *not* recommend a zoo as the place to start, except as a short familiarization course. Animals cannot be expected to behave naturally in confinement.

The type and quality of wildlife sanctuaries vary greatly throughout the world. A national park in the Americas may be virtually a wildlife reserve, whereas in England, for example, it may contain no special concentrations of wild creatures. The degree of protection also varies, depending on the country's resources and its commitment to conservation. The United States is particularly fortunate in having an extremely well-organized network of national parks and national wildlife refuges, knowledgeably staffed and with good information on what to see and where; some reserves even have permanent hides.

Local knowledge is the key to successful wildlife photography, and most professionals make full use of it. If you can arrange to go alone with a local guide, so much the better, but if not it is usually possible to join a small group tour. The fewer people there are, the easier you

Painted Storks nesting, India. In only a few square miles of marshland, the Keoladeo Ghana sanctuary in central India contains so many water-birds in the winter season that it seems like an open-air aviary. This view (far left) was taken from a flat bottomed boat at dusk.
Nikon, 24mm, Ektachrome, 1/60sec, f5.6.

Mountain goat, Sperry Glacier. Within a mile of some overnight cabins in Montana's Glacier National Park, this Rocky Mountain goat showed no signs of alarm when I approached close enough for a full-frame portrait shot (near left). As it was still posing obligingly, I moved away for a view that showed it in relation to its habitat (middle left).
Both shots: Nikon, 180mm, Ektachrome, 1/250sec, f11.

169

will find it to be unobtrusive, and if not everyone is a photographer, you may find your own needs frustrated. If possible, plan your trip to coincide with the most favorable season; for instance, when there is a marked dry season animals may concentrate at water-holes.

Each of the photographs on these two pages was taken in a national park or wildlife reserve, using only the facilities available to all visitors. None was particularly difficult to take, nor did any demand fast reactions or elaborate equipment. After responding to the normal impulse of simply getting any shot on film, try and exploit the subject. If the animal is approachable, such as the mountain goat on page 169, try altering your position for more effective lighting or composition. This kind of graphic control is often possible with many subjects. Spend time watching the way the animal behaves: a creature at an identifiable activity is usually more interesting than a static portrait.

Following this, work around the subject to get a variety of shots and some feeling for the environment as a whole. An image of the animal in its environment can sometimes be more effective than the kind of close-cropped picture often associated with zoos.

A balanced view

More advanced than straightforward excursions into wildlife sanctuaries is the attempt to portray a whole environment in the form of an essay. The location need not be as exotic as the one shown here – the Amazon – but it always involves some research and involvement. A balanced picture of the wildlife and its setting means, first, a balanced pictorial view, not only in subject matter and scale (for example, everything from insects to mammals, and tree-top life to the river bottoms), but also in the variety of color, lighting and composition. Secondly, it involves presenting the special characteristics of the particular place. To do all this comprehensively would be a mammoth task, but at least try to encompass a full range.

The photographs on these two pages were all taken in the Amazon Basin between 1971 and 1974. The complete take was quite large, and

Victoria Regia lilies. In lakes and backwaters, these huge lilies, their giant leaves averaging one meter (39in) in diameter, grow packed together in large rafts. Backlit by the late afternoon sun, the upturned edges of these lilies formed a strong pattern when photographed with a long-focus lens (right). Stopping the lens down to a fairly small aperture increased the depth of field and made the sense of pattern stronger.
Nikon, 180mm, Agfachrome, ¹/₁₂₅ sec, f16.
Forest interior. Although the interior of a tropical rainforest can be very impressive in its silence and gloom, it is normally too dense and confusing to make a good overall view. One answer is to use a wide-angle lens and photograph the canopy from ground-level. I chose this regal Ité Palm as the focus of the shot (right) to add symmetry to the composition.
Nikon, 28mm, Agfachrome, ¼ sec, f4.

Horned spider. This unusually protected spider (below) was photographed slightly larger than life-size with a bellows extension. To bring out some interesting reflections from the carapace, I used a ringflash.
Nikon, 55m Macro plus 80mm bellows extension, Agfachrome, f16, ringflash.

Spectacled Cayman. Caymans are the South American equivalent of alligators, differing only in details in the skull. Although the larger caymans are now rather rare, Spectacled Caymans such as this one (right) are still easily found. The late afternoon sun emphasized the color of a backwater swamp.
Nikon, 180mm, Agfachrome , ¹/₁₂₅sec, f6.3.

Giant Otter. A guide helped me find this Brazilian Giant Otter (below), an endangered species as well as the largest of the world's otters. Unlike many rainforest animals, the otter is active by day. Its behavior is confident and playful. The photographer's problem is therefore to find it rather than having to exercise stealth and caution once it is spotted.
Nikon, 400mm, Ektachrome , ¹/₂₅₀sec, f8.

Victoria Regia flower. Photographed with the sunlight rather than against it, the giant lilies on p 170 appeared completely different. This more conventional lighting suited a detail shot. *Nikon, 180mm, Ektachrome,* ¹/₁₂₅*sec, f8.*
Caladium leaves. These large caladium leaves (right) were shot against the sky after a rain shower. Backlighting and a close viewpoint emphasized the characteristic veining of these plants. *Nikon, 55mm Macro, Ektachrome,* ¹/₆₀*sec, f3.5.*
River turtles. These turtles (far right), basking in shallow muddy water, were packed so closely together that they made an irresistible pattern of broad shells and long necks. A long-focus lens helped to enhance this effect. *Nikon, 180mm, Ektachrome,* ¹/₂₅₀*sec, f5.6.*

these pictures are an extremely small selection. Relatively unphotographed and therefore interesting new ground, the Amazon rainforest also creates some special photographic problems. There is a depressing sameness about the forests which made variety all the more prized when I was able to find it, and the low light levels caused very basic difficulties in photographing the already elusive inhabitants. Clearings and river margins turned out to be the richest source of animal photographs.

The special characteristics of the Amazon forests include a profligacy of growth that belies a remarkably infertile soil, and a whole style of rainforest life that is secretive, where speed in the chase is replaced by agility and concealment.

The assignment

The professional photographer has the advantage that an assignment poses a well-defined set of problems; the difficulty is not so much deciding on *what* to photograph but on how best to portray it. Nevertheless, a self-assigned wildlife project is a good alternative. Rather than just responding to the opportunities that are thrown up, you will have to plan ahead, and apply the techniques you have already learnt. The hopeful result, a good photographic coverage of a single theme, may also be financially rewarding, for editorial wildlife photography is one area that is not the preserve of professionals. Among magazines, the demand for good wildlife stories exceeds the supply.

This particular assignment, on falconry, was shot over a total of two weeks on a grouse moor in northern Scotland. Although the rituals of falconry impose some control over the chase, the speeds and uncertainty of the falcon's pursuit of its prey posed problems. In an assignment like this, there is an obvious need for the kind of overall coverage' just described, but there was no escape from essentially what was really wanted: the moment that the falcon actually catches the grouse in mid-air. This would also be extremely difficult. First, although there is a definite pattern to an ideal sequence, the failure rate is high. At the end of the season, when just the experienced grouse are left, even a hungry, well-trained peregrine falcon succeeds

Falconry, Scotland. On a stormy October day, two falconers wait with their hooded birds while the dogs search the moor for a scent of grouse (above). After an unsuccessful chase (left), one of the falconers, Stephen Frank, adjusts the thongs attached to his bird's legs, while the pointer sniffs the gloved hand, bloodied from a previous kill.
Above: Nikon, 20mm, Kodachrome
Left: Nikon, 180mm, Kodachrome

in only a small percentage of attempts. Then, the speeds that both birds attain are very high. Both falcon and grouse average about 50 mph (80 kmph) flying horizontally, whilst the falcon in its vertical power dive – the stoop – can occasionally reach 200 mph (320 kmph)! Lastly, the grouse is racing for its life, and uses every trick it can to overcome the falcon's aerodynamic prowess; this usually means hugging the contours of the ground and heading for cover, with the result that in most cases it slipped from *my* view even before it escaped the falcon.

I therefore had to prepare the remainder of the assignment so that it would *just* work without this shot – that is, get a stoop-and-chase sequence, and a final shot of the falcon feeding on its prey. In the event, I didn't get a satisfactory shot of the falcon catching the grouse until the next year – too late for the magazine article.

To photograph the falcon in flight, a motor drive was essential. In addition, I used different techniques. On the first day I tried using a 500mm lens, hand-held. Camera shake was no problem, as a bright sun permitted a fast shutter speed, but I found it impossible to keep the bird in focus. The next day, therefore, I changed to a more manageable 180mm lens, relying on the fine grain of Kodachrome to allow an enlargement at the layout stage. This worked well, and the fast 180mm lens let me shoot when the light was poor.

To guarantee some reasonably close sharp photographs of the falcon in flight, I pre-set the focus on occasions when I could predict the flight path, but for the stoop-and-chase action, where I wanted a full sequence, I followed the falcon with continuous re-focusing.

Close-up

Close-up photography, already outlined on p 51, gives an entirely different view of the natural environment – a look at a world that sometimes seems to function quite differently from its full-scale counterpart. Vegetation, particularly flowers, takes on a new variety in close-up, and is a very accessible subject to begin with. At the grass-roots, so to speak, details can be more eloquent than the whole.

Looking at a flower close up, the brain tends to idealize what the eye sees, and interprets a well-defined portrait in three dimensions. The view through the camera, however, is less compromising, and the main problems are isolating the subject from its background and coping with the shallow depth of field.

Shallow depth of field is a feature of close-up work (see p 52). It can be partly overcome by using small apertures, but these require slow shutter speeds so any movement will blur the image. (Flash may be used, but can destroy any naturalistic feeling.) In close-up, flowers are surprisingly mobile even in the slightest movement of air, and often need improvised windbreaks made out of card or some other material. Another way of improving the depth of field is to move back slightly and accept a lesser magnification, but a more creative solution is to accept the inevitable shallow focus and exploit it by concentrating on a single detail. The arrangement of petals, stems and colors, for example, can be made to enhance the out-of-focus effect.

Moving in close to a subject removes the question of how to treat the background, which can be a confusing tangle. If the background is to

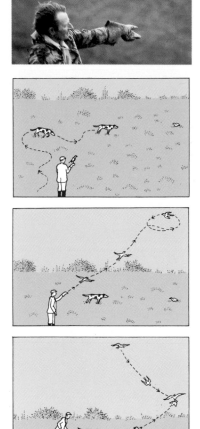

The ideal sequence
The dog locates a grouse hidden in the heather, and 'points' in the characteristic position that gives the breed its name (top). Quickly, before the grouse can run, the falconer unhoods and puts up the falcon which rises to where it has a commanding view of the field and sufficient height to power its descent (center). The falcon is now 'waiting on', and the grouse will not fly unless forced to. At the falconer's command, the dog 'puts up' the grouse (bottom) which turns and flies low. The falcon then begins its 'stoop' and, levelling off at the last moment, it 'binds to', catching the grouse in the air.

174

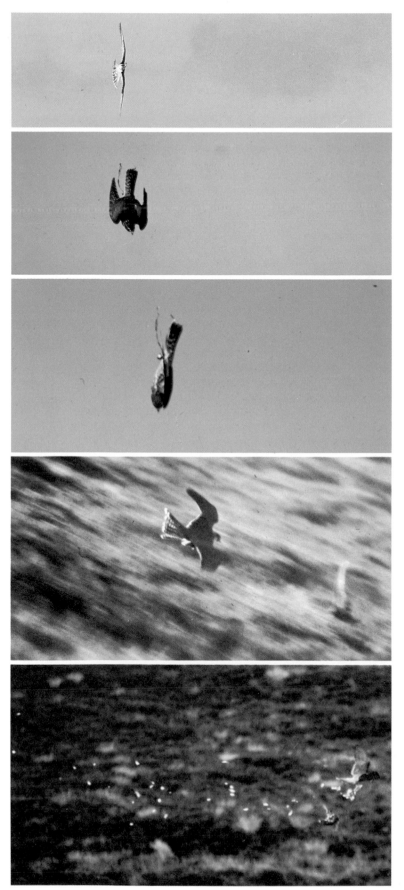

This action sequence, essential to the assignment, has been culled from more than one occasion. The falconer putting the hawk up into the air, and the final strike, were shot at different times to the 'stoop' sequence that starts at the top of this page. Once in the air, and circling, the peregrine falcon begins its stoop by banking steeply with wings outstretched. To accelerate, it then makes a few rapid wing beats, and quickly folds its wings back so that it is almost as streamlined as a bullet.

Second from bottom: Mistiming the power dive usually results in failure. The falcon is then committed to a hedge-hopping chase where its aerodynamic shape is wasted and the grouse has the advantage.

Bottom left: This successful strike was taken on the same moor with the same falcon, but a year later. At a speed that the falconer estimated to be about 100mph (160kph), the falcon hits the grouse with its talons, scattering feathers into the wind, and drops quickly to the ground. If the prey is not already dead from the attack, the falcon will neatly serve it the coup-de-grace by breaking the neck with its beak. Wary of interference, it starts immediately to consume its prey (below). At the speeds at which both birds were flying, a 500mm lens proved too slow and awkward to use, and to ensure accurate framing and focus in this rapid sequence, I used only a moderately long-focus lens. All the flight shots on this page are enlarged from the original transparencies, but as I was using a fine-grain film, the detail is acceptable.

All shots: Nikon, motor drive (flight sequence at 3 frames per second), Kodachrome, ¹/₅₀₀sec, f2.8 (except for bottom right – Ektachrome, ¹/₅₀₀sec, f4).

Shell. For full lighting control, this Murex shell (top) was photographed in the studio with a medium-size flash unit, well-diffused, and a white card reflector placed to fill in shadow details. By using black velvet as a background, I could make the pale shell stand out clearly. *Nikon, 55mm Macro, Ektachrome 64, f27.*
Orchid. One solution to the problems of a confusing background is to close right in on the flower (above), so that it fills the frame completely. Inevitably, at this magnification parts of the flower will be out of focus, but if the composition is effective, this need not be a disadvantage. *Nikon, 55mm Macro, Kodachrome, f32.*

be included, try several different camera positions – one may give a better separation between the flower and its backdrop. Here you can turn the shallow depth of field into an advantage by making the single bloom stand out sharply against a blurred background. If the natural backdrop is still unsatisfactory, you can resort to artifice by arranging your own setting – black velvet or card, for instance.

Beyond these technical problems is the aesthetic one of lighting. As with any natural subject, you are largely dependent on the existing quality of daylight, unless you resort to flash. However, because flowers are relatively small, it is easy to manipulate reflected light, bouncing sunlight into the shadows with small mirrors or pieces of white card. If you have the time, wait and experiment with different types of natural lighting. Direct sunlight may give too harsh an effect when frontal, but as backlighting it strengthens shapes and can make leaves, for example, almost luminous, and when strongly directional will give a sparkle to water droplets. A dull overcast sky can bring a beautiful tranquil lighting and an even illumination.

Wildlife's smaller representatives, such as insects, small frogs and their associates in scale, are not difficult to find. In numbers and variety of species, insects still rule the planet, but they present special problems as they often combine small size with agility and camouflage. All except the largest call for the extremes of close-up equipment – sets of extension rings or bellows, and a new approach to lighting.

To bring most of the subject into sharp focus a small aperture is necessary, but as the creature is likely to move, time exposures by natural light are normally out of the question. Portable flash is the usual solution. An average pocket unit can facilitate apertures as small as f 22 and its flash duration can freeze the movements of most insects.

Using flash in the field calls for careful calibration, and rather than make laborious fresh calculations each time, many close-up specialists use a standard set-up that has already been tested at various distances.

You can calculate the lighting for a pre-determined range of magnification in the studio by first fixing the flash unit to a bracket attached to the camera. (A second flash can be used as a fill-in, either a less powerful unit or one positioned further away, to improve the balance of lighting.) Take the flash guide number (listed by the manufacturer according to film speed) and divide it by the desired aperture. The result (in feet if ASA, or meters if DIN) will be the correct flash-to-subject distance without the adjustment for the lens extension. This adjustment can be calculated from the table below. Finally, make a series of test exposures, bracketing around the desired f stop to check your results. Remember to mark the position of the flash on the bracket, or note the distance from the flash to the subject for each exposure.

Correction for lens extension with electronic flash							
Lens-to-film distance divided by lens focal length	1.2	1.5	2.0	2.5	3.0	4.0	5.0
Magnification	0.2×	0.5×	1.0×	1.5×	2.0×	3.0×	4.0×
Shorten flash-to-subject distance by this factor	0.84×	0.65×	0.5×	0.4×	0.33×	0.25×	0.2×

Arrow-poison frog. This tiny frog (above) earned its bizarre name from an Indian technique of using its venomous secretions to coat the tips of hunting arrows. It was photographed with a pocket flash unit held directly overhead and wrapped in a white handkerchief to diffuse the light.
Nikon, 55mm Macro, Kodachrome, f22.

Close-up with a viewfinder camera

A viewfinder camera is at a distinct disadvantage in close-up work – parallax and the altered magnification of the lens make a direct check of the image impossible in the field. One solution is to construct a wire frame that encompasses the picture area at a predetermined setting. First, decide on the close-up equipment and setting to be used. Then, position the camera on a tripod opposite a perpendicular card. Open the camera back, hold the shutter open with the B setting, and with a

makeshift ground glass screen such as a frosted acetate transparency sleeve, move the camera until the card is in focus. Mark the picture area on the card looking through the camera back; construct the wire frame to these dimensions.

177

Photomicrography

THE MICROSCOPE offers an entirely new range of images to the camera, and although some of the more advanced techniques are complex, basic photomicrography is within the reach of the non-specialist photographer.

Image quality is best when using only the optics of the microscope, so it is always preferable to remove the camera lens before using an adaptor to attach the camera to the eye-piece. A single lens reflex is ideal for this work, as it allows you to operate the microscope and photograph through it with the same eyepiece; if the through-the-lens meter works without a lens attached, it also permits direct exposure readings.

The principal lens in a modern compound microscope is the "objective", the lens nearest the specimen. Flat-field objectives, although expensive, provide edge-to-edge sharpness. The two most important qualities of an objective are its magnification and resolving power. Magnifications by the lenses can be from 5× to 100×, but the total magnification is increased further by the eyepiece, which enlarges the image already produced by the objective by between 5× and 25×. (To find the total magnification, multiply the two together.)

Resolving power depends on the numerical aperture, or N.A., of the objective; this is a measure of the objective's ability to distinguish fine detail, and normally never exceeds 1.0 (special lenses designed to work immersed in oil have higher N.A.s and better resolving power). If you use high magnification with an objective of lower N.A., all you will achieve is "empty" magnification – as a rough guide, multiplying the N.A. by 1000 will give you the maximum usable magnification.

The third part of the optical system, after the objective and eyepiece, is the sub-stage condenser, used to focus the light. An aperture diaphragm also controls the size of the light beam. On some microscopes, an adjustable mirror directs light through the condenser from an outside source, but many modern ones have their own light source.

The normal lighting for photomicrography is tungsten, with a color temperature between 2700°K and 3200°K. Tungsten-halogen lamps (see p213) are the most consistent. A typical microscope lamp has a lens and a field diaphragm to control the beam. To photograph moving organisms, electronic flash is necessary; a supplementary tungsten lamp will therefore be required for focusing and composition.

Setting up the camera

Attach your camera body over the microscope's eyepiece, using an adaptor available from the camera manufacturer. The basic lighting method is "brightfield" illumination, so called because the light is shone through the specimen and the background appears white. The important thing is to center the light source and focus it so that the illumination is uniform over the whole picture area. It is possible to do this by focusing the image of the lamp filament on the condenser.

Exposure: It is difficult to achieve the right exposure the first time, and you should plan a series of tests, even if you can use the camera's through-the-lens meter. Adjust the exposure with neutral density filters rather than by altering the shutter speed which, being mechanized, is less reliable. Test various combinations of eyepiece and objective,

Pine stem. Stained for clarity, this transverse section of a young pine stem (top) is lit by standard brightfield illumination, although because of the fairly low magnification, care was needed to achieve even illumination across the picture area.
Image magnification ×10.
Head louse. Also using brightfield illumination, but at a rather higher magnification, this human parasite (above) was photographed whole and unstained.
Photos: Bill West/Carolina Biological Supply Co.

The microscope

A microscope magnifies the image in two stages. The first magnification comes from the objective lens, positioned close to the specimen. This lens is engraved with its magnifying power, generally ranging from ×4 to ×100. The *primary image* projected by the objective is then magnified a second time, by the eyepiece; this is also marked with its magnifying power, between about ×5 and ×20. The total magnification seen by the eye is the product of the objective and the eyepiece magnifications; for example, a ×20 objective and ×10 eyepiece would combine to give ×200 magnification.

For photomicrography, a special camera attachment is invaluable, allowing focusing adjustment and a light-tight fit. With the camera lens removed, the magnified image from the eyepiece is projected onto the film plane. When changing from visual focusing to the camera, some adjustment is necessary – either the eyepiece lens must be moved higher, or the objective must be focused further away from the specimen.

Camera

Film plane

Eyepiece eye lens

Eyepiece

Eyepiece field lens

Body tube

Objective

Specimen

Stage

Sub-stage condenser

Sub-stage condenser diaphragm

Lamp

Mirror

Base

Setting up the microscope

These are the basic steps, although in practice continual re-adjustment is often necessary, as one adjustment often affects other settings. Considerable practice is needed.

1. If the lamp is separate, place it about 10in (25cm) from the microscope and adjust it so that the light is centered on the mirror.
2. Adjust the mirror so that the light is centered on the iris of the sub-stage condenser.
3. Stop down the field diaphragm on the lamp and focus the condenser until the silhouette of the diaphragm is sharp.

4. Open up the field diaphragm so that its edges are just outside the picture area. The lighting is now correct.
5. Focus the specimen with the microscope's objective lens.
6. Take the eyepiece out and, looking straight down the tube, adjust the aperture diaphragm until it is about ⁴/₅ of the bright circle that you can see. This cuts flare down to a minimum and brings the objective to its maximum resolving power.

Water flea with winter eggs. Using darkfield illumination, this flea (above) was photographed with electronic flash to freeze movement. The eye-piece and draw-tube of the microscope were replaced by a bellows to adapt it for a reflex camera.
Photo: Kim Taylor.
Leica, Ektachrome, image magnification ×8.

and keep careful notes. To reduce the risk of vibration, lock up the camera mirror before each exposure, and use a cable release.

Film: Most normal films can be used for photomicrography, but in view of the importance of resolving fine detail, you should choose a fine-grain emulsion. One problem is that most subjects under the microscope lack contrast. There is now available a film specially designed for photomicrography – Kodak Photomicrography Color Film 2483 – which combines extremely fine grain and high contrast and is ideal.

Specimens: Mounted specimens of all kinds of subjects can be bought from specialist suppliers, but you can prepare your own. Most specimens are either very thin tissue sections, smears or chemical crystals. For tissue sections you will need a microtome, which makes it possible to slice sections of uniform thickness. Smears are straightforward, and chemical crystals can be prepared quite simply by allowing a drop of solution to dissolve on a glass slide. When you have prepared the specimens on the slide, you can make them permanent by cementing a cover glass over them.

Other types of lighting

Some specimens, such as aquatic life, can be seen more clearly if they are lit by oblique rays, and opaque specimens can only be lit in this way. "Darkfield" illumination, as this is called, uses glancing light waves and a dark background. The normal way of achieving this lighting is to use a darkfield stop which effectively turns the circle of light projected upwards from the mirror into a ring. The light misses the center of the condenser and the picture area completely, and only a rim of light strikes the specimen. This cuts down the quantity of light to a considerable extent, and makes color photography difficult.

Cat ovary. Stained with dye to enhance contrast, this section of a cat's ovary (left) was photographed with basic brightfield illumination.
Photo: Manfred Kage.
Image magnification ×200.

Pediastrum duplex The extreme transparent quality of this subject makes conventional lighting techniques inadequate (right). The interference created by phase-contrast lighting, however, enhances the edge detail.
Photo: Dr Frieder Sauer.

Progesterone crystals by polarized light. Prepared by re-crystallizing from a solution of water and methanol, these progesterone crystals (below) take on brilliant contrasting colors when photographed through the microscope's polarizer and analyzer.
Photo: Manfred Kage.
Image magnification ×160.

Polarized lighting can reveal new characteristics in some specimens, and the colors achieved can be startlingly vivid. Two polarizing filters are used, one below the condenser (called the polarizer) and one just below the eyepiece (the analyzer). The polarizer passes light waves that are vibrating in one plane only; if the specimen has polarizing properties, it will split the light into two components, one of which is slightly slower than the other. By rotating the analyzer, you can make these two components interact, creating new colors.

Phase-contrast and interference-contrast microscopes follow a similar principle to that of the polarizer – they split the light into two beams that travel at slightly different speeds. This is done by means of ring-shaped slots, semi-transparent plates, or prisms; by letting the two beams interact with each other, they show details of specimens that are virtually transparent.

Underwater

USING A CAMERA UNDERWATER demands some of the most specialized equipment and techniques in photography, yet its new popularity has resulted in a wide choice of commercial systems that are relatively simple to use and some of them quite inexpensive. Most areas in the world that have worthwhile diving locations, principally coral reefs, cater in some form to underwater tourism, and underwater photographic courses abound. There are even underwater national parks, some of them with signposted nature trails.

The basic choice for the photographer is between buying a special underwater camera and a housing that will enclose a camera. At the present state of underwater camera technology, each system has some advantages over the other. The special optical problems underwater give a theoretical advantage to lenses computed solely for that medium, and equipment that is designed from the start to withstand water corrosion and pressure can be lighter and more compact than housings for surface cameras. Against this, the only amphibious camera currently available, the Nikonos, has no through-the-lens viewing system – a very serious disadvantage in the difficult camera-handling situations encountered underwater – and lacks the mechanical flexibility of most modern cameras; in addition, if you already own a range of lenses, you may find it less expensive to buy a housing than to invest in a completely new camera system and lenses.

Underwater optics

Water has a higher refractive index than air, something that you can easily demonstrate by putting a stick into water at a slight angle – the stick appears to be bent and foreshortened underwater. In effect, the water behaves as an extra lens in underwater photography. This refraction causes three inter-related problems:

1. Objects appear to be one quarter closer than they are.
2. Objects appear to be one third larger than they are.
3. The angle of coverage of a lens is reduced by one quarter, which means that a moderate wide-angle lens with a 35mm focal length, which has a normal angle of coverage of 62°, has a coverage of only 46°, so losing its wide-angle properties.

With a truly amphibious camera, such as the Nikonos, the focusing controls and viewfinder are already calibrated for refraction, so that there are no additional adjustments for you to make. With your own camera in a housing, however, the design of the port is crucial. A flat port will not correct any refraction problems, and will, in addition, exaggerate various optical aberrations (chromatic aberrations will increase, resolution will be reduced towards the edges, and pincushion distortion will be introduced). A dome port, however, will correct the effects of refraction, by acting as a second large negative lens. This restores the angle of coverage of the lens and reduces the apparent size of the subject, but in doing this it actually makes the subject appear even closer. In order to be able to focus properly, most

Diver in the Red Sea. Using a very short-focus lens, the photographer positioned himself close to the sea floor, aiming the camera upwards to get the maximum contrast from the near silhouettes of diver and coral. Calm, shallow water and a low sun provided the best conditions.
Photo: Peter Scoones.
Nikon F2 in Oceanic Products housing, 15mm, Vericolor 'S', 1/250sec, f8.

Natural light underwater. Water modifies sunlight in several different ways. Some is reflected back from the surface, more when the water is choppy and the sun is low. The surface also tends to diffuse the light. As the light rays penetrate deeper, they are scattered by suspended particles and vibrations, which reduce their intensity and the color saturation. In addition, light is absorbed by water, so that at great depths there is virtually no illumination. This absorption affects different wavelengths at different rates; red is absorbed before any other color, and red filters of different strengths are needed to correct this deficiency in natural light photography.

Direct sunlight

Light reflected by surface of water

20ft (6m)

35ft (10m)

Attenuation of light increases with depth

Scattering of light from suspended particles

65ft (19m)

75ft (21m)

90ft (27m)

Selective absorption cuts out different wavelengths at different depths. Red is the first to be removed, followed by orange, yellow, green and blue. Below 100 feet (30m) everything appears colorless.

lenses will need a plus-diopter close-up lens attached. Dome ports also partly correct for chromatic aberration, loss of edge sharpness, and pincushion distortion.

A second characteristic of water is light-loss. This is partly because the surface reflects some sunlight back into the sky (less if calm, more if rough seas), and partly because small-scale striations and suspended particles scatter light rays. This scattering has an additional effect of reducing color saturation.

The third optical consideration is that water selectively absorbs light, taking in the red end of the spectrum first, at shallow depths, and successively shorter wavelengths at greater depths. For this reason, most underwater photographs taken in natural lighting appear blue, and even fish and corals that appear brightly colored to the eye will record on film as a blue-gray except in the shallowest depths. Down to approximately 30 feet (9.7m) this color absorption can be corrected with color compensating filters, but at greater depths correction is impractical. The alternative, except for overall scenic photographs, is artificial light, such as flash.

Working underwater

This is no place to give basic diving instruction; it is best learned from a qualified diving instructor, and, in any case, you will need certification to dive with tanks. Nevertheless, one rule is paramount – never dive alone.

Natural light photography is quite possible at shallow depths; sunlight, in fact, is the only means of lighting scenic shots. Weather conditions are important, the best conditions being bright sun, clear sky and calm, clear water. If possible, use a red filter of the strength that suits the depth you are most likely to be working at (see page 183). Generally speaking, scenic shots that include a view of the surface from below are more successful than ones aimed downwards,

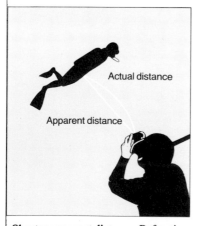

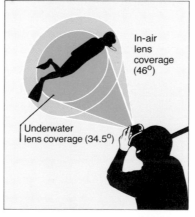

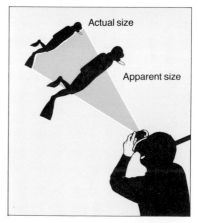

Shorter apparent distance. Refraction has the effect of making objects underwater appear to be one quarter closer than they actually are. This is the basic characteristic that is responsible for the other two effects.

Reduced angle of coverage. The two other effects cause the in-air angle of coverage of a lens to be reduced by one quarter. The focal length does not in fact change, although the narrower angle may give this impression.

Apparent increase in size. Underwater, objects also appear to be larger than they really are, by one third. The reason for this is quite simply that they appear closer. The simplest solution is to move further back by one quarter.

Sea squirts, hydroids and soft corals.
The abundance of creatures in the water
off Komodo Island in Indonesia is evident
from this close-up (below), taken with
electronic flash at a depth of 35 ft (10.5m).
Upwellings around the island provide a
wealth of food in the form of plankton.
Photo: Soames Summerhays.
Nikonos, 28mm, Kodachrome, f16.

Squirrel fish. Photographed off Helen
Reef, which lies between Indonesia and
Micronesia, this common species is shy
and difficult to approach. The close-
focusing ability of a macro lens was ideal
for this well framed shot (below right)
taken at 50ft (15m) with electronic flash.
Photo: Soames Summerhays.
Nikon, 55mm macro, Kodachrome, f9.

Demoiselle fish. This picture (above)
was taken with electronic flash.
Photo: Bill Wood.
Coral in the Red Sea. The close-up
picture (below left) was taken on a night
dive at a depth of 60ft (18m). An
extension tube was used for close
focusing.
Photo: Warren Williams.
*Nikon, 35mm + extension. Ektachrome,
electronic flash, f16.*
Below: This delicate Gorgonia coral was
composed effectively to fill the frame.
Photo: John Kenfield.

185

Underwater equipment

An amphibious camera with water-contact lenses such as the Nikonos (right) is made water-tight by synthetic rubber O-ring gaskets. The interior body, which must be removed for film loading, contains all the moving parts. The lens units are interchangeable, and some (which have not been completely corrected for close-focusing underwater) can be used on the surface, also making the camera practical in wet or dusty conditions in general photography. Because of the camera's small size, a hand-grip is a useful accessory. Electronic flash is increasingly more common than bulb flash, now that electronic units are more reliable. Most electronic flash units use rechargeable nickel-cadmium batteries and can therefore remain factory sealed; a few units are available with replaceable batteries, but these tend to have a lower output. Jointed arms on the flash allow different lighting angles. Bulb flash holders (far right) have the advantage of simplicity and power, although they are slow to use repeatedly. An inexpensive alternative to a purpose-built underwater electronic unit is a custom housing for an ordinary pocket flash.

Camera maintenance

1. Check out a new housing by taking it underwater without the camera inside. Salt water will damage most cameras permanently.
2. It is not enough just to rinse the camera/housing in fresh water after each diving session. Dried crystallized salt can penetrate the screw threads and O-ring grooves, and can eventually cause leakage (although all metal parts are liable to corrode in time). Soak the equipment for at least half an hour in fresh warm water.
3. Coat all screws, threads and the O-rings with special O-ring grease. Check O-rings constantly for grit and sand.
4. Ports are easily scratched, as they are rarely made of glass. Protect them with a soft cover.
5. You may have to "trim off" the weight of the housing so that it balances in your hand; do this by taping small weights inside.
6. Rinse saltwater out of your hair and hands before unloading or disassembling.
7. Never leave equipment in the sun; apart from the damage it can cause to the film, it can cause the O-rings to expand and encourage leakage.

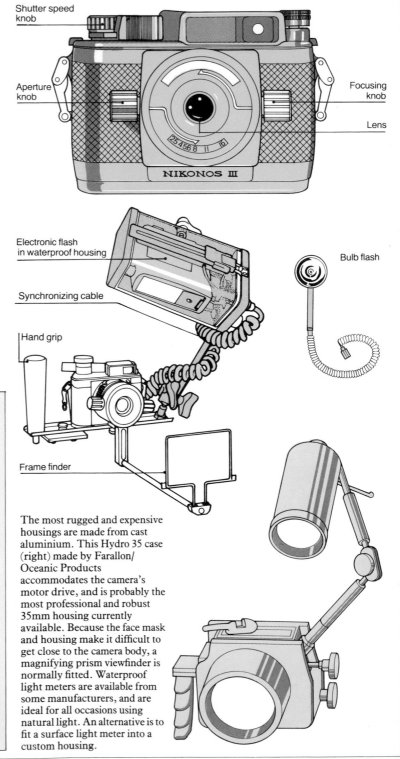

Shutter speed knob

Aperture knob

Focusing knob

Lens

NIKONOS III

Electronic flash in waterproof housing

Bulb flash

Synchronizing cable

Hand grip

Frame finder

The most rugged and expensive housings are made from cast aluminium. This Hydro 35 case (right) made by Farallon/ Oceanic Products accommodates the camera's motor drive, and is probably the most professional and robust 35mm housing currently available. Because the face mask and housing make it difficult to get close to the camera body, a magnifying prism viewfinder is normally fitted. Waterproof light meters are available from some manufacturers, and are ideal for all occasions using natural light. An alternative is to fit a surface light meter into a custom housing.

as lack of contrast is a constant problem underwater. Bracket exposures if in doubt.

Even the clearest water has large numbers of particles that will tend to degrade the image, so that an extreme wide-angle lens is one of the most useful in underwater photography. You may find that currents and a slight negative or positive buoyancy make it difficult to keep still and in position to take shots; for this reason, a heavy working glove on your free hand will help for holding onto coral and rocks. To reduce the risk of camera shake further, hold your breath momentarily just before squeezing the trigger.

Artificial light is nearly always preferable for close-ups, and essential below 30 feet (9.7 m). Although it is possible to use tungsten working lights and movie lights as a supplementary fill-in, electronic or bulb flash, which is corrected for daylight film, is more usual. A flash unit used too near the camera will cause back-scattering, reflecting light off particles in suspension. Use the flash at as great a distance from the camera as possible, preferably on a long jointed arm. An arm will also give you a choice of modelling, and allows you to place the light over the subject in a close-up; this lighting direction, imitating sunlight underwater, appears as the most natural. A second flash unit from a different direction can fill in shadows, and also increase the area illuminated if you are using a wide-angle lens. An alternative to using flash arms is to have your diving partner hold the light, but communications underwater are often difficult, making co-ordination a problem. For proper exposure, follow the instructions provided by the individual flash manufacturer.

The most common style of housing is a contoured case made from a moulded transparent material such as the GE Lexan used in this Ikelite range (below). Gear wheels fixed to the lens controls are connected to external controls to allow focus and exposure adjustments underwater. With these housings, white numerals and lettering on the front of a lens will, under certain conditions, reflect back off the port onto the film, so it is advisable to black them out with paint or black tape.

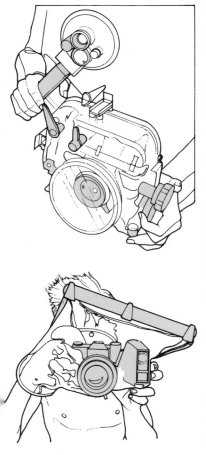

The simplest underwater housing is a soft vinyl bag with a built-in glove and flat port (above). Models like this EWA-Marine are inexpensive, and will accommodate most cameras, although they are safe only down to 30 feet (9·7m).

Red Sea Rock Cod. Photographed at a depth of 80ft (24m), with a 50mm lens, the perspective is slightly compressed.

Photo: Warren Williams.
Praktica in custom perspex housing, 50mm, Kodachrome, 1/125sec, f11.

Action

AN ESSENTIAL FEATURE of photography is its intimate and special relationship with action and movement – the still photograph takes a narrow slice out of the sequence of events in front of the camera and freezes one moment of time. From the beginning, this has been one of the most fascinating attributes of the camera, which on occasions has even given an entirely new view of the anatomy of fast action. Eadweard Muybridge's famous sequences of animals in motion, taken in the 1880s, were done to settle a bet with his sponsor as to whether or not all four legs of a galloping horse were off the ground at the same time. That it took the advent of photography to describe the actions of an animal known to man for thousands of years shows how the photographic process can actually be used to analyze and dissect experience.

By the nature of the process, the camera cannot fail to capture motion in a single permanent image. However, fast action, particularly in sports, has special characteristics, and to treat it with real insight requires fast reactions, a knowledge of the ways in which camera and film respond to subject movement, and an appreciation of the structure and tensions of the action itself.

The most basic quality when photographing action, whatever equipment and techniques are being used, is anticipation. Fast action requires the photographer to be prepared, and this in turn depends on familiarity with the action. Sports photography is perhaps more concerned with action than any other field and the most successful sports photographs, noticeably so, are taken by those who have a close knowledge of their subjects.

Timing
Thinking of action as a finite sequence of events, there are certain instants within the sequence that convey better than others either the sense of movement or the qualities that are special to the particular action. For instance, in a sequence of photographs of someone talking, the photographs taken when the person's mouth is closed usually appear more static and less immediate than those that show the mouth partly open. In violent action, the timing is more important, and the idea of the "decisive moment" becomes vital. In any one sequence of events there is rarely a single "decisive moment" – such moments do not exist independently of the photographer, who always brings a subjective decision to choosing the instant to shoot. For example, here are four distinct "decisive moments" (they are not the only ones):

1. The moment that is crucial to the nature of the action, such as the scoring of a goal, or a knock-out punch. This is the most obvious moment, and, in a sense, represents the peak of the action.

2. The momentary pause in the middle of violent action, for example just before a runner leaves the starting blocks. This kind of moment, full of tension, is natural to certain types of action where the energy is stored up like a coiled spring, ready to be released in a sudden explosion of movement. Because this pause is a slightly less obvious moment, it can have particular dramatic power.

3. The unpredictable moment, where an unusual or unexpected occurrence shows itself in the expression or movement of the subject.

Downhill racing. This spectacular shot of an Olympic skier precisely captures the excitement and spontaneity that many sports pictures lack, yet it was conceived and planned well in advance. The close streaking view was achieved with a wide-angle lens fitted to a motorized camera partly buried in the snow, and triggered with an extension cable. The problem was that, as the skier was travelling at about 60mph (85kph), he would be moving about 15ft (4.6m) between each exposure (a Nikon motor runs at about six frames per second). This was too fast to be certain of capturing the whole image on film. The solution was to use four cameras. They were placed at 3ft (1m) intervals and were triggered simultaneously. They all had fresh batteries and were running at approximately the same speed. Yet even with so many variables involved, success was by no means guaranteed. As the photographer, Anthony Howarth, recounts: "Each run used up about ten frames on each camera, so after 20 runs we had used a total of more than 20 rolls of film. The whole operation took about five hours. When the films were processed, we found one virtually perfect picture (shown left) plus a couple of others that were usable. The rest were just shots of blue sky and snow, occasionally with bits of skis in them."
Photo:Anthony Howarth/Alexander Low
Nikon, 20mm, Kodachrome, ¹/₂₅₀sec, f11.
USC vs UCLA, Los Angeles. The action at this football game is heightened by the compressing effect of a 500mm mirror lens.
Photo: Walter Iooss.

High diver, Mission Viejo. Gold
medallist, Jenny Chandler, appears as
graceful as a bird in flight. The camera
position is the key factor in the success of
the shot. Photographer John Zimmerman
considered a number of positions before
choosing the 50 meter diving board above
the 30 meter board used by the diver.
Photo: John Zimmerman.

With this kind of picture, which reinforces the uniqueness of all
action, chance and quick reactions are all important.

4. The moment away from the action. Searching behind the scenes
before or after a race or a fight can produce some revealing images.
The expressions and attitudes of contestants in a sport can show
catharsis, anxiety, exultation or despair, sometimes providing a
greater insight into a sport than the peak of the action itself. This is
because the extremes of human action often draw on the extremes of
human emotion.

Inherent in the choice of timing are composition and viewpoint.
Both can contribute to the sense of movement, and both must be
chosen to coincide with the moment of picture taking. Compositional
rules are generally more restrictive than helpful, which is why they are
not treated specifically in this book. Viewpoint is less easy to change

Weightlifter. Two decisive moments
show both the strain and deep
concentration in weightlifting, a sport
that distils action into a sudden violent
burst. Russian competitor, Alexeev, was
competing to retain his title at the
Montreal Olympics. With a fine sense of
timing, photographer Gerry Cranham
caught first the charged pause before the
snatch (right). "Alexeev had just resined
his hands – this was the moment of truth.
Although in the end I didn't use it, I had
the camera's motor drive set to
continuous, just in case." Seconds later,
Cranham captured the peak of the action
as he held the weights aloft (above).
Photos: Gerry Cranham.
Nikon, 300mm, Kodachrome.
After the race. This perfectly composed
shot (far right) captures the exhaustion
of athletes at the Mexico Olympics.
Photo: Neil Leifer.

quickly, so it is best to work out as carefully as possible the locations over which the action will take place, and choose a camera site accordingly. Try to choose a viewpoint which simplifies the background for the subject and avoids complicating its shape.

Fast shutter speed

With the right film and lens, freezing action into a single frame is something the still camera is ideally suited to. As discussed on p 26, several factors determine the shutter speed necessary to stop motion – the extent to which the moving subject fills the frame, its actual speed, its angle of movement relative to your viewpoint. It is important to concentrate on stopping only those elements that are essential. For instance, in a photograph of a racing cyclist, the wheel spokes may be blurred, even though the movement of the bicycle and cyclist is stopped. If there is rapid movement across the field of view, there are two alternative methods of focusing. One is to follow the focus, constantly checking it by moving the focusing ring from side to side.

The problem is essentially that of photographing birds in flight, discussed on p 168, and can be difficult. If the action follows a predetermined path, such as a race track, it may be more reliable to pre-set the lens to a known point which the action will pass. Generally speaking, for fast human and animal action, speeds of 1/500 second to 1/2000 second are needed. The effective limit for most focal plane and leaf shutters is 1/2000 second, and even this is often not accurate. For greater speeds, specialized high-speed cameras are necessary, the fastest of which, using electro-optical shutters, can record images at speeds greater than a millionth of a second. Few subjects, however, are bright enough to record images at even a few thousandths of a second, and the most common route to ultra-high-speed photography is through high-speed flash. Ordinary photographic flash units are limited by the ability of their capacitors to discharge energy quickly enough (see p 89) and a pocket flash on normal setting or an average studio flash unit have flash durations only of about 1/1000 second.

Specially developed high-speed flashes, however, can now give a high output with durations shorter than 1/50,000 second.

Sequences

Sequence photography is a succession of shots either on the same piece of film or in adjacent frames. Although, typically, each individual image is a high-speed shot, it is the complete sequence that describes the action, in a way that is quite different from a single photograph. The sequence neither relies on the "moment in time", nor is it an imitation of cine photography. Instead, it is a summary of movement, a rather detached and logical analysis of an action. In a sense, it restores movement to the time-scale of the person viewing the photographs, stretching the time taken by one rapid burst of activity, or compressing the imperceptibly slow movement of, say, a flower opening.

A motor drive is the basic tool of fast sequence photography (it is also an invaluable method of capturing single moments when the activity is too fast for conscious decision). Set for continuous operation, most standard motor drives permit up to 5 or 6 frames per second to be exposed; some models have even faster cycling, but achieve this at some cost to other aspects of camera operation. Viewing efficiency is the most obvious problem, with a single lens reflex; even at 3 frames per second and a fast shutter speed, the mirror is up, and therefore the photographer is shooting blind for most of the time. This can make the action difficult to follow, and the motor drive is best used in short bursts at the peak of action.

On some cameras, by depressing the rewind release lever, successive images can be recorded on a single frame. Such high-speed multiple exposure is difficult to control, but can convey an unusual impression of movement (exposure must be planned for and adjusted as described for stroboscopic shots).

Stroboscopic sequences are shot as multiple exposures, using the light from a fast-recycling pulsed flash to control the succession of images. The camera shutter is normally left open whilst the stroboscopic lamp fires a burst of up to 20 flashes per second. To avoid other distracting elements, this photography works best in a completely darkened studio against a black background. The flash rate should be adjusted to the speed of the action; the faster the action, the faster the flash, for example. If the whole subject moves between exposures and the images overlap only slightly, the correct aperture setting will be the same as for a single flash; if, however, most of the subject remains

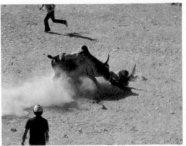

Red Arrows. When this picture (below) was taken, the camera was only 10ft (3m) away from the leading aircraft. This was made possible by a special device designed by Squadron Leader Alan Voyle, enabling the camera to be mounted outside the aircraft and operated from inside the cockpit. Photo: Richard Cooke.

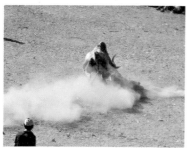

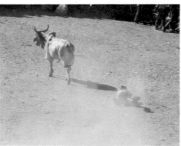

Corraleja. This sequence (left) was taken at a popular regional event in Colombia, where the public tries its luck with local bulls. A charge like this one starts very suddenly, so I had to be ready. I focused on the bull the whole time and pressed the motor drive trigger, set for continuous operation at 3 frames per second, as soon as the charge began. It was important to keep a check on how much film was left in the camera.
Nikon, Kodachrome, 1/500sec, f2.8.

stationary (as with a golfer swinging at a ball), then the aperture must be reduced in proportion to the number of flashes. For example, 32 flashes will give five times the light output of a single flash, which will result in an exposure difference of five times between the moving golf club and the golfer's body; so, as a result, a compromise aperture setting is necessary, depending on the image the photographer wants.

Time-lapse photography is mechanically similar to using a motor drive, with the major difference that it records extremely slow sequences. A flower may bloom in several days, but a camera set to operate at pre-determined intervals can compress this growth into a few photographs. The camera can be activated manually, or linked to an intervalometer that automatically triggers the shutter at set intervals.

Slow shutter speed

By abandoning precision and detail, and aiming for an impression of movement, a slow shutter speed records action as a blur. The effects are not always predictable, but at their most successful can convey a grace and liquidity of motion. This kind of photograph often works better in color, which helps retain a certain order in subjects that can

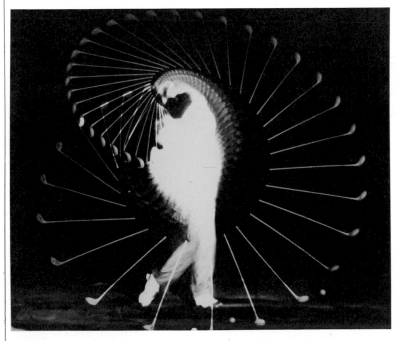

Panning – fixed-focus. With the focus set at a fixed distance which the moving subject is expected to cross, you can be reasonably certain of one, but only one, sharp image. Pan by moving the whole upper half of the body, keeping the arms steady.

Golfer. This early stroboscopic photograph taken in 1938 by the inventor of the electronic flash, converts a familiar action into a whirling pattern. It also analyzes, at a hundred images per second, the precise anatomy of a swing, each individual flash lasting only $1/100,000$ of a second, quite sufficient to stop the movement of golf club and ball.
Photo: Harold E. Edgerton.

Bull-fight, Colombia. A half-second exposure with a telephoto lens imparts a grace and fluidity to the red cape of a bull-fighter. Long exposures combined with violent action work best when the shapes are obvious and the color contrast strong. With virtually no detail, the image here remains immediately recognizable.
Nikon, 400mm, Kodachrome, ½ sec, f32.

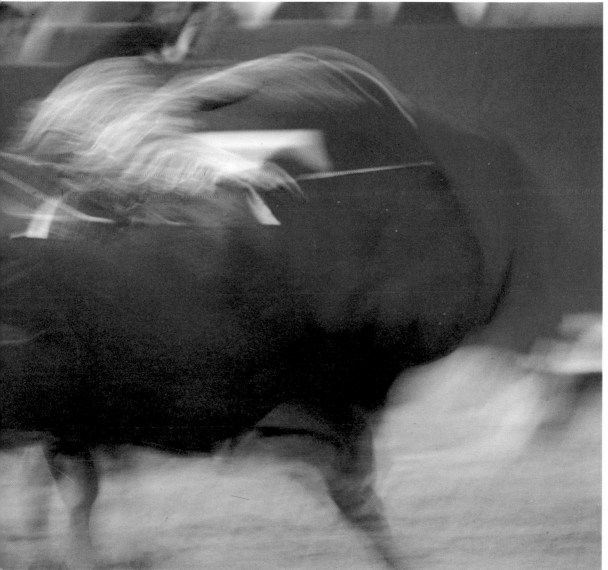

Panning-continuous re-focusing. More picture opportunities are possible by continuously re-focusing the lens. Revolve the focusing ring beyond the distance of the subject after each exposure and work back to sharp focus by progressively finer adjustments.

easily become unrecognizable. As with all strong graphic effects, this technique should be used sparingly, as it verges on the cliché. A plain background, contrasting in tone and color, will show the subject best.

Panning

Panning – following a moving subject during exposure – tends to produce a blurred, streaked background and a sharper image of the subject. The streaks of light from the background not only help to isolate the subject, but also convey a definite impression of the direction of movement. Hold the camera firmly to pan smoothly (or use a tripod with the head very slightly loosened) and squeeze the trigger whilst following the movement of the subject. The slower the shutter speed, the more impressionistic the effect will be – try speeds around 1/15 second for a person walking, and 1/125 second for a fast car. A background with varied tones will give better "streaking" than a plain background.

A variety of panning which produces more impressionistic effects is zoom-and-pan. Using the same technique, but with a zoom lens, turn the zooming ring whilst the shutter is open. It is difficult to use the zooming ring effectively at shutter speeds faster than 1/30 second.

Aerial

A LIGHT AIRCRAFT offers an unprecedented opportunity for fresh images. Familiar landscapes take on a new appearance, and some subjects are only obvious from the air. Preparation is essential – flying time costs money and is easy to waste if you have not already discussed with the pilot exactly what you want.

Sunshine is nearly always preferable, although not easily guaranteed, and acceptable weather conditions are visibility in excess of 10 miles (16 kilometers) with a clear sky or no more than scattered clouds. A light 10–15 mph (16–20 kph) wind will blow away smoke and smog and normally the early morning or late afternoon are the best times of day – the low rays of the sun bring out texture and add warmth to the picture. If you have to fly during the middle of the day, when the lighting is flat, look for subjects that already have strong shapes or colors. Generally speaking, oblique aerial views are the most easily 'read', but vertical photographs, while confusing orientation, often offer the best graphic possibilities.

Flying technique

A single-engined, high-winged aircraft is ideal – my preference is a Cessna. Helicopters can be used, but offer only slightly superior maneuverability (at roughly ten times the cost); in any case, hovering sets up vibrations that make picture-taking impossible without a sophisticated damping support. Whether you use an aircraft or helicopter, however, you should remove either the window or door so that you do not have to photograph through glass.

Ask the pilot to fly low, preferably between 1000ft and 2000ft (300m and 600m) above ground level. There will always be haze present, so the closer you can get the stronger the colors and the contrast, exactly as in underwater photography.

Zea harbor, Greece. The white yachts moored in the marinas of this resort harbor (right) contrast with the water to make a strong pattern. The aerial viewpoint emphasizes the graphics more than the more usual oblique-angle.
Nikon, 35mm, Kodachrome, ¹/₅₀₀sec, f4.5.
Mothball fleet, California. Sometimes the patterns that man creates are only obvious from the air. These are warships of the mothball fleet lying in San Diego harbor (far right). They are arranged with strict military precision – sealed, boxed, and painted gray.
Nikon F2AS, 180mm, Kodachrome, ¹/₅₀₀sec, f5.6.
The aircraft. The ideal light aircraft for aerial photography has a high-wing design for an unrestricted view. If the windows or door cannot be removed completely, the port window, at least, can be opened fully – in flight, air pressure will hold the window firmly against the underside of the wing. Some aircraft, such as this Cessna 216 Centurion (right), have retractable wheels, further increasing visibility.

N6816R

Equipment checklist

1. Two camera bodies, both fully loaded to cut down film changing time in the air (if you have an assistant or friend to load and unload film, so much the better). Single lens reflexes are preferable for precise framing.
2. Motor drive for one or both bodies.
3. Lenses: A normal lens (50–55mm) and a wide-angle lens (possibly 24mm or 28mm) are the most useful. A moderate telephoto lens such as 135mm can be used

on occasions, but it needs a high shutter speed, and sometimes registers areas of soft focus on the film due to rising pockets of moist air.
4. Neck or hand strap – in either case, attach to the waist rather than the neck.
5. Lens hoods.
6. Filters: *B/W* – Yellow, deep yellow and red are the most useful for minimizing haze.
Color – UV and Polarizing filters also to cut down haze and increase color content.

7. Film: Most aerial photography is in color, but there are of course, equally good possibilities in B/W, as the work of William Garnett shows. In either case, a fine grain film is important for preserving detail. An exception to this is infra-red film, which records more detail through haze than the eye, and at a higher contrast. 35mm infra-red color film was originally designed for aerial survey work and can produce some remarkably beautiful images, particularly of forests.

For near-vertical shots, the pilot can side-slip the aircraft by reducing throttle, banking slightly and slipping it towards the target. This reduces vibration and slows down the aircraft. The disadvantage of this technique is that the wing-tip is dipped; if you want to include the horizon in the photograph, the aircraft must bank the other way, allowing you time only for one or two shots.

Camera technique

A motor-driven 35mm camera is perfect, allowing fast composition and shooting as the aircraft flies over the subject. Don't use any part of the aircraft as a support – it will transmit vibrations to the camera – and always use a strap to avoid the expensive consequences of having your camera whipped out of your hands by the slipstream. Most lenses can be used – I normally use either a wide-angle lens to cut down the loss of contrast caused by haze, or a fast medium telephoto lens to pick out selected subjects. On most aircraft it is just possible to use a 20mm lens without including the wing-tip or wheels. Use a UV filter to minimize haze, and, if there is sufficient light, a polarizing filter, which noticeably increases color saturation. Haze is least apparent when shooting away from the sun, although with the sun directly behind you, there will be little modelling in the view. Cross-lighting is a common compromise.

Depth of field is never a problem, even at 1000ft (300m), so leave the aperture wide open and use the fastest shutter speed possible. A speed of 1/500 sec is very safe, especially with a wide-angle lens. However, with a telephoto lens considerable care is needed, even at 1/250 sec.

Grand Prismatic Spring. From the air, the Grand Prismatic Spring in Yellowstone National Park (top) presents a remarkable mixture of colors. In order to emphasize this, I used a polarizing filter to cut down reflections.
Above: This picture was taken into the sun as the plane circled the Spring. It is often possible to use the sun's reflection like this from the air to make a more abstract image, but the colors are lost. *Nikon, 180mm, Kodachrome, 1/500sec, f2.8.*
Acropolis, Athens. For this shot (right) I particularly wanted to show the sprawling city. I needed a low sun to bring out the shapes of the buildings, and as the city's atmospheric pollution is at its worst in the late afternoon, I had to fly early in the morning.
Nikon, 35mm, Kodachrome, 1/500sec, f4.

Architecture

ALL BUILDINGS ARE constructed with a purpose; it may be as simple a function as providing shelter, or it may be to celebrate the majesty of a god in such a way as to inspire awe. The intention may be to house an industrial process with no regard to appearance, or the architect may be pursuing some aesthetic ideal. The first step in architectural photography is to analyze this purpose.

Take time to walk around the building and study it from different angles. If it is an historic monument, there will usually be a guidebook that might suggest some interesting aspect of its design. Decide on the building's essential qualities, those you want to emphasize; these will direct the techniques you use. You may decide to follow the architect's intention and make a literal interpretation of the building's purpose – for instance, by showing how a French cathedral dwarfs and dominates the surrounding town and countryside, as it was intended to do – or you may exploit some particular graphic qualities. Don't restrict yourself to an overall, all-encompassing view. Hunt for

Oak Alley Plantation, Louisiana. I waited until the late afternoon for this shot (above), when the low sun silhouetted the oak trees to create a pattern.
Nikon, 20mm, Kodachrome, ¹/₁₂₅sec, f11.
St James's Palace, London. The inclusion of the pillars in this photograph of the clock tower (above right) made the composition more interesting.
Nikon, 28mm pc, FP4, ¹/₃₀sec, f14.
Santiago Church, Mexico City. The contrast between this colonial church and a modern office block (right) appeared even more emphatic through a long-focus lens. To prevent the vertical lines from converging, the camera was set up on the roof of a building across the plaza.
Nikon, 400mm, Kodachrome, ¹/₁₅sec, f22.

details that can enhance your interpretation of the building – constructional details, like the carved joints in a natural stone wall, or design details, such as the gargoyles on a cathedral's buttress.

There is a danger, however, that, in searching for a new interpretation of the subject, you may mask its essential qualities – you must find a balance between a plain record and too subjective an interpretation. There may be more freedom in handling modern architecture with less rigid rules of design but, generally speaking, architectural photography is not the most obvious vehicle for expressing strong personal style.

Different lenses will give different interpretations of a building's setting. With a wide-angle lens you can move in close and sometimes isolate the building from the immediate cluster of surrounding houses, or, by using a long-focus lens from a distance, you can show its true proportions.

With lighting you must deal with the vagaries of natural light in the

same way as in landscape photography. Usually, the low sunlight of early morning or late afternoon will bring out form and detail. Unlike landscape photography, you may be so restricted in your camera position that this alone will determine the time of day for the shot. Silhouetting the building against the sun, and catching the sun's reflection in windows (particularly with modern office blocks) are two obvious ways of using natural light for a dramatic effect. At night, the floodlighting on many historical buildings – particularly if there is a sound-and-light show – is often to a high standard, and may offer the best lighting of all.

A technical problem specific to architectural photography is converging verticals. Holding the camera at an angle by, for example, pointing it upwards to get the top of a building into the picture, means that the film is also at an angle to the subject and this results in distortion of the image. Unless the camera is level, parallel lines in your picture frame will converge. This effect appears at its most disturbing when the vertical lines of a building converge upwards in a picture taken at ground level. Although this is just the way any building appears to us when we look upwards at it, the brain accepts this distortion from experience, except when it is presented as a two-dimensional image. Deliberate and extreme convergence can be acceptable for effect or compositional reasons; more moderate angles can appear unintentional or be less effective.

There are different solutions to this problem: move further away and use a long-focus lens: use a higher camera position opposite the building: compose the picture with a wide-angle lens aimed horizontally so as to include the foreground and remove distortion: or finally, use the specialized perspective-control or shift lens described on p 46.

Trans-America Building. The sides of this well-known San Francisco building (below) actually do converge to a point; a close wide-angle view merely exaggerates this convergence.
Nikon, 20mm, Kodachrome, ¹/₃₀sec, f5.6.

Using a perspective control lens

Normal lens

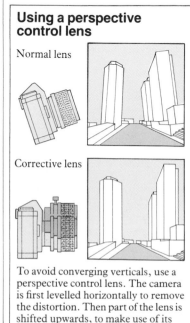

Corrective lens

To avoid converging verticals, use a perspective control lens. The camera is first levelled horizontally to remove the distortion. Then part of the lens is shifted upwards, to make use of its extra covering power.

Skyscrapers, Manhattan. This is a perfect example of a situation where converging verticals have been used expressly for their dramatic effect (below). The photographer made a point of finding two matching buildings to lend symmetry to the composition.
Photo: Tony Weller.
Nikon, 24mm, 1/125sec, f11.

Exterior details. Textures, patterns and embellishments can make interesting studies; as with photography of interiors, they provide a visual relief from the expected overall views of complete buildings. As only a few exterior details are close to ground level, a long-focus lens is usually necessary to be able to isolate them. Large areas of glass can sometimes show interesting reflections such as these in downtown Washington DC (above). The figure of a saint was set in the wall of a small village chapel (left). The carved wooden figures gracing the façade of a Tudor building in Chester (below left) are a well-known feature of the city's architecture. The texture of brickwork is best conveyed by raking sunlight (bottom left). The church gargoyle (below) was accessible by standing on an adjacent parapet.

St Pancras Hotel, London. For this interior shot of a Victorian hotel (below), the only illumination was daylight through the windows. Supplementary artificial lighting might have added detail but I felt it more important to preserve the atmosphere. To compensate for the reciprocity failure, a CC10 filter was used. *Nikon, HS Ektachrome, 20mm, 8 sec, f16.*

Interiors

Working inside buildings is often more of a challenge than photographing their exteriors. Even an extreme wide-angle lens can show only part of an interior, and can introduce some startling distortions, while the balance of lighting, particularly in large interiors, is often very uneven.

Choose your camera angle with care. You cannot include everything in one view, so select a position from which you can see the most important elements, and from which you can convey the right sense of space (if the room feels claustrophobic, there is no need to make it look like a warehouse, but if it has empty, open spaces, show these). It is usually difficult to include both the ceiling and other parts of the interior – it may be better to photograph the ceiling separately, if it is important. In any case, you will almost certainly need a wide-angle lens. As with architectural exteriors, deliberate and definite converging verticals can work very well, but slight convergence looks like carelessness, which it often is. If you can, re-arrange furniture and other movable objects to give the best composition. To our eyes, a room usually appears tidier than it really is, and unless you want a cluttered impression, a little cleaning is worthwhile.

Lighting

Lighting must be considered carefully at the start. The imbalance of lighting in most interiors creates a high contrast, with pools of light and areas of darkness. If the walls are dark, the illumination given by a window will fall off rapidly away from it. However, before immediately bringing in supplementary lights to fill in the shadows, consider the mood of the interior. Perhaps the very unevenness of the lighting gives the interior a special atmospheric quality. This is particularly true of many historical interiors; before electricity or gas-lighting, a good architect designed interiors to work as well as possible with existing window light.

Given that the style of lighting is subjective, there are several ways of altering the balance. Assuming that natural window lighting is the basic light source, there will hardly ever be sufficient light to work without a tripod, particularly as maximum definition is nearly always desirable, and this requires a small aperture. Compensating for reciprocity failure (see p65) will enable you to increase the exposure time, and exposures of several minutes are quite possible. One coincidental advantage of this is that the movements of people can become so blurred during exposures of several seconds that they do not even record on the film; this is a real help in public places like churches and museums.

With supplementary lighting, one cardinal rule is not to allow these additional lights to be obtrusive. If, for example, you aim a direct spotlight into a shadow area from outside the picture frame, then the hard shadows will "point" to the extra light, and the effect will be artificial. Supplementary lighting from outside the picture frame is better when it is diffused, and therefore less noticeable. For parts of the interior that you cannot light in this way, place concealed lights that could appear to the viewer to be part of the existing lighting. In a church, for example, lights can be placed behind the pillars facing

Swimming pool, Chester. The cheerful clash of colors in this new English public swimming pool (right) makes a sharp contrast with the other, traditional interiors shown on these pages. The principal lighting was fluorescent, but the color scheme is so flamboyant that the slight green cast is hardly noticeable. *Nikon, 30mm, Kodachrome, 1sec, f3.5.*

Plantagenet House, Sussex. The open bible was an essential part of this 15th-century bedroom (above). In this position it filled in the otherwise empty foreground, and balanced the image of the bed. The principal illumination was daylight, with an added diffused light aimed downwards at the bible. *Nikon, 20mm, Kodachrome, 1/8sec, f5.6.*

Interior detail. A horse-shoe studded gate in the Indian palace of Fatehpur-Sikri (below), and some fine Victorian tile-work (bottom) are two examples of interesting architectural details that can be found in interiors. Here they provide a useful change of pace from the normal scale of interior views. *Both: Nikon, 180mm.*

Equipment checklist

1. Camera body, preferably with a removable prism head.
2. A ground glass screen etched with grid lines, for aligning verticals and horizontals.
3. Spirit level, for levelling the camera.
4. Lenses: A wide-angle lens or, even better, but very specialized, is a wide-angle perspective control lens, with shift movements. For isolating details, and for working at a distance, a long-focus lens.
5. Tripod and cable release.
6. Filters: Yellow, orange, red and polarizing filters for controlling sky tones; a set of color correction filters for adjusting color temperature in interiors and to compensate for reciprocity failure.
7. Film: Fine-grain film, in both color and black-and-white, meets the need for high definition, but fast film may be needed in poorly lit interiors.
8. Lighting: A complete set of tungsten lights if you are going to work completely in artificial light. Otherwise, a pocket flash for fill-in or "painting",
9. Masks to shade lens from bright light sources; white card reflectors; large diffusing sheet and black velvet, both for covering windows.

Stained glass windows

To keep verticals parallel, photograph the windows from an elevated position, or, as below, use a long-focus lens from a distance. A lens shade reduces flare.
Nikon, 400mm, Kodachrome, ⅛sec, f8.
Bottom: An alternative to daylight is to photograph from the outside using the interior artificial light.
Nikon, 400mm, Kodachrome + 85B filter, ½sec, f5.6.

Saxon church, England. The small interior of this old church (right) was adequately lit by daylight, with the door behind the camera to the right opened to fill in some shadows. The candlelight was purely decorative, but by avoiding extra artificial lighting the historical sense of the church was maintained. By elevating the camera to the full tripod extension, I was able to shoot horizontally and avoid converging verticals while keeping a tight composition. If the camera had been lower, the top of the window frame would have been cropped off, and empty floor would have filled the lower part of the picture. Alternatively, I could have used a perspective control lens.
Nikon, 28mm, HS Ektachrome + red filter for reciprocity failure, 60 secs, f22.

away from the camera. If you do not have enough lights for a large interior, make a multiple- or time-exposure, moving one light from one place to another. This technique is sometimes called "painting with light" and is especially easy with a portable flash unit.

Opening doors can also help lighten dark areas, as can switching on the existing tungsten lights. Blue-coated bulbs can be used to replace those in existing lamp-holders, to restore the color temperature to that of daylight film, although, when tungsten lighting is *subsidiary* to natural daylight (such as a small table lamp), it can look quite acceptable without correction.

It is very difficult to include the main window in the picture and overcome the enormous contrast between the outside scene and the interior, even with the help of supplementary lighting. One tricky solution is to make a double exposure – first exposing for the view outside, and then covering the window completely with black velvet and exposing for the interior with artificial or existing light. Striking the right balance takes experience.

Archaeology

Photographically, archaeological subjects have much in common with architecture, and in the case of, say, the Acropolis, or the Mayan ruins at Tikal, they may be one and the same. However, the condition of many archaeological sites and excavations, and their fragility, cause some special problems. There are often more restrictions to photographing them, and because of the state of the remains it may be more of a challenge to recapture the feeling of the period. What is essential for any useful kind of archaeological photography is a knowledge of the subject. Many aspects of an archaeological site are not immediately obvious, and you may need the help of a guide or guidebook. It is worth studying the site in advance if you intend to produce photographs that are technically useful. For instance, if a particular carved stone is associated with a specific temple on the site, it would obviously be important to show both in the same photograph.

Because the majority of sites are protected, you must first check to find out if you need special permission. Tripods are often banned,

Temple of the Jaguar, Guatemala. The jungle around this Mayan site (top) helped to create atmosphere, and I took the shot just after sunrise to take advantage of the mist.
Nikon, 28mm, Ektachrome, ¹/₁₀sec, f5.6.

Newspaper Rock, Arizona. In the dry desert air, these Indian rock carvings (above) had remained remarkably clear. To show them in their setting, I used a wide-angle lens, staying close to the petroglyphs to keep them prominent.
Nikon, 20mm, Kodachrome, ¹/₆₀sec, f6.3.

Bull's Head, Persepolis. Detail shots are an essential part of archaeological photography. In the case of an arch detail, I waited until late afternoon for strong cross-lighting (above right).
Nikon, 180mm, Kodachrome, ¹/₁₂₅sec, f9.

although you may be able to use one if it has rubber feet and you inform the relevant authorities in advance.

For comprehensive treatment of the subject, divide your shooting into pictures that give an overall view of the site and attempt to evoke its mood, and detail work that covers the important points of interest. The former is usually much more difficult, and, with restricted viewpoints, you are usually at the mercy of natural lighting to provide interest. Watch out for anything modern that intrudes on the picture, such as adjacent buildings or electricity pylons. Of course, in a few instances the great contrast between an archaeological remain and its surroundings can be exploited to make a more effective picture.

In museums, archaeological exhibits are obviously subject to even greater restrictions than sites, and many of the procedures outlined on page 209 apply. Having gone to the trouble of obtaining the permission and co-operation of museum authorities, never touch any of the exhibits yourself; leave all handling to the museum staff.

Copying

IN COPYING PAINTINGS, drawings and other flat artwork, the original enables you to take a measure of your success, since the ideal is generally faithful reproduction. The film itself, particularly if you are working in color, will introduce its own differences, and dyes and chemical processes vary between makes. Most obviously, you should select the film to suit the subject – fine-grain color film (one that can be user-processed if you want additional contrast control) for color work, a slow panchromatic film for continuous-tone black-and-white originals, or lith film for engravings and pen-and-ink drawings. If you are making a color copy, and the photograph is intended for publication, always include a standard color reference in the picture – a Kodak Color Separation Guide taped to the picture frame allows the printers to match the colors without seeing the original.

Alignment

For copying, align the camera so that the film plane is exactly parallel to the original. The simplest method with small pieces of artwork is to lay them flat on the floor or on a table, and point the camera vertically downwards. A spirit level on the camera back will give good alignment, but the best way, with a single lens reflex, is simply to place a small mirror flat on the surface of the original; adjust the camera until the reflection of the center of the lens is in the center of the viewfinder. You can use this method with originals that are flat against a wall. With a painting the only way is to measure the angle at which it is hanging, preferably with a clinometer, and align the camera accordingly. Any of these methods are possible with a direct viewfinder camera, but more complicated because of parallax error.

Lighting

Once the camera is in position, adjust the lighting. Tungsten is more convenient than flash because you can see the precise effect of each alteration, but you must block out any daylight or any other light that would affect the color balance. The most even lighting is with four lights, one at each corner, but if the original is not particularly big, two lights will work well enough. Placing the lights at an acute angle to the painting minimizes reflections, but accentuates any texture and can throw quite large shadows from a deep picture frame. The best compromise is usually 45° to the picture surface. To make the lighting as even as possible, aim each light at the opposite edge of the original;

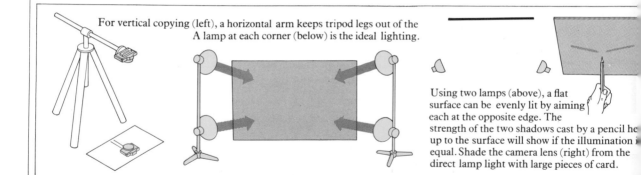

For vertical copying (left), a horizontal arm keeps tripod legs out of the A lamp at each corner (below) is the ideal lighting.

Using two lamps (above), a flat surface can be evenly lit by aiming each at the opposite edge. The strength of the two shadows cast by a pencil he up to the surface will show if the illumination i equal. Shade the camera lens (right) from the direct lamp light with large pieces of card.

19th-century woodcut. There is no need to use color film or even a continuous-tone film when copying this kind of artwork (above), as it contains no graduated tones, just lines of solid black. Line film is preferable because of its high contrast, and if a fine-line developer is used, a great amount of detail can be recorded.

Decorated capital letter. This illustrated manuscript on vellum (left) combines both flat artwork and a reflective surface – gold leaf. The standard lighting technique described here was used, but the lights were diffused and the camera aimed at a slight angle, so as to pick up reflections in the gold.
Both Nikon, 55mm Macro.

check the evenness by placing an incident light meter in the center of the original, pointing at the camera, and alternately shading it from each of the two lights (an even simpler method is to place the end of a pencil against a white card held flat against the original, and adjust the lights until the two shadows cast are equal).

Use a lens shade, mask off any large white areas around the original to cut down flare, and make sure that direct light from the lamps does not fall on the lens. If the original is framed in glass, screen the camera and yourself with black card or black velvet with a hole to fit the lens to eliminate reflections. Alternatively, use a polarizing filter over the lens and sheets of polarizing material over the lights.

Conservation

Copying paintings usually involves working in museums and art galleries, and quite apart from the precautions you would normally take not to damage originals, these institutions impose their own restrictions. Although the regulations in some museums might seem specially designed to frustrate photographers, most restrictions are necessary to conserve the exhibits. Objects containing organic materials, which includes practically anything painted, inevitably deteriorate under bright lights. Heat and ultra-violet are the chief culprits, and over a long period of time can cause serious fading, and worse. The Smithsonian Institution, for example, has the following regulations:

"1. Tungsten-halide lamps must be fitted with filters to remove both heat and ultra-violet radiation (eg, Colortran G-112-7 and Plexiglass U.F.3 respectively).

2. Reduced voltage should be applied to the lamps during preliminary setting up.

3. Lamps may be operated at full voltage only during actual photography.

4. Duration of photography should not exceed eight minutes without an equal interval of cooling."

In black-and-white, filtration and choice of film makes it possible to alter and improve originals. For instance, if the original has stains of a particular color, use a filter of the same color when making the copy – they will be less obvious in the print, and may not even register at all. Conversely, to enhance an image, such as the faded yellow common with old prints, copy through a filter of the complementary color.

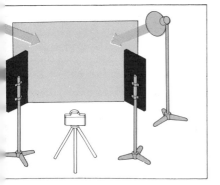

Equipment checklist
1. Camera body: single lens reflex, preferably with removable prism head.
2. Ground glass screen marked with rectangular grid, for alignment.
3. Masking tape, black and white card.
4. Tripod and cable release; a copystand for a more permanent set-up.
5. Clinometer, tape measure, spirit-level, hand-mirror.
6. Filters: color correction filters when working in color; in black-and-white, using colored filters (eg red, green, blue) will allow you to alter tonal relationship in a colored original.
7. Film: fine-grain film for maximum definition.
8. Lighting: two or four tungsten lights with stands.
9. Ultra-violet and heat filters for each lamp.
10. Polarizing sheets for each lamp, and polarizing filter for lens.

The studio

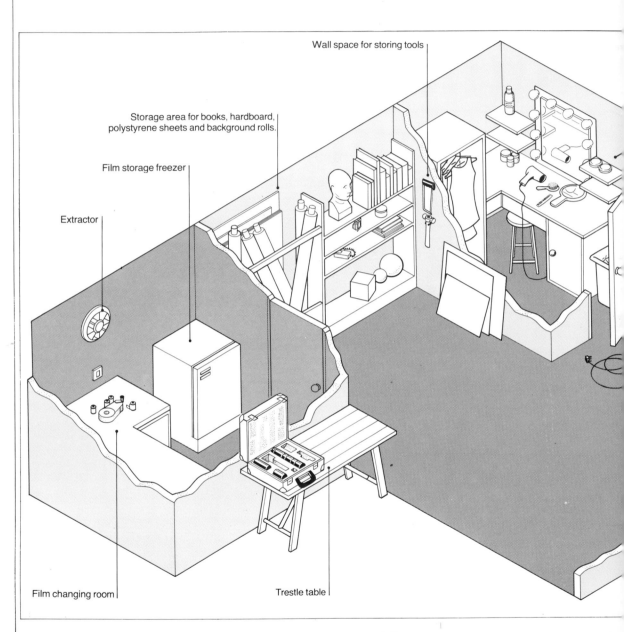

Wall space for storing tools

Storage area for books, hardboard, polystyrene sheets and background rolls.

Film storage freezer

Extractor

Film changing room

Trestle table

STUDIOS USUALLY HAVE to conform to available space, and specially designed, purpose-built studios are an uncommon luxury. The minimum requirements of space and shape are determined by the type of work that will be done in the studio – less room is needed for still-lifes than for portraits or fashion. When using seamless rolls as backgrounds for people, leave sufficient distance between the subject and roll for wrinkles in the paper to be thrown out of focus.

A high ceiling is an advantage, as it allows a greater range of camera positions. If there are existing windows, they will need to be blacked out, either by painting over or with a light-tight roller blind. With the windows sealed, an extractor fan is advisable, particularly in summer.

Light tight blind. Although existing windows can be painted over, a more flexible method of excluding light is to fit a special roller blind (right), designed to run in grooves to give a light-tight fit. The frame, fitted securely against a window, is part of the assembly.

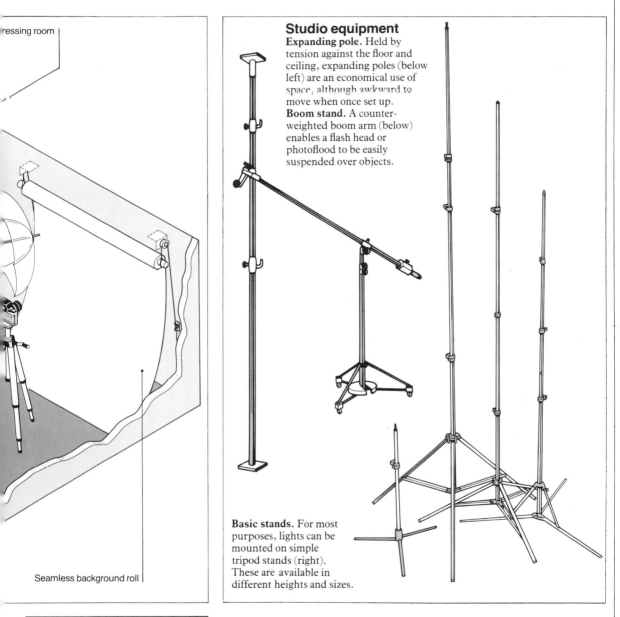

essing room

Seamless background roll

Studio equipment

Expanding pole. Held by tension against the floor and ceiling, expanding poles (below left) are an economical use of space, although awkward to move when once set up.

Boom stand. A counter-weighted boom arm (below) enables a flash head or photoflood to be easily suspended over objects.

Basic stands. For most purposes, lights can be mounted on simple tripod stands (right). These are available in different heights and sizes.

Keep the interior space as simple as possible, with movable rather than permanent fixtures for greater visibility.

The principal items of studio equipment are lighting and background. Once again, the type of studio work will suggest the particular equipment. The larger the subject, the more the lights will need to be diffused; greater light intensity may also be needed. Backgrounds vary from seamless paper rolls – the basic staple in most studios – to esoteric settings for specific still-life shots, such as pieces of slate or unusual cloths. In addition to lighting and backgrounds, a wide range of tools is also necessary – many shots require on-the-spot improvization.

Studio equipment

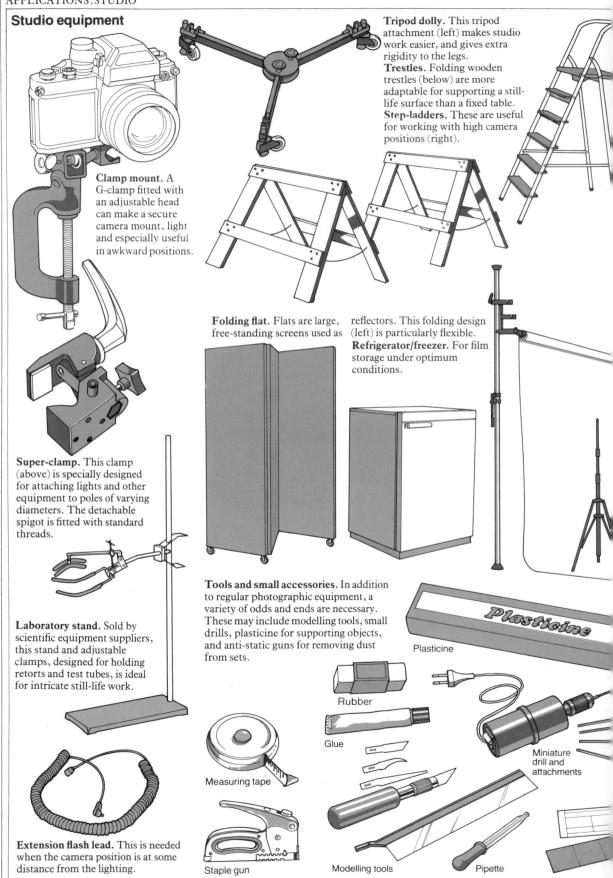

Clamp mount. A G-clamp fitted with an adjustable head can make a secure camera mount, light and especially useful in awkward positions.

Tripod dolly. This tripod attachment (left) makes studio work easier, and gives extra rigidity to the legs.
Trestles. Folding wooden trestles (below) are more adaptable for supporting a still-life surface than a fixed table.
Step-ladders. These are useful for working with high camera positions (right).

Super-clamp. This clamp (above) is specially designed for attaching lights and other equipment to poles of varying diameters. The detachable spigot is fitted with standard threads.

Folding flat. Flats are large, free-standing screens used as reflectors. This folding design (left) is particularly flexible.
Refrigerator/freezer. For film storage under optimum conditions.

Laboratory stand. Sold by scientific equipment suppliers, this stand and adjustable clamps, designed for holding retorts and test tubes, is ideal for intricate still-life work.

Tools and small accessories. In addition to regular photographic equipment, a variety of odds and ends are necessary. These may include modelling tools, small drills, plasticine for supporting objects, and anti-static guns for removing dust from sets.

Plasticine

Rubber

Glue

Measuring tape

Miniature drill and attachments

Extension flash lead. This is needed when the camera position is at some distance from the lighting.

Staple gun

Modelling tools

Pipette

Wind machine. A specialized piece of equipment (above) used principally for fashion and beauty shots where the model's hair needs to look windswept.
Background rolls. These rolls of thick paper (left), normally 9ft (3m) long, are available in different colors and are a mainstay of studio portrait photography. One method of supporting them is a cross-bar supported between expanding poles.

Zerostat gun

Scissors

Metal and plastic rulers

Studio lighting

For the enormous variety of work undertaken in the studio, there is every conceivable style of lighting equipment to choose from. To achieve precise lighting effects for specialized subjects, many photographers construct their own diffusers and reflectors, or adapt commercial makes. The light source is normally either flash or tungsten, but the style of lighting varies from precisely-focused spots to completely diffuse, all-round illumination.

One type of illumination has always had a justifiable appeal – large-area directional lighting. Its origins lie in the traditional "north light" of an artist's studio and some sophisticated box-like reflectors provide a perfect imitation of a window up to 5ft×4ft (1.5m×1.2m) in area. Less expensive alternatives are large umbrellas, frames covered with translucent material and large white areas (even walls) off which to bounce light.

A specialized technique of some importance is lighting backgrounds evenly – not easy over an area large enough to cover a few people. The best method is to use two purpose-built strip-lights, each arranged vertically on either side; if you aim each beam to the opposite edge of the background, just as in copy lighting, the result will be even illumination.

Tungsten lighting

Although now largely superseded in professional studios by flash, tungsten lighting has the advantage of being relatively inexpensive and better able to light very large areas (through increasing the exposure time). Its major disadvantage is the inconsistency of the light output, particularly the color temperature.

Tungsten lamps used in photography are essentially up-rated versions of domestic light bulbs; consequently they have shorter lives, some as little as 2 to 3 hours. They have color temperatures of either 3200°K or 3400°K, compared with about 2800°K for domestic lamps. With use, the tungsten in the filament gradually forms a deposit on the glass envelope, reducing the light output and color temperature. One answer to this problem is the quartz-halogen lamp, in which vaporized tungsten disperses in the halogen gas and re-deposits on the filament. The output and color thus remain constant, but as high temperatures are necessary, quartz is used instead of glass as the envelope.

In fact, any tungsten lamp, even the low-wattage domestic type, can be used in photography, provided the color temperature is known and compensated for with color-correction filters. A color temperature meter should be used for complete accuracy in studio work.

Designs of tungsten lights vary considerably, from small, compact units, such as the Lowell Totalite (left) to the larger spotlights normally used in film studios.

Tungsten lamps are available in different intensities: (a) Clear spotlight lamp with coiled filament gives high intensity; (b) Reflector bulb is partly silvered inside; (c) No. 2 photoflood; (d) Regular photoflood.

Lighting

Reflector attachments. This basic Magnaflash flash head with flash tube and modelling lamp accepts a variety of attachments – general purpose or wide-angle reflectors, barn doors, and different shapes of snoot.

Diffuser attachments. Different degrees of diffusion can be achieved with attachments that vary from plastic opalescent discs to a large shallow bowl fitted with a cap that blocks off direct illumination from the flash tube.

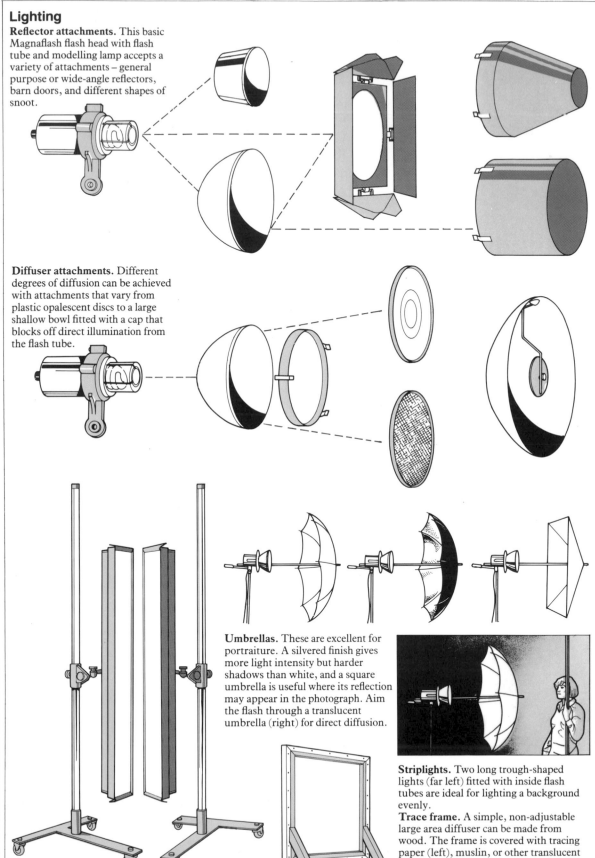

Umbrellas. These are excellent for portraiture. A silvered finish gives more light intensity but harder shadows than white, and a square umbrella is useful where its reflection may appear in the photograph. Aim the flash through a translucent umbrella (right) for direct diffusion.

Striplights. Two long trough-shaped lights (far left) fitted with inside flash tubes are ideal for lighting a background evenly.

Trace frame. A simple, non-adjustable large area diffuser can be made from wood. The frame is covered with tracing paper (left), muslin, or other translucent cloth.

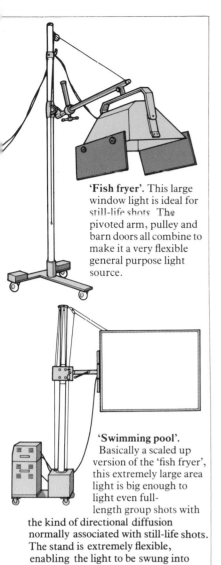

'**Fish fryer**'. This large window light is ideal for still-life shots. The pivoted arm, pulley and barn doors all combine to make it a very flexible general purpose light source.

'**Swimming pool**'. Basically a scaled up version of the 'fish fryer', this extremely large area light is big enough to light even full-length group shots with the kind of directional diffusion normally associated with still-life shots. The stand is extremely flexible, enabling the light to be swung into different positions (below).

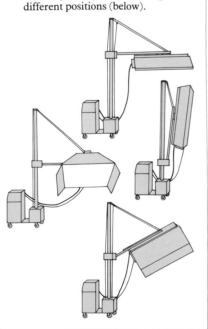

Electronic flash

The scale of studio flash equipment makes its handling characteristics quite different from those of the more familiar hand flash guns (see p 89). At the heart of the studio flash system are high-voltage capacitors with sufficient output to meet the needs of small-aperture studio work. Output is measured in joules (watt/seconds) – as a very approximate guide, 1000 joules diffused through a 2-foot square (·6m square) window light placed 2 feet (·6m) from the subject would let you use an aperture of f 22 or f 32 with ASA 64 film. Fractions of the total power output can be selected, the actual amount of light being controlled by the duration of the flash.

Studio flash systems can be either in the form of a separate power-pack connected to several heads (varying amounts of power can be switched through each head) or in the form of a single integrated unit that combines power and head. The latter design is increasingly popular for its convenience and portability, and although its power output is limited, it is sufficient for most 35mm lenses, which do not stop down as much as large format lenses.

Flash tubes are normally filled with xenon gas, and are commonly ring-shaped, spiral or linear. They are generally balanced to a color temperature of about 5500°K, but different reflectors and diffusers will alter this. For setting up the shot and focusing, a tungsten lamp or fluorescent tube is fitted close to the flash tube, to give representative lighting.

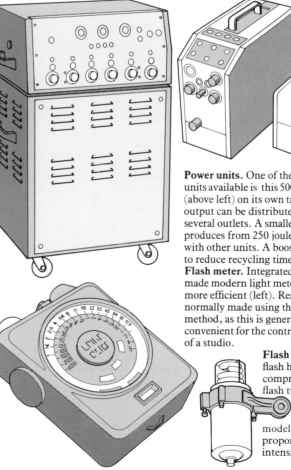

Power units. One of the most powerful units available is this 5000-joule console (above left) on its own trolley. The output can be distributed variably to several outlets. A smaller unit (above) produces from 250 joules up to 1000 with other units. A booster can be used to reduce recycling time.

Flash meter. Integrated circuitry has made modern light meters smaller and more efficient (left). Readings are normally made using the incident light method, as this is generally more convenient for the controlled conditions of a studio.

Flash head. A typical flash head (left) comprises a gas-filled flash tube, coiled for compactness, and a modelling lamp with proportionate intensity.

Portraits

GENERALLY, STUDIO PORTRAITS differ from environmental portraits (see p 126) in that they tend to be more deliberate, more formalized and more controlled. The subject is being brought to a location of the photographer's choosing, and most of the photographic elements, in particular the lighting, can be perfected.

For the beginner, the initial confrontation with the subject can sometimes be a little unnerving; the person who is sitting for you is waiting to be directed and is, in effect, expecting you, the photographer, to make all the decisions. To become accustomed to this kind of situation, it is usually a good idea to start by photographing people you know quite well.

As with environmental portraits, you should make some rudimentary decision about what you want the photograph to show, in other words, what aspect of the subject's personality or appearance you want to depict. You can then approach the session more decisively. The success of the outcome can depend on a mix of elements, including the relationship between you and your subject, the composition, the subject's pose and the lighting. Technical matters such as choice of lens and film also have an obvious effect, but

these are normally straightforward enough to be less of a consideration than the chemistry of the session itself.

In choosing the theme of the portrait, look for anything notable in the subject's outward appearance, a craggy face, lithe figure, or a high cheekbone structure, for example. Generally speaking, if he or she has strong features, you will have less difficulty in making a strong portrait. Many people, however, have less obvious characteristics and you may have to resort to some devices in order to bring life and interest to a bland face.

Perhaps more than anything else, the level of rapport between photographer and subject – or lack of it – determines the general content of a portrait. This is especially true of people who have no experience of sitting for a photographer (actors or public figures have

Jon Anderson. This cover for the *Sunday Telegraph Magazine* (above left) was shot when Anderson, having made several records with Yes, was putting together an album by playing all the musical parts himself. To show his versatility as a musician, I made this triple exposure, moving the single diffused light to the opposite side for the third shot. By using a black velvet background, the multiple exposure was kept clean, and Anderson's dark, long hair and cape made a good natural blend between the three positions.
Nikon, 50mm, Ektachrome, flash sync, f11.

Lieutenant General Shojo Sakurai. The strength of this portrait of a Japanese general who fought the British in Burma in the Second World War is in the timing of the shot. The interest clearly lies in the man's past, and the photographer, Snowdon, managed to capture a deeply-felt moment of reminiscence. "The war was wrong," said Sakurai, "because we couldn't have won it. We should have stopped with Manchuria."
Photo: Snowdon.

usually learnt the skill of striking attitudes at will, which can sometimes be at odds with the photographer's intentions). Some portrait photographers exert a very definite influence over their subject in order to create what they want; and the fact that they are on home ground, the studio, makes this easier. Richard Avedon's portraits are often unsettling in the depths that are revealed with apparent simplicity. They are rarely reassuring or comfortable, and he has stressed the importance of the studio as a means of isolating the people he has photographed.

Another device is to put subjects at their ease by making light conversation, or by encouraging them to talk about themselves and so allow them to suggest, even unwittingly, the way that the session develops.

Portraits by Arnold Newman. The portrait photography of Arnold Newman has a strong unmistakable style, owing as much to his studied approach to the personality of the sitter as to his often striking composition. A particularly well-known technique of Newman's is to integrate his subjects with settings relevant to their work or activity. Strong side-lighting brings an element of tension to the photograph of Norman Mailer (left), while British sculptor, Anthony Caro (bottom), becomes a controlled element of his own work in the kind of geometric composition for which Newman has become recognized. By contrast, the high-key grainy portrait of Marilyn Monroe (below) contains no outside elements, focusing exclusively on a precisely captured expression of vulnerable beauty.
Photos: © Arnold Newman.

Composition and pose

Composition is one very obvious technique for controlling the portrait, and does not need the close involvement of the subject. Clearly there is more scope for strong composition when the scale of the picture is different from the more usual full-face or head-and-shoulders portrait. Close-ups can be striking, so that the subject's face fills the frame, although the intimacy of this approach and the "warts-and-all" detail will not necessarily suit every sitting. Pulling back from the subject gives more choice of composition. One of the greatest exponents of the strongly composed portrait is Arnold Newman, whose striking and graphic compositions lead the viewer's eye forcibly around the picture. One of Newman's most favored techniques has been to use props relevant to the subject as the key element in the composition.

The pose can be studied or unconscious but, whichever it is, you should keep it under your control. Left to themselves, most people fall into a specific attitude; if you allow this to happen, make sure that it is suitable for what you want. Where you place the subject at the start will influence their natural pose – sit someone on a high stool and their shoulders will naturally slump forward and they will tend to feel uncomfortable; stand them against a wall and they will probably lean against it; put them in an armchair and they will normally spread out and relax; tables and desks encourage hands and elbows to rest on them. If you intend to control the pose yourself, it is usually better to encourage attitudes silently by providing these kinds of props rather than baldly to ask the subjects to arrange themselves in precise positions. A self-conscious pose often communicates itself through the photograph.

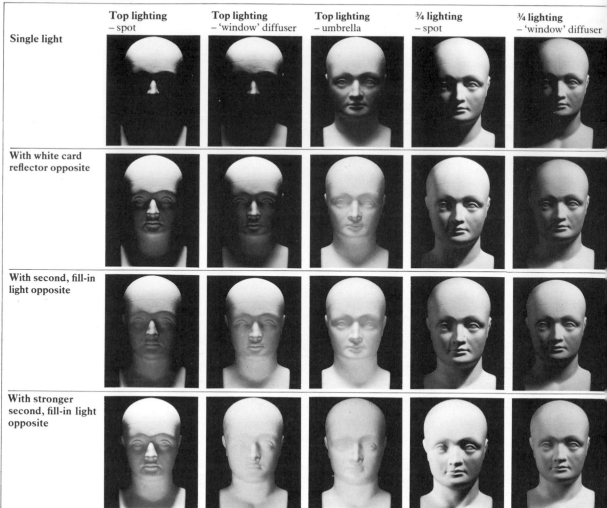

	Top lighting – spot	Top lighting – 'window' diffuser	Top lighting – umbrella	¾ lighting – spot	¾ lighting – 'window' diffuser
Single light					
With white card reflector opposite					
With second, fill-in light opposite					
With stronger second, fill-in light opposite					

Lighting

Because it is easy to demonstrate, lighting is often treated as the main element in portraiture. However, it is possible to become too caught up in the minutiae of light positions, catch-lights and facial shadows. In the end, lighting should be subservient to your overall treatment of the subject.

Lighting styles for portraiture go through fashions, and nothing shows this more clearly than the evolution of fashion photography (see p 222). One extreme of lighting techniques was reached in Hollywood glamor photography of the 1930s with the use of a large number of carefully controlled spotlights, some accenting certain areas of the face, others filling in shadow areas precisely. The effect was quite glittering, being influenced strongly by cine lighting methods of the period, and its practice was time-consuming. Close to the other extreme was the single-umbrella technique that became particularly popular in the 1960s. Here, a large umbrella reflector was used, normally quite high in a three-quarters position to give a flatter, starker effect. It evolved partly as a reaction to the formal stagey styles of the 1950s and was made possible by the growing use of studio flash units that were powerful enough to light a person with a single lamp.

Even more extreme techniques were occasionally used. The direct frontal illumination given by a ring-flash results in completely shadowless lighting (and sometimes also a peculiar red reflection on the back of the retina). Consequently, there is virtually no modelling,

Basic lighting for portraits

The choice of lighting combinations in studio portraiture is almost infinite, and depends on personal taste as well as the subject. The most straightforward of all portrait formats is the full-face head shot. To illustrate some of the basic possibilities, the model head (above) was photographed with a main light in five different positions (top, three-quarters, side, front and back), with different degrees of diffusion and with varying amounts of supplementary lighting. These are by no means the only alternatives, and there are, in any case, subtle differences within the basic positions. Remember that in most portraits the eyes are the chief focus of interest, and the lighting may be determined by their appearance. Generally speaking, eyes can be brought to life by making sure that they catch the reflection of one light.

To begin with, position one main light for the principal illumination. Diffuser attachments (see p 214) control the shadow edges. Then, if necessary, add reflectors or fill-in lights to control the shadow density.

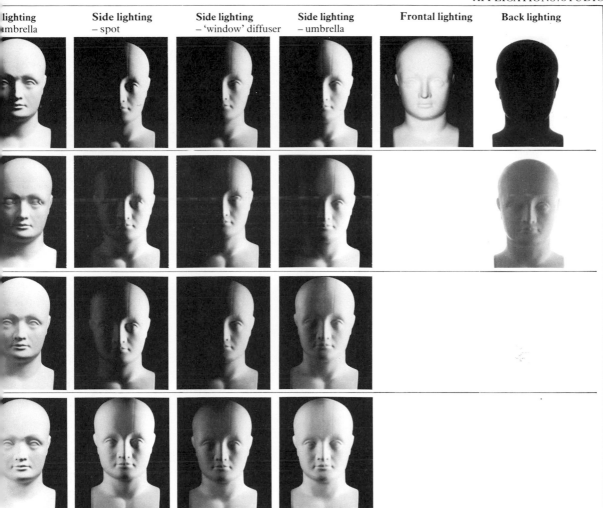

lighting umbrella	Side lighting – spot	Side lighting – 'window' diffuser	Side lighting – umbrella	Frontal lighting	Back lighting

and for this kind of lighting strong make-up is an advantage. Another unusual lighting direction is from below. A cliché of horror films, this lighting seems bizarre because it rarely occurs in real life.

If you use several lights, only one should be dominant. Secondary lights or reflectors can then be used either to control shadows and contrast, or to accent particular parts of the subject, such as the hair. The examples on these pages use a variety of techniques demonstrating that there is no ideal method, merely alternatives.

Studio light sources can be natural daylight, studio flash or tungsten lamps. Daylight, particularly if diffused by a large north-facing window, has attractive qualities, being soft enough to keep facial shadows gentle, yet being directional at the same time. It is, however, difficult to control and with color film you should monitor the color temperature carefully. Artificial lighting is generally easier to deal with, and more consistent. Even though the precise effects of the light cannot be judged before exposure, studio flash units are preferable to tungsten, which can heat up the studio uncomfortably and which normally require fairly slow shutter speeds. Umbrella reflectors are particularly useful as all-round light sources; silver coated ones give the highest light output, but are rather harsh, while translucent umbrellas can be used either to bounce light, or, by pointing them towards the subject, as diffusers. The larger the umbrella and the farther it is from the flash tube, the more diffused the light and the lower its intensity.

To emphasize the girl's hair (above) as much as possible, a single top light was used, fitted with a 'window' diffuser to give definite but softened shadow edges. The shadows below were filled-in very slightly with a white card placed on the floor. Finally, to make the hair glow, a soft focus lens was used.
Nikon, 105mm, FP4.

Fashion

FASHION PHOTOGRAPHY is more finely tuned to shifting styles and interests than almost any other field of picture taking. It is, in fact, a barometer of style, and a means of giving substance to the often subtle changes in the fashion industry. Ostensibly, fashion photography is about selling clothes and accessories, and although it would not exist without the commercial foundation of fashion magazines, couturiers and the clothing industry in general, there is more to it than that. An insubstantial subject would certainly not have attracted the talents of such photographers as David Bailey, Hans Feurer, Norman Parkinson naming only a few.One of the fascinations of fashion photography is that, being so completely concerned with the elusive subject of style, it virtually demands a sensitive, intuitive approach. It does not lend itself readily to cut-and-dried analysis.

The sense of style which is at the heart of good fashion photography applies both to the content of the shot and to its timing. The content includes choice of clothes, accessories, setting, model and make-up, and the overall mood. These items can largely be planned in advance, and the selection of clothes normally precedes everything else. Often a group of clothes is photographed at one session, and the most usual practice is to link them together in a theme. This theme may suggest itself by the very nature of the clothes – autumn colors, for instance, or evening dresses – or it may be artificially developed. Some of the most distinctive fashion photographers impose strong styles themselves on the clothes they work with.

The role of the model varies in importance. In catalogue photography, for instance, the models are often used to do no more than display the fashions. In a major magazine feature, however, the model may dominate the shots, and some models have developed powerful reputations, jealously guarded by the magazine or photographer who has nurtured them.

Given the components for the shots, the actual session itself usually needs fine timing to succeed. When the reaction and pose of the model are critical, the photographer has to establish a very precise relationship. The rapport between photographer and model does not have to be intimate or even cordial, but it does need to be controlled, usually to a greater degree than in most studio portraiture. Most professional models are familiar with the needs of the job and can usually respond quickly to the photographer's ideas.

Beauty make-up photography

Beauty photography is, on the whole, more practical in its approach than fashion work. Closely related to the cosmetics industry, it is chiefly concerned with the task of enhancing appearances. Nevertheless, a fine appreciation of style is still necessary, as beauty is itself a fashionable, changing, quality. Here, the choice of model is of paramount importance – more than anything else, she is modelling herself. Fashions in faces, hair, skin color, figure and other physical qualities change, but some things remain fairly constant. A pronounced facial bone structure, particularly high cheekbones, is nearly always good for photography, as it emphasizes shape. Age, too, is important in most cases, as skin texture and muscle tone are generally at their best in youth. And even the slightest tendency to plumpness

This deceptively simple shot by the most widely published of all fashion photographers shows how a striking pose and effective composition can be achieved with the minimum of props and the simplest location – bare boards and a wall in the corner of a studio. Pictures such as this owe much to the photographer's ability to seize opportunities quickly during the session, something that the 35mm camera is ideally suited to do. Photo: David Bailey/Vogue © Condé Nast Publications

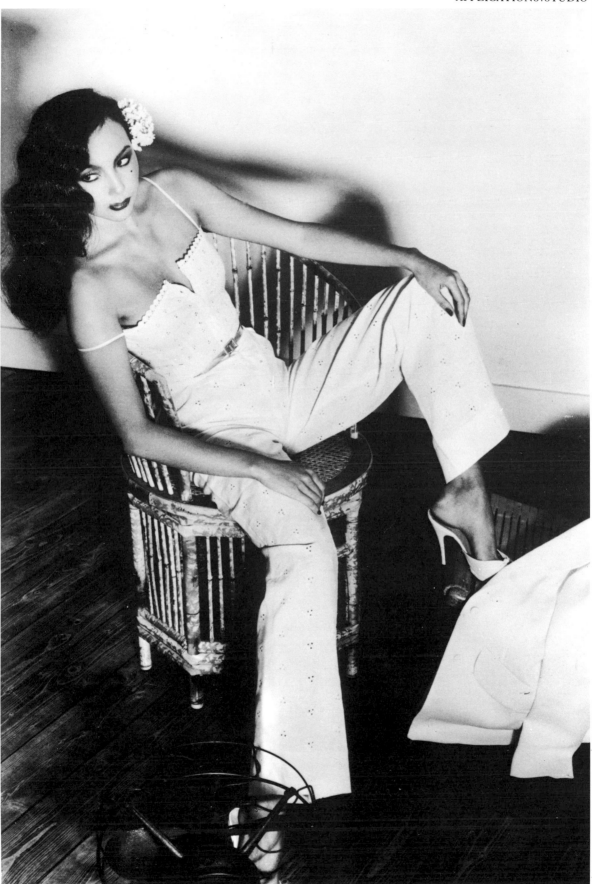

Direct eye contact and a slightly challenging pose create a strong sensuality in this promotional shot for a towelling bath-robe. Hard frontal lighting and a black background help to give maximum contrast to the composition, and make the robe appear a brilliant white against the model's skin.

Here, the use of theatrical lighting virtually creates the composition. With the top hat and bow-tie accessories, the shadow cast by a spotlight in imitation of stages lighting evokes a bright, stylish mood that complements the silk and velvet separates for evening.
Photo: Willie Christie

has not been generally fashionable for many decades.

Having chosen a good model, her make-up and styling are a matter for expert attention. Although most models can do this for themselves, a professional make-up artist can make all the difference. The sequence shown on page 226 shows what can be done with professional knowledge.

There is inevitably an element of perfection in most beauty photography and its aims are chiefly inspirational. The photographer, model and make-up artist are demonstrating by example, and the most acceptable examples seem to be those approaching the current ideal. Homely faces and figures do not generally inspire to the same degree.

Beauty make-up

Well-considered and carefully applied make-up is the most important single element in successful beauty photography. The structure of the model's face will dictate some of the techniques used, as will the lighting and the intended results.

By definition, professional models have good bone structures and complexions, and make-up has less to do with correcting problems than with enhancing the model's best features. Most models can suggest the make-up techniques that best suit their faces.

Make-up must also be applied to suit the camera. Normal beauty lighting is high frontal on three-quarters in position, well-diffused and with ample use of reflectors to fill in shadows. The sequence of photographs shown here was lit in this way, with an additional spot to light the background roll. Most make-up techniques go well with this effect, but harder, less diffused lighting needs smoother and softer make-up. Completely frontal lighting, on the other hand, is flat, and strong, so hard make-up can be applied. If black-and-white film is being used, avoid reds, which will record much darker than they appear in color. Brown is a good substitute, particularly when the same make-up is being photographed in both black-and-white and color.

The final effect can vary enormously. For example, it can be sophisticated (as shown here), natural, exotic, or dramatic. The purpose of the shot may be to advertise the particular product of a manufacturer, or to show a certain color combination. For most full-face shots, a moderate, long-focus lens, such as a 105mm, gives a good perspective. For close-ups of lips or eyes, a longer focal length is better.

1. Apply foundation. Start with moisturizer, and then apply the foundation with a sponge pad. The foundation does three jobs – it provides a basic surface for the shading and highlighting, gives an underlying color, and smooths the surface of the skin.

2. Highlight and shadow areas. Here an underlying shaping is applied, lightening areas that tend to fall into shadow, such as under the eyes, in corners of the base of the nose, and beneath the lower lip. Blend well into the surrounding area.

3. Powder. Powdering sets the foundation before the nex stages, and also flattens the shiny parts of the face. Take more than usual care over this as the camera will pick up irregular shiny patches if it is incorrectly applied.

5. Apply eye shadow. To give a wider appearance to the eyes, the eye shadow is brushed on more heavily at the outer corners. For the lids, the model should lower her eyes.

6. Apply eye highlights. To emphasize the highlighting position, apply the highlighter above the shadow, up to the eyebrows. This gives the eyes a more open appearance.

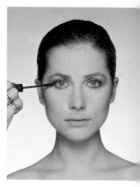

7. Apply mascara. As a fina treatment for the eyes, apply mascara to the upper and lower lashes, using an eyelas comb to separate the lashes from each other.

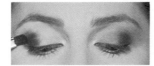

Heavy shading at outer corners

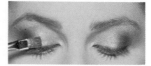

Delicate shading close to rim of eye

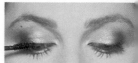

Mascara on upper lashes

A finer brush used under eye

Mascara on lower lashes

Apply shading. The shape of the face is now refined by shading and highlights. Here, this model's face needs little emphasis, chiefly under the cheekbones. To match the top lighting, some highlighter is applied above.

Shape and color lips. If the model has attractive lips, strong shaping and coloring is possible. First define the shape with a pencil liner, and then fill in with a slightly lighter color.

Lipstick put on with a brush

9. The final look. Complete the preparations by styling the hair. Make the final adjustments to the lighting and reflectors. Here, two large sheets of white polystyrene were placed on either side of the face, and the model rested her elbows on a sheet of crumpled foil. Slight over-exposure gives a smoother appearance to the skin.

Photos: Vince Loden
Model: Clare Park
Make-up artist: Celia Hunter

227

Still-life

THE STILL-LIFE image is the essence of studio work, where the photographer's ideas are imposed on a single object or a group. It is the most completely controlled type of image, and needs a rigorous and measured approach. Although the majority of professionals use view cameras for this type of work, most of the principles apply equally to 35mm cameras.

Its motivation may be commercial or personal, and its purpose may be as varied as to display a piece of merchandise, to evoke a period or mood, to create a new image for an everyday object, or to depict an abstract idea through a carefully chosen juxtaposition of objects and lighting. The flexibility of still-life work makes it a favorite vehicle for conceptual work, for example, on magazines, book and record album covers.

What is important is the sequence of building up a still-life composition. Even if the photographer starts with a given subject, so much control can be exercised over the outcome that it is easy to get lost in all the possibilities, or worse still, to miss the best opportunities. So, the most reliable approach is to work step-by-step.

Begin by defining the purpose of the shot, whether to focus on one object, for example, or to express an idea. Conveying a concept needs, by definition, a more intellectual approach and more forethought.

Try to work out a mental image of the shot in advance. Still-life photographers work in different ways, as this is a very idiosyncratic field. Some prefer to have a precise layout in mind at the start, even to the extent of sketches, while others would rather rely on their intuitive ability in the studio. To start with, it is best to have one or two basic ideas in advance, without being too rigid.

Collect together, with the object or objects that you are going to photograph, all the props that might be suitable. It is better to have too many props than too few – you can select them in the studio.

Decide on the background. You may choose to construct one purely out of props, or indeed fill the frame with the subject. Otherwise, you will have to lay down a background: should it be relevant to the subject or should it be abstract and isolate the subject? Should it dominate in color or texture, or should it be unobtrusive?

At this stage you can begin the arrangement. Because of the enormous control possible over the subject, there is normally little use for extreme lenses, although this by no means invalidates them. Decide on a basic lighting set-up, but don't worry too much about it at this point, as it is simply a temporary working arrangement; the final adjustments, and even major changes, can be made later, when you have defined the composition.

If there is one key object in a group, start by placing this. Play around with different arrangements, constantly checking the results through the viewfinder. Consider proportion and lines – you might use diagonals, for instance, to converge on a focal point of the composition, drawing the eye to the main element. You can use the distribution of lighting to do the same. If you are working with just a single object, examine it carefully and decide which are the qualities you most want to bring out.

One compositional tip: at some point remove the camera's prism head and examine the two-dimensional image on the ground glass

Making a color test

To check that the light, background and film are all perfectly balanced, use the basic still-life set described on p230. Take a Kodak color separation guide, gray scale, and any familiar handy object. (I use this skull simply because it normally lives on a shelf in the studio.) After processing, compare the transparency with the originals. If there is a color imbalance, use a weak color compensating filter of a complementary hue (05 or 10 will normally be sufficient strength).

Herbs. This shot (left) was taken for a magazine cover illustrating an article on herbal medicine. I planned a conventional still-life arrangement and the only problem was to make a tight pleasing arrangement.

The first step (1) was to assemble the principal elements in rough positions. The tubs were to form the background, and the book would dominate the foreground. For compositional interest, the book was then re-positioned to add diagonal lines (2). To fill in the now empty space in the lower right-hand corner, the edge of a tub lid was moved in, and some of the other containers re-positioned. To control the verticals, the 35mm perspective-control lens was then adjusted (3), and as final refinements, herbs were scattered in the foreground and the salt bag cut open to give a more casual, less ordered feeling.

screen. The elements of the composition will appear more nearly as they will in the final photograph.

Make the final adjustments to the lighting, bringing in reflectors or secondary lights to brighten shadow detail that you want to preserve. The whole process is therefore one of refinement, starting with many possibilities and narrowing them down to one preferred choice. As the still-life process is one of continuous decision, it is common for still-life photographers to deliver only one image at the end of the day (among advertising photographers the session commonly does take a full day, and sometimes longer). There is no need for rushed decisions.

Looking for props

In professional advertising photography there are full-time specialists called stylists, who will provide a full range of props to a brief. Often the choice of props can make the picture, and time and effort at this stage will pay off handsomely in the final photograph. Make it a rule never to accept second best, and always look for the highest quality.

Apart from your own possessions and those of your friends, which you can legitimately think of as your stock of props, there are some other useful sources.

In cities where there is an established photographic, television or

movie industry, there are specialized prop hire firms who will supply a wide variety of props, usually for weekly hire – anything from a stuffed tiger to an old quill pen. But be careful ; the condition of props like these is inevitably rather poor after constant hiring, and an object that may pass as part of a movie set room may be too tattered to stand the scrutiny of a still-life shot.

It is often possible to persuade an antique dealer to hire you some of his stock. The usual procedure is to pay a deposit of the full price, refundable less a hire charge when you return the object. Stores selling new merchandise are normally less willing to help, but some manufacturers can be helpful in return for some credit.

Street markets selling junk and antiques often have prices low enough to justify buying some props. Look out for the unusual and eye-catching – something that will give a touch of the unexpected.

Lighting

Lighting techniques are as many and varied as the still-life subjects themselves, and depend as much on the taste of the photographer as on the technical requirements of the object in front of the camera. It may be "correct" to use diffuse side-lighting for a wine bottle, but in the last analysis it is the photographer's own ideas that take precedence. The techniques on this page are some of the few that are well-defined, but one of the joys of still-life work is to be able to invent new combinations. Any light is admissible.

Top-light window

There is one extremely useful and basic lighting set-up that can be used as a starting point for many situations. This is the top-light window, often combined with a white laminate scoop. This set-up can cope with a surprisingly wide variety of subjects and has good technical credentials.

A window diffuser for a studio flash head (see p 215) can easily be built or improvised. Photoflood lamps cannot be used – because the window encloses the light (in order not to spill unwanted light) it can quickly build up excessive heat if used with a photoflood lamp; even with a flash head it is better to use a low-wattage modelling lamp. Position the light directly over the subject, pointing straight down. This directional but broad light source gives a generally pleasing range of highlights, and soft shadow edges, and a white surface underneath the subject will throw considerable light back into the lower shadow areas. If the white surface (laminate such as Formica is a good choice because of its even structure and lack of texture) is curved back to form a scoop, it can give the impression of an infinite background, heightened by the pooling of light from the window. When the subject is taken from a low angle, its top highlights will appear outlined against the dark background that grades smoothly from the white foreground. Pieces of white card and small mirrors can be used to reflect light and fill-in shadows.

Small movements of the light can create quite significant changes – move it back, angling to point forward, for stronger highlights and more drama; bring it forward over the camera for a frontal illumination that brings out more information from the subject.

Basic still-life lighting. For small objects without backgrounds, a simple set that gives consistently good results can be built with a table, clamps and a smooth, flexible white surface such as formica. The white sheet propped against the wall so that it falls into a natural curve, gives an even, seamless background to the shot. Suspending a 'window' light directly

"H.M.G." The image of a crown and letters being cut into a sheet of steel was simple, but the mechanics were a little involved. Because of fire regulations, it was eventually easier to move lights and camera to the welder's works. The basic light was a diffused flash, with an extra $^1/_{15}$ second exposure for the sparks. The shot was used to illustrate an article on state nationalization of industry.

overhead suits these Victorian dolls (below) perfectly – their heads and bodies are clearly lit against the shadowed background, while the skirts are well illuminated by reflected light from the white surface. A lower camera angle would show less white foreground, and a higher viewpoint less of the dark background.

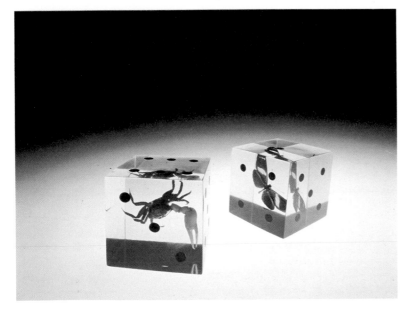

Acrylic cubes. A jacket illustration (left) for a book entitled "The Life Game" called for two specially constructed 'dice', each containing an animal. As the dice were transparent, backlighting was a natural choice. By laying a large sheet of opalescent Plexiglass on two trestles, the light could be aimed upwards from floor level.

231

Controlling shadows

Reflectors. These are necessary to fill in shadows without adding more lights. Hand mirrors of different shapes throw back the most light, but their effect is often very obvious. Crumpled foil glued to rigid card gives slightly weaker reflections, and plain white card gives even less but is least obtrusive. Shadows can even be deepened with black card.

Masking for flare. To improve contrast as much as possible with a standard still-life set, all parts of the background can be masked with black paper or card right up to the edges of the picture area. Small pieces make precise control easier. Check their placement visually through the camera's viewfinder. In a set like the one illustrated here, the shape of the picture area on the background will be roughly trapezoid.

The beauty of this set-up lies in its simplicity – the shadows all fall in one direction, and the highlights are also consistent, something that is difficult to achieve with a number of lights.

Using reflectors

A more elegant alternative to using several lights on one object is to re-direct the light from a single light source. You can grade reflectors according to their effectiveness – mirrors are the most effective, and a number of differently-shaped hand mirrors are useful for selectively filling in very dense shadow areas (they can also double as selective backlighting for transparent objects–see p 239). Cooking foil is also strongly reflective, but is more controllable if first crumpled and then pasted down onto a piece of card. White card gives a softer fill-in, and is particularly helpful when the object itself has reflective surfaces.

There is so much choice when working with reflectors that it is better to practice with one main light source before moving on to reflecting light from secondary flash heads. As a basic principle, choose and use reflectors so that anyone seeing the final photograph is not aware of them. Over-filling shadows is a common mistake.

A white background or a large area of back-lighting will cause flare, bouncing around the internal surfaces of the lens, reducing contrast, and generally degrading the image. If there is a large expanse of white outside the image area, the problem will be more severe. The solution is to mask; although a lens shade is helpful, masking is more precise and more effective at a distance.

To construct a mask, carefully arrange pieces of black card around the subject, just out of the picture area seen through the viewfinder. As an extra precaution, clip more pieces of black card onto supports to shade the lens from the light sources. If the photograph is for publication, and is to be used as a cut-out (see p 235), bring the pieces of black card right up to the edges of the subject; it will not matter if they appear in the photograph, as it will be re-touched in any case.

Lighting from beneath

A quite different way of lighting objects is from below, through a translucent surface. Because this lighting direction is not normal in everyday life, it seems rather unusual in a photograph, and has limited use, although with reflective and transparent objects it can produce interesting results. There are no particular technical problems, except that the object may need additional fill-in lighting from above.

Special problems

For the professional still-life photographer, immersed in the minutiae of daily studio work, there is a very wide range of objects that need special treatment, but for the less specialized photographer, highly polished and transparent objects are the most outstanding headaches.

Polished silver and other bright metal surfaces can reflect the lights, camera and everything in the studio as effectively as a mirror. Without special care, a photograph is likely to show a distracting collection of highlights and irrelevant reflections that can confuse the shape of the object itself. The basic principle in photographing these highly reflective surfaces is to choose carefully the things that will inevitably be

Gold plate. The Lamerie Plate (below), in the collection of London's Goldsmith's Guild, was too valuable to be moved to a studio. But it did need careful lighting to avoid distracting reflections in the mirror-like surface. A large sheet of translucent material was suspended over the plate, and two lights bounced off the ceiling for extra diffusion.

Silver container. The pot-pourri appeared unevenly illuminated with just a single diffused light source and reflector (top). The solution (above) was to construct a conical light-tent (below). Framing and focusing were arranged first, and a light-tent cut to size from tracing paper. Using only one light gave a degree of modelling.

reflected. For example, if the reflection is of a large sheet of white paper, it will not be particularly distracting. So, with a flat reflective surface, such as a silver plate, the problem can usually be solved by bouncing the light off a large white area and carefully positioning the camera.

Rounded surfaces, however, are more complicated, acting like convex or concave mirrors and picking up reflections from every side. The answer is to construct a "light tent" – a seamless translucent enclosure that surrounds the object as completely as possible leaving a gap only for the lens. (For small objects, a cone can easily be made out of tracing paper, leaving a hole just large enough for the lens to poke through.) The lighting is then arranged outside the "tent". Inevitably, with some objects, the lens will show up in the picture as a dark spot – if possible, angle the object slightly so that this appears in a less obtrusive place.

A last resort is dulling spray, commercially available from professional camera dealers. But it should be used with discretion; although effective in removing unwanted reflections, it can also render the object dull and lifeless. A possible alternative to dulling spray is to put

Glass flower and scissors. This still-life magazine cover (below), to illustrate an article on bankruptcy, contained two problem objects – glass and polished metal. Both could be handled by extremely diffuse lighting, provided here by a single light through a thick sheet of Plexiglass. Laboratory clamps held the two objects in place. To provide a subtle

tone for the background, a sheet of black
Plexiglass was also placed so as to reflect
the diffused light source; if it had
appeared completely black, the shadowed
edges of the flower and scissors would
have been lost. The reflection of the
flower in the blade was unavoidable
without harming the composition; it was
removed later by the printer.

Roman glass bowl. The subtle variations
of color in the glass (below) were best
captured by backlighting, but for texture
top-lighting was also necessary. A
window light was aimed at the
background, but adjusted so that a little
spilled on to the bowl (above). As it was
eventually to be printed as a cut-out, the
edges of the glass could be defined by
black card placed close-to.

the object in the freezer for half an hour – the condensation when it is
brought out into the studio will give a similar matte finish.

Glass and clear plastics can combine reflection with refraction, and
unless colored, tend to merge with their background. For the photo-
grapher, refraction is usually the most important quality of a trans-
parent object. It can be used very effectively with backlighting; not
only does this bring out depth in a glass object, it also reduces the
distracting reflections.

You can backlight by arranging the lights underneath a curved
translucent surface, as described on p 230, but a simple alternative is
to angle an overhead light so as to illuminate a plain white back-
ground.

You may decide to add a little frontal lighting to give form, but if
there are to be any reflections, make them simple. A rectangular
"window" light gives an uncomplicated reflection, and to achieve a
more naturalistic effect some photographers put strips of black tape
over the light to simulate the panes of a real window.

A secondary problem is to define the edges of the glass. This is best
done by placing black card or a dark object alongside, giving a dark
edge to the glass.

Illusions

To some extent, much of still-life photography involves illusion,
whether it be re-creating the mood of a period, or simply making a
background seem infinite. But, illusion applied for its own sake
requires a new catalog of tricks.

Suspending objects is the stock-in-trade of the photographic
illusionist. The single viewpoint of the still camera makes it relatively
easy to perform Indian rope tricks in front of it, since the mechanics of
the trick can be kept on the camera's blind side. However, a still
photograph can be subjected to scrutiny, and care must be taken to
hide tell-tale shadows and other evidence.

Back suspension is one of the most common methods of creating an

Suspended globe. To give the illusion
that the globe was floating in mid-air, it
was attached to the end of a horizontal
pole poking through a hole in the white
background with a well-diffused
overhead light placed well forward. Only
the globe and not the pole cast a shadow
on the curved white card.

Oil and hypodermic needle. For this magazine cover (below left) about the injection of oil into the Scottish economy, the hypodermic needed a hidden support through the blue background. The whole base was tilted forwards so that the oil would flow towards the camera and a top window light gave symmetrical reflections.

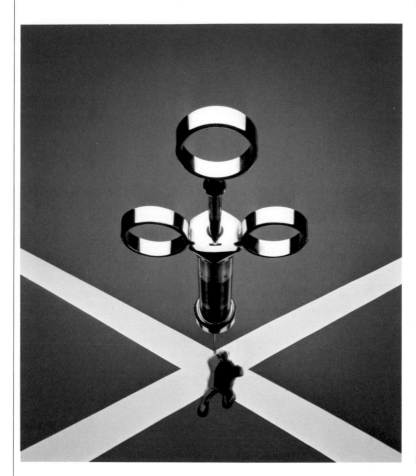

Whisky flask. In order to show the whisky in this hip flask tilting at an unlikely angle, the base of the flask was secured with double-sided adhesive tape, and the whole set tilted sideways. The camera was also tilted to the same angle so that only the liquid, obeying gravity, appeared wrong.

illusion. Fix the object to be photographed securely on one end of a horizontal bar, which projects through a hole in the background. While the shadow of the object can be visible – in fact, the closer it is to the background, the more effective is the trick of levitation – you can prevent the bar showing by using soft, diffuse lighting. On a black background, of course, the problem does not arise, but the illusion is less effective.

Threads and wires are a more obvious method of suspending objects, but less easy to conceal. Lighting is the key to their concealment, and by matching the background color and the thread, a thin thread will be invisible. Nevertheless, some re-touching may be needed (see p 272). If the background does not hide the thread, choose a thread that is slightly lighter in tone – it is easier to re-touch a light thread to make it darker than it is to remove tone. An uncomfortable alternative use of threads and wires is to suspend the object from the ceiling, pointing the camera upwards.

Horizontal-for-vertical is another gravity defying device, and can be especially effective with something that automatically obeys gravity, such as a liquid. Tilt the whole set – background, camera and lighting – to the horizontal. "Key" the illusion with an obvious surface, such as a shelf, and if possible, glue or nail the object to it

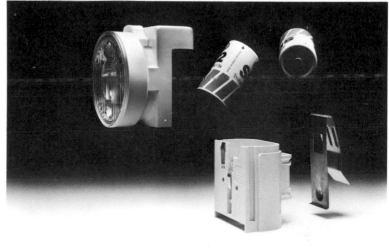

Bicycle lamp. This exploded view (above) was created entirely in the camera in two exposures. The first had the reflector and rear clip suspended by black cotton thread. The base of the lamp rested normally, and the shutter was released at the moment when the swinging parts both faced the right direction. The second exposure was of the two batteries resting against a black velvet background. The camera's ground glass screen was marked so that the two exposures could be properly registered. No re-touching was necessary on the final print.

Oil wealth. This illustration (above) called for a model pipeline. Even so, to have the nearby coins and far derricks both in focus was beyond the capabilities of even a wide-angle lens at minimum aperture. The solution was to create a false perspective by building the nearest pipe as a cone. The exact proportions were found by trial-and-error to suit the camera angle. Two lights were used, one overhead to illuminate the coins, the other covered with orange acetate placed beneath the set to bounce off the white wall behind.

rather than simply letting it rest against the new horizontal backdrop. A variation of this is to tilt the set to one side at an intermediate angle. Glass shots can be combined with this technique, placing the object on a sheet of glass that is well-separated from the background. Adjust the lighting and camera angle so as to avoid reflections in the glass, or use a lightly-textured non-reflecting glass.

Perspective distortion exploits the camera's fixed viewpoint, by creating an illusion of depth where none exists. This is done by building perspective into the set. A famous optical illusion used in studying the psychology of perception is the Ames Room, which is specially constructed so that part of the far wall is much further away than it appears to be. When two people stand in different parts of the room, one appears much smaller than the other, because the observer takes the room as the reference point and believes it to be normal. The Ames Room is an elaborate set, but its principle can be used on a more modest scale in the studio. The value of perspective distortion is in creating depth in the confines of the studio, and in compressing the set into the depth of field of the lens.

The whole repertory of illusory tricks is much larger than this list, but for more advanced illusions the image itself must be manipulated. The ways in which this can be done are described from p 246.

Food and cookery

FOOD PHOTOGRAPHY HAS become a studio specialization in its own right, not only because of the constant demand for food pictures in magazines, books and advertising, but also because it needs a standard of expertise every bit as great from the photographer as from the cook. In nearly every instance, the purpose of cookery photography, whether in advertising, recipe books or magazine features, is to present dishes and drinks in an appetizing and enticing way. With most prepared dishes great care must be taken so that the result appears correct.

The appeal of food is basically sensual and, as it is particularly difficult to convey taste and smell, you have to exploit the visual characteristics of food and setting. These include color, texture, ambience, display and composition. Texture can be conveyed by certain cooking techniques and by careful positioning of lighting. Ambience can be controlled with setting and the general quality of light.

Display and composition can be worked together; for instance, if a food appears close, filling the frame, then it tends to draw the viewer right into the picture as if actually eating.

Problems

There are two main areas of technical problem; first, ensuring that the presentation is correct by culinary standards, and second, coping with dishes which, because of their preparation or composition, are not photogenic. The first problem, authenticity, is particularly important if the food has to be presented in its ideal form or in an instructional way (for example, in recipes). In this case, it is essential that ingredients are of top quality and that the dish is presented and/or prepared according to the standards of the particular cuisine. Unless you are something of an expert yourself, you may need the services of a home economist or food stylist who specializes in the preparation and presentation of food for photography.

The second problem is foods that do not photograph as well as they look. This is particularly applicable to dishes that must be freshly made, such as souffles, gravies, and sauces with fat that can cause problems. It is best to prepare two dishes, a few minutes apart,

Vegetables and shellfish. The raw ingredients of cooking can make good subjects in themselves and are often a useful editorial counterpoint to shots of food preparation, or completed dishes. All the ingredients (right) were photographed for a book on regional Chinese cooking and vary from the commonplace to the exotic. (1) Chives and beans; (2) courgettes, chili peppers and aubergines; (3) a variety of pulses; (4) small crabs from the South China Sea; (5) Pacific shrimps.

1△2▽

3

Pickled onion and cheese. The purpose of this shot was to illustrate home-made pickling. The jar, therefore, was a critical item in the picture and the cheese merely a complementary addition. Side-lighting gave both good definition to the jar and showed off the texture of the cheese well. To bring the pickling vinegar to life, a piece of stiff foil was cut to shape and carefully angled behind the jar to throw reflected light through the liquid. For maximum contrast, a black background was used.

Nikon, 55mm, Kodachrome, flash sync, f32.

4

5

making photographic adjustments with the first dish and then, when everything is ready, quickly bringing in the second dish for actual photography.

Frozen dishes are also problematic. Studio lights can be hot and even the modelling lights of a flash unit will quickly melt ice-cream, ice cubes, etc. Occasionally, fakery is used; one notorious example is to substitute mashed potatoes for ice-cream. But, as most food and drink shots are basically informational, there is little point in showing something which is blatantly untrue. In some situations, such as in advertisements, it may also be against the law. Acrylic ice cubes, which are specifically made for the purpose of photography, are widely used among professionals and are usually accepted on the grounds that they do not actually have any effect on the drink.

Most dishes are hot, yet it is particularly difficult to show this in a photograph. It is not always important, as most people seeing a picture of a meat stew, for example, will automatically assume that it *is* hot, and their perception of it will not need the reinforcement of rising steam. Nevertheless, when it is important to convey a feeling of heat, one answer is to keep the studio area as cold as possible and to photograph the dish against a dark background which will show up the steam most clearly. Another is to use a commercially available liquefied titanium compound which is capable of producing imitation steam.

Studio design

The layout of a food studio is important, as both photographic studio and kitchen must be combined and arranged to suit each other. If you are planning to make food photography your specialization, then you can be faced with a considerable investment in cooking equipment, space, ventilation and plumbing. Double cooking facilities are ideal for the situations such as those mentioned above, and you should also

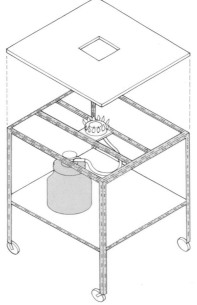

Cooking in the studio. An on-site cooker is valuable, not so much to replace kitchen facilities as to ease the problems of photographing food as it is being cooked. A simple trolley can be made by bolting together angle struts into a frame. A calor gas ring can be located on top, with a lower level for the gas container (right). Finally, a suitable background surface (non-flammable) can be cut to fit over and around the ring.

Brussels sprouts. Labyrinthine problems were encountered in achieving this apparently straightforward image (above). First, the container needed to be large and plain; the only suitable vessel turned out to be a medical specimen jar. Then, it was found that the sprouts tended to fall to the bottom of the container; the answer was to insert a large, stubby candle, studded with short, thick wires into the jar, and carefully arrange the sprouts on the ends of the wires. The next problem was that, in

Christmas pudding. The recipe for this shot (left) called for the following ingredients: 24 prepared puddings; 36 pints of cream; 1 tablespoon of oil, to enhance the hot appearance of the pudding; and 1 packet of cigarettes, to give added steam. Preparation time: one day, taken up chiefly with sculpting cream into the desired shape. Photo: Robert Golden.

make sure that the line of delivery of dishes from the cooking area to the photography area is direct and uncluttered. There may be several people working on a food shot and there should be sufficient room so that they do not get in each other's way. Ventilation and water supply are facilities that most studios are not well equipped with, but for food photography they are essential. Some specialist photographers prefer to separate the kitchen from the studio so that cooking odors, smoke and heat do not interfere with the shooting.

If you practice food photography occasionally, you will still need ventilation and plumbing, but you may find that a portable gas cooker is adequate. In any case, a portable gas ring of the type sold for camping can be quite useful for shots of food being prepared. The dish can be started on a proper cooker and then transferred quickly to a set that incorporates the gas ring.

Lighting

Basic still-life equipment is adequate for food and drink. Heat output from lights can be troublesome with many fresh or frozen foods so that flash is preferable to tungsten. Generally speaking, food looks most appetizing with a fairly diffused light source and a "window" light is the most widely used. Placing the light slightly to the rear to achieve a moderate amount of back-lighting accentuates texture and highlights, although it is important in this case to use fairly strong reflectors from the camera position to fill in shadow detail. Most dishes benefit from even, rather than stark, lighting.

With glasses and bottles, the reflection from studio lighting becomes an element in the composition. For this reason alone, hard spots and umbrellas are unsuitable. The reflection of a rectangular "window" light is reasonably unobtrusive, and can even be made to look like a real window by taping strips of black tape across it. Take great care in the way that the reflection falls on the glass – a simple regular shape is usually best. With bottles and tall glasses, it is common to place the "window" light in a vertical position and direct it horizontally towards the set. In this way, its reflection runs the length of the glass object.

With liquid in transparent containers, you can add life and sparkle by placing a shaped reflector behind them. In the case of a bottle of wine, cut either a piece of white card or silvered foil to approximately the shape of the bottle but a little smaller. Prop it up behind the bottle, out of sight of the camera and angle it to catch the light, in the right position refraction will disguise the reflector and give a glow to the wine. It is possible to overdo this effect, so experiment until you have balanced the main lighting and the back reflections.

boiling water, the chlorophyll would run out of the sprouts. The only solution was to use cold water and insert an air-line, attached to a compressed air gun, to create bubbles. Even this created new problems, as the bubbles tended to erupt violently (inset photograph). To encourage a few surface bubbles, a little washing-up liquid was added, and frothed up. Finally, to reproduce steam over the cold water, cigarette smoke was blown over the surface through a straw. Photo: Robert Golden.

A portable studio

ALTHOUGH NORMALLY a professional rather than an amateur problem, it can happen that the object you intend to photograph cannot be moved to a studio. This could be because it is too valuable, as in the case of a museum exhibit, or because of distance, or for any number of reasons. The only solution is to take the studio to the subject.

Moving studio equipment to another location is not an easy matter, and if it becomes a frequent task, it is worth considering a special set of equipment that will function as a portable studio.

As well as making sure that the portable studio is suited to the task, whether portraits or still-lifes, it must also be simple, adaptable, and, of course, easily portable. Where possible, stands, clamps and reflectors should be selected for the widest range of uses; if one piece of equipment can double up as something else – such as an umbrella which can function as a reflector – so much the better. Portability is obviously important; the equipment must pack into whatever transport is being used. If it has to travel by air, check the baggage restrictions – you may be charged by weight or by piece, according to the route.

Studio flash is normally a much better alternative than tungsten lamps because a portable studio must often be set up under unpredictable and unsatisfactory conditions. It is not reasonable to expect to be able to work in a blacked-out room, and the ambient lighting could be anything from an open skylight to fluorescent lamps. Flash lets you work at such fast shutter speeds that existing lighting has virtually no effect.

Self-contained flash units with integral accumulators are probably more convenient than those whose heads are separate from the power pack. Most countries run on either 110v AC or 220v AC approximately, and a step-up or step-down transformer, depending on the rating of the flash units, will take care of the problem of working abroad. If there is no electricity supply available, a generator is necessary.

In many places you may be able to hire some equipment, and although there is obviously a risk in using unfamiliar lighting, it may save trouble to hire the bulkier and less critical things, like stands and reflectors. Nevertheless, it is prudent to check first that they will be available.

On location

Shooting pre-planned photographs on location bears practically no resemblance to a reportage assignment, even though the location itself may be the same, and the finished product may even look natural and spontaneous. The essential difference is that the image has been carefully determined in advance, something that is usually obligatory in advertising work. If anything, pre-planned location assignments are best considered as a type of studio work, but without the amenities of an enclosed studio space. The techniques of controlled photography are applied, as well as they can be, to the uncertainties of out-of-studio locations.

If the shots are also to be taken outdoors, then the chief problems are weather and logistics. Not only can bad weather physically prevent shooting, but the quality of natural lighting can make all the

This basic still-life set (above) was used for a photography session at a Smithsonian museum in Washington DC. The location had to be changed frequently to be close to the objects, and so the structure was kept to the minimum. Two medium-duty light

Equipment checklist
1. Background material: white or colored card, black velvet, rolls of paper (1m×1½m (39×59in) white formica for still-lifes and 3m (118in) paper background rolls are the most useful, but are bulky and difficult to carry – check if they can be bought at the location).
2. Lighting: basic set-up is one self-contained head with "window" for still-lifes and two self-contained heads with umbrellas for portraits. An extra head in each case gives flexibility, but at the price of portability.
3. Two aluminium lighting stands.
4. (For still-lifes) two adjustable two-way clamps and sectioned 2 meter (6½ft) aluminium cross-bar.
5. White card reflectors, one side covered with crumpled cooking foil. For extra portability, they can be cut into sections and taped back together.

difference to the success of the photograph. The only controls you can exercise over this are to choose a location where the weather is reliable, or to carry portable lighting to the location in order to simulate sunshine. The first alternative can be extremely expensive but may be worth it because of the near-guarantee of suitable shooting conditions; otherwise, weather insurance is essential. Artificial sunshine involves its own logistical problems but, provided that the picture area is not too large, it is a reasonable solution. You will have to consider not only the hire charge for the lights, but also the light output that is needed for the area to be photographed. If there is an inadequate power supply for the lights, then you will need either a portable generator or power take-off facilities from a vehicle.

stands and a cross-bar provided overhead suspension for a studio flash with integral power unit. The white formica scoop came from a local building supplier. The advantage of standardizing a set like this is that shooting can confidently be started at once.

6. Extension lead.
7. Wide range of color correction filters.
8. Camera, lenses, tripod, etc.
9. Spare fuses for flash units.
10. Gaffer tape, insulated screwdrivers and pliers.
11. Spare cable, plugs and plug adaptors.
12. Flashmeter.
Special Options
1. Transformer: remember that, as watts = volts × amps, changing the voltage from 110v AC to 220v AC will halve the amperage, and the fuses may need to be changed. The same applies to changing from 220v AC to 110v AC, which doubles the amperage. Match the capacity of the transformer to the capacity of the flash heads.
2. Generator: again, make sure that it is sufficiently powerful for the flash units you are using.

Location equipment

Oak forest. A straightforward use of smoke gave atmosphere to this shot of a felled tree (right). An oil-fired smoke generator was used, positioned upwind in the background and out of frame. The result was a delicate separation of planes giving a more definite form to the trees and shrubs.
Nikon, 24mm, Panatomic-X, ⅛sec, f16.

Road arrow and smoke. Symbolizing an uncertain future, this photograph, for a magazine cover, called for dense smoke spreading over a sign in the road (below right). Dry ice (frozen CO_2) tipped into a pail of warm water gave the precise effect (bottom); the vaporizing CO_2 hugs the ground, spreading outwards. A diffused flash head suspended over the dry ice made it appear luminescent.
Nikon, 55mm, Kodachrome, 1/60sec, f8.

Extra location equipment. Larger and more efficient reflectors (below) are needed outdoors. Crumpled cooking foil pasted down onto board can be supported on a heavy-duty stand. Large polystyrene sheets are adaptable and disposable.
In most situations a generator (below) is essential. Check that the capacity is sufficient for the quantity of lighting being used.

Room sets

SETS ARE SIMULATED interiors that, in many ways, need the same treatment as architectural interiors discussed on p 204. Exterior sets are beyond the scope of most still photography. For a specific shot which has to follow precise details of layout and content, sets have the advantage over existing rooms in that they can be designed for any camera viewpoint and for ideal lighting.

The most obvious problems of set photography are the time and expense involved in building them; perhaps less immediately apparent is the problem of achieving realism. Most sets are, after all, intended to mimic real interiors, so a lot of attention must be given to achieving authenticity of props, structure and overall atmosphere. Paradoxically, the more ordinary the setting is intended to be, the more difficult it is to create. This is partly because good, "ordinary" furniture and props are less easy to find than objects kept because they are special or unusual – an antique clock would be quite simple to locate, but a pristine 1930s pack of cigarettes might stretch the talents of even a professional stylist.

A second reason why the plain and homely is difficult to recreate is a natural tendency to be too perfect and tidy in the design. Most family living rooms, for example, are mildly chaotic, with idiosyncrasies of decoration and possessions. If you are designing a set, collect as many references as you can for the visible part and try to work in some of the peculiarities that give real rooms their character.

Set-building requires major carpentry work, and to save cost you should decide whether you can incorporate part of an existing room into the set. Before undertaking any construction, first draw a layout as precisely as you can. Work out the exact area to be photographed bearing in mind camera angle and lens focal length. Anything that might fall outside this area can be entirely structural. You must also include on your plan the lighting positions. If you are going to use a daylit window or open doorway, you must leave space "outside" the room to provide simulated daylight. As with real interiors, the most effective window lighting technique is to shine a light through a large sheet of translucent material covering the window area.

By definition, sets allow infinite control over viewpoint, composition and lighting, so that there should be no real problems beyond design. As for props, a set is virtually a large scale still-life, but demanding even more attention to detail by virtue of its actual size. Fortunately, objects at a distance from the camera do not need to be perfect, and the normal stock of film and television prop-hire companies may provide sufficient props.

Italian-American living room. This 1930s set was assembled by the Museum of History and Technology in Washington DC. The care that went into selecting the props is reflected in the authenticity of detail. I included the window and door in the shot, lighting them from outside the set with powerful diffused tungsten floods. The wide-angle lens was stopped right down to render foreground detail sharp.
Photo: Courtesy of Harry N. Abrams Inc.

Manipulating the image

THE ESSENCE OF MOST reportage photography, which began this section of the book, is a documentary approach: a faithful and honest interpretation of the subject. Any gross interference by the photographer would reduce the value of this kind of work. On the other hand, studio photography needs strong direction. The photojournalist generally *responds* to a situation, whereas the studio photographer *creates* a situation to fit a pre-conceived image.

The ultimate control that the photographer has is the manipulation of the image itself. At its most sophisticated, the photographer can take on the role of art director. By combining studio techniques with photo-composites and re-touching, for example, you can achieve the graphic freedom of an illustrator yet retain the basic realism of photographic images. Sophisticated image manipulation such as this is found mainly in advertising, where the commercial results justify the often high costs and lengthy technical work.

The manipulative techniques described here, however, are well within the reach and ability of most photographers. Some are extremely simple. Sandwiching, for instance, needs little more than an eye for a telling juxtaposition and a pair of scissors and tape. Others, like dye transfers, demand time and dedication, and will only appeal to a minority, yet the creative rewards can be great, offering a means of translating virtually any imagined picture into reality.

What makes many of these methods so powerful is that, for most people, a photographic image is inherently real. They are not being asked to suspend disbelief when looking at a photograph; they naturally assume that the image is believable. Being able to play with these images, altering and juxtaposing, the photographer can achieve some very disturbing, often surrealistic effects. The image can be manipulated simply to overcome problems that could not be solved at the time of photography, but it can also be altered to create new and imaginative visions. Producing these tricks purely for their own sake can become a sterile trap, but this can be avoided by rigorously using them with a purpose, to create an image that you have pre-planned.

Combining images: Sandwiching

The easiest way of manipulating an image to produce special effects is to sandwich together two transparencies (the equivalent technique with negatives is double-printing, described on p 270). The great appeal of this method is its simplicity and the fact that no guesswork is involved, as you have the developed transparencies in front of you. As a general rule, sandwiching works most successfully when the dark areas on one transparency coincide approximately with the light areas on the second transparency. Attempting to sandwich together more than two images is not usually very satisfactory – even the lightest areas of a transparency have some density, and several transparencies together tend to look dull and lifeless. Beyond this constraint, there is little more to sandwiching than to collect likely transparencies on a light box and place them in different combinations until you find the one that is most pleasing.

Because combining two transparencies increases the overall density, it is usually better if both images are slightly over-exposed: if you are taking the photographs with the intention of later sand-

Threat to the establishment. This photograph, taken for the cover of a magazine, was to illustrate the threat to the British financial system from impending recession and a new bout of inflation. First of all I chose the most traditional view I could find in the City – the columns along one side of the Bank of England with a top-hatted gilt broker walking by. There were several photographic alternatives that would bring across the idea of a threat, but I wanted something that would be so obviously destructive that it could not be missed or mis-interpreted. After testing with unwanted pieces of film for the precise effect, I held the corner of the transparency over a flame until it bubbled and burst through.
Nikon, 180mm, Kodachrome, $^1/_{125}$sec, f3.5.

wiching them together, be sure to make a wide range of exposures. Often, even when I have no specific intention in mind, I will bracket a range of exposures together of a shot which I think may be useful later, and I keep a special file of transparencies solely for the purpose of sandwiching.

By careful positioning, it is often possible to conceal the fact that there are two transparencies. If you later make a duplicate transparency of the sandwich (see p259), the illusion will be complete; duplicating can have the additional advantage that the contrast can be increased then and therefore correct the dull highlights that are formed in sandwiching.

Lamb and clouds. Sandwiching provided the simplest answer to the problems of this picture. It was to illustrate a magazine article on the bleak economic future for British farming and there was little likelihood of being able to plan the perfect setting. The lamb itself was no problem and by slightly over-exposing against a light cloudy sky, the top half of the transparency remained clear. It was then taped to a stock transparency of storm clouds so that the two images did not overlap.
Both: Nikon, 180mm, Ektachrome-X.

Sandwiching – procedure

1. Experiment on a light box by trying out different combinations. Then remove one transparency from its mount, and tape it down.

2. Position the second transparency and tape that down. Cut round the edges of the tape.

3. Use a blower and an anti-static brush or gun to remove dust particles that could be trapped in the sandwich and then mount it.

Combining images: By projection

Another reasonably straightforward method of combining images is to project a transparency on to the subject you are photographing or on to the background. The only difficulty is balancing the light levels, but the advantage of this system is that you can see exactly how the images will combine before you take the photograph. Projecting transparencies like this is ideally suited to three-dimensional surfaces. Where the surfaces in the transparencies are flat or where their shape is not important to the picture, the multiple exposure method gives better image quality.

To project a transparency on to any surface, use either a slide projector, a projection attachment over a studio light, or adapt an enlarger. With a slide projector you are limited to using the projector's own tungsten lamp as a lighting source and, if you are working in color, you should test to see if any color correction filters are needed.

Consciousness. This photograph was taken for a magazine cover to illustrate a feature on levels of consciousness. (The idea of a rising sun superimposed on a head seemed appropriate.) First, the image of sunrise over a lake was constructed by sandwiching together two transparencies. To ensure that the image would follow the contours of the head, the transparency sandwich was placed in the carrier of a disassembled enlarger and projected. The head, a phrenology model, had been sprayed to a matt white finish, and was separately backlit. *Nikon, 55mm, Kodachrome, f22.*

Front projection. This system of background projection, now available in portable units, enables virtually any existing transparency to be enlarged as a backdrop in the studio. Two special techniques are used: one is a half-silvered mirror that projects the transparency along the axis of the camera lens, the other is a super-reflecting background screen.

The camera and projector are carefully aligned at right angles to each other, with a half-silvered mirror placed at 45° in front of the lens. The projector lamp is an electronic flash tube so that moving the subjects can be photographed. The background transparency is then projected along the lens axis to the screen, which is coated with minute glass spheres that reflect strongly back towards the camera. This coating is the special ingredient of front projection – its reflecting power is so efficient that the image appears only on the screen while the clothes and skin of the model reflect nothing.

With the other two projection systems, you can use your own light source, either tungsten or electronic flash.

The surface you project on to should be light-colored, preferably white, and with a matt finish, if possible. To reduce any reflections spray the area with a dulling spray. Use a cut-out mask in front of the projector lens to exclude parts of the projected transparency that you do not want.

Projected backgrounds

With a special projector and a very reflective screen, you can photograph people or objects in a studio against a projected image. This system is called front projection, and utilizes a half-silvered mirror and a screen that reflects light back only in one direction. The front projection unit beams the image at right-angles to the camera on to the half-silvered mirror, which is angled at 45°. In this way the transparency is projected along the camera-lens axis, so that no shadows are thrown on to the screen by the figures. The figures still have to be lit separately, and some light will unavoidably spill on to the screen; to overcome this problem, the screen has a super-reflecting surface composed of thousands of tiny glass spheres that reflect back to the camera only the projected image. Because the light level is adjusted to this highly reflective surface, the clothes and skin of the figures in front of the screen do not reflect the image.

It is difficult to produce completely realistic photographs using front projection, but you should make every effort to match the quality (and direction!) of the lighting in the background shot using studio lights. If you include the ground on which the figures are standing, you must make it appear to run continuously into that of the projected transparency.

Combining images: Multiple exposure

A very direct method of bringing images together, although it requires some precision, is multiple exposure – making separate exposures on the same piece of film. For the technique to work, there must be fairly large dark image areas remaining from the first exposure in order to leave space for the second exposure. Multiple exposure is easiest to practise in the studio, where everything is controlled and where you can plan each exposure precisely before taking the shot. It is as effective in black-and-white as in color. At its simplest, double exposures can be made of two brightly lit subjects, each on a black background. They can be accurately combined on one piece of film by marking their positions on the camera's ground glass screen (if the prism head can be removed), or by making a proportionate sketch of the frame and subjects on a piece of paper. It is worth experimenting with simple procedures like these before working up to more complex combinations.

Using these techniques effectively depends on practice – the more experience you have, the more certain you will be of the result. Start by practising double exposure on a plain black background in the studio for maximum control. Expose first for one well-lit object placed on black velvet, which reflects hardly any light; then, without winding on the film, make a second exposure of another object, lit in

Federal Reserve Bank, Washington.
The two exposures that make up this
combined image (left) were taken one
hour apart with lenses of different focal
length. The first exposure, at sunset, was
taken with a wide-angle lens, fitted with a
neutral graduated filter to darken the
upper part of the sky. This under-
exposed area of the transparency was
noted on the camera's ground glass
screen, and later, using only floodlit
illumination, the exposure of the eagle
was made, with a long-focus lens.
*Nikon, Kodachrome – (1) 35mm, ¹⁄₃₀sec, f4
plus graduated filter –(2) 400mm, 1 sec, f5.6.*

Counting methods. Part of a paperback
cover for a dictionary of mathematics
(above), the hands, Mayan parchment
and calculator were all at different scales.
The solution, therefore, was multiple
exposure. Each of the subjects was
photographed separately against black
velvet so that the background remained
completely unexposed, ready for the
other images. The position of each was
marked carefully on the ground glass
screen to avoid overlapping.
Nikon, 55mm, Ektachrome, f27.
Photo: Courtesy of David Larkin,
Pan Books.

exactly the same way but positioned in a different part of the frame so
that the two images do not overlap. One obvious use of this technique
in the studio is to alter the relative sizes of objects, but the possibilities
are really limited only by your own imagination. For instance, out of
the studio you can use double exposure to bring the moon into a
landscape.

Provided that the background of each exposure is actually black,
there is theoretically no limit to the number of exposures that you can
make; this demands even greater care in the positioning of objects. If
the background is not quite black – in other words, if that part of the
film receives a small exposure – then the final image will tend to look
soft and weak. What actually happens is that the density of the shadow
areas is reduced. This is not necessarily a disadvantage – the ghost-like
images in this kind of multiple exposure can be used to effect. Double
exposing the moon, for example, against a daytime, blue sky repro-
duces exactly its rather weak daytime appearance.

Re-positioning the camera when making multiple exposures can be
tedious, and if the different subject elements have to be photographed
in different locations or at different times, it is very difficult to insure
against an incorrect exposure. The answer is to re-run the film.

Re-running works exactly as it sounds. First make a range of
exposures of one subject, re-wind the film to exactly the same starting

The basic technique

1. Make an exposure of a single well-lit object against black velvet noting its exact position in the frame on the ground glass screen.

2. Cock the shutter without winding on the film by depressing the rewind release button/lever, or the special double-exposure catch fitted to some cameras.

3. Replace the first object with the second, and position it in a different part of the frame, adjusting the camera position and focus if necessary. Expose.

Re-running

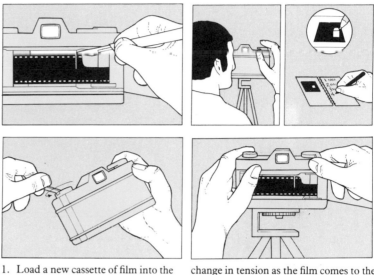

1. Load a new cassette of film into the camera (top left). When the film is in position, mark the back of the film against a clear mark on the inside of the camera body. A light scratch with a penknife will make an accurate mark.
2. Make the first exposures, noting the main elements of the shot, either on the ground glass screen or in a notebook (top right). Also, note the exposures against the numbers on the film counter. If the estimated correct exposure is $1/125$ sec at f5.6, make five complete sets of bracketed exposures, each $1/125$ sec at f4, f4.5, f5.6, f6.3, f8.
3. Rewind the film, but not completely; leave a leader sticking out of the cassette (bottom left). If you hold the camera close to your ear you can hear and feel the

change in tension as the film comes to the end of the take-up spool.
4. Re-thread the film onto the take-up spool so that the scratched mark on the film aligns with the mark on the camera (bottom right). This alignment may take a few attempts, but if you have been able to rewind the film carefully enough so that it is still just threaded on to the take-up spool, it will be much easier.
5. Take the second series of exposures, in such a way that all the exposure variations are permutated. Bracket around the estimated correct exposure as before (in the example it is $1/125$ sec at f4), in sets of five, but this time make each set the same exposure. In this way you will permutate the exposures so that at least one frame should be correct.

Safe deposit can. This magazine illustration (above) required a sardine can to have the appearance of an old-fashioned safe. After the can had been opened, cleaned and painted, a brass safe handle was added by double-exposure to 'key' the illusion. The black surface of the can provided an unexposed area of film in which to drop the second image. The position of the can was marked on the ground glass screen. Black velvet was then carefully arranged around the handle so that the surrounds of the safe door would not interfere with the remainder of the image.

point, and then make a range of exposures of the second subject. The precise starting-point of the film is critical in this technique because, while the vertical alignment on 35mm film in the camera (i.e. the distance from the sprocket holes) does not change, even a slight lateral displacement (i.e. in the direction that the film is wound) will shift the second image considerably. To be absolutely safe with this kind of double exposure, bracket one f-stop over the estimated correct exposure to one f-stop under in ½ stop increments. With experience you may then feel confident enough to bracket less.

Finally, by abandoning the need to keep all the elements separate, overlapping multiple exposure offers the greatest creative opportunities. Ghosting images together pretends to no realism, but the scope for juxtaposition is immense. The ability to bring totally alien images together, one showing through another, makes this approach an invaluable tool in concept photography.

The slide copier

SANDWICHING USES ORIGINAL transparencies; multiple exposure is done in the camera, and so also works with the original film. Clearly, the advantages of these techniques are that the quality of color and resolution remains high, and the procedure is usually fairly simple. However, there are limits to the amount of precision that can be applied to what is, after all, a small film format. Now, if the image quality can be kept high, it would be much more convenient and flexible to work with transparencies that had already been processed. It would eliminate much of the uncertainty, and would be the only way of making precise and complicated conversions.

The basic tool for doing this sort of manipulation is the slide copier, which, at its simplest, allows duplicate transparencies to be made from originals (providing good insurance for valuable originals). For this kind of work, a slide copier is very much more useful than the copying attachments that fit directly onto the bellows of a camera (these need a separate light source). Essentially the slide copier is a calibrated light source with a bellows attachment that permits different degrees of enlargement. The light source is usually a flash tube corrected for daylight; there is a metering system for determining exposure, a filter drawer to alter color balance, and in some models, a separate small flash system to control contrast.

Despite the simplicity of the slide copier, it can be used for extremely sophisticated manipulations of the image. Its real value is that it is a calibrated instrument, allowing the operator to repeat exposures precisely.

Making an accurate duplicate

Although the slide copier can be used for much more than straightforward duplicating, this has to be learnt first in order later to be able to manipulate precisely. What you should bear in mind from the start is that any step away from the original causes an actual loss of image quality. Some techniques – with the slide copier or in various reproduction processes – can create an apparent improvement over the original, but this depends on the viewer. Complete fidelity is impossible, and what you must aim for is the closest match.

Before starting work, it is essential to make a thorough series of tests, using an original of average density and with a good range of colors, including flesh tones, mid-grays, and blue sky. With the manufacturer's instructions as a guide, test all the factors that affect image quality: exposure, color balance, resolution and contrast.

The slide copier's metering system provides the best exposure guide; it normally works from a tungsten light that can be adjusted in proportion to the flash tube. For exposure variations that are beyond the range of the flash adjustments, alter the aperture of the lens. As most metering systems are of the averaging type, you will have to judge each original as if it were a normal scene in front of the camera. A small bright subject against a dark background will need less than the indicated exposure, while a small dark subject against a bright background will need more exposure and so on. Experience will tell you how much to compensate in the exposure.

A good color balance can sometimes be difficult to achieve. The color film in the camera does not necessarily respond to the dyes in the

The slide copier

In principle, the slide copier is a relatively straightforward instrument. The light source is a small (50 joule) flash tube, mounted together with a tungsten modelling light on a platform. This can be raised or lowered mechanically to provide greater or lesser intensity (below). The flash duration, 1/500 second, is fast enough to eliminate the danger of camera shake, but slow enough to avoid the problems of reciprocity failure that tend to occur at speeds of 1/1000 second or shorter.

The camera and bellows are mounted on a focusing track for accurate alignment and to allow different enlargements to be made. The best lenses to use are either a macro lens or an enlarger lens.

Below the transparency holder, a translucent opal screen diffuses the light and a drawer holds filters for color correction. A photo-electric cell mounted on a rotating arm gives an exposure reading which is linked to the calibration controls. The contrast control unit, located between the camera and the transparency, emits a small, evenly diffused amount of light from a separate flash tube; this is reflected up into the lens by means of a thin sheet of glass at 45°. This fogs the film slightly with the effect of reducing contrast. Separate filters can be mounted in front of this light source to alter color in shadow areas.

Making a duplicate

1. With the lens aperture wide open, and the transparency placed in the holder, adjust both the lens and camera positions until the image is correctly framed and focused.

2. Stop down the lens to the aperture previously selected by testing, and, with the photo-electric cell swung over the transparency, rotate the light control knob until the needle is zeroed.

3. According to the amount of fogging needed, select the light output from the contrast control unit by rotating the rear dial. With experience you can judge the best level for each original.

4. Swing the photo-electric cell away, switch the unit from modelling light to its flash exposure setting, and expose by pressing the camera's shutter release.

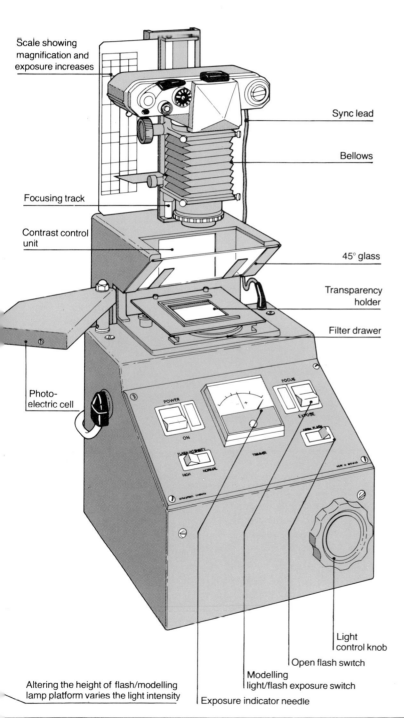

Scale showing magnification and exposure increases

Focusing track

Contrast control unit

Photo-electric cell

Sync lead

Bellows

45° glass

Transparency holder

Filter drawer

Light control knob

Open flash switch

Modelling light/flash exposure switch

Exposure indicator needle

Altering the height of flash/modelling lamp platform varies the light intensity

POWER
ON
FOCUS
EXPOSE
FLASH INTENSITY
HIGH NORMAL

original as it would to the colors in the original scene. Some filtration will be necessary from the start, and where color shifts occur, the ultra-violet content of the flash tube may be to blame. An ultra-violet filter may therefore be a useful addition to your filter pack. Different original film stocks may require quite large filter variations – a Kodachrome original, for example, will duplicate considerably greener than an Ektachrome original on the same Ektachrome film used for duplicating. With some combinations of film and original, you may experience a "cross-over" effect – magenta highlights and green shadows, for example – that is distressingly impervious to correction. The contrast control system described below can help to a limited extent, but the best answer is to choose by experience a film stock that suits the originals you are working with. Most specially manufactured duplicating films for professional use are tungsten rated, and quite unsuitable for this kind of slide copier, even with a correction filter.

Resolution tends to suffer in duplicating. A flat-field lens designed to work at these distances is important – a process lens or enlarging lens are ideal. A fine-grain film is also an advantage, although it may not necessarily be the best choice for color balance – Kodachrome 25 can give excellent results.

Without some form of correction, any color film used for duplicating will enhance the contrast of the original. If the original has insufficient contrast for your taste, the result will be an apparent improvement, but otherwise you must take steps to reduce the contrast range. Some films have a lower contrast than others, so consider your choice of duplicating stock. If the film can be user-processed, then, by over-exposing a half-stop or one stop, and reducing the development time accordingly, the contrast will be reduced (see p 111). Most slide copiers, however, incorporate a contrast control device, which simply fogs the film very slightly. This has the effect of lowering the density of the shadow areas and so limiting the contrast range. A final, and more complicated, technique is masking, done in exactly the same way as described on page 261.

The adjustable bellows permits various degrees of enlargement, and by altering the position of the original, you can make selective enlargement (increased graininess is usually the limit to an acceptable enlargement). The exposure must be increased according to the inverse square law (see p 90), so that, for example, if the image is magnified to twice its size, an extra two f-stops in exposure must be given (i.e. four times the exposure).

Changing the image

Having calibrated your slide copier so that you can produce faithful duplicates from original transparencies, there is no restriction to the wide range of normal camera techniques that can be used on the copier itself, including filters, masking, and even different lenses. Because precise control is possible, it may be better to experiment at this stage rather than at the time of taking the original.

Corrective duplicating

Within certain limits, mistakes with original material can be rectified, or at least some improvements can be made on the copier. Color

Cross-over effect. Sometimes a color cast in the shadow areas may be accompanied by a cast of the complementary color in the highlights. In the duplicate (above) the darker areas of the sky are greenish, and the highlights orange. One solution would be to add a green film to correct the highlighting and strong red filters to the slide copier's fogging unit which controls shadow areas.

Fogging. The natural tendency of duplicates towards high contrast (right, above) can be countered by using a contrast-control attachment, which leaks light onto the film, lightening shadow tone (right, below).

Fogged duplicate

Duplicate

Original

Duplicate

Normal duplicate

Original

correction is the most common use, and is straightforward. Keep a range of color compensating gelatin filters (yellow, green, cyan, blue, magenta, red) as a basic stock; the most useful densities for moderate corrections are 0.05 and 0.10. If the original has a definite color cast, duplicate it with a filter of its complementary color (see the color wheel on p 62). Judge the strength of filter needed by placing the original on a light box and holding different densities of color filter in front of it until you find a visual match; generally, when making the duplicate, you should use a filter of approximately half the density that looks right on the light box.

Contrast corrections are also possible with the contrast control device. You may need to experiment to determine the precise amount and, because the device works by simply fogging shadow areas, over-use may produce some unwanted effects.

Composition can be altered quite simply by selective enlargement. The copier can be used in re-touching (see p 272) either to provide a number of duplicate transparencies on which to work, or to soften the re-touching on the original in a duplicate. In the latter case, use washable dyes on the original; if the re-touching work is even moderately good, the results, when duplicated, should be un-detectable. A weak diffusion filter will mask re-touching marks even more.

Selective filtration with graduated filters works in just the same way as in straightforward photography (see p 157), enabling you, for instance, to balance the exposure for a light sky and dark ground. However, in duplicating you are limited by the amount of detail present in the original; if the sky is already washed out, no filtration

Color correction. Color casts in an original can be altered quite simply, by using a filter of the complementary color to the cast. In this case, the greenish original (left, above) needed a CC10 red filter to make a neutral duplicate (left, below).

Increasing contrast. Most slide duplication introduces an unwanted increase in contrast, but this can improve some originals, particularly those, (such as the one at right, above), where under-exposure has left the image without effective highlights. At the same time, some color correction was made (right, below).

Original

Original

Duplicate

Werewolf. In this cover illustration for a book of horror stories (below), the streaking and luminiscent effects were achieved by using a zoom lens and a slide copier. The original transparency which combined a backlit shot of a girl's head and the eyes and teeth of a cat, was enlarged to 4×5 in (9×12cm) and, using the tungsten modelling light rather than the flash, the zoom control of the lens was operated during a time exposure. The zoom setting was first set at its widest angle and an 8-diopter close-up lens added so that the transparency could be focused close to. The zoom control was turned towards its longer focus setting for the exposure.

Nikon, 35-70mm, Ektachrome 1 sec, f11.

Television time costs. For an article on the costs of screen time on television, a sliced watch and coin needed to be combined on the screen of a television set (right). The two objects were first photographed individually, the screen having been painted black. A piece of black card was then cut into a wedge–shape, and this was laid over the transparency of the watch before duplicating (below). To give a three-dimensional sense, a small strip of brownish clear acetate was also added. The same technique was used to mask off all but a slice of the coin (bottom), and all these shots were copied onto one frame.

will bring it back to life. By placing cut filters underneath the opalescent filter drawer, quite subtle changes can be made using inexpensive toned or colored acetate.

Altering for effect

There is an unlimited number of experiments which you can carry out to filter or distort the image of the original. As with all special effects, try to restrict their use to occasions when they are needed to fulfil a purpose. Most effect filters can be used with the slide copier, from diffusers to multiple prisms. Various lens distortions are possible by using different lenses, but as the working distance is so short, you may have to remove the camera from the copier and place it farther away on a tripod. The streaking effect of a zoom lens described on page 50 can be reproduced by exactly the same method on the slide copier – lack of parallax produces slight differences in the resulting image, but these are not particularly important.

Piranha. To add life to this close-up of the dead, preserved fish (below), an eye was added. First, the fish was photographed and then, separately, a false eye was photographed, backlit and masked. The two transparencies were then combined using a slide copier. Combining during duplication allowed precise control of the way the eye would look.

Security camera. To illustrate a feature on bank security, this camera focused on a bank's loading bay was a good starting point, but to give it life, an eye was added. A backlit false eye was separately photographed using a step prism filter, and the two images were then combined by double-exposing with a slide copier. *Nikon, 400mm (camera) and 55mm macro (eye), Kodachrome originals and duplicates.*

Combining images

The slide copier excels at image combination, bringing a precision to the technique that, even in the small 35mm format, allows very close refined juxtapositions. Sandwiches can be duplicated in the normal way on a copier, the normal increase in contrast from the process compensating automatically for the inevitably reduced contrast range of the sandwiched originals. Multiple exposure is done by the same process described on page 250, but with less uncertainty, as re-running the film is not necessary.

Photo-composites

The most exact method of combining images on film is photo-composition. Essentially, this involves combining a number of separate elements, usually transparencies, on to one piece of film in register and masked (to exclude the unwanted parts of each transparency). With this technique there are, at least in theory, no restrictions such as needing to position a bright image against a dark one; masking in register allows images to be combined in any relationship. In practice, however, a large film format is needed for the more complicated combinations (35mm transparencies can be enlarged first on to sheet film, but this involves the explanation of procedures which are beyond the scope of this book).

A register system enables you to position each element with great precision. The standard equipment consists of a Kodak Register Punch and Register Bar. As a working surface for the slide copier, tape

Saturn from Rhea. This intricate photo-composite (right) involved nine separate original transparencies of subjects, ranging from real landscapes to models and artwork, and for ease of working these were enlarged onto sheet film. The need for extreme precision was reduced by making use of shadow areas in which to drop other images.

Setting up the register bar

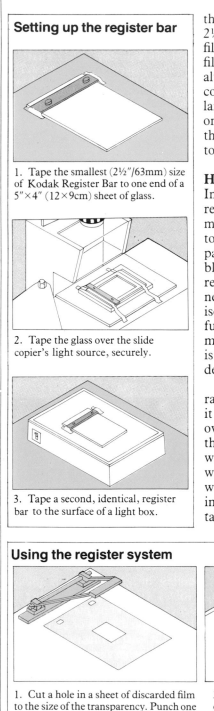

1. Tape the smallest (2½"/63mm) size of Kodak Register Bar to one end of a 5"×4" (12×9cm) sheet of glass.

2. Tape the glass over the slide copier's light source, securely.

3. Tape a second, identical, register bar to the surface of a light box.

the register bar securely to a sheet of glass (the smallest bar, with pins 2½" (6cm) apart, is the most convenient, and will fit onto a sheet of film measuring 5"×4" (12×9cm); then tape this glass over the copier's filter drawer. This replaces the copier's ordinary slide holder (an alternative is a sheet film holder, available with some makes of slide copier). Use the register system by taping each transparency to a larger piece of discarded film, arranging the precise position of each on a light box visually, and then carefully punching register holes in the edges. Whenever one of the mounted transparencies is slipped on to the pins of the register bar, it will always be in the same position.

Hard and soft masks

In order to prevent unwanted parts of each transparency from being recorded, each transparency must be masked. This means nothing more than blacking out, and can be done rather crudely by re-touching (see p272). For an exact mask, contact-expose the transparency with line film, such as Kodalith Ortho type 3. This produces a black-or-clear negative image with no graduated tones. To facilitate re-touching, more than one line contact derivative will probably be necessary. The final mask, when taped to the original transparency, isolates the element you want against a black background. Then a further line derivative from this final mask will produce the complementary mask to be exposed with the second transparency. Line film is simple to use; trial-and-error exposures are normal technique and development can be by inspection under a red safelight.

The limits to this technique result from the film size. Any inaccuracies in masking and register are increased with enlargement, so that it is better not to be too ambitious on 35mm film. One method of overcoming slight problems with register is to use a soft mask rather than the hard one just described. This can be made in exactly the same way, but a sheet of translucent diffusing material should be sandwiched between the original transparency and the hard mask. This will soften the edges. Even softer masks, which can afford to be more imprecise, can be made by cutting shapes out of black paper and taping them under the flashed opal of the slide copier light source.

Using the register system

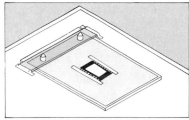

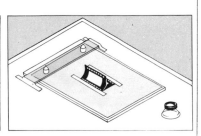

1. Cut a hole in a sheet of discarded film to the size of the transparency. Punch one edge of the sheet with register holes.

2. Fix the sheet onto the register bar on the light box, and mount the first transparency with dimensionally stable tape.

3. Repeat the process with the second transparency, but mount it in exactly the position you want in relation to the first transparency. Check with a magnifying glass. The two transparencies will now remain in register.

Making the masks

1. Contact-expose a sheet of line film with the first transparency, using the method described on p 264. (It may be necessary to experiment a few times in order to get exactly the right amount of masking.)

2. Re-touch the black areas you want to remove from the image of the resulting line negative with opaque or black paint.

3. Contact-expose the line negative with another sheet of line film, to produce a line positive. The black area can once again be re-touched very simply.

4. From this positive mask, a final negative complementary mask is made through the usual contact-exposure procedure.

5. Mount the negative in register, mask with the first transparency attached to a punched, discarded, large sheet of film.

6. Then mount the positive mask in register with the chosen background transparency. Expose each pair in the slide copier on to the same frame of film. A sheet of glass will hold the masked originals flat.

Conversions

TRANSFERRING AN IMAGE on to different emulsions, or altering the standard processing, will produce radically different versions of your original picture. The image combination techniques dealt with so far are normally concerned with juxtaposing unadorned photographs, but transparency conversion introduces major graphic changes.

Line film silhouettes

High-contrast graphic arts film, such as Kodalith, is normally used for transparency masking (see p 260). Its ability to produce dense black images on clear film makes it relatively easy to introduce silhouettes on to normal transparencies; it is even possible to construct an entire color image, using appropriate diffusing materials to soften the harshness of the line film and introducing color filters (the photograph of the man digging in front of the power station was built up this way).

Lettering, whether black or reversed out of a black background, is a variety of silhouette, and reproduces perfectly on this type of film. You can vary the density and the amount of detail resolved through the type of developer, and it is possible to introduce a small degree of tone into the image. (You can develop line film by inspection under a red safety light, as it is orthochromatic, and this lets you exercise fine control.) Several specially-designed developers are available for line film, but fine-line developers are probably the most useful, as they resolve the most detail. They must be mixed shortly before use, and will not keep for long. Developing by inspection allows you more control than following manufacturers' recommended times; use a small transparent dish, holding it over the safelight.

To produce the silhouette from an existing transparency or negative, use the contact-exposing and re-touching technique (see p 261). Use over-sized sheet film for easier handling. Different exposures will result in different areas of the original image being recorded; there are no tonal variations, only black and transparent.

Bas-relief

Bas-relief images, which have the appearance of being embossed in low relief, are created with line film. Begin by contact-exposing a transparency with line film, giving a short exposure so that only the lighter parts of the picture are recorded on it. Then, sandwich the transparency and line negative together, offset by a slight amount so that thin light and dark lines appear along the boundaries of shapes. You can then copy the sandwich to produce a finished result.

As most people are accustomed to viewing things lit from the top left, offset the transparency and line negative in such a way that the light boundary edges are to the top left of the picture. Offsetting in the opposite direction will give an etched, intaglio appearance.

Tone-line

This technique relies on the same principle as bas-relief – using the boundaries between dense areas. It produces an outline image similar to a very precise pen-and-ink drawing by recording only the boundaries between a negative and positive of the same image.

You can use contact exposure to produce the line conversion, as before, or, because the original transparency is not involved in the

The roots of production. To convey the idea of productive wealth (right), I had an image clearly in mind of a man digging on a skyline, and a modern power station looming out of the mist behind. There were a few suitable locations, but in none of them was it possible to guarantee the mist or fog, and this was essential to the shot. The solution was to assemble the picture from different elements. The man digging was photographed in black-and-white, and this re-copied onto line film as a positive (slightly underdeveloped for a low density). The power station was prepared as artwork and also copied onto line film. For the final shot, the line positive of the man was taped to the front of an opalescent plastic sheet and backlit. The power station line positive was taped behind the plastic to soften it. To add color, a sheet of orange acetate was added, curved back so that the intensity of the color would fade towards the horizon.

Bas-relief carving. This black-and-white bas-relief (below) was produced by first contact-exposing the negative onto a sheet of line film, and giving this a weak development. The two pieces of film were then taped together slightly out of register, and the combination printed in the normal manner. The technique can also be used with transparencies.

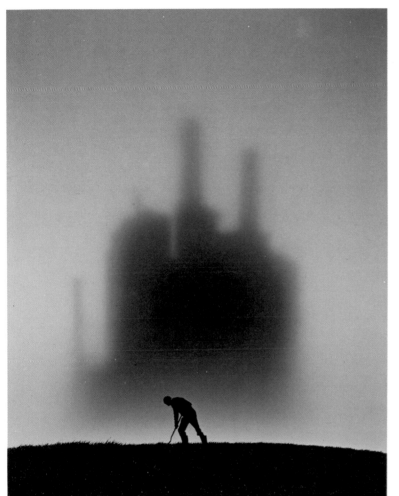

Ibis. Using the technique described in the text, the straightforward photograph of a South American ibis (far left) was converted into what resembles an ink sketch (left) by first making a line negative and line positive from the original negative. These two pieces of line film were then sandwiched together in perfect register, with the two emulsion surfaces facing outwards, separated by the thickness of the two film bases. An unexposed sheet of line film was placed on the turntable and the sandwiched films laid on top of it, as shown in the diagram (right). Then, with the table rotating, the film was exposed to a naked light at an angle of 45°. In this way the exposure picked up just the edges of the two images, positive and negative, through the double thickness of film-base, to show the bird's outlines.

Positive
transparency

Original
negative

High-contrast
film

Turntable

Tone separation and posterization. This negative of a New Mexico adobe church was chosen for posterization because it contained definite shapes and large areas of similar tone. To begin with, the original negative was contact-exposed with line film at different exposures to produce a set of four line positives. Each of these was then contact-exposed to produce a set of four line negatives. These eight pieces of line film formed the working basis for the posterization. Out of the vast number of combinations of positives, negatives, filters and exposure times, the final print (below) illustrates just one interpretation. The two mid-tone negatives were used separately to print the sky two shades of blue, and the densest positive was used to give a magenta hue to the stonework. Finally, the densest negative was printed to give yellow highlights.

Original continuous-tone negative

Low density
line positive

Low density
line negative

final image, you may find it easier to enlarge the transparency on to a sheet of line film. Then, from this line negative, contact-expose a line positive. Tape the two together back-to-back, so that a double thickness of film-base separates the two emulsions, in perfect register this time so that no gaps or edges show from a perpendicular viewpoint. Place the sandwiched films on a record turntable with an unexposed sheet of line film underneath, and expose with a naked lamp at a 45° angle, rotating the turntable throughout the exposure. The light will reach the unexposed film only as thin contour lines through the double thickness of film-base. The outline produced depends on the exposure that you give the original line negative; you can even sandwich together the different tone-line images produced from the same original. Negative originals, both black-and-white and color, can also be the starting point for the tone-line process.

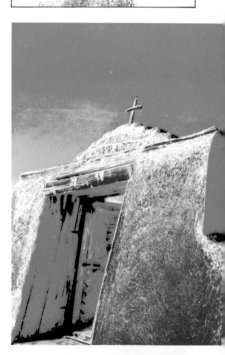

A similar process uses equidensity film. Agfacontour has a mixed emulsion of silver chloride and silver bromide that, with a special developer solution, produces a dense black when well-exposed to light and also a dense black when there is no exposure. Where only partly exposed, the light intensity is insufficient to stimulate chemical development, but just enough to prevent the physical development of the silver halide that occurs without exposure. The effect is a thin contour line between two densities. The possibilities for experimentation are enormous by, for instance, making a second-generation equidensity copy, so doubling the contour lines.

Tone separations

Because line film records only black, and the amount of black image depends on the exposure, it is possible to separate any density of image. The particular skill in this process lies in keeping a count of the steps.

Start by making a wide range of exposures on to line film. It is more convenient to work with a large image, so enlarge on to sheet line film rather than contact-expose. Although there are an infinite number of possible separations, at this stage choose only three – a shadow negative, a mid-tone negative, and a highlight negative.

Next, make three positives by contact-exposing each negative on to line film. These six pieces of film are the basic tone separations and can be used individually, in combination, or sandwiched together to

Mid-range
line positive

Mid-range
line positive

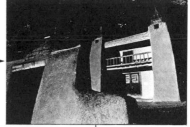

High density
line positive

Mid-range
line negative

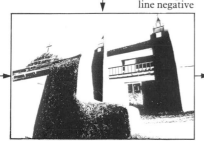

Mid-range
line negative

High density
line negative

produce a variety of separation images. They can be used to make a
new transparency, a black-and-white or color print, as you choose.

Posterization

Posterization is the most common use of tone separations. Color adds
complexity, but gives you a wide choice as you can introduce colors to
the image with filters.

By combining the three negative separations and three positives in
register, you can produce four entirely separate tonal ranges from the
same photograph. Each of these four tonal ranges can then be copied
through a different color filter. Use the register system described on
page 259 , either with the slide copier, or by contact-exposing. With
either method, choose different filters to place over the camera lens or
light source. Experiment with different colors.

Reversal as negative

A very simple way of completely altering colors on reversal film is to
process it as negative instead of as transparency material. The result is
not only a reversal of tones, but also of colors. By taking the photo-
graph so as to avoid obvious shadows, the effect can be puzzling yet
still realistic. Use infra-red color film for even more unpredictable
results – because this film records living vegetation as magenta, the
negative processing will restore plants to green, yet alter other colors.

Reticulation and freezing

Reticulation is nowadays an uncommon mistake in processing, its
characteristic crazed pattern being due to extreme expansion and
shrinking of the gelatin emulsion, caused by rapid changes in tem-
perature during development. To experiment with this effect, use
duplicated copies rather than original film and expose through a CC20
yellow filter to correct for the color shift that reticulation causes.

Another kind of maltreatment for effects is to freeze the processed
film before it has dried. The contractions that this causes work best
with reticulated film, where the gelatin has already been weakened. In
color film this can produce an unusual marbled effect in all three
layers of dye. Simply blow off excess drops of water and place the film
in the freezer. The effects will differ according to whether you leave it
in for a few minutes or a few days.

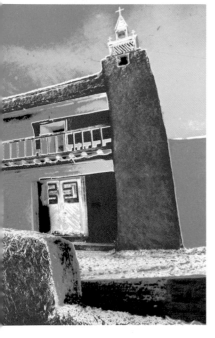

Ink in suspension. To produce the effect
of a colored liquid in suspension against a
dark background (left) was difficult with
straightforward photography – the liquid
would not have appeared bright enough
in cross-lighting. The alternative was to
backlight the shot and process the
reversal film as a negative; the white
background would then appear black.
For the final result of a red liquid in
suspension, *green* ink was dropped into a
jar of plain water.
*Nikon, 55mm macro, Ektachrome, flash
sync, f22.*

265

New technology

MODERN TECHNOLOGY, with its fast pace of innovation, is a rich source of experimental imagery for the photographer. Color video, thermography, lasers, and stress revealed by polarized light are all examples of new and original images that photographers can appropriate for their own use. Such images may not immediately spring to mind as being part of photography, but if they are visually stimulating then they have a place in the photographer's repertoire.

In a sense, these examples are a loose collection of techniques that fit together only because they have no obvious place in normal photography. What they are intended to do is to encourage experimentation and to show that photographic images can be created from a variety of unlikely sources. Don't be deterred by the impossibly high cost of most of these systems; with the right approach you can often persuade organizations that manufacture or use the equipment to help you.

Polarized plastics. The stresses in some plastics during manufacture show up under polarized light. The objects were first placed on a sheet of polarizing material and backlit. A polarizing filter was then rotated in front of the lens until the white background light was reduced to a deep blue (below and bottom). *Nikon, 55mm, Ektachrome, f16.*

Heat image. Thermographic cameras use a scanning system to sense emissions in the far infra-red. Commonly used in cancer research, they can 'map' small differences in temperature. Here, a 35mm camera was used to photograph the cathode ray tube of the heat camera (left). *Pentax, 50mm, HS Ektachrome.*

Laser and mercury. The beam from a low-powered helium-neon laser reflects in a star-like burst of small mercury beads (right). The characteristic speckled appearance of laser light is due to interference patterns. When using any laser, avoid damage to the eyes by using safety goggles if there is any danger of the beam falling directly on the retina.

Video. This is a new technology which is advancing by leaps and bounds, and a large number of specialized effects are now possible using very simple controls. The one real disadvantage for still photography is that the resolution, at 625 lines per inch, is too poor for significant enlargement. In this example, I took an existing transparency (below) – an aerial view of the Green River flowing through Utah's Canyonland National Park. The first two effects (below center and bottom) were achieved with a telecine machine alone. This machine is designed for recording still and cine film on to video tape and has various balancing and format controls. Each of the three primary colors has separate controls both for the gamma (stretching or compressing the black component) and for the gain or amplification. A negative image is formed immediately, with a single switch, and the picture can be squeezed and stretched into wide-screen and Cinemascope formats. Advanced effects (left) need a color synthesizer, in this case CDL Vision Mixer which can "key" highlights and blacks. Crudely put, this means punching a hole in the image and inserting another picture, color or tone.

Scanning

Many printers now use scanners for
making separations from transparencies.
Basically, these machines use a thin beam
of light (sometimes a laser beam) to 'scan'
the density of a transparency that has
been attached to a rapidly rotating drum.
Apart from the great accuracy and
resolution that is possible with this
system, the image can also be
manipulated in several ways. Knowing in
advance what the scanner is capable of,
you may be able to produce a particular
effect without resorting to photographic
manipulation.

Two scanner effects are illustrated
here: image enhancement where
computer processing creates the
appearance of greater sharpness; and
distortion, where the image can be
stretched or compressed;

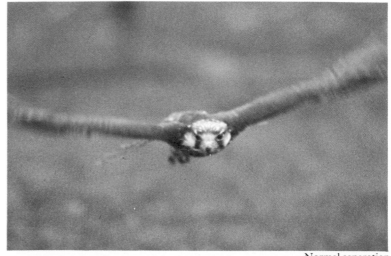

Normal separation

Image enhancement. One of the scanner's abilities is to give an image the appearance of being enhanced – particularly useful with the small 35mm format where a little unsharpness is often magnified greatly. The scanner's computer modifies the signal by increasing the contrast across adjacent areas of detail.

Image stretching. The scanner can be used deliberately to distort a picture, stretching the image either vertically or horizontally. In normal use, the scanner is set to enlarge from the transparency equally along the horizontal and vertical areas (below). In the large distorted version (bottom), the scanner operator set the horizontal enlargement at twice that of the vertical.

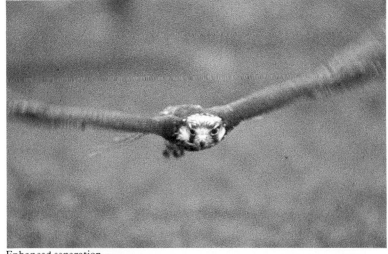

Enhanced separation

Black-and-white print manipulation

IT IS EASIER to manipulate the image on a black-and-white print than in any other photographic medium. The image area can be as large as you like, making detailed work relatively simple, and later re-touching can refine the manipulation quite easily. Mistakes are not irrevocable, as with original transparencies or negatives.

Practically, most print manipulation is concerned with combining images that could not conveniently be put together at the time of taking the photograph. This can be done either by physically joining separate prints together, or by combining negatives in the enlarger.

Photo-montage. Photo-montage is a physical assembly of existing prints, carefully cut together with a scalpel. Re-touching and re-copying are normally used to conceal the places where the prints are joined. First, size up the images that you are going to combine, and make several prints of each, taking care to match tones and contrast by selecting the grades of paper and adjusting the exposure times in the enlarger. (A number of prints will allow you room for mistakes in the assembly.) Where possible, use one print as the background for your picture – this reduces the amount of cutting.

Then, carefully knife round the outline of the image to be super-imposed with a scalpel. On the back of the cut-out print, chamfer the edges gently so that they do not stand out on the final assembly. You

Sliced watch. Using photo-montage, supplemented by re-touching and re-copying, a segment of this pocket watch was first cut from a straightforward print (above). The two parts of the watch print

Masking for precision

For a technical magazine article on American inventions I decided to combine a domestic light bulb (Edison's invention) with an American eagle. The position of the eagle's grasping talons on a plaque suggested the final image, but because the positioning was critical, and the eagle had to be photographed against a wall, precise masking was essential. Having photographed the light bulb and eagle separately, it was still necessary to bring the images into proportion – it was easier to do this beforehand than to alter the position of the enlarger head for each print.

Using red masking tape to cut out the background and opaque applied with a fine brush, I made a print of the eagle, and copied this to the exact size needed to combine with the negative of the light bulb. I then masked this second negative so that no extra light would degrade the already delicate image on the light bulb.

The two negatives – re-copied eagle and light bulb – were then double-printed using the same technique as for the book and library building. An alternative masking method would have been to use line film, but in this case I felt it would have been unnecessarily complicated.

Double printing without masks

To illustrate a special feature on college book reviews in a scientific magazine I wanted to combine the image of a textbook with a university building, in this case the Radcliffe Library in Oxford. With a rough layout in mind, I photographed each separately. The book was shot in the studio against white so that the background would already be partially masked. As the positioning was not critical, and I wanted the two images to blend, there was no need to make precise masks – hand shading would do.

With the negative of the book in the enlarger, I marked the outline of the image on the baseboard. I then exposed one sheet of printing paper, shading the area above the book with my hand.

Returning the sheet to its box, I replaced the negative of the book with one of the library building, positioning it against the marked outline on the baseboard. Then, with the already-exposed sheet replaced on the baseboard, I made the second exposure, masking the lower part of the building so that the latent image of the book would not be over-printed.

were then chamfered at the edges, arranged in their positions and re-photographed. On this final print (above) the three-dimensional sides and interior were airbrushed in, and shadows added.

may also find it less conspicuous if you use a single-weight printing paper. Stick the cut-out down onto the background print with a removable adhesive, and re-touch the edges as far as possible. Air-brushing shadows onto the assembled print can be extremely effective in blending images.

Finally, to remove all signs of the cut-out edges, copy the entire assembly and make a fresh print.

Double printing. Combining the images from different negatives by separate exposure onto the same sheet of paper is the most common of all print manipulations, and with skill may not even need later re-touching. The secret is adequate masking – holding back the exposure sufficiently from one negative so that part of the second negative can be recorded. Dense, over-exposed parts of a negative may provide enough masking on their own, although a fully-developed silver image will still let some light through onto the paper, and a slight tone usually results. Shading the 'empty' part of the negative with your hands or a piece of card can be effective, but for precise results a line film or card cut-out mask may be needed. Essentially, the principle is the same as for double-exposure in the camera (see p250) – hold back the light from one part of the print so that a second image can be printed into this area.

271

Re-touching

RE-TOUCHING CAN BE put to use in two ways – to make corrections to a blemished photograph, or to alter the image deliberately. The former is a standard procedure, particularly with enlarged prints, when scratches on the negative, or just specks of dust, have been magnified and spoil the print. The latter use, however, can require considerable illustrative skill, and is often used to create images that would be impossible, or very difficult, in the camera.

Whatever the purpose, basic re-touching methods are essentially the same. Whether you are re-touching a negative or a print, make a careful assessment of the image, then plan the sequence of activities. Chemical action comes first, followed by dye applications, with physical knifing and body applications last. As a general rule, start with large-area re-touching, and gradually work down to smaller-scale blemishes, finishing with fine spotting.

35mm film is so small that it is normally impractical to re-touch negatives or transparencies directly. The most that can be done with any accuracy is broad tonal alteration on black-and-white negatives. Color negatives or transparencies need more subtle treatment. Occasionally, professional re-touching studios will make large-format duplicates of 35mm originals before starting work, or they may even make expensive dye transfer prints; however, the order of expertise needed for this type of exacting work is normally beyond the casual re-toucher.

Avoid using re-touching as a safety net. It nearly always needs less effort to eliminate mistakes at the source – during the picture-taking or processing – than on the re-touching stand, and a perfect negative is more durable than an elaborately re-touched one.

Black-and-white negatives

Although a range of techniques is available for re-touching negatives, very few can be used on 35mm film. With an image area of only 24×36mm, detailed work is impossible, and the use of re-touching pencils, knifing and even spotting will be obvious in the enlarged print. This is unfortunate, because the negative is often a better place to do the re-touching as it removes the tedium of having to work on each individual print.

What *can* be done on the negative is broad tonal correction. You will probably need to make a test print in order to assess how much re-touching is necessary. Light areas can be made darker by removing some of the negative's silver image; dark areas can be lightened by increasing the density on the negatives. Occasionally you may need to use both techniques on the same negative; if so, use the chemical before applying dyes.

To increase print density, you can remove silver from the negative with a reducer, such as Kodak Farmer's Reducer. If the entire negative is too dense, because it has been either over-exposed or over-developed, then you can apply the reducer overall. If only a part needs correction, concentrate on that area with a brush or cotton swab. If you over-reduce, some density can be put back by using a dye, but you will have lost detail. It is better to work in stages, reducing a little at a time, until you eventually arrive at the tonal value that you want.

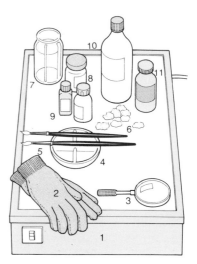

Black-and-white negative re-touching equipment
A light box (1) is the principal working surface. Cotton gloves (2) prevent finger marks on the film, and a magnifying glass (3) is essential for detailed work. A palette (4) is used for mixing dyes, and fine brushes (5) for applying them. Cotton swabs (6) have a number of uses. Water (7), opaque (8) and dyes (9) are the basic materials; de-natured alcohol (10) is used for cleaning negatives prior to re-touching work, and reducer (11) is used for removing density.

How to re-touch black-and-white negatives

Reducing negative density for a darker print tone

1. Prepare the two-part reducing solution according to the manufacturer's instructions and depending on the strength of the mixture that you want. Normally, mix one part of Solution A with two parts of Solution B. Solution B slows down the reducing action. Once mixed, the reducer will remain active only for about 10 minutes.

2. With the negative emulsion side up, on the light box, swab with water for two or three minutes.

3. With either a brush or cotton swab, apply the reducer smoothly and continuously. Keep the boundaries of the reduced area vague, so that the reduction will blend with the rest of the negative.
4. Swab off the solution with water. If the reduction seems insufficient, repeat the process.

Increasing negative density for a lighter print tone

1. Clean the negative on both sides, with a cotton swab dipped in de-natured alcohol.

2. Soften the gelatin by swabbing with water. You can work on either side of the negative – the emulsion side accepts dye more readily, but mistakes are difficult to correct. If you need to apply a consid-erable density of dye, use both sides.

3. Dip the brush in a weak dye solution, and remove the excess fluid by drawing it off against your thumb-nail or a discarded piece of film. Alternatively, use a swab.

4. Apply the dye with gentle overlapping strokes. Some dyes, such as Kodak Crocein Scarlet, are designed to be used on the back of a negative. Others are intended for the emulsion side. Continue to add dye until you reach the density that you want. If, by mistake, you have added too much dye, you can remove it slowly by washing. A 3 per cent sodium hydrosulfite solution will completely remove the dye.

Blocking out backgrounds with opaque

1. Dilute the opaque paste to a working consistency with water.

2. Clean the back of the negative with de-natured alcohol.

3. Apply the opaque with a brush. As opaque is completely dense, it blocks out any image on the print. Although 35mm film is too small for you to be able to work around edges of the image with opaque, the technique can be combined with shading (see p 108) to reduce vignettes or large white areas on the print. Opaque is water-soluble, and can be easily removed.

Black-and-white prints

Because the working area is much larger, and because they are rarely irreplaceable, prints are generally better for re-touching. Also, it is much easier to judge the effects of the re-touching on a positive image. The principal drawback is that, with several prints from the same negative, it must be done separately for each.

If the finished print is intended for display rather than reproduction, take care that the surface texture and color of the re-touched areas match the remainder of the print as closely as possible, so that the re-touching is not noticeable. This means making a careful selection of re-touching materials and techniques, and the use of a printing paper that will accept re-touching well. With dyes and body-color, match the color to that of the printing paper you are using. Some dyes are supplied in slightly different shades of 'black', from brownish to bluish, and can be mixed in advance to give a perfect match. Printing papers vary not only in slight differences of color, but in their ability to soak up dyes; a hard emulsion will accept the dye more slowly than a soft one, and resin-coated papers, where the emulsion is effectively isolated from the permeable paper base, are generally quite unsatisfactory for re-touching. Knifing and bleaching are often noticeable when the print is viewed at an angle to the light, because of the different texture that they leave on the surface of the print. If the print is to be reproduced in a book or magazine, this will not matter, but if it is going to be displayed, you might reconsider using these techniques. However, if you have to undertake re-touching that causes visible differences in the surface texture, one answer is to coat the whole print with a protective spray coating. This, in effect, re-surfaces the print.

As with negative re-touching, there is a definite sequence of procedures that you must follow if you are going to use a variety of

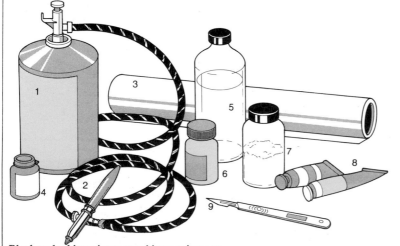

Black-and-white print re-touching equipment
Basic items are a can of compressed air (1), and an airbrush (2), with transparent masking film to cover areas not being re-touched (3). Re-touching fluid (4), gives a 'bite' to the print surface. Bleach (5) and hypo crystals (6) are also needed, and rubber cement (7) can be used for complicated masking. Water-color pigments (8) are used in the airbrush and a scalpel (9) for cutting and knifing.

How to re-touch black-and-white prints

Reducing print density

1. Pre-soak the print in water for 10 minutes to soften the emulsion and paper-base.

2. Lay the print on a smooth surface, such as a sheet of glass, and swab off excess water.

3. With brushes or cotton swabs, apply the diluted bleach or reducing solution to the print. If you are in any doubt about how fast the solution will work, or whether it will cause any discoloration, test first on an unwanted print. In any case, use a very diluted solution so that you have more control – for instance, use Farmer's Reducer at a dilution of 1 part in 6. Work the solution over the print continuously so as to avoid hard and conspicuous edges to the reduced area.

4. (Alternative procedure.) If the areas to be reduced have precise boundaries, use rubber cement to protect those areas that must be left alone. This can be painted on, and dries to a thin coating, which can be peeled off afterwards, and allows the entire print to be immersed in reducer.

5. Use a cotton swab and either plain water or hypo to halt the bleaching action when you judge the effect to be right.

Painting with dyes

1. Pre-soak the print in water for 10 minutes. This enables the dye to penetrate more easily, and prevents hard edges to the dye washes.

2. On a sheet of glass, or other smooth working surface, swab off water droplets and allow the print to dry slightly for about 10 minutes.

3. With either rubber cement or self-adhesive masking film, mask off the areas that are to be untreated. When using masking film, first peel off the backing, and then carefully lay the film down over the whole print, smoothing it down so that there are no wrinkles. Using a sharp scalpel, cut round the edges of the area to be dyed with just enough pressure to break the film but not enough to damage the print. Peel off the film from the areas that have been cut round. Mix a dilute solution of dye, making sure that it matches the hue of the print. Working from two dye bottles, one brownish-black and the other bluish-black, you can prepare a precise match. Apply the dye in washes with a brush. Build up the density in a number of applications. If you make a mistake, or find that the added density is too great, place the entire print under running water for several minutes and begin again.

Hand-coloring

In the case of this advertisement for a cosmetic manufacturer, the advertising agency wanted to give as much emphasis as possible to a new range of colors, and decided that a contrast between a black-and-white image and the colored make-up would be the most dramatic means. The problem was to hand-color the black-and-white print so that the colors appeared completely authentic and matched the actual colors of the make-up.

On a 40×50cm (16×20in) black-and-white print, the first step was to mask the areas that were to remain uncolored. This was done by laying a clear, slightly-adhesive film over the whole print, knifing around the outlines with a scalpel, being careful not to cut into the print itself. As the hand-coloring would add density, the darker area, such as the neck shadows, were washed over with a bleaching solution.

The whole skin area was then sepia toned, using a brush, to provide a base color similar to the flesh hue desired. The remaining masking film was removed and the flesh was colored, starting with broad washes using a No. 8 brush and diluted dye. The stronger colors were then gradually worked in by stages, using smaller and smaller brushes and more concentrated dyes. To make sure that the make-up colors were identical to those of the client's product, the re-toucher applied them to the back of his hand as a reference. The orchid, whose colors were intended to match those on the girl, was also treated in the same way.

After knifing round the areas to remain uncolored, the mask was peeled back.

Darker areas, such as the neck shadows, were washed with bleaching solution.

The stronger colors were gradually worked in using more concentrated dyes.

techniques on one print. All chemical action, such as bleaching, comes first. After thoroughly washing the print to remove all traces of chemical contamination, dyes can be used. Finally, water-soluble body color and knifing can be applied. In each stage, begin with large areas and work down towards detailed re-touching.

Before using any re-touching technique, consider whether there are any simpler or better methods. Knifing, for instance, is a rather drastic treatment, and chemical reduction, or even spotting of the negative, may be better. Again, local density control often can be performed more easily by shading or printing-in (see p 108) than by bleaching. Dyes, although slower to apply, are nearly always preferable to body-color, as they penetrate the emulsion, blend in with the surface of the print and are reasonably permanent.

Dye transfer re-touching

For top-quality re-touching, the dye transfer is unsurpassed. Not only does it give a basic print quality that is far superior to any normal photographic process, but its image is produced with the same dyes used by professional re-touchers. Because of this, accurate re-touching can be indistinguishable from the original print.

The process of making a dye transfer is long, complex and requires great accuracy. It is possible to undertake dye-transfer printing yourself, but the outlay in time and expense is great, and it is a process that at the moment is almost the exclusive preserve of commercial laboratories.

Basically, dye transfer is a form of printing that bears more resemblance to the silk-screen technique used by commercial artists than to photographic color printing. The first step is to make a set of separation negatives, each recording on special black-and-white negative film a silver image of a separate primary color. To stretch an analogy, this is a manual version of the tri-pack process that takes place in color film. However, in order to balance the colors and tonal range, several light masks also may be necessary. Some of them can be sharp and some slightly soft. Much depends on the density and other characteristics of the original transparency (a densitometer is essential for accurate measurements).

Each separation negative is then exposed on to a special film, called a matrix. This forms not a silver bromide image, as ordinary film does, but a relief image in gelatin. Unwanted gelatin can be removed in development.

The actual print-making can be done in normal light. Each matrix which is full-size to the print, is soaked in a dye – the first in a yellow dye, the second in magenta, the third in cyan. Then, one by one, they are rolled onto a sheet of specially-treated paper, which soaks up the dye from the gelatin on each matrix. At every stage in the whole process, register pins and a punch must be used, and considerable experience is needed to keep the registration accurate enough to produce a clean, sharp print.

The dye transfer excels in its possibilities for faithful color reproduction and sets a standard, though an expensive one out of reach for most photographers, against which all color printing can be judged. However, it really comes into its own when faultless re-touching is

Airbrushing with body color

The airbrush is a precise instrument that, with practice, can be used to produce smooth gradations of tone of almost photographic perfection. It is the stock-in-trade of many commercial artists, and is useful when major re-touching is needed. Body-color – opaque watercolor pigment – is used rather than dye, and although there remain the problems of altered surface texture and the danger of smudging, large amounts of pigment can be applied rapidly and effectively. Nevertheless, considerable practice is needed to apply the controlled gradations

Press down for air flow.
Pull back for pigment flow.

of tone that are the airbrush's best attribute.

Most airbrushes are double-action, requiring a downward pressure to increase the flow of compressed air (from either a compressor or a can), and a backward movement to increase the flow of pigment. Synchronizing these two finger movements is the key to successful airbrush use. The principle of the airbrush is to produce a fine spray of pigment; the greater the air-flow, the smaller will be the individual specks. By adjusting this flow you can, to some extent, match the graininess of a particular print. For a soft edge to the airbrushed areas, use either cotton wool or a constantly-moving piece of card instead of masking film.

Basic airbrush technique

1. Dilute a small quantity of pigment in water. The ideal consistency for most airbrushes is that of milk.

Disembodied hand. To realize this surrealist image for a record album cover (below), extensive and skilled re-touching was necessary. The blending of glove into hand was crucial, and the re-touching had, above all, to be completely undetectable. A dye-transfer strip-in technique was used, described in detail on the next page.

2. Partly fill the bowl of the airbrush with the diluted pigment, using a pipette. Test the action of the airbrush by spraying against a piece of card. With the print suitably masked – in the same way as for dye application – begin spraying.

Knifing to remove dark spots

1. With the broad edge of a sharp scalpel blade, gently shave the blemish on the print's surface. Make short strokes, keeping your fingers steady and using your wrist for movement.
2. Stop before all the emulsion is removed, otherwise the roughened paper base will begin to show through.

3. For small spots, use the tip of the blade, but remember that there is a greater risk with this method of cutting through to the paper base. Knifing should never be done before any wet re-touching (such as bleaching or dye application) as it physically damages the print and can result in dye bleeding away from its area of application.

needed. The example shown here was the kind of assignment for which the client wanted the very best result. Freed from a restricted budget, the art director and I could concentrate on a strong image.

The client was a singer and musician, Gilbert O'Sullivan, and this was to be the cover of his next record album. O'Sullivan and art director, Bob Hook, had already decided on the title – 'Southpaw' – referring to the fact that he was a left-handed piano player. He specifically wanted the cover to stress his song-writing rather than his piano-playing, for which he was better known.

The idea of the disembodied hand that was also a glove, writing a musical score, seemed to do all that the client wanted and in a dramatic and unusual way that was necessary if it was to stand out on the record racks. Re-touching would obviously play a large part, but it was essential that the execution should be perfect; knowing that it was clearly an impossible image, anyone looking at the picture would immediately search for traces of trickery. If the re-touching was in any way visible, the whole picture would be a failure.

Only on a dye transfer could the elements be blended perfectly. I used the same re-touchers responsible for the hand-coloring of the cosmetic advertisement on the previous page, the Michael Mann Studio, as they had experience of this kind of work. Their raw

Wet- and dry-dye techniques

Color print re-touching equipment
Basic wet and dry techniques can be carried out with a bottle of stabilizer (1), brushes (2), blotting paper (3), cotton swabs (4), and cakes of colored dye (5).

material, which I supplied, consisted of two transparencies; one was of a hand with pen writing the musical score, the other was a similar shot from the same camera position, but of a gloved hand. A crude assembly of the two images – known as a 'two-part strip-in' – was made at the dye transfer stage by masking. Complex re-touching involving original illustration completed the work.

Starting from transparencies of the hand with pen and of the hand wearing a glove, a dye transfer was made that combined the two images in the correct positions but with rough edges. The forearm was completely masked out, leaving a white space on the print, and where the back of the glove and front of the hand joined there was a rough blur of color (easier to disguise in the re-touching than a sharp edge).

The re-toucher's first step was to work on the inside of the glove. This was entirely original illustration, using the real glove as a reference. Original work like this is a true test of a re-toucher's skill. Next, the background where the arm had been was completed.

Wet-dye

1. Moisten the re-touching brush by dipping it in a solution of water and stabilizer (such as Kodak Ektaprint 3 Stabilizer).
2. Transfer the dye or mixture to a palette.
3. To reduce color intensity, add neutral dye if necessary.

4. Load the brush with dye, then draw it across a piece of scrap paper to form a point and remove excess.
5. Re-touch, making sure that no dye overlaps the edges of the spot (this would form a dark ring).

6. Use blotting paper to remove excess color. It is safer to build up intensity with several applications rather than risk over-saturating the print.

Disembodied hand – procedure

The raw material supplied to the re-toucher for this project was two transparencies which would fit together

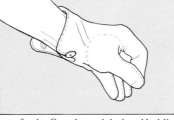

perfectly. One showed the hand holding the pen (above left) and the other showed the hand wearing the glove.

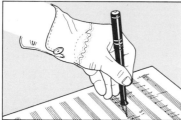

First of all a dye transfer was made and two transparencies were joined together, just leaving the rough edges.

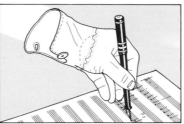

Next, the forearm was masked out, exposing the inside of the glove which then had to be filled in.

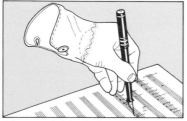

The space left in the background from the removal of the forearm was also filled in, almost completing the image.

Finally, the glove and hand were blended together. The re-toucher used the same dyes as for the dye transfer.

Dry-dye

1. Make sure that the print surface is absolutely dry.

2. Breathe onto the surface of the cake of dye and pick up a small quantity with a cotton swab.

3. Rub the dye-loaded cotton swab over the print in a circular motion.

4. Repeat with more dye of the same color or greater intensity, or with a different dye for a mixed color.

5. Buff with a clean cotton swab to smooth out the dye. This will also lighten the color.

6. To remove excess dye from the print's surface, use the cake of reducer in the same manner, breathing on it and then rubbing with a cotton swab. Afterwards, remove excess reducer from the print by buffing.

7. Make the re-touching permanent by holding the print about 10in (25cm) over steam from a boiling kettle for 5–10 seconds. You can tell when the steaming is complete by examining the print surface; waxy marks caused by applying the dye should have disappeared.

8. By alternatively dyeing and steaming several times, greater intensity can be applied. In each instance, dry the print thoroughly.

9. To remove steam-set colors in an emergency, use undiluted Photo-flo wetting agent with a cotton swab. Do not leave the Photo-flo on the print for more than a minute; remove completely by swabbing with water and stabilizer.

Matching tone and line was one problem; concealing the edges another. Broad tone work such as this is invariably done with a brush: air brushing, which is ideal when working with body-color, is less common now that most professional re-touchers use dyes.

The final work was the blending of glove and hand, done principally with small brush sizes. The dyes used in the re-touching were the same ones used to print the dye transfer, and could be blended into the print so well that even examination with a magnifying glass would not reveal any differences. One particularly nice touch at this stage was the way that the stitching on the glove gradually became stitching on the flesh. This kind of detail helps to 'key' the whole illusion.

Color prints

Re-touching color prints is generally more demanding than working with black-and-white prints. Not only must you work with lines as well as tones, but the construction of color print paper precludes the use of some techniques. Being normally resin-coated, the paper tends to respond poorly to the removal or addition of dyes, and pigments (body-color) are often more effective. There is a big difference between re-touching a print intended for exhibition and one intended for reproduction. With an exhibit print, you can judge the effect of your work visually (do the re-touching under good lighting conditions, preferably daylight), but if a printer is going to make separations from the print, the dyes or pigments that you add may record differently on film. In this case, to be absolutely certain that the re-touching will blend in perfectly, test your work by re-photographing it (see p 208).

Print re-touching should be done in the following order: wet-dye, dry-dye, body color and lastly colored pencils. Dye bleaching is rarely satisfactory with color prints; it is generally better to apply body color in order to lighten tone. Before starting, clean the print surface with de-natured alcohol, to remove the traces of fingerprints and other marks.

For specific makes of color print paper there are special re-touching kits available. It is important to match the dyes, and whenever possible you should follow the manufacturer's recommendations. Kodak, for instance, supply re-touching colors for Ektacolor 37 RC paper; Cibachrome has its own special re-touching kit.

Re-touching colors such as those made by Kodak can be used either wet or dry. Use separate sets of colors for each technique as moisture saturates the dye, which will then later tend to penetrate the paper's emulsion whether it is intended to or not. The wet-dye technique is better suited to spotting, while large area re-touching is better handled with dry dyes.

Body color technique

This is the same technique as used for black-and-white prints, and does not interact with the emulsion. Either apply white opaque as a kind of undercoat, followed by a pigment of the color you want, or just mix the white and colored pigment to exactly the right intensity.

Body color like this can be applied by brush or airbrush. For a smoothly graduated finish without hard edges, airbrushing is particularly effective, although considerable practice is needed.

3: Working professionally

BY NO MEANS ALL photographers have either the hope or intention of becoming professional. There is a spurious cachet to the concept of the professional photographer, for, as John Szarkowsky has said, "a photographer's best work is, alas, generally done for himself." Nevertheless, professional photography can be challenging and creative. It has its own procedures and anyone starting out professionally faces some specific problems.

The question of professionalism in photography is a vexed one. There is one school of thought that reveres the purity of amateurism – in its original sense – of work done for love rather than gain. To this view, commercialism is crass and the value of the photographs taken in the pursuit of a career is diminished proportionally. Equally, there are others who scorn what they see as the insufficiency of expertise and talent among amateurs, and for whom only the dedicated seriousness of the professional is a proper platform from which to practice photography.

Both points of view are extreme, but there are undeniable difficulties for amateurs, who usually lack the time and finance that would help their work, and for most professionals who must work within the constraints imposed by their clients. Some professional photographers find the answer in dividing their work between paid commercialism and personal art, although this has a ring of necessary compromise to it. Perhaps the ideal is to be professional and successful enough to be able to follow personal aims while working for clients, but this is not easy to achieve and very few are able to do it.

Much of this third section of the book is taken up with the needs of professional photography. The progress of confirmed amateurs is too idiosyncratic to formalize in this way, although many of the areas discussed, such as style or copyright, equally apply to both professionals and amateurs.

Style and presentation

STYLE, IN PHOTOGRAPHY as in any art, is an elusive quality, real and definite when it occurs, yet difficult to analyze and dangerous to contrive. There is a temptation to take positive and sometimes drastic steps to acquire a recognizable style because established and respected photographers plainly have marked styles of their own. The work of top professionals is widely used, and, in the nature of the photographic industry, they tend to be assigned to projects that are suited to their styles. The publishing media therefore reinforce photographers' styles. Predictably, the photographer who has developed a particular treatment of, say, composition, will be asked to bring this style to an assignment.

Most new photographers feel that a style is what they need – something that sets them apart and makes their work identifiable. It is hard to deny that there is real commercial incentive to possessing an obvious style. It fixes the photographer's work more definitely in the minds of potential clients, and becomes a specialized area of ability. What often escapes the notice of inexperienced photographers is that the style of an experienced photographer has usually developed slowly and naturally.

The danger of consciously and rapidly developing a style is twofold. Firstly, it has a strong chance of being contrived and therefore empty. Secondly, it may be the entry to a dead-end with increasingly limited possibilities. If you have a commercially successful style, most art directors will help you to keep it as it is. Assignments are all too often briefed in terms of previous photographs.

Nevertheless, without trying to force your work into what may turn out to be an inappropriate style, you do need to direct it, and it is

Ways to develop style

1. Follow your interests. As the second section of this book shows, photography covers an enormous range of subjects. Try to apply your photography to your own special interests even if you don't immediately see a way of doing it.

2. Become familiar with as many areas of photography as possible. Spend time in photographic galleries. Look at new publications, both books and magazines. Also, keep in touch with photography that is purely commercial by studying magazine advertising, posters, book and record covers. Try and discern changes and movements in different areas of photography, but avoid directly imitating them in your work.

3. Experiment freely with new methods and techniques, and, while being careful to control mannerisms, give full play to any natural tendencies you may have in handling the camera. You may end up by discarding most of the results, but then, that is what experiments are for. Search for new

subjects or techniques that break new ground. Modern technology is constantly throwing up new methods of producing fresh images.

4. Keep in touch with commercial needs. Look for areas of photography where there is a real demand by clients, and avoid areas which are already over-crowded with other photographers attempting to do the same thing.

5. In situations where a selection is taken from your work – for instance, when an art director is editing one of your takes – pay close attention to what other people choose from your work. The shots that experienced professionals find the most interesting may be your first indication of a developing style.

6. As a rule, the more innovative you are, the more definite your style will become, and the more readily recognized. Remember though, that some photographers, particularly those whose work is derivative, *never* develop a positive style.

essential to chart your creative progress. As photography has never given rise so successfully to formal movements as has painting, most photographers must fall back on themselves for direction – almost certainly a good thing. Photographic criticism, which would otherwise establish formal boundaries, is relatively new, so there is little direction from this source either. As a result, the development of personal style in photography is often a ragged process blunted by most photographers' lack of practice at thinking clearly about their own work.

Analyze your creative progress – deliberately concentrating on aspects of photography that will further it. No one else will do this for you, though you may find help and advice from individual clients, agents and other photographers. The only way of continuing to develop creatively is to keep your own standards higher than your achievements. Look for weaknesses in your work, style or technique and take action to correct them. For instance, you may recognize a tendency towards cliché or you may find yourself unconsciously imitating other photographers. Rushing off jobs that are well within your competence, or cutting back the time and effort you put into an assignment to the level where it is just satisfactory, are forms of back-sliding and are particularly tempting if the client's expectations are not very high. An antidote to this is to treat every assignment as a candidate for your own portfolio, which itself is the distillation of what you think is best about your work.

The portfolio

A portfolio is a tangible record of your achievement, a selection of work designed for presentation. For the professional photographer it is often the principal instrument in getting assignments, and for someone who has not yet achieved a strong reputation it may be the only way of showing ability to a potential client. Consequently you should take great care in putting together your portfolio – the wrong selection can lose you a commission as easily as the right choice can gain one.

Because a portfolio is a selection of your work – a summary of it – it is inevitably highly subjective. Just as the editing and layout of a photographer's take for a magazine can result in different treatments of the same subject, so the selection for your portfolio can present your work in a variety of ways. If you cover a wide spectrum of photographic assignments it might even be possible to create quite different portfolios. You must decide what you want the portfolio to show, and for this you must bear in mind the people who will be seeing it. If you are seeking a particular kind of work, think of what may interest those clients who assign that kind of work. However, do not slavishly try to show people exactly what you think they want to see. That kind of double guessing may weaken the overall impression, and you should not hesitate to include a few unusual experiments – these will not only show that you are innovative but might catch the eye of someone who has been looking for a different treatment.

For many years the stated principle behind the selection of exhibits at the annual Design and Art Directors Association show has been "The common thing done uncommonly well. The uncommon thing

The portfolio is a presentation of your work, and the case, as well as being sturdy enough to survive constant handling, should have an organized and professional appearance. The material should be mounted, for both protection and display.

done with commercial relevance." Follow that principle in selecting your portfolio and it will look as it should – stimulating and memorable. Remember that in looking for assignments, your portfolio will be competing against others.

The content of the portfolio ought to be fluid. You are after all continuing to produce new work and your creative style and ideas will probably change. Also, a portfolio that evolves gives you a reason to send it back to potential clients to show how your work is progressing. You might consider altering the portfolio to suit individual presentations, particularly if you do different kinds of work. For example, studio still-life shots will probably not be as interesting to the pictorial editor of a news magazine as will reportage.

The comments that potential clients make on your portfolio can be extremely valuable, and after several presentations you might, as a result, want to add or discard some of the photographs. Individual comments can, however, be surprising; different reactions to the same photograph confirm the subjectivity of art direction. Do not necessarily take everything to heart.

Although the content is the most important element in the portfolio, you should take pains over its presentation. There are a number of choices open to you in this area and they will be influenced by the kind of photography you are doing.

Transparency mounts

Although a lupe is needed to see each image, card mounts are a perfectly reasonable method of displaying even 35mm transparencies, and most art directors are accustomed to seeing material in this way. The best mounts are made of thick black card with thinner black masks for each transparency. Transparencies can be mounted individually or, more usually, in groups. Black card mounting shows off color saturation to its best advantage. For additional protection you can fit the mounts into a transparent sleeve with a translucent backing. An alternative to commercial mounts is to cut your own. This is a little difficult to do with great precision for the small 35mm format, and you may find it easiest to use fairly thin card.

Black-and-white prints

As prints usually have to suffer a considerable amount of handling,

Mounting a print

1. Measure the picture area that is to appear when mounted, and mark the frame lines on the borders of the print in pencil.

3. On a second sheet of card – the backing for the mount – position the print and mark round the corners in pencil.

5. Apply glue to the edges of the backing card, position the top piece of card, and press down firmly.

Mounting and labelling transparencies

Make sure, above all, that transparencies are adequately protected and properly identified. Develop a system for logging in transparencies, stamping your name, copyright mark, date and description on them. Many films are normally cut and mounted at the processing laboratory. Use a transparent slip-over cover. If a publisher uses a transparency for reproduction, it will have to be removed from the mount, so be prepared to re-mount used transparencies.

Ⓒ Michael Freeman 1978

INTERIOR OF MUSEO DE
BELLAS ARTES, MEXICO CITY

Mexico 21
 2695

Card mount (below).
Plastic mount
(right).

2. Mark these dimensions on the back of a sheet of thick card, and, using an angled mat cutter cut each of the lines up to the corners. Trim with a scalpel.

4. Having sprayed or brushed a light, even covering of glue onto the back of the print, roll it down onto the backing card using a sheet of tracing paper to avoid making marks.

6. The mounted print is ready for display, but handle it carefully until the glue is completely dry.

you will need to mount them and possibly give them a protective covering. Either use full display mounting or have them laminated professionally. A number of small firms now offer a laminating service specifically for presentations and portfolios, with a choice of backing material, borders, and finish.

Color prints

If color printing itself, or at least the photographic effects that can be achieved with it, are a part of your work, then naturally you should have prints in your portfolio. Otherwise, simply as an alternative way of displaying a transparency, they are not necessarily a good idea. You are trading size and ease of viewing for a loss of quality.

Specimens

Published photographs have a special place in the portfolio and are particularly important when you are starting your career. Human nature being what it is, most people are impressed by any form of established record, and the fact that your work has been selected and used by other publishers will normally make a potential client feel more secure about giving you an assignment. Always collect printed copies of your work, and if possible ask for final proofs from the printer as these are often of higher quality. Laminate cut pages for permanence.

Slide trays

All the above presentation methods can be assembled in a portfolio case (most art suppliers carry a selection of cases). A quite different method of showing your work is by slide projector, and a few of the larger magazine publishers accustomed to handling large numbers of transparencies actually prefer to see material in this way. You can provide your own slide projector (but make sure first that the person you are going to see has such basic facilities as a screen and a darkened room) or you can take just a slide tray. Kodak Carousel trays are standard for clients who normally view work with projectors (but check first). The main disadvantage of projection is the risk of damage by the heat from the projector bulb. Your slides are also unprotected in the projector; glass mounting for protection is dangerous because particles trapped between the film and glass can scratch the emulsion.

Filing. A convenient filing system is to use transparent sheets, each containing individual pouches. These will fit into a standard filing cabinet.

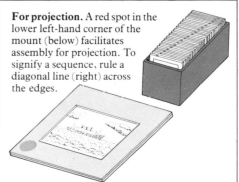

For projection. A red spot in the lower left-hand corner of the mount (below) facilitates assembly for projection. To signify a sequence, rule a diagonal line (right) across the edges.

Assignments

IF YOU INTEND to become a professional photographer – in other words, earn a good living by being a full-time photographer – you face a special problem. You will be relying on work commissioned by other people for their own purposes – publishers, advertising art directors, brochure designers – and you are unlikely to be able to exercise much control over the assignments until you are well established in your particular style and area of photography. Unfortunately, some of this commissioned work may be at odds with the kind of photographic experience you need to develop. The ideal advice would be to undertake only the assignments that will further the development of your style and technique, and to work only for good art directors who will make the best use of your photographs and from whom you can learn. In practice however, you will probably not have the opportunity to be so discriminating when you start.

As a rule, the most interesting assignments are interpretative, relying on the individual photographer's skill and judgement to succeed. This is the most sought-after work, for which there is the most competition – a sixteen-page photo-essay for an international magazine such as National Geographic or GEO, a company report for a multi-national organization, or a prestige advertising campaign. This type of assignment is the ideal for most professional photographers, combining interesting and demanding work, personal prestige and high fees. It is, however, unreasonable to expect the art director responsible for these commissions to assign inexperienced photographers with no track record. By its nature, interpretative photography is always something of a risk for an art director or picture editor – and they must often rely quite heavily on the photographer to deliver work that goes far beyond the briefing. Even highly-rated professionals may turn in disappointing work; less experienced photographers present a much greater risk. Because of this, the kind of assignment a new photographer receives is likely to be more rigidly determined from the start or come from a client who cannot afford the higher fees demanded by photographers with strong reputations.

Choosing an assignment
In the end, some compromise is usually inevitable, unless you abandon the commercial role, concentrate on self-assigned work and support yourself by other means. Exactly where the compromise lies depends on the individual. As a professional photographer, you need a constant flow of work, not only for financial support (the more money you can put back into your photography for film processing and equipment, the more technical scope and freedom you will have), but also to keep your style and name in front of potential clients. On the other hand, pedestrian work will, at best, dull the edge of your perception, and can sometimes completely alter the direction of your photography away from more interesting and creative areas.

A practical plan is to re-assess regularly both your creative development and the type of assignment you are receiving. Assuming that your work and reputation continually improve, you may be able to discard those assignments that are limiting. For instance, I was happy in the first year or two to accept half-day assignments at very short notice; later these became too disruptive for other longer and better-

With commissioned work, it is important to agree all the conditions of the assignment in advance with the client, particularly usage, fees and expenses. A formal agreement such as this one (right) can then later be used for invoicing.

Assignment confirmation/Invoice

Your purchase order no.:

Date:

From:

To:

Project:

Description:

Media Usage:

Photography fees	Amount	
Basic Fee: at per day/ per photograph (if applicable)		
Space Rate: at per (if applicable)		
Travel/Prep Days: at per day		
Postponement/Cancellation/Reshoot:% of basic fee		
Tax (if applicable)		
Total fees		

Expenses		
Film & processing		
Assistants		
Deliveries		
Travel		
Accommodation		
Subsistence		
Equipment/film transportation		
Location search		
Location/studio rental		
Special equipment rental		
Talent		
Sets/props/wardrobe		
Miscellaneous		
Tax (if applicable):		
Total expenses		
Total		

planned assignments and I was relieved to be able to drop them. Of course, as the fees you demand rise, you may have no choice but to break with those early clients who have fixed low budgets. If your reputation becomes stronger and your working time is full, you will have increasing control over the work you are offered. Use this control to improve the quality of assignments you accept. Discriminate in the way your photographs are used. Beware of assignments and clients that set low standards – they may encourage you to think that your work is better than it is.

The client's requirements

Pamela Marke, Photography Director of Time-Life Books in London, is responsible for one area of assignment work – book series that have a strong picture content. Although this is naturally quite different from advertising work, the range of subjects is large, from planned daily studio shooting to reportage work in remote locations lasting several weeks. In a year her responsibility covers over 2 000 published photographs.

"We devise, test and plan a series very carefully and we tend to have a clear idea of what we need in advance. By the time we're ready to commission a photographer, we have a picture script; the content and story are largely worked out. This doesn't mean that we're not receptive to ideas from the photographer – in fact, several really successful picture essays in *The Great Cities* series were suggested and shot by the photographer in the middle of the assignment – nevertheless, we do expect a photographer to cover the whole script.

"I probably see about a hundred new photographers in a year, and we have a very careful system for assessing them. Although I keep an eye on current published work, when it comes to seeing photographers personally, selection hinges on the portfolio. At any one time I have certain specific needs, and I also keep in the back of my mind future assignments. Essentially, when I see a new photographer I am looking for proof of ability, and the only tangible thing is the portfolio.

"For every photographer we make out a portfolio sheet; apart from the obvious details such as means of contact, I note areas of specialization, my own comments, and subjects that would fit current or future planned volumes. I refer constantly to this file of portfolio sheets, particularly when we're planning a new series.

"What I want to see in a portfolio are recent, relevant, original transparencies. Photographers' work changes with time, and I need to see what they've been doing within the last two years. Naturally, most of the material should be relevant to our work – if it isn't, then the photographer hasn't prepared for his presentation and he has not looked at our books. I want to see original transparencies because that is the only way of judging quality.

"I look for photographers who do more than simply cover the subject. They should have the ability to interpret our ideas. We define the content of the book – the style comes from the photographer."

Briefings

Briefings for assignments often receive less attention than they need. As every professional photographer eventually learns, and occasion-

ally by default, a great deal of needless effort can be saved by making sure that the photographer and client are completely in accord right from the start on what is required. It is as much your responsibility as the client's to cover every eventuality before it happens, and if, in the course of talking about it, you sense an area of disagreement it is infinitely better to air differences at the start than to argue intractably once the work has been completed. While a long-standing relationship with a client enables you to take shorthand briefings, with most of the basic points already understood, skimpy briefings with new clients undertaken in a wave of enthusiasm can be disastrous. On a couple of occasions I have made this mistake, the result being a situation that neither the client nor myself were happy with.

A cardinal rule is to take briefings personally. If you have an agent or representative, it may be tempting for them to be an intermediary. If so, you merely increase the risk of poor communications. Achieving an understanding with the picture editor or art director who is employing you – and this is essentially what briefings are all about – is something of an art in itself. A photographic assignment can rarely be defined in the precise terms of, say, engineering specifications. As a general rule the more interpretative the photography, the less easy it is for the client to be literal in telling you what is needed.

Caroline Despard, Picture Editor of the Smithsonian Magazine, says, "The important thing is to choose the right photographer for the job, rather than go into an excessively detailed briefing that plans out the shots in advance. I want the photographer to supply the ideas. With many of the stories that we run in the magazine, it would be impossible to predict the best picture possibilities in advance, and with some stories there is no way of knowing whether the pictures will work until someone actually arrives at the location.

"So, for practical reasons, what I'm really interested in knowing is the way the photographer will approach the subject, not a blow-by-blow shot list. The only situation where this could possibly work is where I'm looking for 'point' pictures – photographs that do no more than illustrate a point in the text – and I try and keep them to a minimum.

"From this, it may sound as if briefings are a simple, casual matter. In fact, it is much more difficult to brief a photographer in such a way as to get the best picture coverage without going into detail. The photographer and I have to establish a rapport. For this reason, I dislike giving briefings through a third party."

Before meeting the client for the briefing, you should familiarize yourself with the house style and general needs. If your assignment will be part of a series or a regular feature (as is usually the case for magazines or long-running advertising campaigns), you can learn a great deal by studying the output to date. Look at a good number of previous photographs. If they show great similarities even though from different photographers, then the house style is fairly rigid. This is by no means always a bad thing, and can reveal strength of art direction rather than resistance to change. In any case, it is as well to know, and if you have any doubts about the way pictures are selected and used, check it out at the briefing, discreetly if necessary.

At the briefing, have a checklist to work from; it doesn't need to be

written down, but you should have some method to avoid forgetting a crucial detail. Don't rely on the client to cover every point.

Basic purpose. What is the immediate background to the assignment, and what does the client see as the creative position of the publication? For instance, this may simply be an uncomplicated extension of an already successful series which needs some variation. On the other hand, the art director may be looking for a new and fresh way of treating an inherently dull product with no obvious photographic possibilities.

Creative requirements. Make sure that you understand not only what is needed creatively, but also if there are particular characteristics of your work that the client is expecting to see in the result.

Layout requirements. In some cases, particularly advertisements, the layout is determined in advance with great precision, and occasionally even down to the basic composition of the shot. If type is to be run over the photography, certain areas of the shot may need to be of more or less continuous tone. If the type is to be black, then the area under it will need to be light; if it is to be reversed out, the area will have to be dark. Check these points and discuss them with the art director (separately if the picture editor or someone else is briefing you). When layout requirements are this precise, you may find it useful to mark the format and type areas actually on the camera's ground glass screen. For a magazine whose covers I have regularly shot for several years I have a small piece of transparent acetate that fits under the prism head printed with the format and masthead.

With other than single shots, the publisher may have certain layout routines. The West German magazine, GEO, for instance, tends to open stories with a number of back-to-back double-page spreads, at least where the picture quality is high enough. If you are aware that the editorial staff will be looking among your take for photographs to fill particular slots, then you are better prepared.

Technical considerations. Because of differences in printing facilities, there may be limitations to the film, and therefore the equipment, that you can use. Separation makers and printers vary considerably in quality and ability and some have difficulty in handling the relatively small 35mm film format. In particular, grainy films may cause problems: if so, you will not be able to use very fast emulsions.

Logistics. When is the delivery date? If you have to mail or courier the films back, make prior arrangements. Should the client approve any intermediate stages, such as props, locations and models? Will the client be present at the shooting? How does the client want to see the material? (In other words, should it be captioned, and should it be selected?).

Risks. Are there any elements in the assignment which are beyond your control? On location, for example, weather often determines the lighting, and this can be fairly unpredictable in some places. Weather, at least, can be insured against. Other assignments may involve different imponderables, such as access and permission to use facilities. Working on an assignment in Surinam photographing Bush Negroes, my first hurdle was to obtain permission to enter the area from the tribal chief. Without this I could not even start, and there

was no guarantee before I arrived there that this permission would be given. In cases like this, both the client and yourself should appreciate the possibility of failure and agree your fees accordingly.

Expenses. There are three main areas of expenses on an assignment. Firstly, there are photographic expenses, covering film, processing, printing, additional re-touching and darkroom time, hire or provision of cameras, lenses, lighting, studio space and other photographic equipment. Next, there are props, models and location expenses or provision of anything that will be included in the shot. Models charge an hourly or daily rate, and most props can be hired, but expendables, such as food and background paper, will have to be purchased. Thirdly, there are logistic expenses, covering travel, subsistence and accommodation if the assignment is on location. If you provide your own transport, there will be a mileage charge to submit.

Cover all these points thoroughly at the briefing, and agree either a general principle as to what the client will pay for, or submit an estimate to be agreed beforehand. Practices vary among countries and fields of photography. Normally, for instance, you would be expected to provide the camera and lenses at no charge, but if a special item is needed because of the nature of the job (such as an extremely long-focus lens), then the client will probably bear the cost. Some organizations have an established procedure for expenses; again, find out what is involved. Occasionally, you might be asked to quote an all-inclusive fee that covers all the expenses. If so, be careful to anticipate all costs, or you could be out of pocket.

Fee. What fee basis will you be working on? Commonly, photographic fees are based on either time or the job (see p 301) and sometimes on a combination of the two, where you could be offered a fixed daily rate as a minimum guarantee with a possible additional payment later if more than a certain amount of your material is used. Agree the time of payment, preferably in writing; thirty days after submission of the invoice, which would be on completion of the assignment, is normal, but a growing number of publishers and advertising agencies hope to delay payments as long as possible.

Copyright. Agree exactly where the rights to the material will lie. This may be related to the fee, but it is a cardinal rule that you should have access of some sort to your photographs after the client has used them. Copyright law varies from country to country (see p 303) and it is important to seek professional advice on the subject. If photography is your living then your stock photographs are a real asset. Signing away the right to them unnecessarily simply deprives you of a future source of income.

Logistics

The logistics of a photographic job can be responsible for its success or failure. Although this applies less critically to studio work, which is generally easier to administer than most fields of photography, it is not uncommon to find situations where organization is by far the most important element in the photograph. Logistics become crucial on location, and especially on long assignments.

It is easy, and natural, to become absorbed in the creative problems of a photograph, but the administrative ones are sometimes more

important. This is frequently the case with professional assignments, because there is an actual commitment to produce pictures that have been planned in advance. It is far easier to alter your plans to fit in with a changing situation when there is no urgency to deliver specific photographs.

The right place at the right time

In the end, of course, it is *creative* skill that will normally make the difference between a shot that is adequate and one that is good, but being able to put yourself in the position to *exercise* that skill requires a talent for organization. I remember one occasion, several years ago, with one particular art director. We were both looking at a newly published book that he had designed and for which I had taken a few shots. There was one excellent aerial picture, by another photographer, of a herd of vicuña just clearing the brow of a hill. The light, the moment, the composition were all just right, and my reaction was one of professional envy. "Listen," the art director said, "It's no great thing. That was simply a matter of being in the right place at the right time. There was nothing else to the shot that was beyond any competent photographer." But this is not to diminish the value of that ability to put oneself in a precise place at a precise time; it is one of the great skills of photography.

The art of photography is not always aesthetic; it can be the art of juggling situations so that you are able to take the picture you want. There is little virtue in simply being able to *imagine* a good picture; what counts is actually producing it. It would, indeed, be perverse *not* to give yourself the very best chance of taking a good shot, yet this is exactly what many people do by failing to anticipate the details of an assignment. Luck plays an unfortunately large part in any kind of location work, but forethought and planning shorten the odds.

Make up checklists covering all eventualities for your equipment, film, travel arrangements, personal baggage and administrative details. Use these each time you prepare for an assignment. You are unlikely to need all the items listed on any one occasion but at least the lists can be used as guidelines.

Clearing Customs

Officially, many countries allow only a small amount of photographic equipment and film to be brought in duty-free for personal use. In practice, this is usually interpreted rather loosely, and even with, say, two or three cameras, half a dozen lenses and a hundred rolls of film there are not often problems. What Customs officers are usually most interested in knowing is that all film and equipment will be leaving with the photographer at the end of the trip. However, if strict interpretation is applied, you may have severe difficulties.

The safest way of clearing foreign Customs is to use an ATA Carnet. Carnets are international Customs documents issued by Chambers of Commerce in most major countries. By making a list of your equipment and the countries it will pass through, a set of documents is issued which, in effect, guarantees to foreign Customs that Duty will not be avoided. The conditions are necessarily very strict, and not only must the Carnet be paid for, but also the equivalent of the full Duty has to be deposited with the Chamber of Commerce.

If this system is too expensive or inflexible for a particular trip, at least make sure that you carry invoices for all your equipment. This will ease passage through your domestic Customs when you return.

Equipment checklist

Camera bodies
Carry at least one spare body. If possible, make sure that all are of the same make, so that parts can be interchanged. If you are likely to need to use two kinds of film at the same time (eg color and black-and-white, or Kodachrome and High-Speed Ektachrome) you will definitely need a third body.

Motor drives, winders and remote control
Will they be worth the weight on this particular occasion? A good compromise is one motor drive unit to fit any of the bodies.

Special cameras
High-speed, panoramic and underwater cameras all have special uses, but if you have no real need for them, they will simply be an extra burden. Remember that a purpose-built underwater camera, such as the Nikonos, can survive rain or dust better than an ordinary camera. A small, simple viewfinder camera may be better than an obtrusive motor-driven Nikon in situations where you need to be inconspicuous. Also, consider taking a cheap Polaroid camera; if you can give to people that you wish to photograph an instant picture of themselves, you may find it easier to gain their co-operation.

Lenses
Even if money were no object, you would not be able to carry all the lenses that you might find useful. Decide what you really need, but take only the best that you can afford – the lens is your most important piece of equipment. Check whether you need any of the following lenses:
Fish-eye.
Extreme wide-angle.
Wide-angle.
Normal.
Moderate long-focus.
Extreme long-focus: If weight is important, consider instead a tele-converter for use with a moderate long-focus lens.
Fast lens, for low-light conditions: This could double up as your normal lens, but also consider whether the high-speed film you are taking might be sufficient with your basic range of lenses.
Macro lens, close-up attachments and extension rings: Many professionals use a 55mm lens as their normal lens; while not particularly fast, its resolution is normally excellent throughout the focusing range. Use a bellows extension for extreme close-ups.
Perspective control lens: This is highly specialized and rather slow to use. Remember that, in an emergency, you can achieve a similar effect by using an extreme wide-angle lens, pointing it horizontally, and cropping the lower part of the picture later.
Zoom lens: If it covers a range of focal

lengths that you find useful, and can
actually replace two or more lenses, then
it may be a useful weight-saver. There are
also some situations, particularly those
involving action, where it has a definite
advantage over fixed-focal length lenses.

Camera and lens accessories
Neck straps.
Lens hoods.
Lens caps, front and back.
Camera body caps.
Filters: UV, polarizing, graduated, soft
focus, effects, neutral density, color
conversion, color compensating.
Filter holder.
Soft release button.
Cable release.
Double cable release.
Extension release for motor drive.
Rubber eye caps.
Spirit level.
Spare batteries for TTL meter, motor
drive.
Spare focusing screen.

Camera supports
Tripod: You will have to compromise
between weight and rigidity. Decide
under what conditions you are likely to be
using it.
Tripod head: Detachable locking screws
often come loose, so carry a spare.
Monopod or table-top tripod.
Clamps, and small ball-jointed tripod
head to fit thread adaptor.

Camera repair kit
Should include jeweller's screwdrivers,
jeweller's claw, long-nosed pliers, file,
heavy pliers, tweezers, tape, spare screws
from old cameras.

Cleaning equipment
Blower brush.
Lens tissues.
Cloths.
Chamois leather.
Anti-static gun or brush.
Lens cleaning fluid.
Toothbrush.
Cotton buds.
Compressed air.

Light meters
TTL heads.
Handheld meter or spot meter.
Flash meter.
Color temperature meter.
Spare batteries.

Lighting
Portable flash + attachments.
Hot-shoe.
Extension cable.
Photo-electric cell if using secondary
slave flash.
Mains adaptor.
Voltage adaptor (transformer).
Spare batteries.
Flash sync junction if using several flash
units.

Small tripod with head to fit portable
flash.
Light umbrella for diffusing portable
flash.
Hand mirror.

Heavy-duty lighting
Heads.
Spare tubes.
Spare modelling lights.
Tripods.
Other stands, including boom arms and
weights.
Power packs.
Power leads.
Reflectors for heads.
Diffusers, including umbrellas.
Barndoors and other shades.
Filters.
Fill-in reflectors – white card, foil.
Sync leads and junctions.
Photo-electric cells.
Spare fuses.
Spare length of lead.

General equipment
Clamps – G, C, and spring.
Scissors.
Retractable-blade knife.
Screwdriver.
Crosshead screwdriver.
Allen keys.
Tape measure.
Clips.
Pins.
Safety pins.
Rubber bands.
Blue tack.
Glue.
Stapler.
Spare plugs.
Plug adaptors.
Tape.
Changing bag.

Cases
Metal case for transporting camera
equipment. This should be strong,
waterproof and dustproof, gasket-sealed
and capable of being locked. Its main
function is to protect equipment on the
move rather than be a case to work from.
It should either have movable
compartments or contain a foam block
which you can cut to take your own
pattern of equipment. When packing,
make sure that there is adequate padding
for all hard-edged items and that the
camera shutters are not cocked (this
relaxes the strain on the mechanism).
Take care that nothing will activate any
electrical equipment, such as the trigger
release of a motor drive, and for extra
safety disconnect batteries. Leave at least
one camera body loaded with a fresh roll
of film in case you need to open the case
and shoot in a hurry. On aircraft always
try to take this case as carry-on baggage.
A Rox 15 K case, which measures

45cm×36cm×15cm
(17½in×14¼in×6in), will just fit
underneath seats in most commercial
aircraft.
Shoulder bag: This should be light
enough and flexible enough to work out of
easily, but it should also be at least
showerproof and fairly well padded. An
anorak or light jacket can be stuffed
inside to double as padding.
Tripod carrying case.
Lens cases.
Camera cases: Most professionals dispense
with these as they slow down the use of
the camera, relying on the protection of a
shoulder bag.
Lead-lined film bag.
Lighting cases.
General accessory case: A
mountaineering stuff-sack is ideal.

Cold weather extras
Winterization: This is a factory or repair
works operation, and involves changing
some of the lubricants for thinner ones.
Once done, you should use the cameras
only in cold conditions until the original
grade of lubrication has been replaced.
Camera tape: This not only protects your
skin from sticking to the cold metal, but
also keeps moisture out of the equipment
(condensed moisture from your breath
quickly freezes in gaps in the body, only
to melt when the camera is taken
indoors).
Space blanket: An extremely useful light
wrap with highly efficient insulating
properties, developed for emergency
mountaineering use.
Electric element heaters: Battery-
powered hand warmers and thermal
garments are also useful for protecting
camera and film from the effects of cold.
Remember that the most serious
problems are:
1. Film becomes brittle and can snap,
particularly if a motor drive is being used.
2. Mechanisms can jam, commonly
because the lubricants have thickened or
moisture has entered and frozen.
3. Batteries become inactive.
Selenium-powered light meter: CDS
meters, such as those in TTL heads, may
cease to work in extreme cold.
Sealable bags and desiccant (silica gel):
Put equipment inside the bags with the
desiccant before taking them from the
cold into a warm room, otherwise
condensation may affect all parts of the
camera.

Tropical extras
Camera tape: Essential for sealing gaps in
the body in dusty conditions.
Desiccant (silica gel): Necessary in humid
tropical conditions, both for equipment,
which can rust and acquire fungus (lenses
can be permanently ruined by fungus),
and for film, which deteriorates fastest
under the combination of heat and
humidity.

Underwater camera or housing: Although this may seem an extreme solution, under the worst conditions, such as during the rainy season in the Amazon basin or the monsoon in South-East Asia, it may be the only practical one.

Film and processing checklist

Film supply

Always try to carry your own film with you on assignment, rather than buy it on the way. Order it in bulk, making sure that all the rolls of each type of film are from the same manufacturing batch (the batch number is printed on the pack). Test one roll of each type before leaving, to make sure that the film speed is actually as stated by the manufacturer and that the color balance is neutral. This way, you can be certain of your results, even though the assignment may be long. If you *do* have to buy film from an unfamiliar source, choose the largest retail outlet you can find (the stock turnover will be faster) and look for the expiry date on the pack.

Film types

Only experience with particular types of work will tell you what quantities of each type to take. Some photographers shoot more film than others, and uncertain subjects, particularly those involving action, will need more film than static, reliable subjects. If in doubt, take six 36-exposure rolls for each day you plan to be shooting; this will probably be more than you need, on average. Take professional film where possible, unless storage conditions will be poor or you expect to wait a long time before having it processed, in which case take standard film stock, which will not deteriorate so quickly.
Basic color transparency film, eg Kodachrome 64, Ektachrome 64.
Fine-grain color transparency film, eg Kodachrome 25.
High-speed color transparency film, eg Ektachrome 400.
Tungsten-rated color transparency film, eg Ektachrome 160.
Special color film, eg Infra-red, Photomicrography.
Color negative film, eg Kodachrome 400.
Basic black-and-white (125–400 ASA), eg Ilford FP4, Kodak Tri-X.
Fine grain black-and-white, eg Panatomic-X.
Ultra-fast black-and-white, eg Kodak Recording Film 2475.
Special black-and-white film, eg High Speed Infra-red, Orthochromatic.

Shooting record

Absolutely essential on a long assignment is a record of what you shoot. If special processing may be required, you must be able to identify rolls without any doubts. For safety, if you have a good subject in

Kodachrome processing laboratories

Australia
Kodak (Australasia) Pty. Ltd.
P.O. Box 4742, Spencer Street
Melbourne, Victoria 3001, Australia
Austria
Kodak Ges.m.b.H.
Albert Schweitzer-Gasse 4
A-1148 Vienna, Austria
Belgium
N.V. Kodak S.A.
Steenstraat 20
1800 Koningslo-Vilvoorde, Belgium
Canada
Kodak Canada Ltd.
Processing Laboratory
3500 Eglinton Avenue West
Toronto, Ontario, Canada M6M 1V3
Kodak Canada Ltd.
Processing Laboratory
P.O. Box 3700
Vancouver, British Columbia
Canada V6B 3Z2
Denmark
Kodak a.s.
Roskildevej 16
2620 Albertslund, Denmark
France
Kodak-Pathé
Rond-Point George Eastman
93270 Sevran, France
Kodak-Pathé
260, av. de-Lattre-de-Tassigny
13273 Marseille Cedex 2, France

India
Kodak Limited
Colour Processing Division
483, Veer Savarkar Marg
Bombay 400 025, India
(Send by registered post)
Italy
Kodak S.p.A.
Casella Postale 4098
20100 Milan, Italy
Japan
Far East Laboratories, Ltd.
Namiki Building
No. 2-10, Ginza 3-chome
Chuo-ku, Tokyo
Japan
México
Kodak Mexicana, S.A. de C.V.
Administración de Correos 68
México, D.F., México
Netherlands
Kodak Nederland B.V.
Fototechnisch Bedrijf
Treubstraat 11
Rijswijk Z-H, Netherlands
New Zealand
Kodak New Zealand, Ltd.
P.O. Box 3003
Wellington, New Zealand
Panamá
Laboratorios Kodak Limitada
Apartado 4591
Panamá 5, República de Panamá

front of you and sufficient time, split the shooting over more than one roll; if a mishap occurs with one, the other will be welcome insurance. Take a notebook and/or pocket tape-recorder, making sure that at the end of each day you have a legible written record. Also take stick-on labels for numbering rolls.

Film storage

Film deteriorates under high temperatures and high humidity, therefore protect it against these two conditions. Before processing, exposed film is more susceptible than unexposed film, and should be your top priority. Do not open cans of film before you are ready to use them, particularly when it is humid. If possible, keep the film in an insulated container, such as a polystyrene-lined cool-box. Always use liberal amounts of desiccant in porous bags. Periodically dry out the silica gel by heating in an oven or gently 'cooking' it over an open fire. In an emergency, rice can be substituted for silica gel, although it is approximately ten times less effective. Packing the film container as fully as possible leaves no room for humid air.

Processing

If you are away on a long assignment, you must either (a) keep all the film with you for processing on your return, thereby

running the risk of its deterioration, (b) send it home for processing, at the risk of it going astray, (c) have it processed locally, or (d) process it yourself. If you send it home, check the methods available beforehand – mail, air freight, or courier – and try to assess their reliability (ask someone with an unbiased opinion and local knowledge, such as a consul or magazine stringer). Also arrange for its reception at the other end, and establish some means of communication whereby you can get an idea of how the processed material looks (an agent may be able to do this for you).

Local processing can be unreliable. If you are using Kodachrome, refer to the list of Kodachrome processing laboratories world wide (above); as soon as you arrive, send in a test film for express processing. Judge the results before sending anything important. For other processing systems, try to contact local professional photographers and ask their opinion about the most reliable laboratory. In small towns and remote areas, you may find that the local professionals process their own film, and you may be able to persuade one to handle yours.

Processing your own film is really only practical with black-and-white materials, and even then it will involve you in a great deal of effort. Think twice before attempting it.

South Africa
Kodak (South Africa) (Pty.) Limited
Processing Laboratories
102 Davies Street, Doornfontein
Johannesburg 2001, Republic of
South Africa
Spain
Kodak S.A.
Irún, 15
Madrid 8, Spain
Sweden
Kodak A.B.
S-175 85 Järfälla, Sweden
Switzerland
Kodak S.A.
Processing Laboratories
Case postale
CH-1001 Lausanne, Switzerland
Kodak S.A.
Processing Laboratories
Avenue Longemalle
CH-1020 Renens, Switzerland
United Kingdom
Kodak Limited
Colour Processing Division
P.O. Box 14
Hemel Hempstead
Hertfordshire HP2 7EJ, England
USA
Kodak Processing Laboratory
1017 North Las Palmas Avenue
Los Angeles, California 90038
Kodachrome Processing Laboratory

Wilcox Station Box 38220
Los Angeles, California 90038
Kodak Processing Laboratory
925 Page Mill Road
Palo Alto, California 94304
Kodak Processing Laboratory
4729 Miller Drive
Atlanta, Georgia 30341
Kodak Processing Laboratory
P.O. Box 1260
Honolulu, Hawaii 96807
Kodak Processing Laboratory
1712 South Prairie Avenue
Chicago, Illinois 60616
Kodak Processing Laboratory, Inc.
1 Choke Cherry Road
Rockville, Maryland 20850
Kodak Processing Laboratory
16-31 Route 208
Fair Lawn, New Jersey 07410
Eastman Kodak Company
Building 65, Kodak Park
Rochester, New York 14650
Kodak Processing Laboratory
1100 East Main Cross Street
Findlay, Ohio 45840
Kodak Processing Laboratory
3131 Manor Way
Dallas, Texas 75235
West Germany
Kodak Farblabor
7000 Stuttgart 60 (Wangen)
Postfach 369, Germany

Personal baggage checklist

In addition to your normal clothing and
personal items, there are some things that
are photography-related. Most location
work is physically active, and frequently
the weather conditions and terrain are not
what you might choose. Your choice of
clothing and footwear should reflect these
considerations.

Clothing

Jacket: Ideally waterproof and with lots
of pockets for film, documents and bits
and pieces. However, many jackets that
are very efficient in this respect can make
you quite conspicuous. A light anorak for
protection from the rain is an alternative.
Footwear: Important if your work
involves a lot of walking, climbing and
scrambling. Jogging shoes are excellent
for general use, but if you are going to be
moving over difficult ground a pair of
boots will be better.

Medical supplies

Particularly when travelling abroad, you
can save a great deal of time by supplying
your own first-aid treatment. Take
plasters, bandages, surgical tape, alcohol,
scissors, antibiotics, water purification
tablets, germicidal cream, and supplies
for any conditions you are personally
susceptible to.

Cold weather extras

Cold weather is not confined to the polar

regions and high mountains. Even in
warm climates, dawn can be cold,
particularly if you are standing around
waiting for sunrise, and aerial
photography is nearly always cold.
Gloves: In really cold conditions, use a
pair of thin silk gloves inside an outer
pair.
Down jacket.
Over-trousers.
Balaclava.
Extra sweaters.

Tropical extras

Light waterproof anorak: In the wet
tropics a necessity
Salt tablets.
Sunglasses.
Suntan lotion and sunburn cream.
Mosquito netting, if you intend camping.

Travel and administrative checklist

Briefing

Do you have sufficient background
information?
What is the best timing for season,
weather, dates of events?
What is the client's deadline?

Other documents

General and specific letters of
introduction/accreditation from client.
List of contacts (sources of information

and help) at the location.
Documentation: Passport, including
relevant visas.
Receipts, guarantees and list of serial
numbers of equipment.
Press card.
Driving licence, including international
licence.
Other forms of identification.
Travel tickets, and separate confirmation
list (most airlines issue a computer print-
out showing confirmation status).
List of alternative transportation
schedules.
Check weight restrictions for baggage.
Insurance: Both personal and equipment
– check exclusions.
Finance: Advance against expenses from
clients.
Cash, in relevant currencies.
Travellers cheques, and separate list of
numbers.
Credit cards, separate list of numbers,
and local contacts in case of theft.
Drawing facilities at local banks.

Insurance

As a professional photographer, there are
several areas of your work where you may
be involved in losses or liabilities.
Equipment. All Risks Insurance will
cover your equipment and film for
accidental loss and damage, although
mechanical failure, wear and tear are
normally excluded. Check that the policy
covers the particular countries involved
in an assignment abroad, and that the
equipment is insured on a 'new for old'
basis.
Car. If you use your car for business
purposes, make sure that your existing
motor insurance covers this.
Home. If you work from home, this may
not cost any more than a normal
household insurance, but you will need to
notify the insurers.
Public Liability. You could be legally
liable for causing injury or damage during
an assignment. In particular, if you use a
studio, you may find yourself responsible
for the entire building.
Travel. If you travel abroad frequently
it will pay you to take out an annual
policy. In any event, check that medical
expenses, loss of deposits, personal
effects and personal accident are covered,
and that the policy includes business
travel.
Health. As most photographers' income
depends on their personal work, insure
against loss of income due to accident or
illness.
Legal Costs. To cover litigation that you
may become involved in.
Weather. You can insure against costs
involved in delays due to bad weather
if you are working on location.
Professional Indemnity. Unless the
client indemnifies you against such
claims, you can insure against your legal
liability for libel and breaches against
various Acts, particularly in advertising.

For this Time-Life book, there were to be two versions of the cover (above) – one untitled for direct mail and the other titled for retail counter sales. The shot therefore had to be adaptable to both formats, and in each case had to fit the existing style set by other titles in the series – combining a strong pattern with an obvious feature of the subject. Here it was the juxtaposition of modern apartments and ancient columns. From the same book, this street scene (top right) from an unspoiled part of the city was taken with deliberate attention paid to the gutter area. I knew that the subject was interesting enough to make a double page spread, so I deliberately offset the composition so that the group of people would not fall exactly in the middle of the picture. As a result it was used as shot.

For a *GEO* feature on the City of London, this close-up (below) summed up much of the spirit of the event and was therefore possible material for a double page spread. Because of this, I composed so that no major point of interest fell in the center where the gutter would have spoilt it. The shot ran as the feature's opening spread.

The layout requirements of this wrap-around paperback cover (above) were precise – specific areas had to be left for title, spine copy and back copy. Both the front and back (right half and left half) had to work independently, and one small circular object had to be located very precisely in the middle of the spine.

Typical of many consumer weeklies, the *Telegraph Magazine* has a masthead running the width of the top, movable strap lines (to fit the picture) and a corner flash. For the photographer, the essential point to remember is to allow a plain image area at the top.

The position of hi-fi equipment and dog (mimicking the well-known HMV record label) determined the width of this shot, and as the magazine format is unusually narrow, it was inevitable that there would be empty space above or below. As the subjects were set on the floor, it made good design sense to place the weight of the picture at the bottom.

Working to layout

If your photographs are intended for eventual publication, then you may have to consider layout when you plan your shooting. Whether in books, magazines, newspapers or any other kind of publishing, art directors face special problems in handling photographs. The proportions of the publication, the central 'gutter' between two facing pages, or the amount of space needed for type on each page, are a few of the limitations that can determine how a photograph is used, or even whether it is selected at all.

There are two kinds of situations where a knowledge of layout is important. The first is where the design precedes the photograph, as usually happens in advertising or with the covers of magazines, books and record albums. Here, you would expect to receive comprehensive instructions from the art director on the overall proportions, how much blank space to leave for type, the positions of various objects in the shot, and so on. The responsibility is with the art director, and your concern is to work within several clear constraints. If, for example, a paragraph of text is to be overlaid onto the picture, then you will probably be asked to include an uncluttered area in the composition that is *light* in tone; this is because small type reads less clearly when it is 'reversed-out' – white against a dark background.

The second kind of situation, which needs more careful thought because it is less precise, is when the nature of the photographs prevents the art director from anticipating the layout. Yet the way that a photograph fits a layout may make the difference between its being used or rejected.

Limitations of the format

Lou Klein, Design Director of Time-Life Books in London, has long experience of just this kind of problem. One major series that needs great care in the layout involves commissioned reportage photography of the world's major cities, almost exclusively in 35mm. "We start by defining our limitations when we decide on a format. A successful series will run for twenty or more volumes, and it has to look consistent. Once we've decided on the book size and typographical considerations, we're committed. It means that we've established formats for every section of the book – end-papers, picture essays, chapter openers, everything.

"When we've done that, we have to live with the overall format for 20 or 30 books, and the picture considerations must be right.

"Now you may think that a 35mm format, which is 2 to 3, would be ideal, particularly as it often fits a double-page spread in many books. But it usually causes headaches, mainly because of the way most photographers frame their shots.

"To start with, we're usually dealing with horizontal shots, and there are two good reasons for this. Firstly, cameras are designed that way – it's more natural to hold the camera level than to turn it on its side. Secondly, 35mm proportions tend to look better when they are horizontal; a vertical 35mm shot is normally too deep and narrow to fill a book page without cropping.

"Given a horizontal format, photographers tend to frame centrally around the focus of interest. A person's face, say, is usually right in

the middle of the frame. There are just a few things we can do with it. We can run it on a single page, but this will leave a large margin top and bottom and may make the shot quite small. Or, we can run it across the whole double-page spread, but then the gutter will run down through the face splitting the nose . . . completely destroying the shot. A third alternative is to off-center the picture, but the symmetry will be lost and the gutter may run down through an eye.

"In the end, we may have to crop the photograph. Of course, every photographer tries to compose the picture perfectly in the viewfinder, and quite right too, but it means that when we do have to use a precisely framed, centered shot, we could murder it. Cropping can improve the use of a picture, but it rarely improves the picture itself, provided of course that it's good to start with.

"What would make my life a lot easier would be to receive transparencies with plenty of cropping space around the area of interest, and with the focus of interest slightly off-center. But, I would never ask a photographer to do that unless it was for a planned position on a spread.

"However, in the last analysis, it's the quality of the shots that is important. We don't let the layouts rule to the extent that we throw away good pictures. We make a big effort for the great shots but to give the full story we may have to use some of the lesser pictures. That's the only way we can do it, balancing the best ones against those that complete other aspects of the story.

"Every picture story in a book, a magazine, or exhibition must open with a great shot. That is what story telling is. But if I asked every one of our assignment photographers to think of nothing but essay openers, it would certainly ruin the content of the take.

"What I really want, of course, is a great shot full of content for every picture in an essay!"

Editing
The actual selection of photographs for use from an assignment can be very different from the majority of the work involved in the assignment itself. The choice and layout of the photographs is a creative activity in its own right, and can add to, or subtract from, the strength of the original photographs.

The number of people involved in editing and layout varies according to the particular publication. It can be as little as one – an art director – or it can be several. In the case of a large publishing organization involved with large print-runs and a high level of textual and illustrative detail, your pictures may be worked on by a picture editor, picture researcher, art director, and editor. Various other people such as the author, copy editor and consultant may be involved.

In the first place, you should edit your own take before anyone else sees it. This is not an assumed privilege; it is your responsibility. It is necessary partly because of the high rate of overage in most takes. The picture editor or art director does not have the time to look through all your shots and is interested in seeing only a useful selection. Editing is considered a part of the assignment also because assignments often develop "on the job". Knowing that you will be editing later enables you to experiment freely.

After several false starts looking for an idea that was simple yet universal enough to fit the enormous scope of this book, an atmospheric shot of the sun was finally decided on. The integration of type and photograph was critical.

The convoluted masthead of this magazine would be completely lost with anything more than a simple texture behind. Also, the complex scrolls work best with a simple strong graphic image. I designed this particular cover for maximum symmetry.

Develop a logical system for your editing, and remember that it involves the essential, if dull, work of captioning. If providing full caption information for each picture seems impossibly boring, consider that it might make the difference between a photograph being used or rejected. First, discard all shots that are technically unsatisfactory, whether wrongly exposed, slightly out-of-focus, or blemished. This can at least save you the later anguish of discovering a slight scratch marring a selection. Beyond this, methods of editing vary. I normally do the following:

1. I have every frame stamped with a roll number, frame number (factory-mounted transparencies are usually pre-stamped by frame) and my name and copyright mark.

2. On the light box, I select the images that I think are quite good, choosing only one of the exposures where several are available. All the unselected frames are boxed, labelled as "overs" and go into storage.

3. From the preliminary section, I choose those that I consider to be the very best, perhaps only a tenth of the previous selection. These are the "first selects" and are the shots that I would like to see used. They are also the shots the client will see first and on which my assignment will be judged.

4. The remaining shots after the "first selects" are taken out and labelled "seconds" and are also delivered to the client, but packaged separately.

Editing black-and-white film cannot be so exclusive, without cutting up strips of negatives into individual frames. Normally, I deliver numbered contact sheets (with roll numbers scratched or written on to the emulsion at one end of the roll) and mark my preferred frames with a chinagraph or grease pencil. The client can then select and order prints from the contact sheets.

As soon as the transparencies have been mounted, stamp them with your name, copyright mark, roll and frame number. This avoids any problems with identification later on.

Methods of reproduction

Even though your original transparencies or prints may be technically excellent, what counts in the end is the way they appear on the printed page. Reproduction quality varies greatly, depending on the kind of publication. If you know how your pictures will be treated, you may be able to adapt your own methods slightly, in order to compensate for the inevitable loss of quality that occurs in printing. For instance, a contrasty black-and-white print will normally reproduce better than one which has many subtle tones of gray. When you are working in color, it is always better to submit transparencies rather than prints. Strong bright colors can be derived more easily from a transparency (which has a wider contrast range) than from a print (which must be copied by reflected light). Of all the elements in printing that control the final quality of the image, paper is the most important. The best paper is coated, to give it a smooth surface that resists spreading ink, and is thick enough not to show through the images on the other side of the page.

The three printing methods all involve one basic process for reproducing photographs – the halftone screen. A photograph, as you can see when making prints in the darkroom, has a continuous range of density, with an almost infinite variety of tones between dark and light. Printing ink, however, does not discriminate so finely; only

black or a very dark tone can be printed as a solid area. To reproduce different tones, it is necessary to convert the photograph into a large number of dots, so close together that at normal viewing distances the eye sees them as a range of tones resembling the original. Although each of the dots is exactly the same in density, a whole range of tones can be reproduced by varying their size.

Screen size

A photograph is converted into a mass of dots by means of a halftone screen, which is sandwiched together with the original photograph to produce a photographic screened negative. Halftone screens come in different degrees of fineness, from around 65 dots to the inch (coarse) up to about 300 dots to the inch (extremely fine). Clearly, the finer the screen, the more detail can be preserved, but if the paper surface is rough (uncoated), a coarse screen will give the best result. The reason for this is that the ink tends to soak into the paper slightly, and spreads, as if in blotting paper. This means that if the paper is rough and the screen used is fine, in a large shadow area, where the detail is recorded only as tiny pinholes between the large dots, the ink will spread right across the gaps. Newspapers have this problem, and so always use coarse screens.

Printing methods

Letterpress. In letterpress printing, the block is in relief, with the ink-carrying dots raised above the area where no image will be recorded. This is the oldest printing method, and because a thick layer of ink can be carried on the raised dots, the inked areas can look dark and rich.

Gravure. In gravure printing, the ink is held on a cylinder surface in depressions; in other words, it is relief in reverse. Because cylinder making is expensive, gravure is normally reserved for large printing runs, but this method does have the great quality of being able to lay down large quantities of ink. This results in extremely rich blacks and deep, bright colors.

Offset litho. In offset litho, the whole surface of the plate is flat. By exposing the image onto a plate with a light-sensitive coating, the area is made receptive to the ink; the non-image forming area, meanwhile, rejects the ink. The inked image is then transferred, or 'offset', from this plate to the paper by means of an intermediate rubber blanket.

One potential problem with offset printing is that, because less ink is used than with other printing methods, there is a danger of weak shadow areas. Because of this, it is better to present photographs that are fairly contrasty, and with black-and-white prints this can usually be done quite easily.

In principle, color printing differs from black-and-white only in that several impressions, each with a different color ink, are needed to form the image. The dot system is still used, but here the close spacing of the differently-colored dots is used to give the illusion of intermediate colors. Most colors can be reproduced on a printed page by using just three inks – magenta, yellow and cyan – although in practice a fourth color – black – is always added, to increase the density of the blacks and grays.

When a picture is photographed through a halftone screen, the light is split up into dots which vary in size according to the relative tone of the image. In the shadow areas the dots are large, crowding out almost all the white background, whereas in the highlight areas the dots are much smaller. Screens vary in degrees of fineness and the choice of screen depends on the quality of paper to be used. This picture (below and right) has been reproduced through four different screens. As the book is printed on coated paper, screens of 65 or even 100 dots to the inch are much too coarse and the dots are clearly visible.

The right screen for this paper is in fact 133 dots per inch and so the final print (bottom right) achieves the best result.

65 dots per inch

85 dots per inch

100 dots per inch

120 dots per inch

133 dots per inch

Fees

In a profession like photography, that covers such a wide range of activity, fees and the ways in which they are paid vary considerably. There is virtually no standardization, and although some sections of the profession tend to conform to similar rates by general practice, the scale of fees is, for the most part, that of a free market.

Fees for assignments reflect the following factors:

1. The complexity and difficulty of the work – the greater the creative, technical and logistical demands of the photographer, the higher the remuneration.

2. The financial position of the client. While a large and successful corporate client will not pay more simply because it can afford to, a small client with limited resources will probably be able to pay less than the average rate. Whatever the merits of the photography, this imposes a ceiling on rates in such a case. Many specialist trade magazines fall into this category.

3. The use the photograph will be put to, judged by commercial standards. If a photograph is used demonstrably to generate sales for a company – as in certain national magazine campaigns where the advertisements rely heavily on the image for success – then it has a definite value to the client, and the fee normally reflects the photographer's contribution.

4. The reputation and ability of the individual photographer. A top-ranking professional, by dint of recognized skills and by being heavily in demand, can command much higher fees than average. As this is the one factor which a successful photographer can strongly influence, the importance of establishing a reputation at every possible stage cannot be over-emphasized.

Exactly what fees you should charge depends so much on your individual circumstances that it is not possible to give a rule-of-thumb guide in a book like this. Several photographer's associations, such as the American Society of Magazine Photographers in the United States and the Association of Fashion Advertising and Editorial Photographers in Great Britain, publish scales of fees, based on general practice rather than on recommendations, and these are useful.

Make it a cardinal rule to agree in advance and in writing the fee and what is expected for it. Always obtain some form of purchase order. As the fee will in part reflect usage, have this spelt out clearly as well.

Advertising assignments

The highest fees in photography are reached in advertising; at the top, not only are the demands extremely high, but the media and sales budgets for nationally advertised consumer products can be large enough to dwarf the most expensive photography. The work principally involves photography to be used in paid advertisements in magazines, posters, newspapers, ancillary promotional publications and literature, and stills used in television commercials.

A feature of advertising assignments is the detailed planning that normally precedes shooting, and as a one-day shoot may require several days of pre-production, the fees reflect this essential non-shooting time and effort. Although the advertising agency (normally the photographer's direct employer) and client may carry a large part

of the burden of pre-production and logistics, the photographer is still expected to contribute quite heavily.

Editorial assignments

This field of assignment is done for the editorial sections of consumer and trade publications, principally magazines, books and newspapers, but occasionally audio-visual presentations and television programmes (still shots for rostrum camera work). Record album covers are a specialization that also contain features of advertising work. Essentially, editorial photographs are not used for the direct selling of anything other than the publication in which they appear. They are partly, and sometimes wholly, the reason for the publication's existence, and must stand or fall on their own merits.

Practically, there are two kinds of editorial photography. Editorial illustration, and reportage/photo-journalism. In principle, and often in method, editorial illustration resembles advertising photography in that the photograph is designed, in advance, to embody a concept. Magazine and book covers are common forms of this kind of work, as are record album covers.

Reportage assignments can rarely be planned exactly in advance, and the magazine or newspaper is largely in the hands of the photographer to produce a successful coverage. The photographer's personal responsibility is greater here than in any other area of professional photography, and assignments can be long and often involve travel.

The standard fee basis for a reportage assignment is a daily rate, which is actually a minimum guarantee. Upon publication, the space rate, which is normally standard for any one magazine, is calculated. If this exceeds the day rate guarantee, then this higher amount becomes the fee. This should be clearly stated in writing at the outset.

Corporate, industrial and publicity assignments

This group includes work done for limited publication, often involving a slightly oblique selling approach, in media that are either distributed 'in-house' or directed at people with special interests in the performance and activities of the client (such as shareholders). Typical outlets for this kind of assignment are annual reports of corporations, institutions and government departments, quasi-editorial features for the house publications of large organizations, promotional literature for industrial contractors aimed at potential customers, and publicity for the entertainment industry (such as stills coverage of major films).

As this is a field that embraces many small specializations, fees vary widely. For the annual report of a large multi-national corporation, the fee can compare with advertising rates. On the other hand, 'front-of-house' publicity for a stage play can be very poorly paid.

Copyright

The questions of the ownership and use of photographs are important ones. Not only does copyright law vary considerably from country to country but there are also differences in the degree to which the law may be interpreted in specific cases. Photographers should be aware of the main points in copyright law in those countries where they are involved in the production, selling or use of photographs, but in any

individual circumstance, where for instance, a dispute is likely to occur, it is essential to seek professional legal advice.

In Great Britain, copyright is basically the exclusive right to do certain acts otherwise restricted by the Copyright Act 1956. The Act contains many apparent ambiguities but ultimately the interpretation of it is fairly strict. The owner of the copyright in Great Britain is not necessarily the creator of the photograph, as is the case with most other art forms, but is the person who owns the material of which the photograph was processed. In the case of an ordinary photograph this will be the negative, or transparency. However, there is an exception when a photograph is commissioned by a third party. In that instance, copyright is vested in that person. Problems can arise in this area: if for example, someone asks a professional photographer to take his portrait, this probably implies that he is prepared to pay for the negative and the copyright will therefore belong to the sitter. But, at the same time, there is nothing to prevent a photographer taking and publishing a photograph of anyone he wishes without making any payment to or obtaining consent from that person. It has recently been recommended that the Act should be amended to provide that the author of a photograph be defined as the person responsible for the composition of the photograph.

The sale of a photograph does not include the copyright and a person who acquires the photograph which is still in copyright does not automatically acquire the right to reproduce it. In order to acquire such rights exclusively, there must be an assignment or licence of copyright in the photograph, in writing and signed by the copyright owner.

It is, therefore, to the photographer's advantage to establish in writing, before undertaking commissioned work, that the copyright owner shall be the photographer, and not the client. Not every client will agree to this, but it is a sensible precaution wherever possible.

Copyright law in the United States was revised in 1978 and, from the photographer's point of view at least, reformed. Under the new Copyright Law (U.S. Copyright Act), the owner of the copyright is, in nearly all cases, the photographer. The principal exception is where the photographer is regularly employed as a member of the staff. Also, the new law only applies to photographs taken after 1 January 1978. This means that, as a freelance photographer, the copyright will remain yours unless you assign it to someone else in writing. The question of ownership is therefore resolved quite clearly, and the situation has changed quite radically from that before 1978, where the person hiring the photographer was generally deemed to own the copyright. So, when signing agreements with clients, be particularly careful if the contract states that the assignment is a "work made for hire". This may prejudice your ownership of the copyright.

To protect the copyright, put a copyright notice on every picture that you release. This should state "Copyright © (name), (year)". Without this, the work can be considered to have been thrown into the public domain, and protection will have been lost.

For important photographs, consider registering the copyright through the Register of Copyrights, Library of Congress, Washington DC 20540. Then, ownership is more easily proved.

Agents and stock photographs

AN AGENT SPECIALIZES in selling a photographer's work for a commission. This is usually around 50% of the billed amount if the material is from stock, and around 25% if the photographs are being freshly commissioned. By no means do all professional photographers have or need an agent, and much depends on your individual circumstances. For a successful professional photographer earning good rates, time is better spent taking pictures than becoming involved in the paperwork and administration that inevitably accompanies selling.

Agents are concerned with two areas of the photographer's work – assignments and stock. Some agents concentrate on only one of these, others handle both. The degree of service varies considerably; at one end of the scale is the large stock library handling material from many photographers with little personal contact; at the other is the advertising representative, who is closely concerned with the style, development and performance of a very few photographers.

Whether you should seek out an agent depends mainly on the field of photography you are involved in. As far as assignment work is concerned, high advertising fees can justify the time and effort of an agent on a 25% commission, but most kinds of editorial work will not generate sufficient money to make it worthwhile. Stock sales are different, because the material already exists. Based on experience, the stock agent can judge fairly accurately the material which is likely to sell. The commission here is much higher – 50% – partly because of the high administrative costs of responding to requests for submissions from clients, and partly because *without* the agent existing as a kind of clearing house, few photographs would reach their market.

You must balance the likely improvement in the nature and quantity of assignment work you may receive against the cost of the agent's commission. One danger to be aware of is the inevitable bias of most agents towards the more lucrative advertising fields.

Avoid disappointment by remembering that, at the moment at least, there are more photographers looking for agents than there are agents looking for new people to represent. There is no doubt that a top agent would substantially improve the work you receive, using his or her reputation, but precisely because these selling skills are so valuable, he or she can be choosy when it comes to selecting a new photographer. If you are just beginning, an agent must invest in you, and therefore is looking for some promise in your portfolio. Take the same care in approaching an agent as you would in soliciting work from a client. They will both judge you in similar ways.

Having once acquired an agent, the relationship is the determining factor in the success of the arrangement. To avoid possible areas of misunderstanding, make sure that you are both clear on certain points (see p306).

Stock photographs

For the professional, assignment photography provides basic income, as the pictures are produced to order. Stock photographs, on the other hand, are existing pictures available for hire. All photographers have a potential stock library, made up of the accumulated work produced for various reasons, commercial and pleasure. Surprisingly few, however, organize these pictures into a system where they can be located

If you plan to handle your own stock photographs, then it is essential to use some comprehensive form of documentation when supplying photographs to customers. This serves as a record of the material sent out and lays down all the terms and conditions of the transaction. The sample form (right) covers all the important points.

Stock photograph delivery

From:

To:

Project:

Delivery note no.:

Date:

Picture no. / description	Print / transparency
Total	**Total**

Terms and Conditions

1. These photographs are submitted at your request on approval only and must be returned within one month except where my permission to reproduce has been obtained. After one month from the date of this delivery note a holding fee of per photograph per month is payable, except where permission to reproduce is granted, in which case the same holding fee shall be payable after six months from the invoice date.
2. The search fee shown below is now payable.
3. No use may be made of the photographs for any purpose whatsoever without my prior consent. Any reproduction rights granted must not be sold, transferred or otherwise dealt with.
4. Upon receipt, photographs are held entirely at your own risk against loss, theft or damage until received back by me. In the event of loss, theft or damage, a minimum fee of per transparency and per print shall be payable by you to cover loss of future resale income. The payment of this fee shall not entitle you to any additional rights in the photographs lost, stolen or damaged. If a lost or stolen photograph is subsequently found, this fee shall be refunded, less a holding fee of 10% thereof for each month elapsed after the notification of such loss or theft. Any loss, damage or theft should immediately be notified to me.
5. Reproduction fees and credit lines are to be agreed before publication.
6. Reproduction fees are payable within thirty days of the invoice date or upon first publication, whichever is sooner. After thirty days 2% per month of the unpaid balance will be charged.
7. All photographs shall remain my property and must be returned immediately after authorized use.
8. Two copies of any reproductions shall be sent to me upon publication.
9. While all reasonable care has been taken to ensure correct identification and captioning of these transparencies, I am not liable for losses caused by any errors.
10. The total number of photographs herein listed shall be presumed to have been received by you unless written notice to the contrary is received by me within 48 hours of receipt by you.
11. No warranty is made in respect of any releases or permissions for these photographs, unless specified in writing.
12. You shall indemnify me against any loss through your use of photographs for a purpose not expressly granted by me.

Upon receipt of these photographs the above terms and conditions are understood to be accepted unless the package is returned immediately to me by registered mail or by hand.

Search fee:

Received the above photographs under the terms and conditions stated on this delivery note.
Please sign and return one copy to acknowledge safe receipt.

Date:

Signed:

Points to clear with your agent

1. How much authority will the agent have to assign rights?
2. What will the agent's commission be, and will the agent waive rights to commission from accounts that you already have acquired and from any low-paid editorial work that you want to continue to do?
3. Will you be able to submit material to other agents (normally not), or make separate arrangements for the sale of your material in countries where the agent has no representation, or will you be able to sell material directly yourself?
4. Will the agent charge you for mounting, captioning, or making duplicates.
5. What percentage of loss or damage compensation paid by third parties will you receive?
6. Will the agent accept any liability for loss or damage by the agency? (Normally not, because of the difficulty of securing adequate insurance.)
7. Is the agent administratively capable of handling material which has restricted use (eg commissioned photographs that require the original client's permission to use or a specific credit)?
8. What is the minimum period after which you can withdraw your material from the agency? Because of the cost involved, most agents insist on being able to have the material for a number of years.
9. Will the agent insist on copyright notices and credit lines on your behalf?
10. How often will statements and payments be made?
11. Are you granting the agent an option for renewal of the contract?
12. In the event of the agency going out of business or changing ownership, you should have a contractual right to the immediate return of your material.

and sent to potential buyers. The great success of stock libraries reflects the enormous gap that exists between clients in need of all kinds of existing pictures, and the millions of transparencies and prints lying idle in filing cabinets. Probably every photograph ever wanted by an art director, however obscure the subject matter, exists. Normally, however, the client and owner never meet.

Stock photography has many attractions. There are times when, as a professional photographer, you may regret the commercial restrictions of your work. With high-paying advertising assignments in particular, you will normally have to earn every penny. Stock photography, on the other hand, can be done for love; you can decide to photograph only what interests you. It is about as independent an existence as any photographer could hope for. A further advantage is that, having taken the photographs gratuitously, their ownership is never in dispute, and the sometimes intense arguments over copyright that occasionally happen in assignment work are happily absent here.

Stock photography is also cumulative. Not only does your stock increase as you continue to shoot, but a picture that has sold once will probably continue to sell over and over again. Looking back on my own stock sales, there are a few pictures that have sold about a dozen times each over a few years, and will probably continue to have active lives until the emulsion has finally been scratched off (stock photographs are subject to considerable wear and tear). The reason for this is that many picture researchers select photographs that they have already seen published. Pointing to the cover of a national magazine and saying "let's use that one" is easier than starting picture selection from scratch.

Finally, you can become known for a specialization through your stock photographs, and this can eventually lead to assignments. Taking your own stock pictures to potential buyers is as good a way of meeting picture editors as any.

Handling and distribution

From this, it may seem that stock photography is full of opportunities. Unfortunately, it is a sad fact that few photographers make a reasonable living solely from stock sales. In a sense, this is not too surprising; shooting purely for stock means investing time and expenses up-front for a product that nobody has guaranteed to buy. But perhaps the major disadvantage is the high cost of selling stock photographs, and this is related to the difficulties of handling and distribution. If you let a stock agency handle your pictures, they will customarily charge 50 per cent commission, and you will only receive the money once the agency has been paid, which will be after publication, which itself may be several months after the material was submitted. If you handle your stock pictures yourself, you will save paying the large commission, but you will have to bear your own administrative costs and find a way of letting potential clients know what you have in the library.

In general, stock sales seem to work best for those photographers who shoot a large amount of material in the normal course of their careers, and for whom the extra sales are a pleasant bonus. But, with persistence, it may be possible to make it your main activity.

Whatever you decide to do with your stock material, make sure from the start that you retain rights on everything worthwhile that you shoot. This may seem obvious, but there are many situations where the client will want the copyright. Fortunately, this is becoming less common, particularly in the United States, where the new copyright law now gives real protection to the photographer. If you can, avoid situations where the client retains copyright, and assiduously chase up material that clients have finished with. When you are shooting for yourself, it may be tempting to photograph what you think buyers will want, but don't be slavish about this. Naturally, as any stock agent will advise, you should not pass up opportunities that would be saleable, but if you constantly try to double-guess buyers, you may acquire a reputation as a very pedestrian photographer. Remember that your work will normally be credited to you, and it becomes advertisement. If the shot is dull, it will harm your reputation.

The retrieval system

With material, you must devise a workable filing and retrieval system. If you are a compulsive organizer, you may find this a rich source of enjoyment; otherwise, remember that the better you plan this system, the easier it will be to live with. Few photographers have the same systems, and the type of material will often determine the way it should be filed. I keep my stock pictures in standard filing cabinets, with the transparencies in plastic sheets of 24. These are on hangers and are arranged principally by place (country, region or city, depending on the amount of material), but in some instances by subject matter (such as food and still-lifes). Retrieval is essentially by memory. The most logical part of the system is that every transparency and negative has a number, made up of the roll number (which progresses sequentially from 1, the first roll I ever shot) and frame number. Thanks to this, pictures can be referred to accurately, even over the telephone, without resorting to descriptions. All the numbers are logged in notebooks, so that if a buyer asks for a more detailed description of a photograph that is being used, I have it. With hindsight, I would have grouped some of the material differently and the system is not a perfect model of efficiency, but it works. Try to anticipate the kind of material you will eventually have, and make up a sensible arrangement of major headings. If your work is entirely in the studio, filing by type of subject will work best, and the subject headings can be arranged alphabetically.

The supreme advantage of giving your pictures to a stock agency is that this is their sole business. Apart from administrative efficiency, they have regular contact with buyers from all over the world, and can often be more successful in pressing for higher fees. Although I keep some stock pictures myself, I send the majority to an agency. There are many to choose from, and before committing yourself to one, find out if any of them specialize in your kind of material. My agent, Bruce Coleman, is particularly strong in wildlife and geographical subjects, which suits most of my stock work. At the start, most agencies will want to see a submission of at least 200 photographs that are representative of a larger selection, all captioned and named. Once accepted, you can send further batches at regular intervals.

Photographic agencies

The following are among the best-known agencies:

United States

Black Star Inc.,
450 Park Avenue S, New York,
NY 10016
Telephone: 212-679-3288
Woodfin Camp & Associates Inc.,
415 Madison Avenue, New York,
NY 10022
Telephone: 212-355-1855
Bruce Coleman, Inc.,
381 Fifth Avenue, New York, NY 10016
Telephone: 212-683-5227
The Image Bank,
88 Vanderbilt Avenue, The Penthouse,
New York, NY 10017
Telephone: 212-371-3636
Photo Researchers, Inc.,
60 East 56th Street, New York, NY 10022
Telephone: 212-758-3420
A detailed list of picture agents in USA is published in Stock Photo and Assignment Source Book (R. R. Bowker Company).

Great Britain

Bruce Coleman Ltd.,
17 Windsor Street, Uxbridge, Middx
UB8 1AB
Telephone: Uxbridge 32333/36398
Telex: 932439
Colorific Photo Library,
Garden Offices, Gilray House,
Gloucester Terrace, London W2 3DF
Telephone: 01-723-5031
Susan Griggs Agency,
17 Victoria Grove, London W8 5RW
Telephone: 01-584-6738
Pictor International Ltd.,
Lynwood House, 24-32 Kilburn High
Road, London NW6 5XW
Telephone: 01-328 1581
Picturepoint Ltd.,
770 Fulham Road, London SW6 5SJ
Telephone: 01-736-5865
A detailed list of picture agents in Great Britain is published (annually) in The Writers' & Artists' Yearbook (A. & C. Black Ltd.).

Audio-visual

AN AUDIO-VISUAL presentation is a completely different medium for displaying photographs than magazines or a gallery. It uses photographs in deliberate sequence, showing them for limited amounts of time. The audio-visual designer completely controls the way in which the pictures are viewed, and many audio-visual programming techniques are borrowed from the motion picture industry.

A typical audio-visual presentation contains around 150 slides, projected in sequence on to a single screen, using two projectors linked by a dissolve unit. This last refinement permits a smooth flow of images, without the disruptive periods of blank screen that are characteristic of a single projector; it also allows the designer to vary the ways in which one image changes to the next. Dissolve rates may vary from an instant to several seconds, and on some machines it is possible to move backwards and forwards between two slides. It is this ability to mimic film editing, combined with a soundtrack, that gives audio-visual presentations their special nature.

Approach audio-visual programming methodically to avoid sequence and timing errors which can make a presentation incomprehensible. Assuming a typical presentation – including photographs, titles, voice–over, music and sound effects – start with a script, followed by a rough storyboard. As work progresses, both of these can be refined until you have a complete list of slides, a commentary timed by seconds and cue words for slide changes. In the final stages of production, it is normal to record the soundtrack before cueing the slides. Recording time at a sound studio is expensive, so the script should be agreed beforehand. If there are any doubts, it is better to over-record and have all possible script variations on the master tape; the music and sound effects can be added later, and a final cut made at the mixing stage.

Although it is possible to cue the slide changes manually during the presentation, this leaves room for mistakes and overlooks the possibility of a completely pre-programmed presentation that can be run independently. There are several methods of recording the programme, but the most common is to use one band of the soundtrack tape for recording pulses that cue the projectors. The recording is done with a hand control, as if running the actual presentation.

You can use original transparencies for audio-visual presentations, but, as they will be subjected to heavy treatment, it is often better to use duplicates. In any case, titling and special effects normally involve duplicating, and it is important to maintain a consistent quality in the slides in any one sequence. Titles can be separate or superimposed on photographs; in either case, line film gives a high contrast image, and can be used as black lettering, or in negative form as a reversed-out title. Make up the title artwork with instant lettering on white card, and photograph this directly onto line film.

Always check the presentation conditions if you can. The room should be completely dark, as any light spilling onto the screen will degrade the image. As with motion pictures, viewers appreciate only what they see in the show, not the work that went into making it.

Use front-projection whenever possible. Back-projection (through a translucent screen) can give a brighter image because the projector can be placed closer, but there is always a 'hot-spot' in the center.

Ultra-slow dissolve. Between six seconds and about 12 seconds, a dissolve is almost imperceptible. This can be especially effective if you make a match-dissolve, for example from one image to another of the same size and shape.

Exponential dissolve. If you start slowly, gradually increasing the speed of the change, you can introduce an element of surprise into the dissolve. You can make effective use of this if, for example, you are changing from one picture with the focus of attention on the left to a picture

Superimposition. By carefully choosing an appropriate pair of slides, it is possible to create a telling effect by showing both together, but the most common use of superimposition is titling over a photograph.

Production sequence
This can vary according to the amount of control needed. With some subjects, the presentation can be completely laid out before shooting; in other cases,

Basic programming guide. Try not to mix formats, unless it is for deliberate effect. Changing from horizontal to vertical is a common mistake and destroys the flow of images. The very method of changing from one image to the next introduces a completely new element. Some of the basic slide changes are outlined below.

Slow dissolve. At around four seconds, the rate of dissolve can be used to create a relaxed and tranquil mood, well-suited to many landscapes, for instance. As an experiment, take a well-known piece of music, such as Vivaldi's 'Four Seasons', and, using appropriate scenic transparencies from stock, match the rates of change to the music.

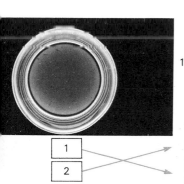

th the focus on the right. The slow start the dissolve is not noticed immediately, t the rapid end to the change snaps the :wer's attention across the screen.

Fast dissolve. This is the workhorse of slide programming. Fast dissolves create a sense of urgency and immediacy, and are the programmer's answer to fast music and themes involving action. Many events that include people, such as a conversation, require this treatment. Also, if you have to show a large quantity of slides in a limited space of time, this may be the only solution.

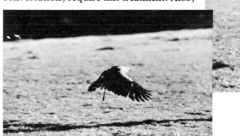

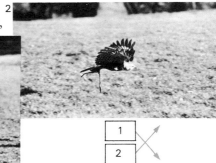

Animation. By oscillating the slider on a manual control backwards and forwards, *without* hitting the change switches at either end, the two pictures can be made to flicker. If the images show repetitive action – for example, a hammer hitting a nail – this useful trick will convincingly animate the sequence. This facility is only available on some dissolve units.

you should be more flexible. The following list gives an approximate guide to the best sequence of events:
1. Story outline
2. Rough script
3. Rough storyboard
4. Shooting storyboard
5. Photography
6. Final storyboard
7. Slide editing, mounting and titling
8. Voice-over recording
9. Music and effects recording
10. Soundtrack mixing
11. Programming
12. Release.

Glossary

A

Aberration. Lens fault in which light rays are scattered, thereby degrading the image. There are different forms of aberration, such as chromatic and spherical aberration, coma, astigmatism and field curvature.

Achromatic lens. A lens constructed of different types of glass, to reduce chromatic aberration. The simplest combination is of two elements, one of flint glass, the other of crown glass.

Acutance. The objective measurement of how well an edge is recorded in a photographic image.

Additive process. The process of combining lights of different colors. A set of three primary colors combined equally produces white.

Aerial perspective. The impression of depth in a scene that is conveyed by haze.

Anastigmat. A compound lens, using different elements to reduce optical aberrations.

Angle of view. The widest angle of those light rays accepted by a lens that form an acceptably sharp image at the film plane. This angle is widest when the lens is focused at infinity.

Angstrom. Unit used to measure light wavelengths.

Aperture. In most lenses, the aperture is an adjustable circular hole centered on the lens axis. It is the part of the lens system that admits light.

ASA. Arithmetically progressive rating of the sensitivity of a film to light (American Standards Association). ASA 200 film, for example, is twice as fast as ASA 100 film.

Astigmatism. A lens aberration in which light rays that pass obliquely through a lens are focused, not as a point but as a line. Astigmatism is normally found only in simple lenses.

Automatic exposure control. Camera system where the photo-electric cell that measures the light reaching the film plain is linked to the shutter or lens aperture to adjust the exposure automatically.

B

Back lighting. Lighting from behind the subject directed towards the camera position.

Barrel distortion. A lens aberration in which the shape of the image is distorted. The magnification decreases radially outwards, so that a square object appears barrel-shaped, with the straight edges bowed outwards.

Bas-relief. A method of producing images that appear to stand out slightly in relief. It is produced by sandwiching a positive and negative of the same image slightly out of register, and then printing the combination.

Base. The support material for an emulsion – normally plastic or paper.

Between-the-lens shutter. A leaf shutter located inside a compound lens, as close as possible to the aperture diaphragm.

Bounce flash. Diffusion of the light from a flash unit, by directing it towards a reflective surface, such as a ceiling or wall. This scatters the light rays, giving a softer illumination.

Bracketing. A method of compensating for uncertainties in exposure, by making a series of exposures of a single subject, each varying by a progressive amount from the estimated correct aperture/speed setting.

Brightfield illumination. The basic lighting technique for photomicrography, directing light through a thin section of the subject. In effect, a form of backlighting.

Brightness. The subjective impression of luminance.

C

Camera shake. Unintentional movement of the camera during exposure, causing unsharpness in the image.

CdS cell. Cadmium sulfide cell used commonly in through-the-lens light meters. Its proportionate resistance to the quantity of light received is the basis of exposure measurement.

Center of curvature. The center of an imaginary sphere of which the curved surface of a lens is a part.

Characteristic curve. Curve plotted on a graph from two axes – exposure and density – used to describe the characteristics and performance of sensitive emulsions.

Chromatic aberration. A lens aberration in which light of different wavelengths (and therefore colors) is focused at different distances behind the lens. It can be corrected by combining different types of glass.

Circle of confusion. The disc of light formed by an imaginary lens. When small enough, it appears to the eye as a point, and at this size the image appears sharp.

Coating. A thin deposited surface on a lens, used to reduce flare.

Color compensating filter. Filter used to alter the color of light. Available in primary and complementary colors at different strengths.

Color contrast. Subjective impression of the difference in intensity between two close or adjacent colors.

Color conversion filter. Colored filter that alters the color temperature of light.

Color coupler. A chemical compound that combines with the oxidizing elements of a developer to form a colored dye. It is an integral part of most color film processing.

Color temperature. The temperature to which an inert substance would have to be heated in order for it to glow at a particular color. The scale of color temperature significant for photography ranges from the reddish colors of approximately 2000°K through standard 'white' at 5400°K, to the bluish colors above 6000°K.

Coma. A lens aberration in which off-axis light rays focus at different distances when they pass through different areas of the lens. The result is blurring at the edges of the picture.

Complementary colors. A pair of colors that, when combined together in equal proportions, produce white light (by means of the additive process).

Compound lens. Lens constructed of more than one element, which enables various optical corrections to be made.

Condenser. Simple lens system that concentrates light into a beam.

Contact sheet. A print of all the frames of a roll of film arranged in strips, same-size, from which negatives can be selected for enlargement.

Contrast. Difference in brightness between adjacent areas of tone. In photographic emulsions, it is also the rate of increase in density measured against exposure.

Converging lens. Lens which concentrates light rays towards a common point. Also known as a convex lens.

Covering power. The diameter of usable image produced at the focal plane by a lens when focused at a given distance.

D

Darkfield illumination. Lighting technique used in photomicrography, where the subject is lit from all sides by a cone of light directed from beneath the subject.

Definition. The subjective effect of graininess and sharpness combined.

Density. In photographic emulsions, the ability of a developed silver deposit to block transmitted light.

Depth of field. The distance through which the subject may extend and still form an acceptably sharp image, in front of and beyond the plane of critical focus. Depth of field can be increased by stopping the lens down to a smaller aperture.

Depth of focus. The distance through which the film plane can be moved and still record an acceptably sharp image.

Diaphragm. An adjustable opening that controls the amount of light passing through a lens.

Diffraction. The scattering of light waves that occurs when they strike the edge of an opaque surface.

Diffuser. Material that scatters transmitted light.

DIN. Logarithmically progressive rating of the sensitivity of a film to light (Deutsche Industrie Norm).

Diopter. Measurement of the refractive ability of a lens. It is the reciprocal of the focal length, in meters; a convex lens is measured in positive diopters, a concave lens in negative diopters.

Diverging lens. Lens which causes light rays to spread outwards from the optical axis.

Dye cloud. Zone of color in a developed color emulsion at the site of the developed silver grain, which itself has been bleached out during development.

Dye transfer process. Color printing process that uses color separation negatives which in turn produce matrices that can absorb and transfer colored dyes to paper.

E

Electromagnetic spectrum. The range of frequencies of electromagnetic radiation, from radio waves to gamma rays, including visible radiation (light).

Electron. An elementary particle with a negative charge, normally in orbit around an atomic nucleus.

Electronic flash. Artificial light source produced by passing a charge across two electrodes in a gas.

Emulsion. Light-sensitive substance composed of halides suspended in gelatin, used for photographic film and paper.

Exposure. In photography, the amount of light reaching an emulsion, being the product of intensity and time.

Exposure latitude. For film, the increase in exposure that can be made from the minimum necessary to record shadow detail, while still presenting highlight detail.

Extension. A fixed or adjustable tube placed between the lens and camera body, used to increase the magnification of the image.

F

f-stop. The notation for relative aperture which is the ratio of the focal length to the diameter of the aperture. The light-gathering power of lenses is usually described by the wider f-stop they are capable of, and lens aperture rings are normally calibrated in a standard series: f1, f1.4, f2, f2.8, f4, f5.6, f8, f11, f16, f22, f32 and so on, each of these stops differing from its adjacent stop by a factor of 2.

Field curvature. In this lens aberration, the plane of sharpest focus is a curved surface rather than the flat surface needed at the film plane.

Film speed rating. The sensitivity of a film to light, measured on a standard scale, normally either ASA or DIN.

Filter. Transparent material fitted to a lens alters the characteristics of light passing through it, most commonly in color.

Fish-eye lens. A very wide-angle lens characterized by extreme barrel distortion.

Flare. Non-image-forming light caused by scattering and reflection, that degrades the quality of an image. Coating is used to reduce it.

Flash. See electronic flash.

Flash guide number. Notation used to determine the aperture setting when using electronic flash. It is proportionate to the output of the flash unit.

Flash synchronization. Camera system that ensures that the peak light output from a flash unit coincides with the time that the shutter is fully open.

Fluorescent lighting. Vapor discharge lighting in which the inside of the lamp's jacket is coated with phosphors. These add a continuous spectrum to the single emission spectra. The color recorded on film is difficult to predict, depending on the type and age of lamp, but is generally greenish.

Focal length. The distance between the center of a lens (the principal point) and its focal point.

Focal plane. The plane at which a lens forms a sharp image.

Focal plane shutter. Shutter located close to the focal plane, using two blinds that form an adjustable gap which moves across the film area. The size of the gap determines the exposure.

Focal point. The point on either side of a lens where light rays entering parallel to the axis converge.

Focus. The point at which light rays are converged by a lens.

Fresnel screen. A viewing screen that incorporates a Fresnel lens. This has a stepped convex surface that performs the same function as a condenser lens, distributing image brightness over the entire area of the screen, but is much thinner.

G

Gamma. Measure of the steepness of an emulsion's characteristic curve being the tangent of the acute angle made by extending the straight line position of the curve downwards until it meets the horizontal axis. Average emulsions averagely developed have a gamma of about 0.8, while high contrast films have a gamma greater than 1.0.

Gelatin. Substance used to hold halide particles in suspension, in order to construct an emulsion. This is deposited on a backing.

Grade. Clarification of photographic printing paper by contrast. Grades 0 to 4 are the most common, although they are not precisely comparable across makes.

Grain. An individual light-sensitive crystal, normally of silver bromide.

Graininess. The subjective impression when viewing a photograph of granularity under normal viewing conditions. The eye cannot resolve individual grains, only overlapping clumps of grains.

Granularity. The measurement of the size and distribution of grains in an emulsion.

Ground glass screen. Sheet of glass finely ground to a translucent finish on one side, used to make image focusing easier when viewing.

Gyro stabilizer. Electrically-powered camera support that incorporates a heavy gyroscope to cushion the camera from vibrations. Particularly useful when shooting from helicopters, cars and other vehicles.

H

Hardener. Chemical agent – commonly chrome or potassium alum – that combines with the gelatin of a film to make it more resistant to scratching.

Hyperfocal distance. The minimum distance at which a lens records a subject sharply when focused at infinity.

Hypo. Alternative name for fixer, sodium thiosulfate.

Hypo eliminator. Chemical used to clear fixer from an emulsion to shorten washing time.

I

Incident light reading. Exposure measurement of the light source that illuminates the subject (of refracted light reading). It is therefore independent of the subject's own characteristics.

Infra-red radiation. Electromagnetic radiation from 730 nanometers to 1mm, longer in wavelength than light. It is emitted by hot bodies.

Intensifier. Chemical used to increase the density or contrast of an image or an emulsion. Particularly useful with too-thin negatives.

Inverse Square Law. As applied to light, the principle that the illumination of a surface by a point source of light is proportional to the square of the distance from the source to the surface.

Ion. An atom or group of atoms with a positive or negative charge, because of too few electrons (positive) or too many (negative).

J

Joule. Unit of electronic flash output, equal to one watt-second. The power of different units can be compared with this measurement.

K

Kelvin. The standard unit of thermodynamic temperature, calculated by adding 273 to degrees centigrade.

L

Latent image. The invisible image formed by exposing an emulsion to light. Development renders it visible.

Lens. A transparent device for converging or diverging rays of light by refraction. Convex lenses are thicker at the center than at the edges; concave lenses are thicker at the edges than at the center.

Lens axis. A line through the center of curvature of a lens.

Lens flare. Non-image forming light reflected from lens surfaces that degrades the quality of the image.

Lens shade. Lens attachment that shades the front element from non-image forming light that can cause flare.

Line film. Very high contrast film, which can be developed so that the image contains only full-density black, with no intermediate tones.

Long-focus lens. Lens with a focal length longer than the diagonal of the film format. For 35mm film, anything longer than about 50mm is therefore long-focus, although in practice the term is usually applied to lenses with at least twice the standard focal length.

Luminance. The quantity of light emitted by or reflected from a surface.

M

Masking. Blocking specific areas of an emulsion from light. For example, a weak positive image, when combined with the negative, can be used to mask the highlights so as to produce a less contrasty print.

Matrix. Sheet of film used in the dye transfer process that carries a relief image in gelatin. This is temporarily dyed when printing.

Mean noon sunlight. An arbitrary but generally accepted color temperature to which most daylight color films are balanced – 5400° Kelvin, being the average color temperature of direct sunlight at midday in Washington DC.

Mercury vapor lamp. Form of lighting sometimes encountered in available light photography. It has a discontinuous spectrum and reproduces as blue-green on color film.

Mired value. A measurement of color temperature that facilitates the calculation of differences between light sources. It is the reciprocal of the Kelvin measurement $\frac{\text{one million}}{\text{Kelvins}}$

Mirror lens. Compound lens that forms an image by reflection from curved mirrors rather than by refraction through lenses. By folding the light paths, its length is much shorter than that of traditional lenses of the same focal length.

Monopod. Single leg of a tripod, as a lightweight camera support for handheld shooting.

N

Nanometer. 10^{-9} meter.

Negative. Photographic image with reversed tones (and reversed colors if color film), used to make a positive image, normally a print by projection.

Neutral density. Density that is equal across all visible wavelengths, resulting in an absence of color.

Normal lens. Lens with a focal length equal to the diagonal of the film format. It produces an image which appears to have normal perspective and angle of view.

O

Open flash. Method of illuminating a subject with a flash unit, by leaving the camera shutter open, and triggering the flash discharge manually.

Optical axis. Line passing through the center of a lens system. A light ray following this line would not be bent.

Orthochromatic film. Film that is sensitive to green and blue light, but reacts weakly to red light.

P

Panchromatic film. Film that is sensitive to all the colors of the visible spectrum.

Panning. A smooth rotation of the camera so as to keep a moving subject continuously in frame.

Parallax. The apparent movement of two objects relative to each other when viewed from different positions.

Pentaprism. Five-sided prism, which rectifies the image left-to-right and top-to-bottom.

Photo-electric cell. Light sensitive cell used to measure exposure. Some cells produce electricity when exposed to light; others react to light by offering an electrical resistance.

Photoflood. Over-rated tungsten lamp used in photography, with a color temperature of $3400°K$.

Photomacrography. Close-up photography with magnifications in the range of $\times 1$ to $\times 10$.

Photomicrography. Photography at great magnifications using the imaging systems of a microscope.

Photon. A quantum of light and other electromagnetic radiation, treated as an elementary particle.

Pincushion distortion. A lens aberration in which the shape of the image is distorted. The magnification increases radially outwards, and a square object appears in the shape of a pincushion, with the corners 'stretched'.

Polarization. Restriction of the direction of vibration of light. Normal light vibrates at right angles to its direction of travel in every plane; a plane-polarizing filter (the most common in photography) restricts this vibration to one plane only. There are several applications, the most usual being to eliminate reflections from water and non-metallic surfaces.

Posterization. Darkroom technique that converts an image into areas of flat single tones, using tone separations.

Primary colors. A set of any three colors that, when mixed together can be used to make any other color, and when mixed together in equal proportions produce either white (by the additive process) or black (by the subtractive process). Red, green and blue are one set of primary colors; cyan, magenta and yellow are another.

Printing-in. Photographic printing technique of selectively increasing exposure over certain areas of the image.

Prism. Transparent substance shaped so as to refract light in a controlled manner.

Process lens. Flat-field lens designed to give high resolution of the image on a flat plane. This is achieved at the expense of depth of field, which is always shallow.

Programmed shutter. Electronically operated shutter with variable speeds that is linked to the camera's TTL meter. When a particular aperture setting is selected, the shutter speed is automatically adjusted to give a standard exposure.

R

Rangefinder. Arrangement of mirror, lens and prism that measures distance by means of a binocular system. Used on direct viewfinder cameras for accurate focusing.

Reciprocity failure (reciprocity effect). At very short and very long exposure, the reciprocity law ceases to hold true, and an extra exposure is needed. With color film, the three dye layers suffer differently, causing a color cast. Reciprocity failure differs from emulsion to emulsion.

Reciprocity Law. EXPOSURE = INTENSITY \times TIME. In other words, the amount of exposure that the film receives in a camera is a product of the size of the lens aperture (intensity) and the shutter speed (time).

Reducer. Chemical used to remove silver from a developed image, so reducing density. Useful for over-exposed or over-developed negatives.

Reflected light reading. Exposure measurement of the light reflected from the subject (cf incident light reading). Through-the-lens meters use this method, and it is well-suited to subjects of average reflectance.

Reflector. Surface used to reflect light. Usually, it diffuses the light at the same time.

Refraction. The bending of light rays as they pass from one transparent medium to another when the two media have different light-transmitting properties.

Relative aperture. The focal length of a lens divided by the diameter of the entrance pupil, normally recorded as f-stops, eg a 50mm lens with a maximum aperture opening 25mm in diameter has a relative aperture of f4 .

Resolution. The ability of a lens to distinguish between closely-spaced objects, also known as resolving power.

Reticulation. Crazed effect on a film emulsion caused by subjecting the softened gelatin to extremes of temperature change.

Reversal film. Photographic emulsion which, when developed, gives a positive image (commonly called a transparency). So called because of one stage in the development when the film is briefly re-exposed, either chemically or to light thus reversing the image which would otherwise be negative.

Rifle stock. Camera support that enables a camera normally with a long lens, to be hand-held more securely, in the same manner as a rifle.

S

Sabattier effect. Partial reversal of tone (and color when applied to a color emulsion) due to brief exposure to light during development of an emulsion.

Safelight. Light source used in a darkroom with a color and intensity that does not affect the light-sensitive materials for which it is designed.

Scoop. Smoothly curving studio background, used principally to eliminate the horizon line.

Selenium cell. Photo-electric cell which generates its own electricity in proportion to the light falling on it.

Sensitivity. The ability of an emulsion to respond to light.

Sensitometry. The scientific study of light sensitive materials and the way they behave.

Separation negative. Black-and-white negative exposed through a strong colored filter to record an image of a selected part of the spectrum, normally one-third. Used in dye transfer printing, and also in non-photographic printing.

Shading. Photographic printing technique where light is held back from selected parts of the image.

Sharpness. The subjective impression when viewing a photograph of acutance.

Short-focus lens. Lens with a focal length shorter than the diagonal of the film format. For the 35mm format, short-focus lenses generally range shorter than 35mm.

Shutter. Camera mechanism that controls the period of time that image-focusing light is allowed to fall on the film.

Single lens reflex. Camera design that allows the image focused on the film plane to be pre-viewed. A hinged mirror that diverts the light path is the basis of the system.

Slave unit. Device that responds to the light emission from one flash unit, to activate additional flash units simultaneously.

Snoot. Generally, cylindrical fitting for a light

source, used to throw a circle of light on the subject.

Soft-focus filter. A glass filter with an irregular or etched surface that reduces image sharpness and increases flare, in a controlled fashion. Normally used for flattering effect in portraiture and beauty shots.

Solarization. Reversal of tones in an image produced by greatly overexposing the emulsion. A similar appearance can be created by making use of the Sabattier effect.

Spherical aberration. In this aberration, light rays from a subject on the lens axis passing through off-center areas of the lens focus at different distances from the light rays that pass directly through the center of the lens. The result is blurring in the center of the picture.

Split-field filter. Bi-focal filter, the top half of which consists of plain glass, the lower half being a plus-diopter lens that allows a close foreground to be focused at the same time as the background.

Spot meter. Hand-held exposure meter of great accuracy, measuring reflected light over a small, precise angle of view.

Stop bath. Chemical that neutralizes the action of the developer on an emulsion, effectively stopping development.

Subtractive process. The process of combining colored pigments, dyes or filter, all of which absorb light. Combining all three primary colors in this way produces black (an absence of light).

T

Test strip. Test of various exposures made with an enlarger.

Through-the-lens (TTL) meter. Exposure meter built in to the camera, normally located close to the instant-return mirror of a single lens reflex or to the pentaprism.

Tone. Uniform density in an image.

Tone separation. The isolation of areas of tone in an image, normally by the combination of varying densities of line positives and negatives.

Toner. Chemicals that add an overall color to a processed black-and-white image, by means of bleaching and dyeing.

Transparency. Positive image on a transparent film base, designed to be viewed by transmitted light.

Tri-chromatic. Method of reusing or reproducing specific colors by the variable combination of only three equally distributed wavelengths, such as blue, green, red or yellow, magenta, cyan.

Tri-pack film. Color film constructed with three layers of emulsion, each sensitive to a different color. When exposed equally, the three colors give white.

Tungsten-halogen lamp. Tungsten lamp of improved efficiency, in which the filament is enclosed in halogen gas, which causes the vaporized parts of the filament to be re-deposited on the filament rather than on the envelope.

Tungsten lighting. Artificial lighting caused by heating a filament of tungsten to a temperature where it emits light.

U

Ultra-violet radiation. Electromagnetic radiation from 13 to 397 nanometers, shorter in wavelength than light. Most films, unlike the human eye, are sensitive to ultra-violet radiation.

V

Vapor discharge lighting. Artificial lighting produced by passing an electric current through gas at low pressure in a glass envelope.

Variable contrast paper. Printing paper with a single emulsion which can be used at different degrees of contrast by means of selected filters.

Viewfinder. Simple optical system used for viewing the subject.

W

Wavelength of light. The distance between peaks in a wave of light. This distance, among other things, determines the color.

Wetting agent. Chemical that weakens the surface tension of water, and so reduces the risk of drying marks on film.

Wide-angle lens. Lens with an angle of view wider than that considered subjectively normal by the human eye (ie more than about 50°). Wide angles of view are characteristic of lenses with short focal lengths.

Z

Zone System. A method of evaluating exposure, with implications for the photographic approach to a subject, developed by Ansel Adams, Minor White and others. Light measurement is converted to exposure settings by dividing the tonal range into specific numbered zones.

Zoom lens. Lens with a continuously variable focal length over a certain range at any given focus and aperture. It is generated by differential movement of the lens elements.

Index

Figures in **bold type** denote a major text
 entry.

Bibliography and credits

Bibliography

Ansel Adams, Morgan & Morgan, New York.
Ansel Adams, *Basic Photographic Theories*, Morgan & Morgan, New York.
Ansel Adams, *Camera and Lens: The Creative Approach*, Morgan & Morgan, New York.
Ansel Adams, *Natural Light Photography*, Morgan & Morgan, New York.
Ansel Adams, *The Negative: Exposure and Development*, Morgan & Morgan, New York.
Ansel Adams, *The Print*, Morgan & Morgan, New York.
Diane Arbus, Aperture, New York.
Richard Avedon, *Avedon Photographs 1974–1977*, Farrar, Straus & Giroux Inc, New York.
Bill Brandt, *The Shadow of Light*, Gordon Fraser, London.
Henri Cartier-Bresson, *The Decisive Moment*, Simon & Schuster, New York.
L. P. Clerc, *Photography: Theory and Practice*, Focal Press, London.
The Concerned Photographer, Grossman Publishers, New York.
O. R. Croy, *The Complete Art of Printing and Enlarging*, Focal Press, London.
Eliot Elisofon, *Colour Photography*, Thames & Hudson, London.
Harold Evans, *Pictures on a Page*, Heinemann, London.
Andreas Feininger, Morgan & Morgan, New York.
Focal Encyclopaedia of Photography, Focal Press, London.
Helmut and Alison Gernsheim, *The History of Photography from The Camera Obscura to the Beginning of the Modern Era*, McGraw-Hill, New York.
Great Photographic Essays From Life, Time-Life Books.
Ernst Haas, *The Creation*, Viking, New York.
Ernst Haas, *In America*, Viking, New York.
D. H. O. John, Photography on Expeditions, Focal Press, London.
Kodak, *Close-up Photography and Photomacrography*, Eastman Kodak, US.
Kodak, *Creative Darkroom Techniques*, Eastman Kodak, US.
Kodak, *Kodak Color Films*, Eastman Kodak, US.
Kodak, *Kodak Filters for Scientific and Technical Uses*, Eastman Kodak, US.
Kodak, *More Special Effects for Reproduction*, Eastman Kodak, US.
Kodak, *Notes on Tropical Photography*, Eastman Kodak, US.
Kodak, *Photography from Light Planes and Helicopters*, Eastman Kodak, US.
Kodak, *Photography Through The Microscope*, Eastman Kodak, US.
Kodak, *Photography Under Arctic Conditions*, Eastman Kodak, US.
Kodak, *Photomicrography*, Eastman Kodak, US.
Hugo van Lawick, *Savage Paradise*, Collins, London.
Neil Leifer, *Sport*, Harry N. Abrams Inc, New York.
Life Library of Photography, Time-Life Books.
Les Line, *The Audubon Society of Wild Birds*, Harry N. Abrams, New York.
Les Line, *The Audubon Society Book of Wildflowers*, Harry N. Abrams, New York.
Les Line, *The Audubon Society Book of Wild Animals*, Harry N. Abrams, New York.
Don McCullin, *Is Anyone Taking Any Notice?*, MIT Press, US.
Eadweard Muybridge, *Animals in Motion*, Dover, New York.
Helmut Newton, *White Women*, Stonehill Publishing, US.
The Persuasive Image: Art Kane, Morgan & Morgan, New York.
Paul Petzold, *Effects and Experiments in Photography*, Focal Press, London.
Ernest M. Pittaro, *Photo-Lab Index*, Morgan & Morgan, New York.
Flip Schulke, *Underwater Photography for Everyone*, Prentice-Hall, US.
Susan Sontag, *On Photography*, Farrar, Straus, & Giroux, Inc, New York.
Edward Steichen, *The Family of Man*, The Museum of Modern Art, New York.
John Szarkowski, *Looking At Photographs*, The Museum of Modern Art, New York.
The Techniques of Photography, Time-Life Books.
Minor White, *The Zone System Manual*, Morgan & Morgan, New York.
The World of Camera, Thomas Nelson, London.
The World of Cartier-Bresson, Gordon Fraser, London.
Worlds Within Worlds, Secker & Warburg, London.

I would like to thank the many individuals and organizations who have helped in the preparation of this book. I received valuable professional advice and comments from Bruce Coleman, my agent; Caroline Despard of *The Smithsonian Magazine*; Lou Klein and Pamela Marke of Time-Life Books (London); Kodak Ltd; Stephen Peltz; and Alan Sutton. Photographic services and equipment were supplied by Downtown (London); Kiran Genty of Studio 287 (London); Keith Johnson Photographic (London); Paulo Colour Processing (London); Penn Cameras (Washington DC); Roger Pring; Tantrums (London); and Westminster Hospital (London). Holographic Developments Ltd (London) supplied laser equipment and the Moving Picture Company (London) allowed me the use of their telecine and video facilities.

In addition, my special thanks are due to Stephen Frank and his falcons; His Excellency Granman Gazon of the Ndjuka People, Richène Libretto and André Pakosie for their help with the assignment in Surinam; David Larkin of Pan Books; Michael Mann for the re-touching work on page 277; Joyce Mason for the calligraphy on page 208; NASA for help in visiting their facilities in Houston and Huntsville; Sujit Sen-Gupta; Andy Stewart, President of Harry N. Abrams Inc; Boontham Tehpahwan, my guide in northern Thailand; Margaret Thoren, editor of *The Banker's Magazine*; and the US Travel Service for frequent help in visiting several American national parks.

Michael Freeman

Photographs were all taken by Michael Freeman with the exception of the following: **146–149** Don McCullin. **178** Bill West (Biophoto Associates). **180** Kim Taylor (Bruce Coleman). **181** Manfred Kage (Bruce Coleman), Dr Frieder Sauer (Bruce Coleman). **182** Peter Scoones (Seaphot). **185** Soames Summerhays (Heather Angel), Bill Wood (Bruce Coleman), Warren Williams (Seaphot), John Kenfield (Bruce Coleman). **187** Warren Williams (Seaphot). **188** Anthony Howarth and Alexander Low (Daily Telegraph Picture Library), Walter Iooss (*Sports Illustrated*). **190** Gerry Cranham, John Zimmerman (*Sports Illustrated*), Neil Leifer (*Sports Illustrated*). **192** Richard Cooke. **194** Harold E. Edgerton. **203** Skyscrapers and Gargoyle by Tony Weller, Brickwork by David Kilpatrick. **217** Snowdon. **218** and **219** Arnold Newman. **223** David Bailey (Condé Nast Publications). **224** Willie Christie. **226** and **227** Vince Loden. **240** and **241** Robert Golden.